Art criticism and its institutions in nineteenth-century France

EDITED BY
MICHAEL R. ORWICZ

MANCHESTER UNIVERSITY PRESS
MANCHESTER AND NEW YORK

distributed exclusively in the USA and Canada by St. Martin's Press

Published by Manchester University Press
Oxford Road, Manchester M13 9PL, UK
and Room 400, 175 Fifth Avenue,
New York, NY 10010, USA

Distributed exclusively in the USA and Canada
by St. Martin's Press, Inc.,
175 Fifth Avenue, New York, NY 10010, USA

British Library Cataloguing-in-Publication Data
A catalogue record is available from the British Library

Library of Congress Cataloging-in-Publication Data

Art criticism and its institutions in nineteenth-century France /
 edited by Michael R. Orwicz.
 p. cm.
 Includes bibliographical references.
 ISBN 0-7190-3859-6. – ISBN 0-7190-3860-X (pbk.)
 1. Art criticism – France – History – 19th century. 2. Art criticism – Social
aspects – France. 3. Art criticism – Political aspects – France. I. Orwicz,
Michael R.
 N7485.F8A78 1994
 701'.18'094409034 – dc20 93-46023

ISBN 0 7190 3859 6 *hardback*
ISBN 0 7190 3860 X *paperback*

Printed in Great Britain
by Redwood Books, Trowbridge

Art criticism and its institutions
in nineteenth-century France

Contents

Contributors

Dario Gamboni is Professor of Art History at the University of Lyon II and a member of the Institut Universitaire de France. He is the author of *La Plume et le pinceau. Odilon Redon et la littérature, Un iconoclasme moderne. Théorie et pratiques contemporaines du vandalisme artistique*, and numerous articles on art criticism in nineteenth-century France.

Anne Higonnet teaches in the Art Department of Wellesley College. She is author of *Berthe Morisot. A biography, Berthe Morisot's Images of Women* and a dozen essays on aspects of nineteenth- and twentieth-century visual culture. She is currently working on a book about private art museums between the revolutions of 1848 and the Second World War.

Anne Larue is an Associate Professor at the Université de Reims. She is the editor of an anthology of criticism on Eugène Delacroix and is currently researching the links between painting and literature in the nineteenth century.

Ségolène Le Men is a research fellow in the CNRS, attached to the Musée d'Orsay, where she has organised exhibitions on the printed image. She has published on French Romantic book illustration, the history of children's books and visual pedagogy. Her publications include *Les Abécédaires français illustrés au XIXe siècle*, and (with Luce Abéles) *Les Français peints par eux-mêmes, Panorama social du dix-neuvième siècle*.

Neil McWilliam is a Lecturer in Art History at the University of East Anglia. His publications have covered various aspects of nineteenth-century French art and culture, concentrating on the July Monarchy and the 1848 revolution. He is the author of *A Bibliography of Salon Criticism in Paris from the July Monarchy to the Second Republic 1831–1850*, and *Dreams of Happiness. Social Art and the French Left 1830–1850*. He was a founding editor of the *Oxford Art Journal* and editor of *Art History*.

Linda Nochlin is the Lila Acheson Wallace Professor of Modern Art at the Institute of Fine Art, New York University, and is best known for her work on Realism, Gustave Courbet and questions of gender and

power in the nineteenth and twentieth centuries. Her books include *Realism, Women, Art and Power and Other Essays, The Politics of Vision*, the exhibition catalogue *Courbet Reconsidered, Realism and Tradition in Art, 1848 – 1900* and *Impressionism and Post-Impressionism, 1874 – 1902*.

Michael R. Orwicz is an Associate Professor of Art History at the University of Connecticut. His publications have focused on art criticism in late nineteenth-century France, state formation and visual culture in the early Third Republic, and visual representations of Brittany. He is author of the forthcoming book *The Spectacle of Brittany: Painting and the Politics of Culture in the Early Third Republic.*

Adrian Rifkin has recently published *Street Noises, Parisian Pleasure 1900 – 1940*, and has written numerous articles and broadcasts on French popular culture and aesthetics in the nineteenth and twentieth centuries. He is Professor and Head of the Department of Fine Art at the University of Leeds.

Susan L. Siegfried is a specialist in late-eighteenth and early-nineteenth-century French art. Her publications include the catalogue *Works by J.-A.-D. Ingres in the Collection of the Fogg Art Museum* and a number of articles on such subjects as spectatorship and *trompe l'oeil*, documentation and the rhetoric of battle painting, and entrepreneurial practices of artists. She is currently completing a book entitled *Boilly: The Painter of Modern Life in Post-revolutionary France*. As a Research Projects Manager at the Getty Center, she has also been exploring the role played by computer technology in the humanities.

Martha Ward is Associate Professor of Art History at the University of Chicago. She is author of *Pissarro, Neo-Impressionism and the Spaces of the Avant-Garde*, and co-author with Christopher Parsons of *A Bibliography of Salon Criticism in Second Empire Paris*. Her most recent work has focused on nineteenth-century exhibition installations and the history of viewing practices.

Introduction

MICHAEL R. ORWICZ

Art criticism has always held a marginal place in the discourses of art history. It occupied virtually no space in earlier conventional studies centered on an artist's career, on the development of style, on iconography or even those studies concerned with the broader considerations of the cultural history of art. As art criticism was given a place, the established tradition was to presume that 'the critics'' interpretations were themselves formulated in their direct engagement with the work of art, and functioned simply as a reflection of the art that the discipline so unyieldingly held at center stage. Inscribed in this conception of the history of art as the history of works of art, criticism acquired two principal roles. On the one hand, it served as a gauge of *la fortune critique* that an individual artist or art work obtained. Taking the form of a series of anecdotes or other decontextualised fragments of text, art criticism functioned here essentially as a measure of the artists' agency, their originality or intent, or as a means of verifying a work's prominence within a movement, the character of its innovation, or its claim to disrupting conventional paradigms within the artistic field. In this rhetoric, which finds an echo in art-historical modernism, it was 'the critics'' negative judgement – their undifferentiated monologue of shock and hostility – that was invariably given the most weight. For this discourse was read as proof of the *mis*interpretation of art and artist so essential to maintaining art history's construction of an *avant-garde*, and the implicit hierarchy of modernist values that followed.

The other space to which art criticism has traditionally been consigned is to a nebulous history of taste. Here, and Lionello Venturi is a particularly good example, 'the critics'' aesthetic judgments are seen merely to reflect broader changes in style, and to indicate the qualities that a work or artist shared with a 'period style', a theme or a body of datable technical mutations.[1] Here too, the presumed homogeneity of 'the critics'' discourse was only

occasionally disrupted by the emergence of a singular voice, the gifted critic who 'got it right', from Diderot or Baudelaire, right down to Clement Greenberg. This constructed hierarchy among critics, generally established through such contemporary standards as the literary quality of their judgements or the degree to which they approximated current aesthetic values, was also underpinned by an assumed homology between art-critical discourse and the object which it so transparently describes. Since the overriding objective of art criticism here has been to illuminate works of art or artists, its authority, legitimacy and indeed its very 'truth' have ultimately been seen to be embedded in the work itself. And the closer that criticism came to confirming the perceived historical significance that the artwork or artist played in art history's scenarios, the greater the value its knowledge was considered to have been.

The work of T. J. Clark and Nicos Hadjinicolaou has, of course, singularly disrupted these conceptions of art criticism.[2] Focusing on the conjuncture between visual representation and the social and political relations of a specific historical moment, their studies were the first to stress the complex role that art criticism plays in negotiating the relationships between culture on the one hand, and a range of social and ideological formations on the other. In different ways, they immediately dispelled that comfortably uni-lateral rapport that criticism had maintained with art by inscribing 'the critics'' referents well within a much broader network of social and political discourses. The language of criticism was now con-stituted as a key site that made manifest the intricate layering of a multiplicity of discourses – at once social *and* sexual, political *and* aesthetic – to which art could, often obliquely and always in particular historical circumstances, give rise. While for both Clark and Hadjinicolaou, an explicit interrogation of the theoretical and methodological terrain in which criticism itself might be situated remained largely outside their principal objectives, many of the subsequent uses to which art criticism has been put by both art-historical and cultural studies originated in an often dialogical relationship with their work. The theoretical and historical concerns that underpin the essays presented in this collection certainly begin there.

More recent references to the 'critical reception' of a work of art or artist have not only become entirely routine in the field of art history, but have come to play an indispensable part in studies of nineteenth-century issues that consider themselves critical. To a large extent, the trend follows on the heels of that more generalised tendency toward greater 'contextualisation' of art's

histories that has finally permeated the discipline. Yet with few exceptions, attempts to draw at least some of the diversity and complexity of criticism into the discourses of art history have produced very uneven results, at least where problematising the enterprise of art criticism is concerned. At the most general level, one outcome has been the emergence of discrete studies of a single picture's 'reception', or monographs and exhibition catalogues that invariably include an artist's 'critical reception'. Rooted in the vaguest sort of empiricism, these studies continue to presume that 'the critics'' meanings are generated by the art itself, and imagine that a collection of anecdotes and fragments of discourse can actually produce a historicised understanding of art and artist while posing few historical or theoretical problems in themselves. The strategy itself represents a new way of renewing and legitimising the objectives of conventional art history, by lending the cachet of 'systematisation', 'rigor' or 'cultural context' to that old ideal of art history as a history of works of art. What invariably remain unanswered are questions concerning the very status of art within art criticism, that is, the nature of its determination in the production of art-critical meaning. Similarly, the historical conditions in which the critical discourses were produced, conditions at once within and outside the aesthetic or cultural fields, go entirely unaccounted for. Neither do we know anything about the intertextual and intratextual relations in which such a body of criticism was generated and deployed, or the stakes that selecting this particular artist and those specific formulations represented in 'the critics'' strategies at a particular historical moment.

At another level are the investigations of individual critics' aesthetic judgements and careers which, like studies of individual buyers, markets or institutions, are indeed valuable from both a historical and an empirical perspective. But they too have done little to change the fundamental ways in which the discipline has constructed the unity and coherence of this ready-made category, 'the critics'. Leaving aside such broader theoretical issues as the question of agency, subjectivity, authority or the institutional sites in and through which 'the critics' mobilised their discourses, these studies tend to replicate modernist tropes by transmuting 'eminent' or *avant-garde* literary figures into the 'great critics' defending the 'great artists' of their time. Yet, the very heterogeneity of 'the critics' – both as a category and as agent and subject in discourse – needs to be questioned here. What is important to consider is how such a status was itself historically constituted, negotiated and transformed throughout the nineteenth century. In historical terms, this means accounting for the diverse social and professional

formations on which the critics' competence was founded, their different institutional affiliations, the dispersed and multiple sites in which their discourses emerged and the variety of literary or journalistic forms that it could take. In short, it means considering the ways in which art criticism, defined as a social and a discursive practice, acquired and negotiated its relative autonomy and its authority.

The most prominent and certainly the most significant manner in which art criticism entered into the discourses of art history over the past two decades has been as a kind of evidence for a 'social', and often pointedly critical, reading of visual representation. Initially springing from Marxist and feminist interrogations of the social and political functions of art, and more recently inflected by a range of post-structuralist and psychoanalytic theories concerned broadly with the nature of representation, the best studies have been involved in mapping the role of the 'visual' as an instance in broader regimes of knowledge and ultimately power, whether social, political, sexual or racial. Here, criticism acquires the status of sign, illuminating or reflecting a body of deeper social concerns that are somehow 'revealed' in what often tends to be labeled as 'the critics'' 'anxieties', 'confusion', or 'silences' when confronting pictures. Considered as a symptom of other concerns and interests, the knowledge that criticism is seen to produce is immediately corroborated by turning to a range of discourses and practices from other fields, be they moral, medical, judicial, economic, etc. Yet, compelling as this line of argument may be, the language of criticism here is once again taken to be entirely transparent. Not only are the 'meanings' of words considered to be somehow evident and remarkably stable across a range of disparate discursive fields and practices, but their very use is presumed to be straightforward, directly 'communicative' and non-strategic in their function or value. More important still is that the *glissement* between various discourses and practices – gendered linguistic, social, professional, political – that underwrites this use of critical discourse, suggests a structural and functional equivalence between what were historically distinct and uneven fields of activity. In this scenario, while the discourse of art criticism is clearly no longer only a 'response' to art, it is no more than an effect of other cultural and social processes. It has no autonomy as a social and professional practice, nor any materiality as a linguistic or discursive process. Its specific conditions and modes of production, historically shifting and determinant in the formation of *its* objects, are scarcely ever alluded to. And its objects are simply fused with those of the other discourses and practices which it is seen to reflect. The question here

is not whether statements that emerge in one discourse function intertextually across a range of other enunciations and knowledges. Clearly they do. Rather, what is at stake is just how the unity of objects and effects that a critical art history constructs between diverse discourses can actually be produced, while at the same time taking into account their specificity.

The essays in this collection have not been brought together as a bid to institute art criticism as yet another discrete field or sub-specialisation within an already rationalised discipline. For the question of where and how we position art criticism in art's histories will not be solved by simply renegotiating or upgrading its status within existing art historical paradigms. Rather it must be based on a critical re-examination of the epistemology by which art history writes out a body of questions, problems and relations that it still sees to be fundamentally outside the visual field. This essentially means engaging in a different kind of cultural history, in which the artistic instance occupies a place, but not a pre-determined privileged position over the entire field of social and cultural discourses, and institutions and practices, which shape, sustain and traverse it.

The aim of this anthology, then, is to provide an opening wedge into this sort of inquiry. It takes as its starting point the conception of art criticism as discourse, that is, a historically constituted representational and signifying practice, embedded in a complex of shifting social and material conditions – linguistic rules, literary codes, gendered cultural, political and institutional formations – which in different ways mediated the content, form and the very objects of criticism. The institutions to which the title refers comprise some of the explicit and implicit historical structures and practices which Foucault described as constituting at once the limits and possibilities for discourse to emerge and to operate.[3] Their range is as vast as it is differentiated. It includes, for example, consideration of the nature and conditions of the press in which so much nineteenth-century French criticism was disseminated. Here, Susan Siegfried (chapter 1) argues that the systems of censorship and police surveillance of the Parisian press in the post-revolutionary period constituted art criticism as a site where contemporary political affairs came to be allegorised through the critics' use of a non-political language of culture. Arguing that the public's 'ability to interpret such allegories depended on their understanding of the political connotations of the aesthetic modes and values employed', Siegfried shows how the production of the overlapping meanings of art criticism was imbricated in a shifting interplay between political and aesthetic significations. Similarly,

Martha Ward (chapter 9) explores how the ways of reading and writing journalistic art criticism in Paris were inflected by transformations in the market strategies of the mass-circulation press at the end of the period that concerns us. For Ward, the new formats and styles of newspapers, the redistribution of the categories 'news' and 'culture', and the growth of press-clippings agencies simultaneously altered the form and content of art criticism in the 1890s while transmuting the professional status of the critic.

The conditions of art criticism that have least concerned the history of art are the complex of linguistic codes, literary structures and rhetorical conventions intrinsic to the very nature of criticism as discourse: formalities which, as Foucault claimed 'far from being that from which it must be freed ... constitutes the very law of its existence'.[4] Adrian Rifkin (chapter 2) looks at art criticism precisely as one such repository of systems of rhetoric. Charting the determinant role that conventions of the (re)presentation of time, periodicity, and the ordering of history played in the production of art criticism's meanings, he examines how the rhetorical field is itself situated in relation both to the art object and to the objects of critical discourse. Anne Higonnet (chapter 8), on the other hand, investigates another set of rhetorical devices by which writers and critics in the later nineteenth century designated the subjects of their texts as 'masculine' or 'feminine'. Higonnet argues that far from being an incidental feature of art criticism, writing the gender of both the image and subject constituted a means by which critics at once promoted their own professionalisation, ranked forms of visual expression and ratified existing modes of sexual difference in late-nineteenth-century France. Taking the case of Eugene Delacroix's critics in the first half of the nineteenth century, Anne Larue (chapter 4) argues that terms as ubiquitous as 'Romanticism' and 'Classicism' had no inherent content in themselves, but rather functioned as a textual strategy within critical debate. She explores the nature of the structural opposition in which these terms operated as well as the scope of meanings they acquired in the dynamic of their antinomy, the rhetorical touchstone of which was the artistic subject.

A relatively constant feature of nineteenth-century criticism, itself historically changing and subject to the vicissitudes of a range of cultural circumstances, is the status given to the artistic subject. Constructions of artistic biography not only deployed a well-established range of biographical tropes and rhetorical devices but increasingly drew their authority and legitimacy from their writers' affiliation with certain cultural institutions, along with their propensity to structure, to periodise and to problematise artistic

production and biographical narrative along codified lines. And yet, as a dominant structuring device, these narratives were often underwritten by a number of political interests. Taking the case of the critical and biographical texts devoted to Jacques-Louis David in the half-century following his death in 1825, Neil McWilliam (chapter 3) proposes that interpretative constructs of the individual and his artistic production obey implicit structural models in which David's psychological characteristics are infused into a period 'style'. These interpretations, McWilliam argues, are calibrated around opposing ideological interpretations of the French Revolution and David's role within it. Similarly, Linda Nochlin (chapter 6) asks how a former Communard like Gustave Courbet, an exile, a still-controversial and prickly painter during the decade between 1879 and 1889 was transformed into something approaching a republican cultural hero of the Third French Republic. Her essay explores both the goals and strategies of the reconstruction of Courbet by examining several critical texts from this period, texts that both justified and to some degree prompted this new Republican interpretation. My own essay (chapter 7) investigates the competing biographical and critical constructions of Edouard Manet which emerged during the 1884 retrospective that canonised him as a central figure in the development of a French national art and Republican culture. Examining the dialogical structure of these interpretations, I argue that the disparate Manets which finally emerged were strategically bound up with their writers' competing interests over the nature of cultural politics and its institutionalisation within the newly consolidated Republican regime.

Finally, the broader question of the social and professional nature of art criticism, its relative autonomy or degree of embeddedness within other social, professional and literary practices, and the various criteria by which the art critic's jurisdiction, competence, authority and legitimacy were historically negotiated, is taken up by two contributions. On the one hand, Ségolène Le Men (chapter 5) argues that throughout the Second Empire, art criticism operated not only as part of a particular literary genre, *Kunstliteratur*, but as what Roman Jakobson called a process of 'intersemiotic' and 'intrasemiotic translation'.[5] Drawing on Philippe Burty's reviews for the *Gazette des Beaux-Arts*, she investigates how criticism and the medium of engraving were functionally and metaphorically linked as equivalent modes of the 'transposition' and 'reformulation' of the objects of the visual field. For Le Men, it is precisely the transpositional nature of art criticism that implies its 'double competence, one in artistic connoisseurship and the other in writing'. Dario Gamboni (chapter 10) also asks what entitled a writer at the

end of the nineteenth century to appear and act as an art critic. Examining various modes of art writing – 'academic', 'literary' and 'journalistic' – he argues that while art criticism did emerge as a field of its own during this period, any definition of its nature must account for the particular limits of its social, professional and discursive autonomy and its dependence upon the diverse fields that intersected and traversed it throughout the late nineteenth century.

Notes

1 Lionello Venturi, *The History of Art Criticism* (New York, 1938).

2 T. J. Clark, *Image of the People, Gustave Courbet and the 1848 Revolution* (London, 1973); 'Un Réalisme du corps: "Olympia" et ses critiques en 1865', *Histoire et Critique des Arts*, no. 4 – 5 (May 1978), pp. 139 – 55, and more recently *The Painting of Modern Life: Paris in the Art of Manet and his Followers* (New York, 1985). Nicos Hadjinicolaou, 'La "fortune critique" et son sort en histoire de l'art', *Histoire et Critique des Arts*, no. 3 (November 1977), pp. 7 – 25; ' "La Liberté guidant le peuple" de Delacroix devant son premier public', *Actes de la Recherche en Sciences Sociales*, no. 28 (June 1979), pp. 3 – 26; and *La Production Artistica Frente a sus Significados* (Mexico City, 1982).

3 Michel Foucault, *The Archaeology of Knowledge and the Discourse on Language* (New York, 1982).

4 Foucault, *The Archaeology*, p. 151.

5 Roman Jakobson, 'Aspects linguistiques de la traduction', in *Essais de Linguistique Générale* (Paris, 1963), pp. 78 – 86, originally published in Reuben A. Brower (ed.), *On Translation* (Cambridge, Massachusetts, 1959).

1

The politicisation of art criticism in the post-revolutionary press

SUSAN L. SIEGFRIED

One of the most dramatic effects of the Revolution was the declaration of freedom of the press in 1789. In the space of two years, the number of officially sanctioned journals in Paris alone skyrocketed from four to well over 300.[1] Yet this phenomenal explosion of the press was soon checked by sporadic waves of censorship. Starting as early as 1792, following the execution of the King, journals closely tied to discredited political factions were weeded out: first the royalist journals; then the Girondins; next the Dantonists and Hébertists; and finally the Jacobins. As state power was reconsolidated, opposition was ever more systematically quelled, until by the end of the nineties the number of journals in Paris was down to seventy-three.[2]

This decade of relative freedom of the press, punctuated by spurts of censorship, came to an abrupt end with Bonaparte's *coup d'état*. In January 1800, the most draconian censorship laws that France had seen since before the Revolution cut the number of political newspapers from seventy-three to thirteen. From 1810 to 1811, the number of these officially sanctioned newspapers was further reduced from thirteen to only four.[3] Throughout this period, the content of the daily press was subjected to strict police surveillance.[4]

The elimination of what remained of the Republican press, along with the suppression of the legitimist royalist press, severely narrowed the range of permitted political opinion. Only the centrist press, sympathetic to the nationalistic, Bonapartist state, was allowed to persist.

Along with the redefinition of public politics, a redefinition of the politics of cultural criticism was taking place. After the Revolution, culture was thoroughly politicised in a way it had not been, or had not been seen to be, in the *ancien régime*. Francis Haskell has discussed the political dimension that emerged in critical writing on the visual arts during the post-revolutionary period as a result

of this general politicisation of life.[5] Concentrating on language, he examined critics' application of political terminology to non-political aesthetic and artistic matters, a practice that he viewed as widespread by the 1820s.

I want to consider a related and earlier development in the history of French criticism. By the Napoleonic period culture was politicised and yet, owing to the severity of official censorship, writers could not directly criticise the institutions of church and state. The result, I will argue, was an allegorisation of public affairs in cultural criticism, as never before. This practice represents the inverse of the one that Haskell explored – that is, critics' use of non-political terminology, or aesthetic modes and values, to discuss political matters. Readers' ability to interpret such allegories depended on their understanding of the political connotations of the aesthetic modes and values employed, for such a system could not have work-ed without an interplay between the political and the aesthetic.

One effect of censorship was to force the equation of political commitments and aesthetic values, in a programmatic sense. For example, while an association of the rococo style with eighteenth-century corruption had begun to be made as early as 1794, that equation was not formalised until the late 1790s and Empire, presumably as a result of efforts to constitute a history of art since the Revolution.[6] In Napoleonic criticism, the politicisation of the aesthetic was institutionalised. A new kind of cultural politics was in play, with an allegorical mechanism that made it fundamentally different from the cultural criticism of the *ancien régime*. It also developed from a different kind of politics, politics in the modern sense, in which ideology played a much more explicit role.

In order to establish a context for the new type of cultural criticism, this essay will first consider a number of structural and professional developments within the post-revolutionary press. These include the expanded range of subject matter covered, the emergence of a cultural supplement called the *feuilleton*, and the practice of signing reviews and the ethos of accountability that accompanied that practice. Within the domain of the growing professionalism of the right-wing press, exemplified by *Journal des débats*, the essay will then consider the emergence of a new, allegorical model of cultural criticism in the reviews of the literary critic Geoffroy and the art critic Boutard.

One effect of the new censorship laws was to expand the types of subjects covered in the periodical press to include, among other things, the arts. A bit of background might be in order here: during the preceding decade, ever since the 1789 Revolution, the content

of what was published in the press was relentlessly political. We can, in fact, draw a similar profile of the contents of most newspapers published during the 1790s, no matter how ephemeral, and regardless of their political stripe: most of these contained either four or eight pages, of which one-fourth was given to foreign news, one-fourth to debates in the national legislature, and one-half to domestic news and editorial comment.[7] In other words, the revolutionary press offered its reading public a monotonous, steady diet of political and military news.

There is ample evidence that the publishers of these newspapers believed their readers might expect and want something else. With new journals cropping up every week, a surprisingly high percentage of the prospectuses announcing their publication promised coverage of the theatre, literature, sciences, the arts – in other words, something like the variety of news that had characterised the most successful pre-revolutionary newspapers.[8] But inevitably, the journals of the 1790s failed to deliver what their prospectuses promised, and politics remained the order of the day.

This will not come as a surprise to anyone who has tried to find, for example, reviews of the Salon of 1793 or 1795. In 1793 in particular, at the height of the Revolution and under full impact of the Terror, hardly any articles on the fine arts were published at all.[9] There were, of course, exceptions, like Détournelle's short-lived *Aux armes et aux arts!*, from 1794, and the *Décade philosophique*, begun in 1794 – two specialised, intellectual journals (including coverage of the arts) that emerged from the free-market competition of the mid-1790s.[10] However, these were exceptions to the rule of political and military coverage that, by one estimate, amounted to 80 per cent of the total space in periodicals of the time. Of the remaining 20 per cent, only a very small fraction was devoted to the arts, the rest going to coverage of such issues as economics, agriculture, social services, and the like.[11]

All of this changed in 1800, largely because the new press laws specifically exempted from censorship any 'journals devoted exclusively to the sciences, the arts, literature, commerce, or announcements and advertisements'.[12] That is not an insignificant exemption, for it indicates a larger view of culture as politically neutral, or at least non-threatening, a point to which I will return. One result of that escape clause was a proliferation of specialised cultural, scientific, and commercial journals. With more than sixty journals under publication during the Napoleonic period, fewer than one-third carried political news.[13] The daily press was affected as well, and the thirteen newspapers officially licensed to carry political news suddenly expanded their coverage to include

articles on the theatre, literature, the arts, the sciences, philosophy, and religion.

In some respects, the new variety of news coverage represented a return to the winning formula that the publisher Charles-Joseph Panckoucke had pioneered before the Revolution in two of the major Paris papers, the *Journal de Paris* and the revamped *Mercure de France*.[14] But there was an important difference. The pre-revolutionary newspapers had not carried political news beyond standard news reports from European and American capitals;[15] they filled their columns instead with a potpourri of cultural items, of often unpredictable length – a little of this, a lot of that. In 1800 the leading newspapers in Paris, so saturated with political and military news, marshalled their coverage of culture into a separate section of the newspaper, called the *feuilleton*, where it sat as an adjunct to the 'real' political and military news from France and abroad.[16]

This 'cultural supplement', if you will, ran across the bottom of the page, sharply divided from the political and military news above by a horizontal rule that sliced off the cultural from the political and military arena. In fact, this sense of physical separation could be quite literal, for in some instances, the *feuilleton* was printed in such a manner that it could be sold separately, or cut away from the main body of the newspaper.[17] To further demarcate the cultural news, it was set in smaller type, so that in a sense it appeared as a fat, dense footnote running across the lower margin of the page.

These characteristics of typography and format demonstrate that the cultural realm did not have equal status with the political news. Symbolically, the *feuilleton* relegated culture to a lesser compartment, making it almost a postscript to the real news, even as it brought culture to the front page.[18] Though the weight seemed to be at the top of the page, ironically it was the lower register that was the real source of the newspaper's appeal.

Owing to the pervasive censorship, the political columns at the top of the page were predictably dull, flat, and monotonous; the government's stage-managing of the political news, whether domestic or foreign, ensured that all the papers carried more or less the same thing.[19] In contrast to this one-note samba, the cultural columns gave the newspaper its personality.[20] The articles in this section were lively and diverse, offering an ever-changing kaleidoscope of topics. Reader interest began to form around the staff writers, who emerged as personalities, if not for the first time, with a regularity that became predictable. The writers' identities were publicly declared through signed reviews and articles, a practice relatively new to journalism.

During this period critics' signatures usually took the form of initials. This convention was specific to the periodical press, where different forms of signature were used for different categories of news. Full names and titles were reserved for decrees, proclamations, and official reports signed by the highest-ranking authorities. At the opposite extreme, routine reports on domestic and foreign affairs (which in dailies occupied most of the space) were almost never signed, which created an impression of unmediated objectivity equated with the name and reputation of the newspaper. In contrast to both categories, articles on culture were signed with initials, the trace of personality which identified them as opinion pieces. (Different newspapers and journals even imposed their own in-house styles of signature by initials.) This restrained form of signature did not prevent writers – especially opinionated writers – from forming followings and being publicly criticised (though such personality cults paled by comparison with those fostered by certain political journalists at the height of the Revolution). Indeed, the signature primarily served to hold staff as well as freelance writers accountable to both the public and the government, since they could be identified and reached through the publication's editorial office.[21] In any case, it seems clear that initials were not used defensively, to protect the identity of writers, for that literary or journalistic convention persisted well into the nineteenth century, long after Napoleonic and other forms of press censorship had been eliminated.

In pre-revolutionary journalism, anonymity and pseudonyms had served as a smoke-screen, a means of protecting authors from official censorship. This was particularly true in the art world, where the Royal Academy of Painting and Sculpture waged a successful campaign to block or at least censor published criticism of the works put on public display by its members.[22] There were ways around the Academy's ban on published criticism, but these required cloak-and-dagger tactics of secrecy – above all when, as Richard Wrigley has shown, the art reviews anonymously published in a leading newspaper originated from inside the Royal Academy itself.[23] By the 1770s and 1780s, this repressive situation had produced two types of response from critics. Some went underground, joining other more directly political writers in channelling their radical frustrations into a kind of guerrilla warfare that flourished in the clandestine pamphlet trade, that 'rich seam of literary muck' to which Robert Darnton has called our attention and which, as Tom Crow has demonstrated, produced some of the most politically pungent art reviews of the pre-revolutionary decades.[24] However,

the majority of such 'oppositional' critics, as a recent study by Bernadette Fort has shown, turned instead to satire, producing comic Salon reviews whose parodic and irreverent tone, rather than overtly political content, challenged the dominant social purview of art.[25] Whether high-minded and austere or popular and farcical, both forms of criticism depended upon anonymity to protect their authors from official censorship.

One immediate effect of the Revolution's declaration of freedom of the press was that it undermined the eighteenth-century tradition of anonymity – and also, by the way, largely made irrelevant the clandestine trade in 'serious' political pamphlets. After all, if something could be said in a legitimate newspaper, why bother with an illicit pamphlet? As a way of gauging the extent of this change, it is worth remarking that, even when press censorship was re-introduced in the 1790s, right-wing journalists, who were the targets of that censorship, continued to sign articles that criticised the government, openly running the risk of imprisonment.[26] The principle of free expression had quickly become well enough established to allow these journalists to operate without the need to cloak themselves under the old shrouds of anonymity and pseudonyms. It might also be noted that in the deregulated economy of the 1790s, journalists' need to advertise themselves provided an equally compelling stimulus to their declarations of identity.

If the declaration of freedom of press ushered in a new ethos of accountability, the liberation was only apparent, for it brought into play a complex dialectic between freedom and control of the press. Although the lifting of censorship may have killed the underground press, it also introduced a new notion of censorship in the form of 'accountability'. Once editors took responsibility for what they published, censorship became internal to the publication process, and, by extension, to the writing process itself. In other words, accountability was another form of control.

Art criticism was affected by the new ethos of accountability. While the use of pseudonyms and anonymity hung on as a literary custom well into the nineteenth century, it was increasingly countered by critics who signed their reviews. One writer commented on this situation in 1799, in a review of the Salon reviews being published that year. He saw the need to take strong exception to some anonymous, satirical pamphlets being hawked at the entrance to the exhibitions, while not bothering to criticise the reviews published in the periodical press on the grounds that these had at some level to be accountable to their reading public:

I do not intend to speak at all of the Salon reviews done in newspapers: those carry the name of an author or an editor. If [the reviews] are just, they honour [the authors'] taste and judgement; if they are unjust, since they present themselves full face, it is up to displeased or mistreated painters to respond to them.[27]

Respond readers did, artists and public alike: the publication of 'letters to the editor' was symptomatic not only of the emergence of critical personalities but also of the idea of the accountability of the press. By 1801 Monsieur Deloynes, who had succeeded Cochin and Mariette as editor of the important collection of art criticism that bears his name, not only expected the critic Chaussard to reply to several published letters that took issue with his views but admonished him for failing to do so.[28] In fact, few writers engaged in this kind of public dialogue with readers, but the press collectively maintained the impression that it was always possible to do so. Because certain newspapers, such as the *Journal des débats*, had no policy of publishing letters to the editor, other journals stepped into the breach and published readers' letters responding to articles by those writers. Thus the press as a whole worked to cultivate the perception that it was a forum for the exchange of ideas, accountable to the reading public.

Art critics' willingness to declare themselves owed a great deal to two factors: first, the Institut, the successor to the pre-revolutionary Academy, played a significantly diminished role in the Parisian art world; and second, the right-wing press boasted a professionalism that was favorable to cultural criticism.

The survivors of the purge of 1800 tended to be politically centrist journalists, since, as mentioned, the Republican press and the legitimist royalist press had been suppressed. The right-wing journalists among them were survivors in every sense of the word: they had weathered years of censorship and survived financially in the new and highly competitive free market of publishing. They had developed into seasoned professionals, with a sharp instinct for survival and a strong *esprit de corps*.[29] A model for this new type of professional journalism was the *Journal des débats*, purchased and revamped by the Bertin brothers in 1800.[30] They completely overhauled the *Débats*, a relatively obscure paper that had reported on the debates in the national legislature (hence its title). By purchasing the subscription lists of defunct papers, they soon acquired far and away the largest subscription base of any paper in France.[31]

With the drastic reduction in the number of licensed newspapers, most publishers expanded their editorial staffs and also their pool of freelance journalists, rounding up a corps of talented writers to cover the expanding range of news.[32] The profits from the *Journal des débats* enabled the Bertin brothers to attract the best writers available. They treated their staff of salaried writers and reviewers respectfully and paid them well, commanding their loyalty and establishing stable, long-standing affiliations.[33]

This expansion of editorial staffs in 1800 encouraged further specialisation in reporting, which came to include the art critic.[34] After 1800 we begin to see a new breed of art critic: not merely a man of letters who dabbled in criticism of art, this new critic had had some kind of professional artistic training, while not necessarily a practising artist himself. The most influential of these professional art critics was, of course, the critic for the *Journal des débats*.

In 1800, the Bertins gave the job of reviewing art for the *Débats* to a man who was relatively unknown at the time, Jean-Baptiste-Bon Boutard. We know almost nothing about Boutard, except that he had been trained as an architect during the *ancien régime*, a profession he seems never to have practised, and that he probably owed his job with the newspaper to having married the Bertins' sister.[35] In any event, he became almost overnight a powerful voice in the Paris art world thanks to the influence and prestige of the newspaper that sponsored him. Already by 1802, other critics were sarcastically referring to his articles as 'the Gospel of the *feuilleton*... the divine *feuilleton*... the infallible *feuilleton*'.[36]

Boutard also accumulated influence owing to the length of his affiliation with the *Journal des débats*. He reviewed art in the *Débats* over a period of seventeen years,[37] a sort of nineteenth-century version of Hilton Kramer, formerly with the *New York Times*. It might be argued that the prospect of steady employment by a journal, along with the accountability that came from signing reviews, began to lend a certain respectability to the practice of art criticism during this period. When Boutard retired from the *feuilleton*, his influential position passed to Etienne-Jean Delécluze, who came to the job with more respectable credentials than his predecessor and stayed on as the *Débats* art critic for the next forty years.[38]

Boutard is chiefly important, however, because his reviews provided a new model of art criticism, which was later taken up by critics such as Delécluze and Adolphe Thiers. Modern politics were allegorised in Boutard's criticism, in a way that they never had been in Diderot's reviews nor in those of any other eighteenth-

century critics. The 'radical' critics that Tom Crow discusses, for instance, were much more directly critical of the institutions of church and state than Napoleonic critics could afford to be. Boutard's politicisation of aesthetic values resulted in a serious, systematically conceived criticism. This went well beyond the parodic tone of the eighteenth-century 'oppositional' critics Fort has explored. The systematic nature of Boutard's approach can be appreciated by considering several key points of his criticism. I will begin with the probable model for his particular brand of cultural politics, the *Débats* literary and theatre critic Geoffroy.

Julien-Louis Geoffroy was known as the 'king of the *feuilleton*', for he was largely responsible for establishing its contentious style. Geoffroy inaugurated his career at the *Débats* by launching an all-out attack on the *philosophes* and anything connected with 'l'esprit révolutionnaire'.[39] He engaged in a polemic against Enlightenment ideas that characterised the most extreme opponents of the Revolution. He attacked the major writers, dramatists and philosophers of the eighteenth century, beginning with Voltaire – whose reputation up until this time had remained largely unscathed – and including Rousseau and Diderot. Although Geoffroy praised the sentimental religiosity of contemporaries such as Delille and Chateaubriand, his main strategy was to pit the Enlightenment thinkers against luminaries from the age of Louis XIV – Corneille, Racine, Molière, Boileau.[40] His elevation of the cultural standards of the seventeenth century was by no means new; that referent had been much in play during the eighteenth century. But in the Napoleonic context it acquired a new cast owing to the monarchist (and, originally, also the Catholic) overtones of the empire. Whereas more moderate theorists of the period tended to downplay the age of Louis XIV, or at least qualified their admiration with enlightened misgivings about the effects of ecclesiastical and aristocratic patronage,[41] Geoffroy's insistence that the best French literature and theatre had been produced under the absolutist monarchy of Louis XIV was an arch-conservative, if not reactionary, position, and acted as a critique of Napoleon's attempt to launch his regime as a new *grand siècle*.

Thus in the Napoleonic context, Geoffroy's emphasis on seventeenth-century culture acquired an explicitly political sense. The implication of his fulsome praise of the golden and God-fearing age of Louis XIV was a return to the late seventeenth-century political system of an absolute prince, controlled by the clergy. To the extent that Napoleon aligned his government and social institutions with this ideal Geoffroy gave him wholehearted support, much to the dismay of Bonapartists who insisted on the

Revolutionary origins of the regime.[42] By this time Geoffroy was sixty years old and, apart from having the courage of his convictions, he may have felt he had nothing to lose by his risky attacks on the sources and consequences of Revolutionary culture. In any case, he sometimes strayed openly from his ostensible purpose of reviewing literature and theatre to comment on current events – always with a royalist bias.[43]

Geoffroy's readers did not, however, need overtly political critiques to understand the political debate that was shielded by his discussion of literary and philosophical issues. The public of this period was well versed in reading between the lines of historical analogies like the ones Geoffroy constructed: this metaphorical mode of interpreting the present with reference to the past was a centuries-old tradition in France, one that the Revolution had in recent years raised to a new level of intensity and saturation by driving home analogies between the Roman Republic and the French Republic and making constant reference to modern-day Catos and Brutuses. From here it was not a big step to interpreting an apology for the age of Louis XIV as an apology for the revival of monarchist institutions.[44]

We have plenty of evidence from official (and quasi-official) censors that at least some of Geoffroy's readers understood his criticism this way. Two reports to Napoleon accused the *Journal des débats* of harboring and fostering monarchist or Bourbon sympathies.[45] Suspicions like these must have been based on the commentary in the paper's *feuilleton*, since the stonewalling editors of the political and military columns above the dividing line were careful not to give their opinions away.

With the new centrism we find in the press after 1800, the opportunities available at a crypto-royalist newspaper like the *Débats* drew critics like Boutard out of the woodwork. He had kept an extremely low profile during the revolutionary decade; at a time when public avowals of patriotism were mandatory, this complete withdrawal from any form of public commitment suggests that his political sympathies ran to the conservative side. In using his position as art critic as a political platform, safe because it was inconspicuous, it seems likely that Boutard picked up some pointers from Geoffroy, his older and more experienced colleague on the *feuilleton* of the *Débats*.

Boutard's criticism paralleled Geoffroy's in a number of respects. Like Geoffroy, Boutard disparaged the theorists and critics of the eighteenth century, in particular Diderot and Dubos.[46] Boutard's critique of Diderot and Dubos – specifically, their misinterpretations of Poussin's *Et in Arcadia* – was meant to demonstrate the

incompetence of literary men to write about art, compared with critics such as himself who had had artistic training. Boutard thus advanced a reaction against the dominance of literary criticism that had spread during the eighteenth century, as the art world became increasingly sensitised by the emergence of a public sphere of journalistic criticism. The Royal Academy's attack on critics, for example, had partly been undertaken as a defence of artists' right to judge works of art over and above men of letters.[47] To cite another well-known example, the sculptor Falconet had attacked writers – in particular, the canonical ancient writers Pliny and Pausanias – who invade and misrepresent the pictorial realm of artists.[48]

In continuing this older theme, however, Boutard changed its political connotations. Given his politically conservative tendencies, his critique of eighteenth-century writers certainly implied an attack on the left-liberal leanings of the *philosophe* tradition of art criticism that had been established by Diderot and was perpetuated in Boutard's day by contemporaries such as Chaussard. Indeed, that politically liberal and enlightened outlook still generally prevailed in criticism and aesthetic theory of the Napoleonic period.[49] It is thus noteworthy that a new politics of culture was introduced by the right – that is, that the attack on Napoleonic culture came from the political right, rather than, as the cultural conservatism of the regime might lead one to expect, from the left.

Like Geoffroy, Boutard also extolled works from the age of Louis XIV as constituting the highest models of excellence. He held up not only the Old Masters but (more surprisingly) the classical writers of the seventeenth century as the standards against which he judged contemporary art. For example, the highest praise that he bestowed on any living artist was to say that Girodet's painting was on a par with the work of Racine.[50] What he meant by this was that on the level of technical execution, the works of Girodet and Racine were comparable. Does this mean Boutard was just a stickler for technique?

In his reviews, Boutard certainly comes off as a formalist, very much concerned with brushstroke and lighting and balance and composition and all the rest. Informing this preoccupation with technique was a subtext, which read: it was not enough for an artist to have ideas; the important thing was having the technical skills to carry them out.[51] Understanding this subtext and, more to the point, the judgments of works of art that followed from it depends upon understanding Boutard's reactionary view of the Revolution as a débâcle for the fine arts. In his opinion, art in

France had been declining ever since 1789; by 1800, after a ten-year free-for-all, where anyone could exhibit and almost anything was allowed, he saw the arts in France perched on the brink of disaster.[52]

At some level, the political equivalent of Geoffroy's attack on the *philosophes* was Boutard's attack on the *penseurs* or *meditateurs*, a group of young artists in David's studio who took their belief in the purity of ancient art to a radical extreme.[53] The *penseurs* were more interested in theory than they were in making art: they were bookish, reading so-called primitive texts like Ossian and Homer and especially the Bible; they imitated their ancient heroes, wearing long hair and beards, dressing up in cloaks and sandals like Agamemnon and Paris; and they met in groups to talk about what art should be, only rarely producing paintings for public display. Boutard saw in them a manifestation of the excesses of the Revolution, the danger of ideas taken too far, the prospect of a kind of conceptual art that challenged and mocked the entire system of artistic production in Paris.[54]

Boutard's attack on the *penseurs* is interesting because he saw these artists as politically symptomatic of decadence. Even the critics of David's Neo-classicism had not gone that far. It is the political conception of Boutard's attack, not his attack on the *penseurs per se*, that is important. (The *penseurs'* own political position was actually quite ambiguous.) By interpreting a current movement in art as symptomatic of decadence, Boutard went further than proponents of the 'hard-line' theory of artistic decline, who shied away from saying that contemporary art was doomed to inferiority.[55] The only possible exception in France was Quatremère de Quincy, but his ideas exerted little influence during this period; besides, Quatremère saw the decline of modern art beginning with the High Renaissance, rather than, as in Boutard's more politically determined aesthetic system, with the Revolution. To the contrary, a traditional reformist optimism about the prospects open to contemporary art prevailed both in officialdom and in artistic circles under the Directory and Napoleon. It makes Boutard's animus against the *penseurs* all the more striking.

Like Geoffroy, Boutard had a hidden agenda, and so his statements about individual works of art cannot be accepted as having been generated purely by a response to the works themselves. Even though his criticism presented itself as an impartial explanation of pros and cons, it was freighted with a whole set of other, non-artistic concerns and values, not least of which were his political views. This was explicitly recognised in 1817 once censorship was relaxed, by a contemporary who commented on the politicised

nature of Boutard's aesthetic judgements: 'M. Boutard has an admirable skill for denigrating everything good and beautiful in the way of art that was made during the course of the Revolution... [He] simply does not know how to discuss architecture, columns, arabesques, or rose-windows without mixing in something of politics or anti-philosophy.' [56]

We can see how the crypto-royalist leanings of the *Débats* art critic worked themselves out in Boutard's response to an issue like Napoleonic military painting. Whatever Boutard may have thought about Napoleon's military policies and his use of art as propaganda, it would have been unwise for him to take aim at these policies openly in the current atmosphere of censorship. But he could and did damn those policies covertly by judging the paintings strictly in aesthetic terms: what he said in effect was 'They'll never make great art'.[57] To prove his point he forced a comparison between Gros and the Old Masters, countering the enthusiastic celebration of Gros' *Pesthouse at Jaffa* by fellow artists when it was unveiled at the Salon of 1804: 'What would this painting weigh,' he demanded rhetorically, 'put in the balance with the most sanctimonious exercise by Raphael?' [58] In other words, would the painting being touted as Gros' masterpiece stand up to the worst of Raphael?

To condemn contemporary military paintings on aesthetic grounds was to question Napoleon's programme of artistic patronage and to imply criticism of the military policies that underlay the entire regime. It is worth underscoring the novelty of this aesthetic allegory of modern politics: during the *ancien régime*, no similar attack was made against an art for being too closely tied to the political policies of a regime. To be sure, the Napoleonic government first raised – or, to be more precise, put to the test – the issue of whether a public art should or should not serve the state. The issue was never resolved, as the Prix Decennaux competition of 1808 amply demonstrated. It seems that Boutard had put his finger on an important new element in the French art world.

The counterpart to Boutard's attack on Napoleonic military painting was his championing of Girodet. He consistently reserved his highest praise for Girodet, comparing him (as we have seen) with Racine, that paragon of classical technique. For his part, Girodet played the field of patronage so judiciously – the paintings he exhibited ranged from convoluted pieces of Napoleonic propaganda, such as *Ossian Receiving Napoleonic Officers* and the *Revolt at Cairo*, to more controversial subjects such as his *Portrait of Chateaubriand* and *The Burial of Atala* – that the very ambiguity of his political position has allowed people to see him as courting

crypto-royalist sympathies and clients. Yet however much Girodet's politics may actually have been in line with those of Boutard, the relationship between their political views was never overtly expressed. Rather, Boutard allegorised his political views in aesthetic terms. His elevation of the painter to the cultural standards of the age of Louis XIV was, by implication, anti-Napoleonic.

Boutard's colleagues were quick to grasp the political thrust of his aesthetic programme. In the 1802 *Journal des arts*, a contemporary significantly picked up and talked about the political inflections of a seemingly apolitical piece of art criticism, interpreting Boutard's support of Girodet as an anti-Napoleonic position:

> It is certainly consoling for France to see that for the first time, a Frenchman has done something capable of pleasing the Feuilleton of the *Débats*. It is not sufficient, gentlemen of France, to be blessed with genius, wit and talents. To cover the biggest and most beautiful country in the world with mills, factories, and monuments – a mere trifle! To extend the glory of your arms from the rivers of Suez to the banks of Panama – puerility! To conquer the esteem and admiration of Europe and give peace to the world – a pretty lot of nothing, all of that! To please the Feuilleton, that is the essential, the important, the difficult [thing], and a camel would more easily pass through the eye of a needle. Miracle then! Girodet is neither a king, a priest, a knight, nor a member of the ancient Academy of Painting, and he has made a good painting![59]

This sort of comment on Boutard's criticism, in which culture is seen as an allegory of public affairs, would have been inconceivable in the eighteenth century.

The exemption of cultural journals from the censorship laws of 1800 clearly indicates that the government regarded this area of journalism as politically neutral. But we have seen how the strict surveillance of political and military news, which kept those columns of the newspapers tight-lipped and obedient, caused political criticism to go underground and surface in another guise. Virtually the only space left to it was the cultural columns, and in the *feuilleton* of the *Journal des débats* there is ample evidence that the criticism of culture served as a surrogate for the free expression of political opinion.[60]

In effect, the government was content to relegate cultural concerns to a marginal position, considering the *feuilleton* as a playground instead of a battlefield. Yet therein lies the danger, for the playground, as anyone who has observed it well knows, is where children act out their aggressions, battling against any injustices or oppressions they perceive. Within this microcosm, critics played

out the frustrations of their society, fighting real battles with toy guns. Our task is to understand that even if the guns don't kill, even if the playground seems innocent, the battles are none the less very real.

Notes

An earlier version of this article was presented at the College Art Association Conference, New York, 1990. I am grateful to Julie Bates Dock and Alex Potts for their comments on the text.

1 This conventional statistic is derived from a table published by Jacques Godechot, 'La Press française sous la Révolution et l'Empire', in Claude Bellanger *et al.* (eds), *Histoire générale de la presse française*, I (Paris, 1969), p. 436. The table in turn is based on A. Martin and G. Walter's catalogue of the periodical collection in the Bibliothèque Nationale, *Catalogue de l'histoire de la Révolution française*, V (Paris, 1943). See also Jeremy Popkin, 'Journals: The New Face of News', in Robert Darnton and Daniel Roche (eds), *Revolution in Print. The Press in France, 1775–1800* (Berkeley, Los Angeles, London, 1989), p. 150.

 Some recent studies of the revolutionary press tend toward more expansive statistics, having extended their scope of investigation to include provincial library holdings in France. Censer, for example, states that throughout France sixty journals published in 1788 jumped to 500 in the space of two years; he does not break these figures down for Paris. See Jack Censer, *Prelude to Power: The Parisian Radical Press, 1789–1791* (Baltimore and London, 1976), pp. 8–9.

2 Eugène Hatin, *Bibliographie historique et critique de la presse française* (Paris), p. 310. Relying on Martin and Walter's catalogue of the Bibliothèque Nationale collection, Cabanis states that only sixty-five journals were being published in Paris by 1799–1800; André Cabanis, *La presse sous le Consulat et l'Empire (1799–1814)* (Paris, 1975), pp. 9–10.

3 Cabanis, *La presse*, pp. 11–14, 36–41; Hatin, *Bibliographie*, p. 310. On pre-revolutionary censorship, see Daniel Roche, 'Censorship and the Publishing Industry,' in Darnton and Roche, *Revolution in Print*, pp. 3–26.

4 Cabanis, pp. 165–231; Henri Welschinger, *La censure sous le premier Empire* Paris, 1882, pp. 7–130; and *Le livre du centenaire du Journal des Débats, 1789–1889*, Paris, 1889, 75–89 (hereafter cited as *Livre du centenaire*). Napoleon also blocked circulation of foreign newspapers, such as the *Gazette de Leyde*, which before the Revolution had played a critical role in reporting on French domestic affairs; see Welschinger, pp. 85–6.

5 Francis Haskell, 'Art and the Language of Politics', *Journal of European Studies*, IV (1974), pp. 215–32; reprinted in *Past and Present in Art and Taste* (New Haven and London, 1987), pp. 65–74.

6 Haskell, *Art and the Language of Politics*, pp. 66 and 68.

7 Jeremy Popkin, *The Right-Wing Press in France, 1792–1800* (Chapel Hill, 1980), p. 5.

8 Popkin, *Right-Wing Press*, pp. 11–12.

9 William Olander, 'Pour transmettre à la postérité: French Painting and Revolution, 1774–1795', diss. (New York University, 1983), pp. 260–2. A systematic view of the paucity of art criticism published during these years has recently been provided by Neil McWilliam, Vera Schuster and Richard Wrigley (eds), *A Bibliography of Salon Criticism in Paris from the Ancien Régime to the Restoration, 1699–1827* (Cambridge, 1991), pp. 106–8.

10 Edited by the architect Athanase Détournelle, *Aux armes et aux arts! Peinture, sculpture, architecture, gravure. Journal de la Société républicaine des arts* was published between 6 pluviôse and 29 floréal l'an II [25 January – 19 May, 1794]. The more substantial *La décade philosophique, littéraire, et politique, par une société de républicains*, published (with variations in the title) from April 1794 up to September 1807, has been studied by Joanna Kitchen, *Un journal 'philosophique': 'La Décade' (1794–1807)* (Paris, 1965), and M. Regaldo, *Un milieu intellectuel: la Décade philosophique (1794–1807)*, 5 vols. (Paris, 1976).

11 These percentages are based on a sample taken in 1790, which is summarised in Censer, pp. 73–7 and 137–8 (Appendix B, tables 2 and 3).

12 'Actes du Gouvernement. Arrêté du 27 Nivôse', *Journal de Paris* (30 nivôse an VIII [20 January, 1800]), p. 540.

13 A survey taken in April 1803 listed 68 journals under publication in France, a number that dropped to 64 by 1814 (Hatin, *Bibliographie*, pp. 312–13; Eugène Hatin, *Histoire politique et littéraire de la presse en France*, VII (Paris, 1864), pp. 412–13). Of these 60-odd journals, 13 were licensed to carry political news while Hatin describes another 8 as political in content; see *Bibliographie*, pp. 310–16. Cabanis (pp. 16–18) discusses the attempts made by some journals to survive the purge of 1800 by eliminating political news altogether.

14 On Panckoucke, see Suzanne Tucoo-Chala, *Charles-Joseph Panckoucke* (Pau, 1977).

15 For a detailed discussion of political reports carried in French as well as foreign journals circulating in France before the Revolution, see Jeremy Popkin, 'The Prerevolutionary Origins of Political Journalism', in Keith Michael Baker (ed.), *The French Revolution and the Creation of Modern Political Culture. I: The Political Culture of the Old Regime* (Oxford and New York, 1987), pp. 203–23.

16 On the early history of the *feuilleton*, and the influential adoption of it by the *Journal des débats*, see Hatin, *Histoire*, VII, pp. 442–4; the chapter by Georges Viollat, 'A travers le feuilleton (1800–1830)' in *Livre du centenaire*, pp. 582–8; and Ruth Jakoby, *Das Feuilleton des Journal des Débats von 1814 bis 1830: ein Beitrag zur Literaturdiskussion der Restauration* (Tübingen, 1988). Some cogent remarks on the later history of the *feuilleton* may be found in Peter Hohendahl, *The Institution of Criticism* (Ithaca and London, 1982), pp. 16–17 and 86–7.

17 The *feuilleton* of the *Publiciste* (1797–1810), a major newspaper, was published as a detachable, cut-away section. (A separately bound, nearly complete collection of these is housed in the library of the Corps législatif, Paris.) Some newspapers published *feuilletons* under different titles. For example, in 1797 the cultural and commercial supplement of the *Quotidienne* was called *Feuilleton des spectacles, modes, annonces et avis divers* (and later, *Feuilleton de littérature, spectacles, et anecdotes*). Other examples of separately published *feuilletons* are mentioned in Hatin, *Histoire*, VII, p. 442 and Popkin, *Right-Wing Press*, p. 193, n. 28.

18 In French the common figure of speech for *feuilleton* is the *'rez-de-chaussée'*, an architectural metaphor taken up by historians of the press to describe this layout; see Hatin, *Histoire*, VII, p. 454, and Alfred Pereire, *Le Journal des débats, politiques et littéraires, 1814–1914*, Paris, 1914, pp. 8 and 144.

19 Cabanis, *La presse*, pp. 233–311, and Welschinger, *La censure*, pp. 7–130.

20 Cabanis, *La presse*, pp. 105–7, and Hatin, *Histoire*, VII, pp. 452–64.

21 When, for example, the *Journal des débats* was brought under strict imperial supervision in 1805, Napoleon stipulated that 'No article can be placed in the newspaper unless it is signed with a letter [Aucun article ne pourra être mis dans le journal s'il n'est signé d'une lettre];' quoted in Pereire, *Le Journal*, p. 27.

22 Thomas Crow, *Painters and Public Life in Eighteenth-Century Paris* (New Haven and London, 1985), pp. 7–18, 147, and 162; Richard Wrigley, 'Censorship and Anonymity in Eighteenth-Century French Art Criticism', *Oxford Art Journal*, VI (1983), pp. 17–28.

23 Wrigley, 'Censorship', p. 19.

24 The phrase comes from Simon Schama, *Citizens* (New York, 1989), p. 176, and refers to Robert Darnton's studies *The Literary Underground of the Old Regime* (Cambridge, 1982), and 'The High Enlightenment and the Low-Life of Literature in Pre-Revolutionary France', *Past and Present*, no. 51 (1971), pp. 79–103. Art reviews published in this context are discussed by Crow in *Painters and Public Life*, pp. 92–6 and 183–6, and 'The *Oath of the Horatii* in 1785: Painting and Pre-Revolutionary Radicalism in France', *Art History*, I (1978), pp. 424–71.

25 See Fort's important article, 'Voice of the Public: The Carnivalization of Salon Art in Prerevolutionary Pamphlets', *Eighteenth-Century Studies*, XXII (1989), pp. 368–94.

26 Popkin, *Right-Wing Press*, p. 57.

27 J. V. [Joseph Lavallée?], 'Variétés', *Journal des arts, des sciences, et de littérature*, no. 9 (15 fructidor an VII [2 September 1799]), pp. 3–4: 'Je n'entends point parler des critiques du salon faites dans les journaux: celles-là portent un nom d'auteur ou d'éditeur; si elles sont justes, elles honorent leur goût et leur jugement; si elles sont injustes, comme ils se présentent en face, c'est aux peintres mécontents ou maltraités à leur répondre.'

28 Manuscript note by Deloynes in *Pièces sur les beaux arts, 1673–1808* (Collection Deloynes), XXVIII, no. 699 (Cabinet des estampes, Bibliothèque nationale), referring to published letters from M...., 'l'un de vos abonnés, "Aux rédacteurs du Journal des arts" ', *Journal des arts, des sciences et de littérature*, no. 158 (10 vendémiaire an X [2 October 1801]), pp. 25–7 and L. C., 'Au citoyen P. Ch., rédacteur de l'analyse du Salon dans le Journal des arts', *Journal des arts, des sciences et de littérature*, no. 159 (15 vendémiaire an X [7 October 1801]), pp. 62–4.

29 Jeremy Popkin, 'The Journalists of the Directory: An Opinion-Making Elite', *Proceedings of the Consortium on Revolutionary Europe, 1750–1850* (Athens, Georgia, 1980), I, pp. 3–12; Popkin, *Right-Wing Press*, pp. 25–64.

30 Hatin, *Histoire*, VII, pp. 437–44; Pereire, *Le Journal*, pp. 7–11.

31 The original purview of the newspaper was indicated by its full title, *Journal des débats et loix du pouvoir législatif, et des actes du gouvernement* (hereafter cited

as *Journal des débats*). By 1803 the *Journal des débats* accounted for 30 per cent of subscriptions to all daily newspapers printed in Paris (10,125 out of 35,580 total subscriptions; its closest competitor, the *Publiciste*, had 3,850 subscribers). Following re-organisation of the press in 1810–1811 subscriptions to the *Débats* steadied at about 20,000, still double and often quadruple that of its nearest competitors. These figures are drawn from Cabanis, *La presse*, pp. 320–2. Hatin gives even higher subscriptions rates for the *Débats* during the Empire, without, however, citing his sources; *Histoire*, p. 457.

32 Popkin, *Right-Wing Press*, pp. 170–3.

33 Though fragmentary, surviving evidence indicates that Boutard received a steady salary from the *Débats* – 3,000 francs per year in 1805, and 600 francs per month (or 7,200 francs per year) in 1814; see Cabanis, *La presse*, pp. 135–7, and Pereire, *Le Journal*, pp. 23–7. The young François Guizot (who seems to have earned less annually than Boutard) remarked that his income from writing for the *Publiciste*, while not making him wealthy, enabled him to live comfortably (Cabanis, p. 137).

34 The increasingly specialised division of news coverage is documented in lists of editorial staffs of the *Journal de Paris* in 1812 and at the *Moniteur universel* in 1811, both of which are summarised in Cabanis, *La presse*, p. 106, n. 90. Editorial responsibilities at the *Journal des débats* are described by Pereire, *Le Journal*, pp. 23–4.

The art critics regularly employed by the *Journal de Paris* and the *Moniteur universel* were respectively, Charles Landon and A. L. Castellan. We know something of Landon's earnings. Like most writers for the *Journal de Paris* he was paid by the piece, at the rate of 1800 francs for four articles per month (Cabanis, p. 137, n. 45). Landon was evidently well enough established to choose his material: the *Journal de Paris* routinely hired another critic, Fabien Pillet, to review the Salon exhibitions since Landon presumably avoided competition with his own enterprise, a series of illustrated books called the *Annales du Musée* that included reviews of the Salons.

35 On Boutard (1771–1838), see *Livre du centenaire*, pp. 466–71, and the entries in M. Michaud (ed.), *Biographie universelle ancienne et moderne*, Paris, [1880?], V, p. 343, and in *Dictionnaire de biographie française*, Paris, 1954, VII, p. 37.

36 L. V., 'Tableau de Girodet. Un mot, en passant sur deux mots du Feuilleton des Débats', *Journal des arts, des sciences, et de littérature*, no. 211 (5 messidor an X [24 June 1802]), pp. 14–16.

37 Boutard worked as art critic for the *Journal des débats* from 1800 to 1817 (not 1838, as sometimes stated). In 1816 he moved into arts administration under the Bourbon government and thereafter only occasionally contributed articles to the *Débats*. Remarks on his career in arts administration may be found in Pierre Angrand, *Le Comte de Forbin et le Louvre en 1819* (Paris, 1972), pp. 16, 143, 148–9, and 169.

38 Delécluze reviewed art for the *Débats* from 1822 until his death in January 1863, though after 1855 his contributions became sporadic. Delécluze's affiliation with the *Journal des débats* is discussed by Pereire, *Le Journal*, p. 110, and *Livre du centenaire*, pp. 471–6. His career as a critic has been studied by Robert Baschet, *E.-J. Delécluze, témoin de son temps*, Paris, 1942.

39 Hatin, *Histoire*, VII, pp. 453–5. Geoffroy's criticism has been collected in *Cours de littérature dramatique ou recueil par ordre de matières des feuilletons*, E. Gosse, intro., 6 vols (Paris, 1825). The basic study of the critic is by C. M. Des

Granges, *Geoffroy et la critique dramatique sous le Consulat et l'Empire (1800 – 1814)* (Paris, 1897); on his career at the *Débats* see also *Livre du centenaire*, pp. 69 – 70 and 416 – 23.

40 The observation was made by Geoffroy's fellow critics Charles Sainte-Beuve and Abel-François Villemain, both quoted in Hatin, *Histoire*, VII, pp. 462 – 3 and 473 – 4.

41 For aesthetic theorists see A. D. Potts, 'Political Attitudes and the Rise of Historicism in Art Theory', *Art History*, I (June 1978), pp. 194 and 203 – 4.

42 On Geoffroy's conditional support of Napoleon see Hatin, *Histoire*, VII, p. 453, and Cabanis, *La presse*, p. 93.

43 Hatin, *Histoire*, VII, p. 454: 'Liberty, which did not exist during this period in the political part of the press properly speaking – liberty, which did not exist on the first floor of the newspaper (if we may be permitted this term) took refuge on Geoffroy's ground floor [*rez-de-chaussée*, or *feuilleton*]. From there [liberty] said everything it wanted to say, everything that needed to be said. There the highest political questions were at stake, even in spite of the sovereign, in the form of *political and literary ephemeris* or under the pretext of a bad tragedy. [La liberté, qui n'existait pas à cette époque, pour la presse, dans la partie politique proprement dite, la liberté, qui n'existait plus au premier étage du journal, qu'on nous passe ce terme, se réfugia dans le rez-de-chaussée de Geoffroy. De là elle dit tout ce qu'elle voulut dire, tout ce qu'il fallait dire. Les plus hautes questions politiques s'y agitaient, en dépit même du souverain, sous la forme d'*éphémérides politiques et littéraires*, ou sous le prétexte d'une mauvaise tragédie.]'

44 Napoleon's press censors were anxious about any references made to the Bourbon monarchy, whether complimentary or derogatory, because they could not control interpretation of these – nor, indeed, of any other – historical analogies; see the discussion in Cabanis, *La presse*, pp. 209 – 11.

45 In 1803 Senator Pierre-Louis Roederer, a political economist and distinguished contributor to the *Journal de Paris*, drew up a report on the press for Napoleon, in which he complained about the pro-Bourbon, anti-Revolutionary (and thus, in his view, anti-Napoleonic) tendencies of the *Journal des débats*. The complaint was reiterated the following year by the Minister of Police Joseph Fouché, in a report of October 1804. The two reports are discussed in Hatin, *Histoire*, VII, pp. 478 – 87; Welschinger, *La censure*, pp. 87 – 90; and Cabanis, *La presse*, pp. 208 – 9.

46 M. B[outard], 'Salon de l'an XII. (No. X.) M. Garnier', *Journal des débats* (29 brumaire an XIII [20 November 1804]), pp. 1 – 4.

47 See André Fontaine, *Les doctrines d'art en France* (Paris, 1909), pp. 186 – 298.

48 See Denis Diderot and Etienne Falconet, *Le Pour et le contre; correspondance polémique sur le respect de la postérité, Pline et les anciens auteurs qui ont parlé de peinture et de sculpture*, Y. Benot, intro. and notes (Paris, 1958), pp. 116 – 235.

49 Potts, *Political Attitudes*, pp. 191 and 194.

50 M. B[outard], 'Salon de l'an XII. No. IX (M. Girodet),' *Journal des débats* (24 brumaire an XIII [15 November 1804]), p. 3.

51 Boutard argues the point most forcefully in the following reviews: 'Salon de l'an XII. No. VI (M. Hennequin)', *Journal des débats* (9 brumaire an XIII [31 October 1804]) and 'Salon de l'an 1806. No. VIII, MM. Roehn et Richard', *Journal de l'Empire* [*Journal des débats*] 12 October 1806. Boutard's

emphasis on technical skill over ideas also served to validate his own credentials as a critic – his training as an architect – in line with his reintroduction of the argument that artists were better qualified than writers to judge works of art.

52 [Jean-Baptiste-Bon Boutard], 'Variétés. Du Salon', *Journal des débats* (29 fructidor an VIII [16 September 1800], p. 3.

53 The classic account of the *penseurs* was given by E. J. Delécluze, *Louis David, son école et son temps* (Paris, 1855), pp. 69–78 and 419–38.

54 Boutard became increasingly explicit and snide in criticising the *penseurs*, as the following sequence of reviews makes clear. 'Variétés. Salon de l'an IX', *Journal des débats* (20 fructidor an IX, 22 brumaire an X [7 September, 13 November 1801]; 'Salon de l'an Dix', *Journal des débats* (18 fructidor an IX [5 September 1802]; 'Arts. Peinture', *Journal des débats* (2 messidor an X [21 June 1802]; and 'Salon de l'an XII', *Journal des débats* (3 vendémiaire an XIII [25 September 1804]).

55 Potts, *Political Attitudes*, pp. 199 and 202–3.

56 Quoted in Hatin, *Histoire*, VIII, pp. 197–8: 'M. Boutard a un art admirable pour dénigrer tout ce qui a été fait de bon et de beau en fait d'art durant le cours de la Révolution ... [Il] ne sait point parler d'architecture, de colonnes, d'arabesques, de rosaces, sans y mêler quelque peu de politique ou d'anti-philosophie.'

57 Boutard's use of this strategy is most evident in his review of the Salon of 1806, where a large number of Napoleonic military paintings were presented; see M. B[outard], 'Salon de l'an 1806. No. 1', *Journal de l'Empire* [*Journal des débats*] (16 September 1806).

58 M. B[outard], 'Salon de l'an XII. No. 1 (M. Gros)', *Journal des débats* (3 vendémiaire an XIII [25 September 1804]), p. 4: 'que peseroit ce tableau mis dans la balance avec la moindre capucinade de Raphaël et du Corrège?'

59 L. V., 'Tableau de Girodet', *Journal des arts* (5 messidor an X [24 June 1802]), pp. 14–15: 'Il est bien consolant pour la France de voir, pour la première fois, qu'un Français ait fait quelque chose capable de plaire au Feuilleton des Débats. Il ne suffit pas, messieurs les Français, d'avoir le génie, l'esprit et les talents en partage; couvrir de moissons, de manufactures et de monumens [*sic*] la plus vaste et la plus belle contrée du globe; bagatelle! Etendre la gloire de vos armes des rives de Suez aux bords de Panama; puérilité! conquérir l'estime et l'admiration de l'Europe et donner la paix au monde; belle misère que tout cela! Plaire au Feuilleton, voilà l'essentiel, l'important, le difficile; et un chameau passerait plutôt par le trou d'une aiguille. Miracle donc! Girodet n'est ni roi, ni prêtre, ne cordon bleu, ne de l'ancienne Académie de Peinture, et il a fait un beau Tableau!'

60 The same argument can be made for cultural criticism published during this period in the *Décade philosophique*, the *Mercure de France*, and the *Publiciste*. See the discussions in Cabanis, *La presse*, pp. 30–2; Welschinger, *La censure*, pp. 87–90; and Hatin, *Histoire*, VII, pp. 415–36 and 552–70.

2

History, time and the morphology of critical language, or Publicola's choice

ADRIAN RIFKIN

Probably one of the most problematic and least explored aspects of art criticism is the nature of its relation with art and to art's history. While it clearly does have something to do with art, and, indeed, is denoted in terms of this very something, it would be unwise to assume that this relation need necessarily be thought of as more than contingent, or, for that matter, that the history of art criticism itself is something more than the sum of a series of contingencies between which there is no essential isomorphism. Yet the history of art, in placing art at the centre of its own enterprise, requires that art criticism should share its special preoccupation, both as a discursive aid to or extension of its own procedures and as a specially privileged access to art's production of meanings. Yet even in this latter instance, if we were to take it as meaning that art criticism is a meaning produced by art, or for art (a subject produced within the scopic field of its object, for example, or a filling-in of meaning on an empty or indecipherable surface/mirror), we would still have to admit that the correspondence between the discourse and its particular utterances – between art criticism and the criticism of a given painting – cannot necessarily be fixed, and certainly not as the term of a singular and exclusive identity.

If, as a consequence, one must try to think of art criticism as differing from a criticism of an art-object, it becomes even more difficult to think of a means of theorising art criticism in a way that will try to define this relation as anything more than the determinable intersection of maybe radically different discursive series. Ironically, such a theoretical unframing of art criticism would then call for a purely pragmatic reading of its relation to art as a means of differentiating, rather than of integrating, the particularities of their respective historical development. The way in which the one provokes the other within the institutions of public writing, their particular and sometimes mutual effects on each other, might be understood as either incidental or central, rather depending

on where or how the frame configures things. Thus the study of the critical reception of a work of art as a significant element in the assigning of meaning to it is not only just one operation amongst the many that are possible, but in itself has an unstable or equivocal status. The interest of such an operation may, then, lie as much in observing the way that it is required by the demands of a particular conception of art as an object of interpretation, as in any of the meanings that it manages to elaborate.[1]

Of course the grounds of such a differentiation must themselves be historically complex and could not form the base for a pre-emptive strike against all and any referential meaning in art criticism. In the end these grounds will at the same time be those for establishing the nature, possibility and limits of reference, of 'being about'. Indeed it is the complex time-scales of its materials that is one of the most difficult things to settle in analysing the value of art criticism as a type of historical document. There are so many points of apparent crisis in its history, from Diderot writing about Vernet in 1767, to the reception of Ingres' *Saint-Symphorien* (1834) or Manet's *Olympia* (1867), that it is tempting to rest with such moments, test and exhaust them for the density of their signification of social process, rather than for their ability to signify.

One striking and important exception to this is Marian Hobson's important discussion of Diderot's use of the rococo technique of *papillotage* in his classic 'Salon' of 1767. Concentrating on the ways in which the critical text is made, making in turn a particular relation between nature and representation, Hobson is able to reveal unexpected continuities and disjunctions not only between the text and its object, but also between different critical texts. Thus while Diderot's engagement in the practice of a style that he condemns in painting is marked by a general, philosophical change in the relation of art and nature from being 'that of reference to that of replica', Diderot and his opponent Cochin share in their writing a mode of paying attention to the work of art as something that itself is made. As Hobson argues, aesthetic thinking itself forms a relation between the art-object as produced, made, seen and experienced as one that shifts around and through the languages of art as a system of representation.[2]

We must accept, then, that even the most dramatic turning-point in the sociability of criticism turns on words and formulations that are already up and running: elliptical, rich in their inertia and unresponsiveness to the new: words to name a form, signal a historical reference, phrases of affection or abuse that are scarcely ever honed to suit one object or art form rather than another.[3] Or techniques of writing that might, as with Diderot, be deployed

in an ironic *contre-sens*, producing a signifying tension between rhetorical form and indicated or avowed values and desires. It is out of this tension between a practice and the disavowal of its equivalent in painting that Diderot is able to open a space for Chardin, whose virtue precisely lies in his antinomic relation to this style. And while Diderot the *encyclopédiste* is in conscious control of the all-crucial notions of reality, experience or illusion that play around the understanding of the status and meaning of the work of art, this is neither necessarily nor even likely to be the case with an art critic either less centrally located in the philosophical thinking of the time or whose agenda is very different. If some of these languages and forms might themselves last a long time, mean different things to different writers or readers – age, social position, gender, class, all these have to be accounted for – then conditions of their utterance must be understood as continuous and inseparable factors of instability, neither identical with rhetorical form nor absent from it.

A popular theme in the history of art criticism is scandal, but a scandal in 1747 is hardly a scandal in 1869. Lafont de Saint-Yenne's views on the Salon of 1746, *Réflexions sur quelques causes de l'état présent de la peinture en France*[4] (conventionally seen as the origin of French art criticism), belonged to a dissident fragment of a defined élite, and for that reason interacted crucially with the power structures of the *ancien régime*. In 1869 Eugène Vermersch's wry and cunning moralising of Carpeaux's *La Danse*, to take another scandal that has been especially well treated, came from a readily defined stratum of the radical Bohemia, but belonged to the world of a syndicated press.[5] A scandal was mounted out of this press's need to fill so many columns of commentary and *faits divers* with tittle-tattle and amusement. A good story appeared all over the place to ensure sales rather than to express a morality. In one case we might well talk of a turning point, or at least a point of crisis where the fault-lines of monarchical legitimacy become clear in a way that they were not in other parts of the mid-eighteenth century social formation. In the other nothing happens at all, other than the instrumental use of morality as a journalistic sales-pitch rather than as a mark of dissidence. Unless, that is, we want to read the Paris Commune back into a highly troped piece of professional journalism – just because Vermersch became a Communard. Neither the noise of the two occasions, nor their meanings, can easily be subsumed under a history of art criticism.

If there is a relatively constant factor, itself historically changing, it is the highly problematic status of art criticism in the French social formation, as both within and outside of official discourses

and institutions, and, at the same time, having a position that depends upon the vicissitudes of the lives of significant critics, for example Diderot or Voltaire, who are writers of quite different kinds of text, of which their writings on art are only one aspect of their difference; or, a century later, Baudelaire and Sainte-Beuve or Charles Blanc. How accurately can we locate the dozens of other writers, other than within some generalised and inadequate notion of influence, or of an equally over-generalised currency of thinking and expression? Moreover, there is little reason to expect philosophic consistency within even a single author's writing, if the short-term aim of a text is a relative political positioning or getting the attention of the reading public. All the more, then, the relation of criticism to aesthetic and social theory must be thought of not only as elliptical but as one of different orders of practice to each other, both in the work of an individual and in the wider field of literary practices.

As Tom Crow, writing of the mid-eighteenth century, puts it in his *Painters and Public Life*, 'it would be naïve even to try to ascribe any encouragement of particular styles or themes in painting to a single, univocal class voice or political interest ... Nor need there be any automatic coincidence between private preferences and public decisions; a unity of "taste" can be posited on neither the collective nor the individual level'.[6] Indeed, as Locquin long ago underlined, even so influential a public figure as d'Angivillier, committed to the production of the historical genre, was inclined to favour the officially despised Dutch landscape genre in his private collection.[7] This discrepancy between orders of sociability, affectivity, taste and discourses is so productive in the representation of the experience of art in the eighteenth century that it generates norms and tropes not only to structure the aesthetic thinking of the revolutionary period, but also the critical language of the nineteenth century – when criticism is poised to enter the nascent mass press as one of its selling points.

It is useful to take just one instance of this kind of problem in order to situate us at a moment before the early nineteenth century. It concerns not a debate about art criticism, but a little, undeclared debate about the meaning of art. It takes place in two places, and at two times. First in L'An III, in the discussion at the *Jury des Arts*. François Gérard, a radical young painter from David's studio, declares that, because the language of art is the language of nature, painting is a universal language – 'ils [les arts] parlent à tous les hommes; leur langue n'est point conventionnelle, elle est celle de la nature, et part-tout elle est entendue.'[8] This is an important assertion for him, if we can construe importance from a set of

rather summary, printed minutes. It seems to articulate the highly serious view he takes of his profession and enables him to reject the anti-nature degeneracy of the old Académies. Hardly surprising in 1795 when, in so many ways, the arts offer models of social progress and backsliding, framings of the images of nation and of people. Within the context of the *Jury*, and wider debates on art, we may be sure that Gérard also has an interest in invoking the supremacy of history painting as a universal value. And so the appeal to an ethically saturated concept of the natural as a validating source must be understood as a rhetorical manoeuvre that appropriates and opens the space of the universal precisely within an interested discourse.

At about the same time another member of the *Jury*, a little-known landscape painter, Neveu, is planning the courses in drawing for aspiring military engineers at the École Polytechnique. His interventions to the *Jury* are acute and practical, and even if he takes no issue with Gérard, he appears to hold a rather different view about the language of art when he expresses himself in the *Journal de l'École Polytechnique*.[9] He has to justify its role in an educational practice appropriate to the work of an urgently functional institution, established to support the revolutionary war effort. For him it is part of 'l'utilité du dessin aux fonctions de l'ingénieur' that it is 'un langage universel', capable of replacing the word through its often superior clarity. He too is pushing a professional position, the value of an expertise in looking, in training the hand and the mind of a battlefield engineer. Neveu, and we have no way of knowing what he thought of Gérard, suggests that the importance of art for engineers lies in the fact that the language of art is purely conventional. It is because it uses signs derived from nature, rather than because it imitates nature directly, that it can stake a claim to universality and hence to being a presence in, or a substitute for, other kinds of discourses.

What are we supposed to make of this difference between the two artists? It would be tempting to mount a number of arguments. For one, Gérard and Neveu are working from the experience of a deeply fissured practice of art. Landscape can by no means make the same claim for public universality as can history painting, even if the public prefer to look at it in increasingly large numbers at the Salons of the Revolutionary period. The accession of artists to official status has always involved an acknowledging of the relative value of their genre, so here, we might want to say, academic rites survive without the Académie. The artist practising the lower genre claims a more modest universal.

Or perhaps the two artists have a rather different understanding of the relation between academic aesthetics and the important

developments in theoretical linguistics that mark the French Enlightenment. Gérard veers to a more Cartesian understanding of nature, Neveu's opinion derives from an alternative, empiricist mainstream worked out of Locke by Condillac.[10] This is attractive, as it makes the pair themselves more interesting. But given the rather summary education of artists at this time, it is unlikely. Just as likely, there is really no philosophical difference of opinion between them that either might have noticed. What they have both got hold of is some bits of a discourse that is casual, banal, quotidian – an involuntary level of argument for a position, whatever the clarity of that position or unconsciousness of the frailty of its rhetoric.

Altogether less attractive, this latter option holds out the possibility of seeing that the relation between aesthetic words and art itself is highly conventional. The amount of meaning that can be made is necessarily limited by this conventionality, or rather the field of difference is restricted by the nature of usage or, in a broader sense, by rhetoric. Meaning may be generated by the way in which the rhetorical field itself is situated in relation to the object, so that two identical comments on a single painting, or a level of agreement that a painting is 'good' may mask, or be disarticulated by, the position of the overall rhetorical usage. Moreover, this fixing of the work of art as the only still point in a play of difference is bound to have some effect on the understanding of what art is.

Be this as it may, this set of suppositions, refusing art criticism its privilege or even its name, does enable us to loosen up some of the questions about its production of meanings, other than those that are teleologised by the need to re-avow art as its necessary or singular object. Indeed the adoption of such an approach is already a time-honoured stratagem in literary criticism and there seems to be no good reason why art criticism should miss out on the act of following 'this process by means of which "one sign gives birth to another" '.[11] What, then, I will try to lay out here is a way of reading a particular body of that which we will still call 'art criticism' in terms of its status as the repository of certain systems of rhetoric, and I will conclude by suggesting some of the problems that follow from this.

Take now the following phrases written around the Salon of 1806:

> Cet ouvrage, comme on le voit par son titre, n'est pas circonscrit dans un spectacle du moment: il embrasse de plus vastes et sur-tout de plus utiles considérations.

They come from the *Avant-propos* of one of the principal critical effusions of that event, P.-J.-B. Chaussard's *Le Pausanias français – Salon de 1806*, a massive volume, over 500 pages in length, that was brought out as a *feuilleton* during the period of the Salon.[12] The declared purpose of this foreword is, then, to re-present in the present – that is to say during the Paris Salon, which is precisely the 'spectacle of the moment' – what had been a journey round the geographical limits of the ancient world, as if this metaphoric delimitation of the Salon's space will frame or set the limits for the question 'Quel est à cette époque l'état des Arts du Dessin en France?'. It is to begin a new history, 'L'ouverture du Dix-Neuvième Siècle', in the textual space already completed by Pausanias for Greece, Vasari for Italy and Félibien for the centuries of François I and Louis XIV, each one an account resembling, in its own rhetorical structures of description and judgement, what is most desirable in the age that it represents. It will be like these.

The enterprise is not without its perils or its ironies. For if Pausanias' own text is 'un des plus précieux trésors de l'Antiquité' this in itself says little for either Antiquity or its distinguished successors. For the centuries of Pericles, Alexander, of the Médicis, François I and Louis XIV all 'virent s'enflammer et s'éteindre et avec eux le flambeau des arts'. The success of Chaussard's text will be to outlive its utility, the utility which consists only in offering up the space of a rhetorical repetition of previous texts whose survival is wholly dependent on the loss of their subject. The text that outlives its time lives as more complete than the mere artistic records of its time, as it is always an iteration of judgement made in a series of judgements whose temporality is not that of their separate subjects, but that transcends them. This transcendence, then, is in the repetition of rhetorically stable judgement whose repetition is also doubled by and representative of the cyclical rise and fall of civilisations and styles of art as the process of history. Each segment of the metaphoric chain (Pausanias – Vasari – Félibien) is taken metonymically in the place of what can now never be more than the representation of the series of their works of art. That is to say, those centuries that 'burned brightly, yet only to die down'. And, if the will to historicise thus becomes specifically atemporal, then it is inside the rhetoric of the historical/critical text that history is conserved and accumulated.

Indeed this notion of the conservation of historical time within the articulation of rhetorical systems can be evidenced at a number of discursive levels throughout Chaussard's Introduction. Literally, Renaissance Italy 'conserves ... some remains of the healthy doctrine' of Antiquity, by substitution – 'Eschyle dans Michel-Ange,

Euripide dans Léonard de Vinci...'.[13] This allows a comparison to be made between the conditions of artistic production of the ancient and modern world, delimiting the possibility of progress in the dynamic of place, time and individual genius. Yet this comparison is one in which the value of material conditions as an explanation for artistic achievement must be subordinate to a trope of cycle and origin, which it is to substantiate. If the origin, Antiquity, remains the highest point, its repetition, in Renaissance Italy, is humbling for ourselves ... 'et lorsque par hasard, nous trouvons aujourd'hui la moindre pièce de leur armure, nous nous en couvrons tout entier.'[14] The only future for the present is to retrieve the position of the origin of the discourse that offers it up for a future. Antiquity, its status as origin bound up with its mode of imitating nature, becomes a second nature whose replication both accomplishes the repetition of a trope and the figuring of social progress in this repetition.[15]

The general mode of historical narrative recommended years before by Condillac and Mably, that of speeding up and slowing down, eliding and detailing, according to the worth of a given period, is carefully observed in the transition between the principal moments of civilisation.[16] Perhaps, then, it is this narrative propriety which lends itself to the description of a present whose value is yet to be established. At each turn of the story the present is enabled as just another turn, its value invested in its potential as rhetorical space. The criticism of art, itself a purely synchronic act of rendering the spectacle, will map the potential for the historicity-as-rhetoric of its moment. Hence, criticism, as a form of discourse, is in this way distinct from history and art, and mediates between them. It will demonstrate the detail that gives the present its right to fill the space-time of historical narrative as ample, worthwhile and belonging to origin.

Yet this narrative device also coincides with the Academic convention of providing only correct models for imitation in the École des Beaux Arts and the Académie de France in Rome. As rhetoric it is fully implicated in the system which it takes to task. A shift in opinion on historical value tends to emerge not so much as a difference about the relation between history and the present, a reconstitution in principle of the present, but itself as a correct or incorrect handling of the language of judgement. History is thus itself doubly conserved, or both conserved and protected in differing interests. One of the most influential counter-attacks on *Le Pausanias* first and foremost takes it to task for its wilful use of the trope of inversion – 'ils ne sont partout qu'inversions inusitées, comme *paternel gouvernement, extraordinaires génies, septentionales*

gothicités ...'.[17] This correction of Chaussard's grammar takes priority over the somewhat competitive refutation of individual judgements and the satirical abuse of Chaussard's masquerade as an antique sage. He was, after all, one of those little-repentant men of '93 who liked to dress up and adopt classical pseudonyms – Pausanias, Publicola. To mock his rhetoric was also to undermine his project.

All these considerations are useful in looking at a field of art-critical discourses in which the word 'history' plays such an important role in linking judgement to education and production through the genre of 'history painting'. For if, as I have already suggested, there is no necessary link between art criticism and art through the word 'art', then, none the less, there are significant isomorphic elements in the way that 'history' operates as a trope in the rhetoric of art and of art criticism. For in both, the word 'history' functions to complete a rhetorical gesture through the insertion of their discourse in appropriate systems of knowledge. For art criticism it acts as the invocation of its already existing and completed relation to an epoch. For art it is the denoting of a space in a timeless hierarchy, or, rather, in a hierarchy of which the temporal specificity is not of its essence; that is to say, the Academic hierarchy of genres and source materials in a web of articulation within and between institutions of discourse and education, exhibition and commissioning. And, as it happens, Chaussard is still as virulently anti-Academic in 1806 as both he and the Baron-to-be Gérard had been back in 1793. Indeed this unevenness both links and disrupts the fields of art and art criticism, enabling us to map the modes of their overlapping and separation and to see more clearly how a structural isomorphism in rhetorical function does not implicate any systematic identity of meaning.

The ordering of similar historical materials is differently figured as narrative and judgement in the practices of art and criticism, as well as in the sources on which they draw, such as histories of the ancient world, connoisseurs' books and numismatics. In a contemporary collection, Ennio Quirino Visconti's *Iconographie Grècque* of 1811, historical narrative establishes the archeologically and numismatically correct sequence of medals or coins in a connoisseurial discourse at the same time as it provides Napoléon Bonaparte with appropriate antecedents. The dating of coins itself it useful in telling accurately the rise and fall of dynasties together with accurate images of great men. Thirteen pages on the Seleucides, the kings of Syria, for instance, both yield up a variety of moral, political or military examples and give numismatics an historical interest in the present, a purpose for its taxonomies. Yet in the

transposition of their materials for a painting or an opera through a common subject like *Antiochus and Stratonice*, they participate in the moral and narrative substance of an image or performance that have their own network of connections to Antiquity and to the present-day institutions of the production and consumption of art and music.[18]

And, at this point in time, when the demands made on historical narrative have been given a special interest by the construction of a new Imperial mythology, the reordering of the relation between the possible modes of historical representation and their rhetorical procedures renders it ever more unstable. Given that this instability, unlike that of the 1789–93 period, occurs within the formulation of a monolithic rather than a plural political discourse, more than one teleology is forced to look like another on the very site of their difference, and the flowing over, or over-determination by each other, of historical rhetorics takes on a new configuration. It may be this, then, that can help to account for what seems very much a silence or uniformity in 1806, a block in meaning which forcibly, as Susan Siegfried has so ably demonstrated, has to be found outside the texts in the interlocking systems of political interests and artistic conflict.[19]

Yet it is worth persisting with Chaussard's stratagems and trying to tease out their historical and rhetorical conditions and conventions. Certainly he is caught in a divergence of interest between the movement of history that represents itself only in its fully completed records or relics and the need, on the one hand, to represent the beginning of an upward curve whose eventual downturn is already inscribed in his language and, on the other, to make free comparisons between the individual works of different epochs – comparisons that now enable individual agency to be inscribed in a historical cycle that is not of any agent's making.

To a certain extent this is simply a matter of ringing some variations in judgements of quality and historical weighting as a means of mounting opposition to an Academic discourse on the site of its own linguistic conventions. Thus Chaussard downgrades the role of Louis XIV, Le Brun and Mansard in the achievements of French art, shifting the myth of Poussin the marginal and the exile to the centre of attention.[20] It is despite the political and social structures of his time that Poussin shone, just as the age of the Médicis enjoyed such favourable conditions for the production of art that it could have existed without them. In blaming Perrault for the infelicity of coupling columns on the Louvre façade, Chaussard situates the artist within a system where individual choice is both possible and a source of merit or condemnation. He can introduce

a sufficiency of distinctions around instances of artistic judgement, taste and choice of historical model (Palmyra rather than Athens by Perrault) that it becomes possible to make new judgements in the Salon within the limits of a dominant language, to make judgement critical. To occupy a radically different discursive site would have been to ironise those very conventions that Chaussard needed to appropriate, and, in so doing, to slip entirely out of the field of elevated discourse. And, of course, the Académie was the instrument of the Napoleonic project that Chaussard so approved.

This problem of address, of tone and speaking position, was to be found at its starkest in the Vaudeville style of Salon criticism – a genre that had grown in popularity from the middle of the previous century.[21] In the *Observations critiques de M. Vautour sur l'exposition des tableaux de l'an 1806*, the 'writer', M. Lambin, trails his maid Julie around the Salon and expresses differences of opinion with his aunt Aurore. M. Lambin rises to the frisson of Girodet's *Deluge*, while his Aunt can only cry out 'Ah! M., quittons ce tableau, je crains mes attaques de nerfs.'[22] And even here, however intentionally ludicrous the tone, Aunt Aurore echoes a form of judgement that goes back to the *Mercure de France* on Vernet's *Storm*, that is central to the classical and Academic critique of the Gothic, and that is not far removed from Chaussard's own reservations.[23] In one of a number of pamphlets entitled *Arlequin au Muséum*, the eponymous narrator, accused of criticising only by means of puns and word-games, gives vent to a farcical but deadly accurate account of the requirements of history painting, 'cet heureux phénix est encore à trouver'.[24] Total dissolution of value is at the mercy of nothing more than improper allocution.

Yet the Vaudevilles and Arlequins joined voices with the 'serious' critics in unmitigated admiration around the spectacle of Bergeret's *Death of Raphael*. Raphael's death seemed to fill a space between genre and history, rhetoric and agency. Empathy with this other, crucial myth of origin was as readily compatible with the authority of history painting as with its farcical deconstruction. History painting's difficulty, its inability to meet the criteria of either past or present, for a moment worked as well for the one discourse as for the other. Salon criticism, we might then want to argue, could not at this point be more than a conflict of illo- and allo-cution. It is interesting to note that Chaussard's own writing is much less rich in comparison and metonymy of the different affective modes of art and music than it had been in 1798. Then, in his great, social allegory-reportage, *Le Nouveau Diable boiteux*, his writing on Gluck was closer to the representation of artistic expression than his criticism of 1806. The prior text is the 'nearer' to the criticism

of the mid-nineteenth century, while in 1806 we seem to be a long way from a romantic conception of art, even if art itself is already almost there. In works like Girodet's *Deluge* or his earlier *Ossian*, public allegory and pictorial image are hardly getting along quite as well as they might.

In 1806 the problem runs like this. For Chaussard to proceed to speak of individual works of art, he must first of all enmesh himself in an unperceived aporetic, which is the entrapment of historical narrative both in the repetition of a single rhetorical trope of repetition – the figure of universality – and in the interested judgement of his own time. 'Il faut parler à la raison et sur-tout à l'intérêt du lecteur.'[25] And as we know all too well, reason and interest are not easily reconciled in the claim for universal values. Within only two of his thirty pages' run-up to the practice, or application, of criticism, Chaussard has already made his task impossible.

Chaussard's choice is, he would like us to believe, a 'more useful' thing to do than to allow oneself to be circumscribed by this 'spectacle of the moment'. But the approach to just this circumscription is doomed through the aporetic of historicity and interest. How and on what terms will Chaussard enter the moment except on the grounds of a rhetoric whose persistence depends on that moment's very transience? When he asks (when the flame of the Arts lights up) 'à celui de la Gloire, quel doit être son éclat', the answer to his antiphrase 'La durée en égalera-t-elle sa vivacité?'[26] is already inscribed in the rhetoric of loss. The value of his own text as an evaluation of the art that it will appraise will not be known until it is inscribed in the repeated evaluation of another art that succeeds the death of his own epoch and its arts. Such is the condition of art criticism as a system of meaning. And, of course, this has nothing much to tell us about art in 1806. Except, perhaps, that its fetishising as a timeless phenomenon precedes the full emergence of the romantic artist, and proceeds from other logics than those of the formation of the bourgeois subject.

Notes

1 A key text in sustaining this mode of argument is Jacques Derrida's *La Vérité en peinture* (Paris, Flammarion, 1978).

2 Marian Hobson, *The Object of Art – the Theory of Illusion in Eighteenth-Century France* (Cambridge University Press, 1982). See chapter 1, 'Illusion and the Rococo'.

3 One might, for example, take the use of the word *épouvante* as subtly linking the criticism of Gothic architecture in Academic and classical theory over a period of nearly two centuries to the aesthetic acceptance of early romantic themes in salon painting. See below and also footnote 23.

4 See Annie Becq, *Genèse de l'esthétique française moderne: de la Raison classique à l'Imagination créatrice* (Pisa, Pacini, 1984), 2 vols. For a discussion of this see especially vol. 2, p. 489 and pp. 516ff.

5 The best documentation is in Anne Middleton Wagner, *Jean Baptiste Carpeaux, Sculptor of the Second Empire* (New Haven and London, Yale University Press, 1986).

6 Thomas E. Crow, *Painters and Public Life in Eighteenth Century Paris* (New Haven and London, Yale University Press, 1985), pp. 117–18.

7 Jean Locquin, *La Peinture d'histoire en France, 1747–1785* (Paris, 1912).

8 *Procès Verbal, Jury des Arts*, n.d., published according to the decrees of the 9 and 25 Brumaire, An 11. This extends a footnote discussion in my article 'The Words of Art, the Artist's Status: Technique and Affectivity in France 1789–98', in *Oxford Art Journal*, Vol. 14, No. 2 (1991), pp. 73–82.

9 *Journal de l'Ecole Polytechnique*, Vol. III, Cahier 6. *Journal Polytechnique ou Bulletin du Travail fait à l'École Centrale des Travaux Publics* (Paris, Imprimerie de la République, then Imprimerie Impériale, Germinal An 111).

10 For a discussion of Condillac's role in eighteenth-century aesthetics see Becq, *Genèse*, vol. 1, pp. 444–64. See also Nicolas Rousseau, *Connaissance et langage chez Condillac* (Geneva, Droz, 1986); Jacques Derrida, *L'archéologie du frivole* (Paris, Galilée, 1990); E. Bonnot de Condillac, *Traité de l'art d'écrire correctement la langue française, par Condillac, précepteur de l'infant duc de Parme en 1750* (Paris, Dufort père, 1812).

11 Paul de Man, *Allegories of Reading, Figural Language in Rousseau, Nietzsche, Rilke, and Proust* (New Haven, Yale University Press, 1979). My reading of the historicity of discourse owes much to this and other of de Man's essays and has benefited enormously from discussions with Fred Orton and his students. I hope that its difference from N. Bryson's approach in his *Tradition and Desire* (Cambridge University Press, 1984 – see p. 129 onwards for an alternative tropology of art practice) will be clear, as will its critical relation to chapter 1 of Michel Foucault's *L'Archéologie du savoir* (Paris, Gallimard, 1969). A remarkable, original and complex account of the temporal and narrative structures of the theoretical language and practices of art in France from the seventeenth to the nineteenth centuries may be found in Claudine Mitchell's 'The Problem of the Representation of Time in French Painting 1860–1875 with Particular Reference to History Painting' (unpublished PhD thesis, University of Leeds, 1985).

12 P.-J.-B. Chaussard, *Le Pausanias français – Salon de 1806* (Paris, F. Buisson, 1806), p. 5. I had wished to work *Le Pausanias français* against other of Chaussard's writings, in particular *Le Nouveau Diable boiteux, tableau philosophique et moral de Paris – Mémoires mis en lumière et enrichis de notes par le Docteur Dicaculus de Louvain* (Paris, F. Buisson, 1799). These were then to be mapped against Landon's *Annales du musée* on the one hand and the Vaudeville style of Salon criticism on the other. This will be more substantially developed in my forthcoming *Staging an Artist, Ingres between Then and Now*.

13 Chaussard, *Le Pausanias français*, p. 24.

14 Chaussard, *Le Pausanias français*, p. 24.

15 In this respect Chaussard's writing belongs to the series of speculative histories and 'futurologies' that characterised the later 1790s and the Empire, such as Emeric-David's essay of 1805, *Recherches sur l'art statuaire considéré chez les*

anciens et les modernes; ou mémoire sur cette question proposée par l'Institut National de France. Quels ont été les causes de la perfection de la sculpture antique et quels seraient les moyens d'y atteindre? (Paris, An XIII), and Joachim Le Breton's *Rapport sur les beaux arts* (Paris, 1810?).

16 *De la manière d'écrire l'histoire*, published separately under the name of both brothers, Bonnot de Condillac and Bonnot de Mably: confused publishing history, but see *Oeuvres complètes de l'Abbé de Mably* (London, 1789), vol. 2.

17 Deloynes, item 1054, *Journal de l'Empire* (1806). This and other Salon reviews below from Collection Deloynes, vols. XXXVII and XXXVIII, in the Cabinet des Estampes, Bibliothèque Nationale, Paris.

18 Even in Chaussard's own writing, for example, the speed with which he passes over ancient Rome as a source of judgement in the *Pausanias*, and the loving care that he devotes to it in his scandalous and titillating allegory *Héliogabale* (Paris, 1798), suggests both the strains and adaptability of historical tropes.

19 See Susan Siegfried's essay, chapter 1 in this volume.

20 Chaussard, *Le Pausanias français*, p. 32.

21 I must here express my disagreement with Bernadette Fort's 'Voices of the Public: The Carnivalization of Salon Art in Prerevolutionary Pamphlets', *Eighteenth-Century Studies*, XXII, no. 3 (1989), pp. 368–94. My assumption for both the earlier vaudeville pamphlets and those of the 1800s is that they represent an appropriation of an imaginary public voice within a system of critical discourse, thereby constructing a site of difference and a public to go with it – a public that is not so much going to overturn anything, but that is going to be able to amuse itself at the salon within the framework provided by official discourse. The importation of Bakhtinian models of carnival into a modern 'civilised' discourse makes more claims for difference in literary style than is needed to follow the meaning of the texts.

22 Deloynes, item 1026, p. 11.

23 For the Vernet, see Hobson, *The Object of Art*, p. 48.

24 Deloynes, item 1029, p. 12.

25 Chaussard, *Le Pausanias français*, p. 5.

26 Chaussard, *Le Pausanias français*, p. 6.

3

Life and afterlife: Jacques-Louis David, nineteenth-century criticism and the construction of the biographical subject

NEIL McWILLIAM

> Nous sommes dans un siècle de biographies
>> Sainte-Beuve, *Premiers Lundis*, 1826

In the years following the artist's death in 1825, Davids began to proliferate. Appearing throughout France and Europe, they took on a variety of forms, from relatively laconic obituary notices to more discursive biographical and critical studies, each anchored upon the same bedrock provided by the life and works of the late master.[1] Perhaps more than any other artist of the period, David bequeathed a legacy – both personal and professional – the controversial nature of which ensured continuing discussion and debate. Described in 1834 as 'this man whose name has never been uttered without love or hatred',[2] David underwent post-humous reappraisal and mutation, as contending aesthetic and political forces shaped him to their particular polemical needs. As a biographical subject, David is thus a multi-faceted, protean figure who strikingly reveals the conventionalised, ultimately fictional nature of a form of writing central to the development of art history during the nineteenth century.

It is the shape and potential range of utterances on David which will form the focus of the present investigation. In mapping out the discursive polarities within which competing representations of the artist were constructed, we shall point to the rhetorical underpinning of a literary and critical genre which claimed to illuminate the authentic meaning of cultural products through privileged access to the mentality of their maker. Such claims, as José-Luis Diaz has shown,[3] characterise biographical writings in early-nineteenth-century France, which display a preoccupation with personality and anecdotal incident generally dismissed as inconsequential by *ancien régime* writers, for whom the 'vie d'artiste' was an exercise in edification rather than cultural exegesis. The texts encountered here, drawn from a broad spectrum of sources

addressing a variety of publics, display a shared belief in the capacity of biographical narrative to reveal the 'true' nature of the painter on whom they focus. As we shall see, however, the dramatic contrasts contained within them suggest ideological and aesthetic overdeterminations which necessarily inflect the process of writing the life and framing the works. Pierre Bourdieu has spoken of 'the biographical illusion',[4] with its precarious evocation of an 'authentic', elaborately individualised subject demanding credence as a coherent psychological being, co-extensive with the acts, utterances or artefacts which attach to its name. The term is particularly apposite in relation to David's incorporation as a biographical subject within the broader cultural and political narratives of his age, the 'illusion' operating in both senses to buttress claims on the past by later generations implicated in conflicts – pictorial and political – in which the deceased artist played a crucial symbolic role.

The ingredients which constituted David as a biographical actor were unusually, perhaps uniquely, difficult for contemporaries and successors to assimilate. By playing such a conspicuous role in the artistic reforms of the previous century, he was regarded – for good or ill – as a seminal figure in the subsequent evolution of the French school. By transgressing the boundaries of his art and entering the world of radical politics, he confronted later generations of biographers and critics with an altogether more sensitive problem, intimately rooted in the ideological divide which had split the nation since 1789. On both counts, attitudes towards David could not remain neutral, since they carried broader implications. To pronounce on the artist was to declare one's position.

From the first anonymous biography in 1824 to Delécluze's major study, published some thirty years later, some resolution of this problem was sought in distinguishing the painter from the public figure, focusing on the works themselves rather than on the ostensibly contingent circumstances of their production.[5] Yet, however conscious an attempt was made, occluding the 'conventionnel', the regicide, the opponent of the Academy and First Painter to the Emperor, proved no easy task. Even in physical descriptions of the artist, judgemental criteria inflect the portrait which emerges, investing every feature with more or less explicit moral connotations. Three separate sketches, written from contrasting aesthetic and ideological perspectives, will illustrate this point and introduce some of the themes central to the biographical representations of David which circulated in the decades after the painter's death. The first of these descriptions appears in the study published in 1850 by Miette de Villars, a committed Jacobin

apologist and unqualified admirer of the artist. Though in large part reproducing Montabert and Parisot's 1837 portrait, careful editing transforms their largely negative assessment into a more agreeable characterisation:

> David was tall, well built and seemed vigorous; his eye was lively and his gaze penetrating. Overall, his features suggested a combination of wisdom with a strong character. His brown hair curled slightly. His gestures and bearing had about them something calm and distinguished. When he was trying to please a woman, he was not without grace, and could be extremely friendly in private.
>
> He was simple and cheerful, despite a rather blunt manner.[6]

Twelve years later, in 1862, a highly critical account of the artist by the more conservative Ernest Chesneau underpins a strikingly less flattering evocation, elaborated around the self-portrait of 1790:

> The brow protrudes and shows little openness; the hair is brown, thick and coarse, the eyes dark and lifeless, though not without sparkle: the cheeks are full and somewhat flaccid; the outline of the mouth is somewhat disfigured by an accident which the artist has been obliged to show; the complexion is dull and somewhat grey.

With the precision and self-assurance of a physiognomist, Chesneau sums up the artist's features as revealing 'a character without breadth, common in origin, but ambitious and tenacious'. Though still under-developed at this relatively early age, a 'desire to dominate' is also apparent to the critic's penetrating gaze[7] – a desire which is apparently given full rein in our final description, taken from Michelet's account of the Terror in the *Histoire de la Révolution française* of 1847. Though relegated to a firmly subsidiary role in Michelet's richly expansive narrative, David is briefly glimpsed confronting Fabre d'Eglantine at the dramatist's trial in 1794. As head of a Comité de sûreté générale described by Michelet as being 'dominated, brutalised' by the artist,[8] David takes on an almost guignolesque violence appropriate to the high drama of the moment: 'The chair had been taken by that terrifying figure David, whose rolling eye, wild dishevelment and deformed cheek, puffed up with fury, could fascinate the weak'.[9]

This transformation from genial artist to ranting zealot, as awesome and dangerous as the degeneration of Dr Jekyll into Mr Hyde, raises a number of central points. The connotations of the shifting physical description are clear enough – the eyes, for example, judged as 'vifs' by Miette and 'durs et sans vivacité' by Chesneau, deteriorate into a 'roulante prunelle' in Michelet's highly charged prose. The artist's deformed mouth undergoes similar transformation: overlooked entirely by Miette, it serves

Michelet as an emotive index to David's degenerate excess. More subtly, though, these three faces of David infiltrate moral associations typical of the contrasting biographical constructs and critical evaluations which structured accounts of the artist during the nineteenth century. While in Miette's estimation, David's features reveal a psychological equilibrium, Chesneau's language evokes a far more complex blend of rigidity and weakness, detectable in the painter's wiry hair and flaccid cheeks. Yet, despite the uneasy, somewhat forbidding personality implied in his description of the artist's brooding brow and colourless complexion, this David is still distanced from the manic tyrant evoked by Michelet, a vignette of unreason in the spiralling violence of the Terror.

These portraits provide us, then, with three significantly contrasting representations of David, foregrounding in turn balance, narrowness and irrationalism – three themes which are continually recirculated in the artist's textual afterlife. As a posthumous text, David is organised around four recurrent tropes, whose changing permutations negotiate the evaluative spectrum epitomised by Miette, Chesneau and Michelet. Organised as two antithetical pairings, these tropes can be identified as reason versus emotion, and convention versus nature. An examination of these couplets, uncovering the aesthetic and ideological ramifications they condense, will provide some of the key elements of the syntax from which contrasting Davids could be assembled during the nineteenth century. As will become quickly apparent, far from divorcing the painter's work from the details of his life, commentators of the period habitually characterised the style and subject of the canvases through reference to the originating personality of the artist himself. The four motifs identified here, re-ordered in differing combinations, provided the diagnostic formulas from which an aetiology could develop. With few exceptions, whether eulogistic or critical of David as an artist, favourable or hostile to his incursion into public life, commentators throughout the mid-nineteenth century rooted cultural exegesis in the characeral strengths or weaknesses identified in the man himself.

'A cold imagination and a bloodless dogmatism',[10] Henri Delaborde's assessment of David, echoes an indictment frequently reiterated by both aesthetic and political adversaries of the artist. The claim that 'David had a great deal of knowledge, but not enough feeling'[11] lay at the core of a critical position which accused the painter of an excessively systematic and rationalist mentality, debilitating to his art and dangerous in his political inclinations. While few went so far as to dispute the timeliness of David's challenge to the artistic establishment of the *ancien*

régime[12] the rigidity of his outlook encouraged certain critics to condemn the extreme consequences of his intervention.[13] Though capable of offering what Louis Vitet described as 'an entirely rational and contemplative pleasure',[14] David's major history paintings were frequently condemned for their contrived structure and lack of emotional immediacy. The theatricality of his compositions – 'organised according to rule, following convention in their poses'[15] according to Léon de Laborde in 1856 – echoed what many of the artist's opponents regarded as their lack of emotional depth. For Ernest Chesneau, David's characters 'leave us indifferent. What passions do they arouse? None, since not once have they themselves experienced the storm of passion, which has never disturbed so much as the expression on their faces.' Rather than infusing his characters with an emotion he was incapable of experiencing himself, David merely imposed an appropriate expressive mask on each of his protagonists, 'methodically and mathematically'.[16]

Yet the rationalism discerned as the dead hand immobilising David's art and depriving it of poetic depth could be inflected into a broader, more damaging indictment. Pictorially, David's rationalism was equated with the dominance of abstract principle over emotional resonance; in his politics, the same systematic mentality was identified with an ideology founded in theoretical dogma having little purchase on reality. It was in this susceptibility to bloodless abstraction that David's opponents sought the origins of the artist's bloody legacy of 1794. Vitet was one of those who made the connection, in his obituary notice of 1826:

> His mentality prevented him from seeing clearly; that is why there is something incomplete, cold and inanimate in even his most beautiful works. If such a mentality is joined with such a character, then you will inevitably be fanatical in politics and dogmatic in art. We can thus say that, at the Convention as well as in his studio, David's soul was continually duped by his head.[17]

As a structuring motif, the concept of reason thus elides politics, pictorial practice and personality, grounding the perceived shortcomings of David the artist and David the public figure in the psychological limitations of the man himself. As Henri Delaborde claimed in 1855, 'Whether Terrorist or painter, he sought counsel only in his own brain'.[18]

This biographical representation of David as a narrow and dogmatic rationalist was challenged on a number of fronts, in a counter-discourse which emphasised qualities of emotion, passion and sentiment – qualities of the heart rather than of the head,

generous and expansive rather than prescriptive and unyielding. Though advanced most frequently by David's political apologists on the republican left, it also served such former pupils as Etienne Delécluze in exonerating the artist from repeated charges of pedagogical exclusivity and intolerance. In a survey of David and his school emphasising the diversity fostered by the master's open-minded tuitional practice, Delécluze strategically demoted his mentor's standing as a theorist to highlight his practical achievements as a painter.[19] Repudiating accusations that David's work betrayed the rigid application of abstract principles, Delécluze presented an artist enthused by his métier and avid for novelty until the very last.[20] For the David who emerges out of Delécluze's text, painting is but another word for feeling. As he states in the opening remarks to his final chapter: 'David was not an intellectual, still less a systematic figure; his instincts were overwhelming, and it was them he obeyed'.[21]

Though Delécluze was unwilling to extend his indulgence for his former master to David's political career, it was precisely here that the spontaneous, instinctive figure he invoked gained widest currency. The 'fiery imagination'[22] and 'exquisite sensibility'[23] of the man described by the republican critic Alexandre Decamps as 'the impetuous painter of the Mountain'[24] were mobilised in advancing the image of a figure passionately engaged in the struggle for freedom and justice. As an artist whose work was revivified and sustained by its immersion in the unfolding political drama, David exemplified for a new generation of radical critics in the 1830s and '40s the ideal of art at the service of progressive change. If their anti-establishment posture fostered contempt for many of David's pupils now in positions of institutional power, they singled out the master himself as an impassioned exponent of artistic commitment. From such a perspective, David the revolutionary artist channelled his fervent political enthusiasm into works of urgency and power. Thus, in 1834, the young republican Barthélemy Hauréau could present the painter as typifying a generation of 'battling republicans, sublime in their irascibility, with a hot-blooded temperament, and a strong pair of lungs', a 'head full of dreams and poetry' guided less by rational calculation than by the emotional pull of events.[25] Hauréau's relative indifference towards David's classical subject-matter contributes to an overall assessment of his career in which ardent political commitment provides overriding impetus to his greatest work. As an individual 'driven less by discretion than by passion',[26] Hauréau's David displays a temperament of almost romantic intensity at odds psychologically with the cold, cerebral figure circulated within the rationalist discourse.[27]

The contrast between convention and nature parallels this structuring antithesis between reason and sentiment, overlaying and reinforcing the opposing appraisals of the artist's temperament which it articulates. Convention – the recourse to antiquity as a model for artistic inspiration – signifies the application of reason to the creative process. By contrast, assertions of David's naturalistic inspiration frequently serve to confirm his spontaneous and emotional personality, immersed in the world around him rather than alienated from it by a veil of dogmatic theory.

Amongst those critics who insisted on the conventional nature of David's art, reliance on the antique was interpreted as evidence of the painter's creative debility. From such a perspective, the laboured recycling of motifs from the past, unconvincingly reassembled in clumsy and lifeless tableaux, bespoke a prosaic and calculating *bricolage* masquerading as aesthetic high-mindedness. For Louis de Maynard, writing in 1833, David's classicism betrayed a lack of creative self-confidence in which 'his antiquarian studies and his regard for decorum almost always vitiated his spontaneity'. In common with a number of other commentators, Maynard asserts that 'his genius lies in his memory',[28] pedantic and controlled, sterile in its inhibited reliance on the authority of the past:

> Timid and unadventurous, even at his most daring, he is like both a master and a pupil at the same time, continually turning towards antiquity like a mother who is uniquely able to guide him and protect him from the moderns and the temptation of their work; unlike Michelangelo, he is never ignited by his own thought, never throws it on to canvas with four of those strokes which reach across the whole universe of art, like the four strides of Homer's Jupiter. He trembles, fumbles, corrects. ... He moves like an old man who tries to seem young by conjuring up adolescent memories.[29]

Maynard's imagery here – evoking the impotence of old age, the timid obedience of the pupil, the child anxiously seeking maternal guidance and protection – identifies David as a weak and hesitant sensibility, compensating for a profoundly attenuated sense of individual identity by clinging to the antique as a source of authority and legitimation. Authority, too, underlies Louis Vitet's diagnosis of David's commitment to an idealist aesthetic which disciplines the potentially disconcerting diversity of nature into a systematic pattern distilled from the classical tradition. Arguing that 'his mind could achieve repose only within a dominating idea or system', Vitet maintains that in his study of nature David 'subjected it, so to speak, to the control of those abstract models in which he saw the law of beauty'. It is this, he

asserts, that explains the 'incomplete way in which he saw nature: he studied it only insofar as it confirmed his system; in other words, only to the extent that it did not contradict it'.[30] Once again, then, the debility of an artist intimidated by the undisciplined richness of the natural world seeks resolution in a retreat to system, rule and precedent. Disciplined himself by the example of the ancient world, David interiorises its authority to impose order on nature, cauterising and erasing those forms which imperil the control he seeks through the act of representation.

The outcome of this process, in terms of the painter's success in using his medium as an effective vehicle for emotional immediacy and narrative depth, aroused widespread scepticism amongst David's critics, who found his vision of antiquity and his sense of human drama desiccated and unconvincing. While Michelet questioned whether any artist whose inspiration originated outside his native tradition could successfully engage his contemporaries,[31] others found his interpretation of the ancient world inherently flawed. Both Alphonse Rabbe, in 1827, and Gustave Planche, reviewing the Salon of 1831, likened David's scenes from ancient history to the discredited classical tradition which still dominated the French stage. 'Affected, solemn and theatrical, stylistically irreproachable, perfect in its details, but entirely lacking in overall effect',[32] David's compositions were dismissed by Rabbe as lacking all spontaneity, while for Planche his vision of antique heroism betrayed the schoolboy's shallow erudition rather than the sweep and vision of a Shakespeare.[33] Nor did sympathy increase with the passage of time; some thirty years later Ernest Chesneau could dismiss the historical compositions as stiff and lifeless – 'whether body or mind, attitude or gesture, everything is tense ... passion, which should energise his figures, paralyses them'.[34] As a common theme across such remarks, the artist's dependence on antique sources and the deficiencies in his dramatic sense are recurrently attributed to a common source – the rationalist origins of David's classical aesthetic. As Henri Delaborde remarked in 1855: 'Always keen to formulate a poetic system, he never shows the enthusiastic outpourings of the poet'.[35] Emphasis on David's naturalistic inspiration frequently supplemented assertions of the painter's spontaneous, unsystematic attitude towards his work. The insistence on David's unmediated responsiveness to nature strengthened his promotion as an anti-academic figure and, in certain contexts, contributed to fostering his reputation as a cultural activist committed to an art inspired by the political climate of the present rather than the pedantic example of the past. Refuting accusations of lifelessness and dependence on antiquity, the naturalist discourse

foregrounded David's indebtedness to a more marginal pictorial tradition, centring on Caravaggio and Le Valentin,[36] at the same time as insisting on the importance of natural observation in his work. For former students such as Muller and Delécluze, for whom David's art exemplified 'energy and love of truth',[37] emphasis on naturalism underwrote insistence on the master's open-minded tuition and distanced him from those pupils whose formulaic classicism had compromised his own reputation in the 1820s and '30s. More generally, David the naturalist could be decisively positioned as an opponent to the generation of rococo painters which preceded his emergence in the 1780s: it is this innovative 'imprint of reality', demonstrated through the 'study of the model and tonal vigour', which is highlighted in an anonymous article on David and his school in 1861.[38] Similarly, in an assessment published shortly after the painter's death, David is said to merit recognition as the French school's first naturalist, an achievement realised with the *Oath of the Horatii* in 1785, in which 'for the first time we saw complete truth, nature itself before our eyes'.[39]

Yet truth to nature could count as more than a merely aesthetic achievement. For radical commentators such as Esquiros and Miette de Villars, naturalism carried greater symbolic force, further repudiating accusations that David was capable only of an abstract, rationalist perception of the world around him. Miette's assertion that 'no artist excelled him in observing and painting nature faithfully'[40] works within a text dedicated to the aesthetic and political rehabilitation of the artist to discredit suggestions that he had been temperamentally divorced from his world. Strategically positioned within such a text, nature's implicit signification exceeds any narrow discrimination of aesthetic systems, evoking instead an originating mentality which is read out of the canvas and into the life.

Reason and sentiment, convention and nature – the textual ingredients out of which competing biographical models could be assembled thus carry certain privileged connotations. It is for this reason that particular combinations recur, re-presenting what might be described as preferred descriptions of the artist, which broadly correspond to identifiable aesthetic and ideological positions. Yet in the same way as these positions themselves reveal certain gradations which prevent them from being reduced to monolithic oppositions, so too the disruption of the dominant models we have outlined also occurs, presenting biographical readings which deviate from the norms examined so far. The concept of reason, in particular, operates on a number of different registers to reposition David within differing discourses. Most strikingly, the artist's

status as a painter of contemporary life and his political activities during the revolution elicit conflicting interpretations of his mentality and motivation in which reason – its excess or its absence – serves as the central structuring motif.

The excess of reason was a central theme in radical misgivings during the 1830s and '40s over David's achievement as a socially committed artist. While leading theorists on the republican left agreed on art's potential as a catalyst for political change, and emhasised the need for creative activity to be guided by a central 'pensée', or directing idea, the contribution made by formal values in communicating abstract concepts became an increasing preoccupation. Belonging to a generation hostile to the remnants of classicism still apparent in contemporary production, such critics tended to see style as integral to a painting's didactic effect. It was here that David became vulnerable to criticism; his deference to antiquity, the ordered rationality of his compositions and the apparent deficiencies of his pictorial technique all conspired to foster the image of an artist exclusively preoccupied with content at the expense of its effective communication by formal means. Thus Charles Blanc, while acknowledging David's eminence in the philosophical tradition of the French school, expressed reservations over the painter's lack of 'individualité' and 'fantaisie', arguing that 'fundamentally, his mind was prosaic and his soul without tenderness'.[41] For Théophile Thoré, another leading advocate of art's radical potential, David provoked similar doubts. His admiration for the creator of an 'art for the people, an art for all' was qualified by reservations over the painter's 'stiff and lifeless style' and the narrow range of emotions it was capable of conveying.[42] For both commentators, reason frustrated David's potential as a truly effective radical artist. Rather than evolving a style as engaging and immediate as the ideas he felt impelled to communicate, rationalism was seen to have attenuated his expressive impact. Even during the revolution, Blanc argued, the turbulence and urgency of the present was distilled by David into images in which marmoreal forms evacuated all sense of the immediacy of political struggle:

> He would leave the Jacobin club or sessions of the Convention with his head full of images of ancient liberty; then, when he stood before his canvas, in the silence of his studio, the enthusiasm he had felt at the shouts of Danton or Saint-Just's gaze gradually cooled and his pedantic mentality gained the upper hand. Thinking only of his mission as the regenerator of painting, he drew his austere nudes, struggled to achieve elegance, and above all formal purity, endowing his models with an ideal beauty adapted from Greek and Roman sculpture.[43]

Yet, if reason compromised David's credentials as an effective cultural activist among certain sectors of the French left, for the painter's political opponents, the excess of reason, manifested as a delusive isolation from reality, underlay what they regarded as the sustained irrationalism of David's revolutionary career. As the most controversial moment in his biography, David's political involvement of the 1790s attracted extensive comment and speculation. Those most favourably inclined towards the artist entered a plea of mitigation, throwing responsibility for David's ideological entanglement on the demagogic allure of Marat and Robespierre, and presenting the painter himself as a 'citizen fooled by a number of dreadful, hypocritical charlatans'.[44] Yet even when trivialising his motivation as revealing the 'good faith of an artist unsuited to the ways of the world',[45] commentators frequently associated this impracticality with a misguided rationalism. Seduced by the moral austerity of the ancient world with which he identified so completely, David is portrayed as incapable of discriminating between past and present, aspiring to resurrect antique virtue amongst his contemporaries with little regard or understanding for the concrete realities of the political situation. As a 'Republican legislator misled by the memory of Greece and Rome', 'carried away ... by his enthusiasm for the republics of Antiquity' and 'sincerely expecting the revival of ancient habits',[46] David was regarded by a succession of commentators as the victim of his own abstractions. It was thus a moral absolutism, as unyielding and as rarefied as his aesthetic credo, which critics saw as the overriding impulse behind David's political career.

This commitment to an abstract ideal was interpreted by many commentators as evidence of a profound disequilibrium. As David's 1826 biographer remarks: 'his vivid imagination and the extreme enthusiasm of his republicanism filled his death with illusions',[47] while others note the 'incredible illusions that he nurtured in his exalted imagination',[48] and the 'credulity' and 'weakness' which blinded him to the vices of Marat and Robespierre.[49] Insistence on imagination as the driving force behind his excessive and erratic behaviour projects David as an individual caught up by events and denied any firm purchase on reality by the disembodied, abstract nature of his ideology. It is this disequilibrium which provides an explanatory model for the series of revolutionary works which culminated in the *Marat*, images seen by many as standing apart from the overall evolution of David's art. For Chesneau, for example, the *Marat* provides a tantalising glimpse of modernity in which 'everything is painted soberly and sincerely, composed without over-emphasis, with a stamp of severe reality'.[50] For

Delécluze, too, the work typifies a naïveté and spontaneity which infuses David's work at this period, while Laborde remarks contemptuously: 'The only occasion he painted with his heart was to show Marat bathed in his own blood'.[51] The widespread consensus that in pictorial terms the *Marat* revealed David at his strongest and most persuasive simply confirmed for many the perversity of an artist whose highest inspiration could be induced by such an apparently loathsome subject. In some respects, the David who emerges within such a discourse is presented as a neurotic figure, caught in what Auguste Rabbe described as 'a long aberration of ... judgement'.[52] The painter's repressed imagination runs out of control under the pressure of rapid political change, unconstrained by a reason rendered impotent by its delusive commitment to false abstractions. Irrational violence and lack of judgement thus stand within such a discourse as the consequences of an inflexible reason being ruptured by the pent-up violence of instinct in an explosion of neurotic energy.

For Michelet, too, David's character takes on neurotic overtones, though within a rather different interpretative model. David acquires almost emblematic significance for Michelet as a Jacobin archetype, much as Géricault was presented in his 1848 Collège de France lectures as typifying the disillusioned youth of the Restoration.[53] Described as 'ce Prométhée de 93', Michelet's David is a pained and violent mass of repressed energy, whose unappeased power turns inward with self-destructive force. Here, the artist's neurosis, acted out in a hatred of nature[54] which spawns the unnatural tyrant glimpsed in the historian's account of the trial of Fabre d'Eglantine, originates in his love of abstraction, in his search for perfection identified with mastery and control. His neurosis is the neurosis of the society around him, his torment the internalised struggle of an anguished nation: 'David epitomised effort. In this respect, he embodied his times. An artist suffering from great torment, an awkward and violent genius who persecuted himself, David's troubled soul contained the struggles and conflict from which the Terror erupted'.[55]

Significantly, the David exemplified in Michelet's critique shares much in common with textual representations of Robespierre who, since the time of Thiers, had entered history as a 'narrow and common intellect',[56] castigated by his political opponents as rigidly doctrinaire and emotionally flawed. While Jacobin apologists such as Hauréau or the socialist militant Albert Laponneraye significantly emphasised his 'gentle manner' and his 'unusual sensitivity',[57] Robespierre's adversaries more frequently focused on a range of characteristics strikingly reminiscent of hostile appraisals of David.

At once fascinated and repelled by the Jacobin leader, Michelet describes Robespierre as 'rational and logical by nature', a 'lover of abstractions' who 'descended only unwillingly from generalisations'.[58] Proud, hard-working and rigid, like David, Robespierre represents the antithesis of nature in his narrow and determined promotion of a single, obsessive ideal. Impelled by will rather than understanding, his allegiance to an abstract political code mirrors in its partiality the occluded vision frequently attributed to David. Like the painter, the politician stands condemned for his intellectual exclusivity, which effaces true comprehension of nature through a philosophical *parti-pris* as disabling as the painter's commitment to antiquity:

> He had nothing ... of the broad, speculative sweep; he followed his masters, Rousseau and Mably, too obediently. In sum, he lacked a varied knowledge of men and matters; he knew little of history, little of Europe.[59]

More hostile still to a figure whom he associated with the progressive degeneration of the national spirit, Hippolyte Taine broadened the attack on Robespierre. Insisting on the Jacobin's indebtedness to the eighteenth-century rationalist tradition, Taine's evocation of Robespierre's prose style, with its indictment of the politician's failure to engage with reality, reformulates many of the charges levelled against David's pictorial practice:

> His writings and speeches are nothing more than streams of abstract, empty sentences. Lacking in precise, developed facts or individual, characteristic detail, there is nothing here which appeals to the eye through the evocation of a living figure, there are no personal observations, no clear, frank or original impressions.[60]

Both Robespierre and David demonstrate the transformation of reason into irrationalism, the point beyond which abstraction evaporates into neurotic fantasy, unchecked by the restraining consciousness of the real world. While critical assaults on David's sacrifice of nature to the antique present the artist's idealist aesthetic as an impediment to creativity, Robespierre's construction of a political ideology on moral imperatives rather than lived experience provokes social catharsis. For a figure such as Taine, the doctrine of natural rights, as divorced from nature as the Davidian ideal, similarly fails to embrace the complex diversity of life itself. Oblivious to the constraints imposed by reality, the Jacobin, whose political responses follow the dictate of such abstract principles, stands accused of violating nature in an irrational pursuit of order reminiscent of the anti-naturalism of David's classical vision:

He doesn't care for real men and doesn't see them. Nor does he need to see them. With closed eyes, he forces his mould down on to the human material he wishes to shape; never does it occur to him in advance that this material is varied, shifting and complex.[61]

Denigration of David for having subordinated nature to abstract principle thus inhabits the same discourse which identified rationalism as the source of national crisis after 1789. The doctrine of natural rights and David's rehabilitation of the antique were seen to form two facets of a common thread in recent French cultural and political history over which many commentators expressed uneasiness or open hostility. The feeling that Enlightenment rationalism had spawned an ideology which was against nature apparently informs much of the reticence expressed about David. Significantly, Etienne Delécluze, for whom the painter's revolutionary canvases resemble those of a 'sleepwalker who laboured without realising it', makes much of the work executed by David during his imprisonment after the 1st Prairial. The fact that he should have used the opportunity to paint his only landscape – a view of the Luxembourg gardens from his cell window – works as symbolic confirmation that David's 'bout of ... political fever' had been overcome and an equilibrium between reason and nature finally secured.[62]

Delécluze's psychological reading of the landscape sketch typifies a widespread tendency in writing on David from the 1820s onward to interpret the artist's work through reference to his biography and personality. While for admirers and former students, it is the painter's 'simplicité' and 'bonhomie'[63] which retain attention, critics of the artist's work incline to a less charitable assessment, associating pictorial deficiencies with weakness of character. Described by Maynard as 'a dwarf in an age of giants',[64] David is characterised for his detractors by 'the most extreme weakness',[65] which he attempts to compensate through an imperious and unyielding effort of will.[66] Perceived not only in his painting but also in his politics, David's fundamental weakness as an individual is identified with his incompleteness as an artist. Establishing a symmetry between the painter and the work, critics such as Chesneau and Delaborde portray David as an incomplete sensibility, lacking the essential equilibrium between reason and emotion from which superior artistic achievement can grow. As Chesneau concluded in 1862: 'David was neither a painter of genius nor a painter of feeling; he was a painter of intelligence'.[67]

Throughout his afterlife, then, biography worked to construct diverse and contradictory representations of the individual – David, painter and *conventionnel*. Caught up in the disputes and

debates which ranged across the century, David remained alive in biography as a potent and pliable symbol, implicated in the simmering conflict around the Academic system as well as in the ongoing ideological struggles over the revolution and its aftermath. The different faces of David we have examined project an image of the past refracted by the preoccupations of the present, rendering notions of objectivity and distortion redundant. At once central to all of this, yet irreducibly illusive, is the figure of David himself, upon whose imputed personality so much authority was focused and through whose acts and utterances access to the works was invested. The predominance of psychologised readings – of the equation between talent and temperament – is a striking feature of biographies of the artist. Sustained beyond death through the texts of the life, new Davids were born in a dialogue with the century, assembled through the interplay of images and motifs, tempered by the needs and conflicts of the day, fashioned in the aesthetic and political ferment he had at least nominally left behind in 1825.

Notes

1 An extremely useful and wide-ranging listing of texts devoted to David, covering the period from the 1780s to the 1940s, is to be found in the 'Bibliographical Essay' at the end of D. L. Dowd, *Pageant Master of the Republic, Jacques-Louis David and the French Revolution* (Lincoln, Nebraska, 1948), pp. 143 – 64. Supplementary information can be found in R. Verbraeken, *Jacques-Louis David jugé par ses contemporains et par la postérité* (Paris, 1973).

2 'Cet homme dont on n'a jamais prononcé le nom sans amours ou sans haines.' Barthélemy Hauréau, 'David', *La Montagne. Notices historiques et philosophiques sur les principaux membres de la Montagne* (Paris, 1834), p. 65.

3 José-Luis Diaz, 'Ecrire la vie du poète. La Biographie d'écrivain entre lumières et romantisme', *Revue des sciences humaines*, vol. 98, no. 224 (October – December 1991), pp. 215 – 33.

4 P. Bourdieu, 'L'Illusion biographique', *Actes de la recherche en sciences sociales*, nos. 62 – 3 (1986), pp. 69 – 72.

5 'Les amateurs, de quelqu'opinion qu'ils soient, distinguant l'artiste de l'homme, aimeront sans doute à le juger sans passion, c'est-à-dire par ses oeuvres.' Anonymous, *Notice sur la vie et les ouvrages de M. J.-L. David* (Paris, 1824), p. 6.

6 'David était d'une taille élevée, bien fait, et paraissait vigoureux; son oeil était vif et son regard perçant. L'ensemble de sa physionomie annonçait la prudence alliée à un caractère ferme. Ses cheveux bruns étaient un peu bouclés. Son geste et son maintien avaient quelque chose de calme et de distingué. Lorsqu'il cherchait à plaire à quelque femme, il ne manquait pas de grâce, et devenait fort aimable dans l'intimité.

'Il avait de la simplicité, de la bonhomie, malgré une certaine rudesse de

manières.' Miette de Villars, *Mémoires de David, peintre et député de la Convention* (Paris, 1850), p. 38.

7 'Le front est bombé et peu ouvert; les cheveux bruns et plantés drus sont sans souplesse, les yeux noirs et sans vivacité, quoique ne manquant pas d'éclat, les joues pleines et un peu molles; le dessin de la bouche est défiguré par un accident que l'artiste a dû reproduire, enfin le teint est terne et légèrement plombé.'; 'désir de dominer.' Ernest Chesneau, 'Louis David', *Les Chefs d'école* (Paris, 1862), p. 7 (reprinted from 'Le Mouvement moderne en peinture, Louis David', *Revue européenne*, vol. 15 (May 1861), pp. 76 – 105).

8 Jules Michelet, *Histoire de la Révolution française*, vol. 2 (1847) (Paris, 1952), p. 777.

9 'On avait mis au fauteuil cette terrifiante figure de David, dont la roulante prunelle, le débraillement sauvage, la difforme joue, bouffie de fureur, pouvaient fasciner les faibles.' Michelet, *Histoire*, p. 706.

10 'Une froide imagination et un dogmatisme sans entrailles.' Henri Delaborde, 'Peintres et sculpteurs modernes de la France. David et l'école française', *Revue des deux mondes*, nouvelle période, 2e série, vol. 10 (15 May 1855), p. 755.

11 'David avait beaucoup de savoir, mais pas assez de sentiment.' J. N. Paillot de Montabert and Valentin Parisot, 'Notice historique sur J.-L. David', *Biographie universelle* (ed. Michaud), vol. 62 (1855), p. 207. This text was first published in 1837.

12 Some commentators, however, attempted to diminish David's significance through emphasising the role of Vien, a strategy often found in the Legitimist press. See, for example, the comments from *La Quotidienne* in 1827, cited in Charles Farcy, *Manifeste du Journal des artistes contre la nouvelle école de peinture, soi-disant shakespearienne, romantique etc.* (Paris, 1828), p. 4:

> C'est à lui [Vien] qu'il faut faire honneur de la régénération de notre école et non à son élève David qui ne nous a apporté que la sécheresse et la régularité des contours et la raideur des poses académiques dans tous ses tableaux.

By contrast, Alphonse Rabbe ('David (Jacques-Louis)', *Biographie universelle et portative des contemporains* (Vieilh de Boisjoslin and A. Rabbe, eds), vol. 2 (Paris, 1830), p. 1221) and Charles Blanc, ('Louis David', *Histoire des peintres français au XIXe siècle* (Paris, 1845), p. 157) present Vien as a weak character incapable of asserting himself to the necessary pitch achieved by the more wilful David.

13 See Léon de Laborde, *De l'union des arts et de l'industrie*, vol. 1, *Le Passé* (Paris, 1856), p. 163.

14 'Un plaisir tout rationnel, tout réfléchi.' Louis Vitet in A. Mahul, 'David', *Année nécrologique. Année 1825* (Paris, 1826), p. 132.

15 'Arrangé[s] d'après des règles, posé[s] suivant des conventions.' Laborde, *De l'union*, p. 169.

16 'Nous laissent indifférents. Quelles passions soulèvent-ils? aucune, parce que la passion n'agita pas chez eux un seul de ses orages, et jamais dérangea un seul trait de leur physionomie'; 'méthodiquement et mathématiquement.' Chesneau, 'Louis David', p. 16. See also, for example, Delaborde's accusation that David lacked insight into 'l'expression des affections intérieures' and his comment on *La Mort de Socrate*, in which

il ne faut admirer, à notre avis, que les témoignages d'une intelligence vigoureuse. Là plus qu'ailleurs l'inspiration se fait sentir, mais là encore cette inspiration semble venir tout entière de la tête.

L'élan du coeur, l'accent ému, la puissance expansive, voilà ce qui fait défaut à une oeuvre si robuste d'ailleurs et si grave.

(Delaborde, 'Peintres et sculpteurs', pp. 754, 753).

17 'Son esprit ne lui faisait pas voir assez; de là ce qu'il y a d'incomplet, de froid, d'inanimé dans ses plus beaux ouvrages. Unissez un tel esprit à un tel caractère, il faudra de toute nécéssité, que vous soyez fanatique en politique et systématique dans les arts: aussi, l'on peut dire qu'aussi bien à la Convention que dans son atelier, l'âme de David fut continuellement la dupe de sa tête.' Vitet, 'David', p. 131.

In his defence of the artist, Etienne Delécluze distances himself from the aesthetic positions outlined by David during his speeches to the Convention, describing them as 'doctrines dogmatiques' which are 'toute[s] théorique[s]'. He does, however, point to the intellectual affiliation with classical theories exemplified by Plato's *Republic*. See Etienne-Jean Delécluze, *Louis David. Son Ecole et son temps* (Paris, 1855) (reprint, Paris, 1983), pp. 176 – 7.

18 'Terroriste ou peintre, il ne prend conseil que de son cerveau.' Delaborde, 'Peintres et sculpteurs', p. 755.

19 See, for example, Delécluze, *Louis David*, pp. 127 – 9, which presents David's principal achievement in the 1780s as his practical application of the theoretical pronouncements of contemporaries such as Winckelmann.

20 In his account of the setting aside of the *Léonidas* to work on the *Couronnement*, for example, Delécluze emphasises David's susceptibility to 'les brillantes compositions de son élève Gros sur des sujets contemporains', and describes him undertaking a similar project 'toujours impatient d'explorer toutes les voies de son art' (*Louis David*, p. 245). Delécluze further evokes David's receptiveness to 'des modes qu'il n'avait pas encore employés' during his years in exile, remarking that, as ever, 'son âme était vivace, énergique et susceptible de grandes révolutions quand il s'agissait de son art' (p. 367).

21 'David n'était pas un savant, encore moins un homme systématique: ses instincts étaient impérieux, il leur obéissait.' *Louis David*, p. 398.

22 'Imagination ardente.' Miette de Villars, *Mémoires de David*, p. 34. The same phrase is used in [Anon.], 'David (Jacques-Louis)', *Biographie des grands hommes et des personnages remarquables qui ont vécu sous l'Empire* (Paris, 1852), p. 307 in a biographical sketch sympathetic to David's political career.

23 'Sensibilité exquise.' [Anon.], 'David', *Biographie*, p. 307.

24 'Le fougueux peintre de la Montagne.' Alexandre Decamps, 'Salon de 1835', *La Revue républicaine*, vol. 4, no. 12 (10 March), p. 264.

25 'Républicains d'émeute, irascibles jusqu'au sublime, de tempérament chaud et de solides poumons'; 'tête de vague et de poésie.' Hauréau, *La Montagne*, pp. 71, 66.

26 'Modéré non de calcul, mais de passion.' Haureau, *La Montagne*, p. 66.

27 Describing David's mentality in the wake of Thermidor, Hauréau uses a Byronic analogy to drive home the artist's disillusionment: 'Il conservait dans l'âme ce dégoût de Manfred disant: Bravo! à la mort; et comme ceux qui n'espérent plus en rien, il se laissait aller nonchalemment au présent' (Haureau, *La Montagne*, p. 79).

28 'Son génie, c'est de la mémoire.' [Louis de Maynard], 'David et son école', *Revue étrangère*, St Petersburg, vol. 6 (April, 1833), p. 96. On the theme of memory, see also Alphonse Rabbe, 'David', p. 1222, who describes the artist's talent as the 'fruit du travail et de la mémoire'.

29 'Jusque dans ses hardiesses, timide et peu oseur, maître et écolier à la fois, se retournant sans cesse vers cette antiquité comme une mère seule capable de le guider et de le préserver des modernes et de la tentation de leurs oeuvres, jamais, comme Michel-Ange, brûlé par sa pensée, il ne la lance sur la toile et ne la fixe en quatre de ces traits qui franchissent tout le domaine de l'art, semblable au quatre pas du Jupiter d'Homère. Il tremble, rature, corrige … Il marche comme un vieillard qui s'efforce de rajeunir en évoquant ses souvenirs d'adolescence.' Maynard, 'David et son école', p. 96. This is paralleled by emphasis on David's susceptibility to figures of authority – notably Robespierre and Bonaparte – in public life. See, for example, the remark by Chesneau ('Louis David', p. 10): 'A cette âme sans ressources… il fallut toujours une idole.'

30 'Son esprit ne pouvait trouver le repos que dans une idée dominante, dans un système'; 'la soumettait pour ainsi dire, au contrôle de ces types abstraits qu'il regardait comme la loi du beau'; 'manière incomplète dont il vit la nature: il ne l'étudiait qu'au profit de son système, c'est-à-dire en cela seulement qu'elle ne le contrariait pas.' Vitet, 'David', p. 131.

31 Jules Michelet, 'David – Géricault. Souvenirs du Collège de France (1846)', *Revue des deux mondes*, vol. 138 (15 November 1896), pp. 245–6.

32 'Guindées, solennelles, théâtrales, d'un style sans reproche, parfaites en détails, nulles d'effet en totalité.' Rabbe, 'David', p. 1222.

33 Gustave Planche, 'Salon de 1831', *Etudes sur l'école française (1831–1852)*, vol. 1 (Paris, 1855), p. 110.

34 'Tout est tendu, le corps et l'esprit, l'attitude et le geste … la passion, qui devrait animer ces héros, les paralyse.' Chesneau, 'Louis David', p. 11. See also Vitet, 'David', p. 132, who refers to 'ces figures dont aucune affection humaine ne semble altérer les traits' and the extract from the Goncourt journal for 2 May 1858, cited by Verbraeken, *Jacques-Louis David*, p. 133, 'Prud'hon, Corrège qui a lu Virgile; David, Prud'hon qui a lu Homère.'

35 'Partout l'ardeur à formuler une poétique, nulle part la verve et les effusions du poète.' Delaborde, 'Peintres', p. 754.

36 On Caravaggio, see, for example, [Anon.], 'David et son école', *Le Magasin pittoresque*, vol. 29 (January 1861), p. 2. The copy of Le Valentin's *Last Supper* is frequently alluded to by commentators in this context.

37 'Une énergie, un amour du vrai.' Delécluze, *Louis David*, p. 129. See also H. Muller, 'Souvenirs d'atelier', *Annales de la Société libre des beaux-arts*, vol. 15 (1845–6), p. 176.

38 'Empreinte de la réalité'; 'étude du modèle et la vigueur du ton.' Anon., 'David et son école', p. 2.

39 'Nous avons vu pour la première fois une vérité entière, la nature même mise sous nos yeux.' J. R. A., 'Quelques Vues sur l'école de David, et sur les principes de la peinture historique', *Revue encyclopédique*, vol. 34 (June 1827), p. 584.

40 'Nul artiste sut, mieux que lui, observer et peindre plus fidèlement la nature.'
Miette de Villars, *Memoires de David*, p. 42. The paragraph is a modified
plagiarism of A. Th. ..., *Vie de David* (Brussels, 1826), p. 229. See also
Alphonse Esquiros, *Histoire des Montagnards*, vol. 2 (Paris, 1847), p. 27.

41 'Au fond, c'était un esprit sans rêverie et une âme sans tendresse.' Blanc,
'Louis David', pp. 186, 170. Blanc describes David's compositions as being
'rigoureusement raisonnées', though suffering from an 'afféterie de pinceau'
(p. 173).

42 'Art du peuple, de tout le monde'; 'style froide et immobile'. Théophile Thoré,
'Les Peintres du XIXe siècle. Louis David', *Trésor national* (Brussels, 2nd
series, vol. 3, 1843), pp. 75, 78. Comparing him with Poussin, a common
critical strategy, Thoré brings out David's lack of breadth: 'L'esprit de David
est politique, plus spécial et par conséquent plus étroit ... David n'a guère
exprimé que le dévouement social, les vertus civiques et le sacrifice. Il n'a
qu'une seule pensée, sublime il est vrai, et il l'a répétée avec une conviction
invincible, tout le long de sa carrière' (p. 73).

43 'Il sortait du Club des Jacobins ou des séances de la Convention, la tête
remplie des images de l'antique liberté: puis, lorsqu'il était en présence de
sa toile, dans le silence de son atelier, l'enthousiasme que lui avaient com-
muniqué les cris de Danton et le regard de Saint-Just, se refroidissait peu à
peu; son esprit exact reprenait le dessus et ne songeant plus qu'à sa mission
de régénérateur de la peinture, il dessinait les nudités austères, cherchait
l'élégance et surtout la pureté des formes, donnant à ses modèles une beauté
idéale renouvelée de la statuaire grecque ou romaine.' Blanc, 'Louis David',
p. 200.

44 'Le citoyen dupe de quelques charlatans hypocrites et atroces.' A. Th. ...,
Vie de David, p. 2; the phrase is repeated in Mahul, 'David', p. 119.

45 'Bonne foi d'un artiste inhabile aux choses de la vie.' Rabbe, 'David (Jacques-
Louis)', p. 1218.

46 'Législateur républicain égaré par les souvenirs de la Grèce et de Rome';
'entraîné ... par son enthousiasme pour les républiques de l'antiquité';
'attendant de bonne foi le retour des moeurs anciennes'. A. Th. ..., *Vie de
David*, p. 2; Mahul, 'David', p. 118; E. Miel, 'David (Jacques-Louis)',
Le Plutarque français, vol. 7 (1840), p. 12.

47 'Son imagination ardente et l'extrême exaltation de son républicanisme
remplissaient sa tête d'illusions.' A. Th. ..., *Vie de David*, p. 93. The notion
of 'exaltation' is also used by Miel, 'David (Jacques-Louis)', p. 12.

48 'Incroyables illusions qu'il entretenait dans son imagination exaltée'
Delécluze, 'Louis David', p. 169.

49 A. Jal, 'Notes sur Louis David, peintre d'histoire', *Revue étrangère*, St Peters-
burg, vol. 55 (September 1845), p. 625. The imagery of blindness is used,
among others, by Delécluze, 'Louis David', p. 167.

50 'Tout est peint sobrement, sincèrement, composé sans emphase, avec un
cachet de réalité sévère.' Chesneau, 'Louis David', p. 22.

51 Delécluze, 'Louis David', p. 176; 'La seule fois qu'il avait peint avec son
coeur, c'est en représentant Marat baigné de son sang.' Laborde, *De l'union*,
p. 169. Delaborde, 'Peintres', p. 756, remarks: 'Jamais il n'a prouvé mieux
que dans son *Marat* la vigueur de sa manière, jamais il ne fit acte plus formel
de grand peintre, et cependant cette toile ne peut être mise en lumière qu'au
risque de diffamer sa mémoire.'

52 'Une longue abérration de ... jugement.' Rabbe, 'David', p. 1219.

53 See Jules Michelet, 'Cinquième Leçon, 13 janvier 1848 (Leçon non professée)', *L'Etudiant* (Paris, 1970), pp. 107 – 15.

54 'Il haissait deux choses cruellement et leur faisait la guerre: la nature d'abord, la molle nature du XVIIIe siècle, puis les arts de son temps', Michelet, *Histoire*, vol. 2, p. 540.

55 'David fut l'effort même. Par là il exprimait son temps. Artiste tourmenté de la grande tourmente, génie pénible et violent qui fut son supplice à lui-même. David dans son âme troublé avait en lui les luttes, les chocs dont jaillit la Terreur.' Michelet, *Histoire*, vol. 2, p. 540.

56 Adolphe Thiers, *History of the French Revolution*, vol. 1 (London, 1838), p. 347.

57 'Air de douceur'; 'sensibilité peu commune.' Albert Laponneraye, 'Notice historique sur Maximillien Robespierre', *Oeuvres de Maximillien Robespierre*, vol. 1 (Paris, 1834), pp. 11, 4.

58 'Naturellement raisonneur et logicien'; 'Ami des abstractions [qui] ne descendait pas volontiers des généralités.' Michelet, *Histoire*, vol. 1, p. 479.

59 'Il n'avait pas ... le haut essor spéculatif, il suivit de trop près ses maîtres, Rousseau et Mably. Il lui manquait enfin la connaissance variée des hommes et des choses, il connaissait peu l'histoire, peu le monde européen.' Michelet, *Histoire*, vol. 1, p. 489.

60 'Ses écrits et ses discours ne sont que des enfilades de sentences, abstraites et vagues; pas un fait précis et plein; pas un détail individuel et caractéristique, rien qui parle aux yeux et qui évoque une figure vivante, aucune observation personnelle et propre, aucune impression nette, franche et de première main.' Hippolyte Taine, *Les Origines de la France contemporaine*, vol. 5, *La Révolution. La Conquête jacobine*, vol. 1 (Paris, 1899 ed.), pp. 236 – 7.

61 'Des hommes réels, nul souci: il ne les voit pas; il n'a pas besoin de les voir; les yeux clos, il impose sa moule à la matière humaine qu'il pétrit; jamais il ne songe à se figurer d'avance cette matière multiple, ondoyante et complexe.' Taine, *Les Origines*, p. 23.

62 Delécluze, 'Louis David', p. 178.

63 Alexandre Lenoir, 'David. Souvenirs historiques', *Journal de l'Institut historique*, vol. 3, 1835, p. 4. See also Jal, 'Notes', p. 625; Delécluze, ('d'une bonhomie, d'une sincérité presque enfantine'), 'Louis David', p. 222.

64 'Un nain à une époque de géants.' Maynard, 'David et son école', p. 94.

65 'La plus extrême faiblesse.' Rabbe, 'David (Jacques-Louis)', p. 1218. See also the Goncourts' description of David as 'un esprit faible et ouvert aux surexcitations extrêmes', Edmond and Jules de Goncourt, *Histoire de la société française pendant la Révolution* (Paris, 1895 ed.), p. 351.

66 On the theme of 'volonté' in David, see, for example, Delaborde, 'Peintres', pp. 755, 761 – 2.

67 'David ne fut ... ni un peintre de génie, ni un peintre de sentiment: il fut un peintre d'intelligence.' Chesneau, 'Louis David', p. 57. Delaborde remarks, 'ce qui lui manqua dans toute sa carrière et en face de tous les sujets, c'est un fonds de sensibilité, c'est l'âme.'

4

Delacroix and his critics: the stakes and strategies

ANNE LARUE

'Delacroix was an educated man; he was well connected, at ease in the highest social circles and, against his wishes, was taken to be the leader of a revolutionary new school of painting.' This is Maxime Du Camp's description of the great Romantic painter, published in the chapter on 'Painters' Studios' in his *Souvenirs littéraires*. He adds, 'The exalted praise he received for having broken with tradition did not please but worried him, as it seemed to bar him from access to the Academy.'[1] Du Camp's image of Delacroix as a cautious man, anxious to protect his career and his reputation as a 'traditional' artist, stands in direct contradiction to the image of a painter who is chiefly remembered for his audacity, his inventiveness and innovatory and subversive energy. This surprising, and more sober, view of the Romantic painter that Baudelaire, and many after him,[2] compared to a 'tiger' is not simply the opinion held by Du Camp alone. Half of Delacroix's critics thought of him as a 'Classicist'; the other half defended the opposite image of the 'Romantic'.

From the outset it seems futile to try to arrive at the 'truth' about Delacroix, to seek his true 'essence', or even to suppose that such a thing exists. To ask whether Delacroix was a Classicist or a Romantic is to pose a rhetorical question, since the very act of categorising him is a matter of personal judgement. Depending upon the opinion one has of Delacroix or Romanticism, one implicitly approves of or denies his being placed into one or other category. The very process of categorising an artist within a 'movement', still fundamental to art history, is being radically challenged. We now see that art movements are not simply 'facts' of art history, but that they are linked to broader systems of value. Since the values and judgements of art critics may be influenced by trivial rather than aesthetic considerations, we may be confused by the tendency of a supposedly historical discipline to accord so much credence to criticism, and borrow extensively from its concepts,

rather than considering criticism from a sociological perspective. In Delacroix's case criticism plays a central role in determining the significance of the artist. We often come across the rather banal stereotype of the artist endlessly constrained and hampered by the critics, but beyond this it is important to note the extent to which it is criticism, and criticism alone, which defines the great aesthetic categories on which the historical period from 'David to Delacroix' is founded. Does critical judgement merit such primacy? Or, to put it another way, is criticism really responsible for the aesthetic thinking of a given period? Can art criticism take the place of history of art, or is its function completely different?

Approaching art criticism from a sociological position, rather than responding to its every critical judgement, allows us to reconsider the disputes in which the writers of the time were engaged, and perhaps also to reconsider their texts as strategic, rather than as the discourse of truth that they are often purported to be. Exploring the art criticism of Delacroix's time, we will not try to establish aesthetic criteria in order to assign him to categories of Romanticism or Classicism, but rather identify the tactics which led a certain writer to choose one category over another. While we run the risk of emptying the terms 'Romanticism' and 'Classicism' of their meaning, foregrounding them instead as opposites within a system, this is precisely what needs to be done. Is it possible to ascribe a deep meaning to either 'Romanticism' or 'Classicism' beyond the system within which they function as opposites? Isn't the inherent dynamic of these movements one of conflict? We will go as far as suggesting that, in Delacroix's time, 'Romanticism' and 'Classicism' were terms without inherent content, but were self-referential labels, signs without referents, two spaces devoid of meaning defined simply in terms of the dynamic of their antinomy, their main purpose being to oppose one another. No doubt this hypothesis sounds rather crude and unmodulated, but I want to suggest that the deep content of these terms has been eclipsed by the dynamic of their structural opposition.

The first reason for refusing to base our historical evaluation of the aesthetic on the content of the terms generated by art criticism is the conditions of production of this criticism. As L. Venturi and A. M. Christin have noted, the criticism of an age is essentially journalistic, and aimed at contemporary painting:[3] it is therefore doubly vulnerable, firstly to being limited by the context of its production, and secondly by its lack of hindsight. What status should we accord these writings which were often written to score points, to hurt or ridicule, written in spite or irony, rather than to make a constructive contribution to the history of art? Closely

tied to their context, and linked to specific events, these writings are often opinions without nuance and without depth, not the province of aesthetics but of strategy and tactics. With each group on opposite sides of a chessboard, wanting only to play their own game, the great debate between the Neo-Classicists and the Romantics, which is our object of investigation here, is like a chess game in which two sides are opposed, regardless of their aesthetic aims, the latter being reduced to the level of mere pretext. Such a hypothesis accounts for the way in which Delacroix was strategically positioned by his critics, and the way he functions as a kind of touchstone, separating the two camps opposed in everything – except, ironically, their ideas about painting.

I

I want to begin with the twentieth century, since the question of whether Delacroix was a Classicist or a Romantic remains the focus of debate. The question still raised in 1963 was 'Is Delacroix really a hero of bourgeois art?'[4] For a number of contemporary critics, Delacroix is obviously a hostage to ideology. We have to wonder why a debate that should have been settled years ago – Poussinists versus Rubenists, long hair versus old beards, David versus Delacroix – is still so powerful today.

At the heart of the conflict are two statements made by Delacroix himself, which have created this dualism, irreconcilably divided into warring factions. It could be said that it was Delacroix himself who was responsible for the ambiguity from the start, and that it was he who initiated the chasm into which the critics fell, turning his work into the battlefield of their ideas. René Huyghe, André Joubin and Philippe Jullian[5] repeatedly emphasise Delacroix's conservative tendencies. Recalling his statement. 'I am a pure Classicist!', they claim to want to restore what they think of as historical truth, namely that the painter was not in the least 'Romantic', that he was Classical, and this holds true for his pictorial style as well as his anti-revolutionary politics. On the other hand, Pierre Daix and Guy Dumur[6] explore the revolutionary connotations inherent in the notion of Romanticism. For them, Delacroix's famous statement, 'I admit it: I am a Romantic' is the painter's true credo. According to the former group Delacroix made a youthful and erroneous venture into socialism – a cardinal sin – before finding his true destiny. For the latter, the young and fiery artist who so ardently embraced the cause of Liberty dropped the cause in order to take his ignominious place alongside the infamous. According to the editor of the *Lettres françaises*, we should

not confuse the sad and callous 'egregious old man of fifty' with the young man who painted *Liberty on the Barricades*.[7]

The journal *Connaissance des Arts*, especially in its articles by Philippe Jullian or Pierre Granville, considers that Delacroix was decidedly not a Romantic. 'Let us be accurate', writes Granville; 'Delacroix was a Romantic, in terms of the trivial anecdotal side of Romanticism, especially at the outset of his career. But this phase was rapidly left behind.'[8] The view is shared by René Huyghe who, in his *Delacroix ou le combat solitaire*, emphasises the painter's aristocratic background, his hatred of crowds and of riots, and the Classicism of his painting.[9] André Joubin, who edited the 1832 edition of the painter's *Journal*, insists that there is a shift between the diarist of the early years, a few brief pages from the pre-Romanticist days (1822 – 24), and the diary of his maturity, Delacroix's 'true' diary, which differs from the early work as much in terms of length as in terms of its aesthetic significance (1847 – 63). Joubin's assumptions, as an editor, are particularly interesting and deserve closer attention. For Joubin the *Journal* is a 'monument to French art' which traces the 'transition from Romanticism to Classicism'.[10] He considers Delacroix to be a 'Classicist' who began with a brief Romantic interlude. In his view the main significance of the *Journal* is that it confirms this hypothesis. The diaries reveal a clear division between two contrasting periods:

> The writer's silence over twenty three years must be taken into account if we are to understand the rhythm of Delacroix's creativity of thought. It also enables us to witness the contrast between the first journal and the second, and to see with great clarity, which is all the clearer for the absence of a transitional phase, the development of Delacroix's genius from Romanticism to Classicism.[11]

This supposed evolution is all the more striking for its retroactive perspective as, historically speaking, Neo-Classicism precedes Romanticism, or is more or less contemporaneous with it. It is thus difficult to 'become' Classicist. Joubin, however, is not referring here to this type of concrete reality. He is in fact discussing two great abstract tendencies, universal constants of the human mind, considered independently of their inscription in history. 'Classical' and 'Romantic' function as antinomies, rather as Eugenio d'Ors sets up an opposition between classic and baroque, with each tendency corresponding to a fundamental structure of thought, independent of any manifestation in historical evolution.[12]

If we think in terms of universal constants, as critics implicitly seem to do, we note that the debate then becomes completely

displaced onto the terrain of the personal strategies of the commentators. When contrasting the political tendencies of the editors of the two journals *Connaissance des arts* and the *Lettres françaises*, we can see that the question of Delacroix's 'Romanticism' rehearses what is also a contemporary political debate. Using the ambiguity which Delacroix himself expressed in his statements, claiming adherence to two contradictory positions, the critics debate this issue, which one imagines would be decided on aesthetic criteria alone, without reference to any aesthetic criteria.

Why should this debate be taken up again now? It seems that, despite being couched in a different vocabulary, the terms of the opposition that are used today are very similar to those that were used by critics in Delacroix's century. Then, the opposition between Classicism and Romanticism took a very similar form to the opposition of 'right' and 'left' wing politics in France of the 1960s – the centenary of Delacroix's death. Transposed into the sphere of art history, the vocabulary of 'right' and 'left' loses something of its denotative value when compared to the ideological significance of the opposition through which this pair is polarised. Is it not also possible to trace the same process of opposition through the polarisation of Racine and Shakespeare, conservatives and radicals, defenders of drawing and advocates of colour, the bald and the long-haired? These pairs of antinomies articulate the same structure, through different, albeit interconnected, spheres and to different degrees. The taking up of literary, political, social and aesthetic positions are different aspects of the same predicament. Fundamentally there is only a single opposition in play, and it may be this opposition alone which generates the meaning of the others.

If is difficult now to think of 'Romanticism' as purely and simply an aesthetic movement, independent of its political context. It must have been even more difficult, at the time, to think critically about the difference between its polemic and motivating politics. Should we conclude that it is impossible to separate aesthetics and politics, and that the critics of Delacroix's era, like contemporary critics, were simply rehearsing 'ideological' positions? The clarity of the oppositions, the abstract nature of the concepts at stake, the antagonistic quality of the divided opinions, all contribute to criticism in which aesthetic issues ultimately play a minor role.

II

In his *Histoire du Romantisme* Theophile Gautier describes the Battle of Hernani, in which he was an ardent protagonist.[13] He thought that to decapitate the 'hydra of *perruquinisme*' – a herculean task if ever there was one – was a 'straightforward', natural and inevitable act: 'Is it not quite obvious to oppose youth and decrepitude, long locks and bald pates, enthusiasm and routine, the future and the past?' It was on this structure of antinomies that Gautier and his contemporaries constructed their closely interconnected political and aesthetic discourses. The phrase 'Rubens is a red', reproduced in the entry for 28 July 1849, of the *Journal pour rire*,[14] underscores this link between the political and aesthetic levels. 'Colour', especially red, was experienced as subversive and radical. Gautier writes of the 'seditious colours prohibited by the Academy', horrifying the students of David's studio, who favoured 'drab tones'. If we compare the symbols of revolt of the nineteenth and twentieth centuries, the long hair, youth, colourful clothes, they seem remarkably similar.

The conflict between the Colourists and Draughtsmen in the nineteenth century is often described as one episode of the eternal conflict between Ancients and Moderns; but this conflict of positions cannot be interpreted as a difference of aesthetic style. Gautier is useful in that he clearly describes the existence of two camps, whose oppositional status is much more significant than their aesthetic differences, and whose vitality is very much linked to conflict. As the philosopher writes, we are positioned through opposition: and Gautier gives a brilliant account of this intransigent and simple, almost Manichean, opposition.

How did Delacroix become a bone of contention for the critics? He clearly laid himself open to criticism by maintaining ambiguous and contradictory positions. Moreover, at various points of his life, the painter's tactics are also characterised by the same contradiction and indecision. While Gautier offers us a view of the Romantics' battle as a straightforward and clear-cut world, Delacroix gives us a quite different account of these same strategies. Devious and indecisive, he calculated his opinions, made opportunistic choices, conforming whenever he thought it best to fit in, only to rethink his strategies and oscillate again between contradictory opinions. Delacroix could be seen as one of those tortured souls who dream of transcending social rules entirely but who devote such energy and ingenuity to trying to avoid them that they become completely immersed in them. Some of Delacroix's comments in his *Journal* (quite apart from the very fact of keeping a journal) testify to this. On the one hand, he writes of being 'absolutely unmoved' by the 'ideas

that obsess my contemporaries', much preferring 'the memory of a tune or a painting'.[15] But on the other, his biographers record his determination to find commissions, his taste for society, his social aspirations; his correspondence includes many letters of intrigue, letters of thanks, of mediation, recommendation or request; his journal records his frequent visits to various clubs and coteries, always careful (sometimes to the point of pusillanimity) to make a good impression and to get on well with everyone. It is not surprising that more than one young woman, in the salons, was supposed to have said, 'He certainly is witty, that M. Delacroix, what a shame he is a painter!'[16]

Without laying too much stress on psychological aspects, it is worth noting that they nevertheless correspond quite closely to the painter's 'political' behaviour. Delacroix was first adopted by a certain kind of anti-institutional rebellion, no doubt because he did not follow the most prestigious path for painters, which was to start at the Ecole des Beaux-Arts in Rome and from there move to the Academy; instead he acquired his standing as a Beaux Arts academician through a more circuitous route. The essays written in his youth, and especially his 'Lettres sur les concours', testify to his anti-institutional rebellion.[17] At this time Delacroix was very much afraid of the arbitrary power that he felt could undermine and destroy 'genius'. This obsession became incarnated in his preoccupation with the figure of Tasso, whose plight, of being unjustly incarcerated in a madhouse, brought him to tears of rage and helplessness;[18] and he painted several versions of Tasso in the asylum.

In 1830, Delacroix chose to represent *Liberté*, drawing her profile, unaware that this motif would be immortalised for posterity and used for decades to come on French postage stamps.[19] The revolution of 1848, however, did not please him, and he despised the *'barbus'*, like Millet.[20] It was, in fact, during the July monarchy that Delacroix was particularly successful, since Thiers' patronage brought him a number of commissions for large murals. Delacroix was afraid of the Republic, and apprehensive about its consequences. As it turned out, he need not have been. For it was Charles Blanc, the brother of Louis Blanc and the director of the Académie des Beaux-Arts during the Second Republic, who, after Thiers, became one of his best patrons. But, if we are to believe his journal, the irony of fate did little to restore his sense of humour. Delacroix continued to pursue his career with obsequious humility, using tactics and being careful not to get a 'bad' reputation. He kept his goal firmly in mind throughout the political changes that unsettled nineteenth-century France. The turning-point came in 1838 when Delacroix opened a studio for assistant painters, and thus proved

himself successful on his own terms. It was not a studio of appren-
tice painters in the usual sense, but a kind of small business;
Delacroix trained the painters in his own style, and selected his
assistants from among the most adaptable and gifted of them. It is
likely that Delacroix started this studio in order to train the man-
power necessary to complete the increasing number of commissions
he was receiving from the State.[21] This is, no doubt, true, but for
Delacroix having a studio of pupils also represented the kind of
'recognition' to which he felt entitled once he had become successful,
as he had once he began to receive numerous commissions for
mural decoration.[22] Delacroix gave himself the title of *maître*,
expressing his need for social recognition; a need which led him
to apply repeatedly to the Academy, where he was finally accepted
in 1857.

III

1833 was the moment of the Romantic 'brotherhood of arts', with
its rejection of the hierarchy of power and its aspirations to egali-
tarianism. In his 'Lettres sur les concours' of 1831, Delacroix
argues for direct State commissions to artists, and rejects the power
of intermediary institutions such as the Salon Jury, the Academy,
the Prix de Rome, all of which he thought set up barriers between
the State and artists, thereby obstructing artists' careers. In 1833,
Delacroix, along with other Romantic artists, painted tempera
murals in the apartment in which Dumas was to hold his
magnificent fancy-dress ball. Dumas' description of the fraternity,
published in his *Mémoires*, is emblematic for the Romantics, if only
because he, like Gautier, is nostalgic. Dumas conjures up a lost age,
when those now dead were still alive, and evokes this time with over-
whelming emotion. Leisure, youth, pleasure, freedom, enthusiasm,
commitment to working for the commune: all these Romantic
qualities were represented at the ball held in Dumas' apartment,
the artists celebrating one another, with the painters illustrating the
poets.[23] The ball was perhaps the greatest and only enactment of
the brotherhood of arts. There Delacroix, the virtuoso, triumphed
by painting a large panel in a matter of hours. Of still greater
importance to him was the admiration of his peers: 'This was all
wonderful to behold; then the others formed a circle around the
master, and every one of them, without jealousy and without envy,
had left his work to come and applaud this new Rubens who was im-
provising both the composition and execution of his masterpiece'.[24]
 But the Delacroix who opened a traditional painting studio in
1838 no longer had anything in common with the Delacroix of

Dumas' ball. Painting was still, for him, collective work; but the democratic fraternity within which recognition was freely given 'without jealousy and without envy' to the 'master' who revealed himself to be 'a new Rubens', had disappeared and been replaced by the hierarchy of the workshop, in which the 'master' ruled over a stable of apprentices. In fact the studio was first and foremost a training ground for subordinate practitioners, with the conception of the work being valued much more highly than its material execution. The tradition of the primacy of conception over execution, of 'art' over craftsmanship, is a notion which Delacroix in no way challenged.[25] Delacroix's transformation from a member of the fraternity of artists to the hierarchy of the studio is described by some commentators as his transformation from 'Romanticism' (conceived, strongly ideologically, as a pure egalitarian idealism) to 'Classicism' (the term, curiously, taking into account a wider range of social constraints). It can be thought, quite legitimately, that the artist's preoccupation with his career was at the forefront from his 'Romantic' years onwards ('glory is not an empty word for me', he wrote in the *Journal* of his youth), and that it was only his strategy that adapted itself to changing circumstances. The most important thing here, however, is not so much Delacroix's career strategies as the almost natural imbrication of ideological and aesthetic notions that these strategies reveal. 'Romanticism' and 'Classicism' are not artistic categories but refer to quite a different process of transformation. It is significant that all of Delacroix's nineteenth-century critics note this transformation, whether it be to applaud or deplore it. The transformation is everything but aesthetic, unless we understand the term as referring to the ideological conflicts that underlie it.

IV

Delacroix dreaded the bad publicity that critics created for his painting: as early as 1828 he wrote an article entitled 'Art Critics' for the *Revue de Paris* which indicates his anxiety about them. It expressed the fragility of a painter who sees himself as the butt of 'theorists' and critics who, in their 'passion for judging', fight their battles on the artist's terrain, very much 'at the artist's expense'. For the critics, 'the arts are a vast domain to which they all have the key, and into which they will not allow anyone else to enter'.[26] Delacroix admits that he feels 'harshly pulled' by his 'chain', and that he suffers at the hands of these 'vigilant dragons', who replace one idol for another on the throne of their adulation. Paradoxically, he ultimately agrees that the critics have their use,

and with bad grace defers to their power: 'even whilst wounding you, they tell the world of your existence'.[27]

As for criticism itself, Delacroix was so malleable as to offer no resistance to its terms. His almost naïve desire to succeed, his devious career strategies might already have stimulated critics; but there was more to it than this. His indecision over whether he was a Romantic or a Classicist reflected the most lively controversy of his generation, whereas his career strategies were blindly adaptive to the ideological shifts that he observed around him. Rather than being the ideal scapegoat/victim of the nasty critics, who turned on him sadistically, Delacroix was, as Marie-Madeleine Dujon has convincingly argued, the very incarnation of the tensions and divisions of his age. The 'polemic between tradition and renewal finds fertile soil in an era in which society is in oscillation; Delacroix's work is the illustration and product of such an era', she claims.[28] If Delacroix was at the heart of controversy, it was not because of his artistic originality. Quite the opposite. He was so influenced by the aspirations and the contradictions of his time that he ended up personifying them. He became a living symbol, and as such was merely *representative*.

Delacroix participated actively in the intellectual life of his time. It might even be argued that the intellectual climate of the time, in which artists were 'well versed in theory' and had an important voice, forced him to participate. There are many accounts of the painter's oratorical talents. A brilliant conversationalist, he 'could dissect an oaf with one witticism', wrote Théophile Silvestre.[29] Berryer claims to have been charmed, 'in a thousand ways, particularly by his conversation'.[30] Charles Blanc found that the artist's speech was 'brilliant, colourful, slightly staccato, full of surprises, full of fire'.[31] The romantic and egregious Mademoiselle Mars, who posed as Dona Sol in the Battle of Hernani, thought him to be 'a young painter with talent, spirit, sophistication and excellent character'.[32] All in all, 'an educated and spirited man', according to Berryer, but also 'a conversationalist' whose conversation was 'brilliant, clever, ... in short, a nourishing conversation' which he was able to take into the 'skirmishes of the salon' as well as to use it to express his opinions in the 'intimacy of his studio'. Baudelaire, who was also of this opinion, adds that his conversation was 'devious, full of sudden attacks and flights' and that Delacroix, excited by an adversary, would 'play cat and mouse with his opponent for a while' before delivering the final blow. Baudelaire expressed more criticism of Delacroix than anyone else, even whilst seeming to be his most loyal supporter.[33]

Delacroix's articles can be read as forms of self-defence. Under

the guise of discussing Gros or Rembrandt, the artist is engaged in a polemic which concerns his own work, for which he argues indirectly in his youth, and at the very start of his career Delacroix was among the first contributors to two important journals, *La Revue de Paris* and *L'Artiste*, and published a polemical essay in each in the years they were launched (1829 and 1831 respectively). He thus seemed to position himself well within critical discourse. Maurice Tourneux categorises these essays as 'manifestos' and 'declarations of war'.[34] Apart from his journal, from 1822 onwards Delacroix reserved a space for himself for meditative thought which he continued to maintain through both his paintings and his words. According to his friend Piron, Delacroix's critical writings were entirely motivated by his being on the receiving end of attacks from journalists: 'The art of Delacroix's writing was born of the need to defend himself.'[35]

At a time when for weeks on end several columns of newspapers were given over to reviews of the Salon, and when jostling and restless crowds queued from dawn for this annual event at the Louvre,[36] when a Baudelaire had no choice but to write about the Salon in order to be taken seriously as a writer,[37] painting was clearly a very important and very public matter. And a painter's critical discourse was an integral part of this vast cultural movement. All his life Delacroix was acutely aware of the necessity of inserting himself into the world of criticism, patronage and official recognition that surrounded art.

V

Delacroix has gone down in history as having been especially brutally vilified by the critics. Yet the scathing tone of his critics' rhetoric should not be read by contemporary standards. We have to relativise the 'struggles', conflicts and verbal explosions that characterised both the 'Classicist' and the 'Romantic' sides. The 'massacre of painting', executed with a 'drunken broom' and 'tartouillade' are some of the famous terms, quoted by Tourneux and by most reference texts, to indicate the tone of the 'insults' which were said to have been levelled at Delacroix.[38] Gautier himself was shocked by them, as he writes in his chapter on Delacroix: 'The artist was abused and insulted in a way which would have been more appropriately addressed to a thief or murderer.[39] For Tourneux, Delacroix's entire career was marked by the 'constant correlation between insults and eulogies.'[40] M. M. Dujon notes that 'traditional art history and monographs on Delacroix maintain the myth which represents the critics as

having been unfair or blind to him ... In fact he was supported as often as he was attacked'.[41] Gautier claims that the 'Romantics' were not short of repartee, and that whenever the 'old beards' attacked them there was a prompt reply 'and we did not let their insults pass unavenged'.[42]

The critics attacked the 'modern school' in the most orthodox of French traditions, with corrosive Voltairean irony. It would be very interesting to carry out a textual analysis of these humorous texts, which were usually right on target, but which were later consigned to the archives as 'documents' of the history of nineteenth-century polemic. The criticism of the time, as ephemeral as journalism, was first and foremost a matter of tactics. Poisonous virulence is a weapon which, once removed from its immediate context, loses meaning. Criticism tells us less about the painter who is being eulogised or abused than about the critic himself. And too much aesthetic depth should not be attributed to these hasty and superficial judgements, for criticism is not a unified and consistent discourse. Nevertheless – and particularly in Delacroix's case – these judgements are informed by certain recondite and recurring motifs: notably that of the two diametrically opposed camps which constituted a real dividing line between critics, along which cliché, banter and wit are used to fuel a profound underlying antinomy.

In an anonymous epigram of 1827, the tendency of critics towards joking is especially notable: 'D[elacroix], S[cheffer] and C[hampmartine], leaders of the new school, have reaped no rewards, but in order to offer them compensation, they will be offered two hours a day sitting at the morgue. New talent should be encouraged.'[43] This proved to be the spirit in which Napoleon III naïvely subsidised the Salon des Refusés where 'one could laugh from the front door onwards'.[44]

However, the 'new school' was being lampooned in terms that were more complicated than they might, at first sight, appear. In a short, mordant book written in 1829 to explain the ridiculous and amusing fashion for Romanticism ('in a few hours' to ladies on their Sunday excursions to the Bois), F. de Foreinx notes that at the last Salon there was a painting of 'the entirely new theme' of Achilles with Hector's corpse, and makes ironic comments on the modern school's claim to change the subject matter of painting as 'impudently interrupting the speech of the senior artists'.[45] Foreinx also makes fun of the *Massacre at Scio* using the joke which was then very much in circulation in critical circles from which the popular idea of Delacroix as leading a 'massacre of Art' was derived.[46] The way in which Foreinx colludes with popular

anti-Romanticism is through shared irony, using ideas which already, at this time, are beginning to become clichés: the modernism of the subject-matter, the taste for convulsive death, ugliness or dirt.[47] 'Ah the hideous witch!' cries Elisa de Mirbel in *La Révolution littéraire*, referring to the painting of Lady Macbeth, 'Delacroix has, more than ever, developed a taste for ugliness!' Here, the theme of ugliness enters into a strategy of the rejection of 'Romantic subject-matter': which would allow a critique of Shakespearean subject-matter, and, in terms of the vocabulary of the time, its morbid and convulsive themes. D..., in the *Moniteur*, notes in 1824 that we should not confuse 'Racine's poignant pictures with Shakespeare's gory dramas',[48] whilst another critic of Romanticism praises *The Justice of Trajan* because it is 'a piece from Delacroix's second period, where he finds inspiration in Greek and Roman culture'.[49]

This small but indicative sample of critical writing on Delacroix has the shared characteristic common to all camps, which is a tendency to create antinomies. Beauty and Ugliness, Racine and Shakespeare, the Ancients and the Moderns, remain underlying criteria that implicitly dominate all the critical discourses: on the one hand the morgue, blood and the massacre of Art, on the other a referential hieratic style which rejects aspects of realism such as the 'ugly'. Here we find the criteria of aesthetic judgement which previously had informed the work of Lessing and Winckelmann, and which become assimilated in nineteenth-century criticism as the implicit basis for structural antinomy. Another element should be noted: the role of 'subject-matter'. Some critics, hating the convulsive and violent themes that were supposed to characterise Romantic painting, found evidence of them on the slightest pretext; sometimes the painting's title alone was enough to incur suspicion. A Shakespearean subject, such as Macbeth? The title alone connotes a world of violence which leads E. de Mirbel to be disgusted by the 'hideous witch'. On the other hand a classical horse pulling a Greek corpse around the ramparts of Troy would not inspire such disgust, no matter what the nature of the atrocity denoted, and Foreinx cites one such painting as the apogee of the Classical tradition – which, after Lessing and his *Laocoon*, could never be suspected of portraying perverse tendencies.

Is the heart of the problem to be found in subject-matter? It seems difficult to understand that the choice of subject-matter, from ancient history or modern literature, could have been the cause of such fierce controversy: and yet the 'war of subject-matter' is one of the Romantics' controversies. Was it a question of inverting the hierarchy of history painting, and of challenging

its dominance? In any case while the 'daubers' described by Gautier secretly scribble 'themes' and 'compositions' taken from contemporary literature, they also 'officially' draw the plaster casts of figures from classical antiquity, following the tradition of the Ecole des Beaux-Arts.

Did the artists themselves really defend their notion of 'Romantic subject-matter', drawn in a systematic and consistent way from this rather compendious category of 'modern' literature that included Dante, Shakespeare, Byron and Walter Scott?

Or was this battle of subject-matter fought implicitly and mostly by the critics? For Pierre Pétroz, who saw the state of the arts in Second Empire France as a sorry if not inoffensive one, the battle over subject-matter was fought by the 'art rioters' in the years 1822 – 55, who fought against the official and academic tradition of the time.[50] But was it subject-matter alone that was capable of structuring the opposition between the discourses of the critics? Could some subjects be considered to be 'Romantic' above all other criteria? Are the critics' arguments regarding colour, composition, drawing, idealism, spirit, method only there to conceal this other, deeper criterion?

In 1864 Philippe Burty noted that painters 'were leaving Homer to rest on his Trojan banks ... and following Shakespeare, Byron and Goethe into a more agitated ocean'.[51] Was this simply a matter of fashion? For Edmond Estève, analysing Byron's influence on painting, the significance of the fad for 'Byronic subjects' should not be exaggerated. According to him the 'war of subject-matter' was very much a retrospective invention, a fashion which was, in its time, of limited influence. Estève considers that the painters' 'natural sympathy for the contemporary' led them to prefer Byron over Horace, and argues that there was a 'demise of classical studies' and a 'growing ignorance about classical antiquity' that was characteristic of most painters.[52] This cannot be said of Delacroix, who knew the classics and mythology, referring, for example, in the *Journal* of his youth to Gideon and the Midianites. Baudelaire, for example, considered him to be one of the few educated artists in his 'century of spoiled children'.[53] Beyond the question of fashion, is it possible to claim that 'subject-matter' was the bone of contention that divided the critics of the time?

The preference for 'modern subjects' was not limited to Romantics but made itself felt in painters of all denominations, including those who were defended by even the most oppositional critical camps. An example of the two extremes are Delacroix and Horace Vernet. In 1839 Vernet painted the classical subject *La Ballade de Lénore, ou Les Morts vont vite*, while at the same time illustrating,

in lithography, the Romantic *La Fiancée d'Abydos* or *Le Naufrage de Don Juan*. 'It was work and we shall say no more', commented Sainte-Beuve in *Les Nouveaux Lundis*, displaying his fundamental contempt for the applied arts. Sainte-Beuve nevertheless raised this issue of the 'subject-matter', asking: 'Do artists have to continue to work within the genre of academy painting? Must they be forever painting versions of Ajax, Leonidas, Hector, Ulysses ... or should they take on new, living subjects ... as have that brave élite Delacroix, Schnetz, Scheffer and Horace Vernet?'[54]

Delacroix can, therefore, be placed alongside Vernet as fighting the same battle: 'In this search for the mastery of truth, each proceeded in his own way and with his own means: some by emotion, some by exact rendering of movements and faithful copies, others by audacious colours, tones and intensity.'[55] What is striking in Sainte-Beuve's comment is the central part played by the criterion of contemporary subject-matter, which becomes the linchpin of his argument: it is 'modern subject-matter', and this alone, which allows him to group Delacroix together with Horace Vernet. Yet everything else would seem to indicate that these two painters belonged to opposite camps. Delacroix hated his rival,[56] but this was less significant than the fact that the two painters were championed by opposing groups. Horace Vernet was championed by the Neo-classicists – such as Delécluze, who considered him to be an 'original artist' of 'rare talent'[57] – for his skill in portraying battles and horses, the principal elements of history painting, which guaranteed him commissions. The defenders of 'Romanticism' were scathing about drab colours – in his *Journal* Delacroix attacks David for being a 'grey' painter[58] – whilst their opponents praised the painters' faithful rendering of local colour, as demonstrated by a painter such as Horace Vernet.[59] Sainte-Beuve, ignoring the oppositions of style and conception that separate the two painters, unites them in the name of 'Romantic subject-matter', a new and unifying characteristic. But would this have been corroborated by the painters themselves? Did Delacroix ever change his opinion that Vernet produced execrable painting?[60] Is it right to think of the 'Romantic' painters as waging a 'war of subject-matter' or would it be more accurate to identify this as a characteristic of the critical discourse alone?

There is little evidence in the paintings themselves that the 'Romantic' painters limited themselves to modern subjects, such as literature (preferably contemporary), rather than history or the Bible. In fact, their work proves that the established Romantics eschewed neither military nor religious paintings. Delacroix found themes from classical antiquity quite acceptable,[61] and was not

afraid to make use of them for paintings such as his *Justice of Trajan* of 1840. Would the choice of a 'Classical' subject in itself have been enough to guarantee him the favour of opposition critics? On the other hand, the most 'traditional' of painters (as was the case with Horace Vernet) manifested evidence of Byronic influence and contamination by the 'passionate'. It seems then that the question of subject-matter does not position itself neatly along the same lines of opposition as do other criteria, at least according to the claims of one or other aesthetic party. Whatever 'camp' they were considered to belong to, the artists, in fact, depicted ancient or modern themes according to the context in which they were painting, and the commissions they received. The distinctions between 'innovative', modern subjects and 'traditional' historical ones was far from causing a real split between painters, at least in terms of the work they produced.

Describing Delacroix's *La Bataille de Nancy*, in a diatribe which unwittingly recapitulates all the 'classical' (in both senses of the word) arguments levelled at the latter by his critics, the critic Vergnaud claimed that Delacroix's painting was worthless: 'Badly maimed horses in a more than foreign land, beneath an impossible sky, an incredibly dirty colouring and drawing which is wilfully inaccurate.'[62] However the selfsame Vergnaud, who disliked *Le Prisonnier de Chillon* because of its 'arch-romantic whimsy', deeply admired *Christ on the Cross!*[63] Delécluze, a fierce opponent of Delacroix from the start (it was he who used the word *tartouillade* in 1822) very much liked his *Medea*, thus undermining any assumption that selection of a traditional subject alone would be enough to dissolve the opposition of critical opinion.[64] But if it is not a question of subject-matter, what is it that sets up the opposition? Might it be colour? Those of Delacroix's critics who hated his 'colourism' were opposed to the 'aesthetics of colour' praised by Charles Blanc.[65] However, what are we to conclude when Delécluze praises the colour in *Liberty Leading the People*?[66] A similar critic praises Delacroix's verve and energy while criticising his 'excessive ardor'.[67] Thiers, who is thought to be a forerunner of taste on the subject of Delacroix ('Delacroix is a genius'), and who offered him so many commissions for decorative murals, is rather moderate in his famous 1822 article, from which the eulogistic opening lines are often quoted: the 'subject' of Dante and Virgil seems close to exaggeration, and could even 'be criticised for wanting in nobility' despite the 'severe taste' which 'highlights the draughtsmanship'. And the colour? 'certainly very beautiful' but 'rather garish'.[68]

Delécluze, on the other hand, in the course of his more or less annual articles on the painter, offers him abundant advice[69] and

virtually stops launching into diatribe, when comparing him (not always unpleasantly) to other artists. It is all the more surprising then to find that his writings have sequential but not logical continuity. His arguments change and alternate without any apparent reason. A painting such as Delacroix's *L'Empereur Charles-Quint au monastère de Saint-Juste*, exhibited at the 1833 Salon, shows how much the critics are liable to alter their usual stance under the slightest of pretexts. Did the subject seem historical and traditional? Delécluze declares himself captivated by the artist's 'beautiful idea', even though he 'urges the author' towards even greater nobility advising him to return to this theme once again, 'in a more precise and elevated form'.[70] Gautier, on the other hand, who was to become one of Delacroix's most ardent defenders, writing about him for the first time, begins with very moderate praise, criticising Delacroix for the softness of his style and the drabness of his colour.[71] Charles Lenormant, who did not particularly like Delacroix, admired the *Charles-Quint* painting, which he thought had a good composition – the 'Classical' quality *par excellence*.[72] Clearly, then, the 'modern subject-matter' is not the touchstone of critical appreciation. Even the most classical theme – such as *The Justice of Trajan* – is no more likely to soften the opposition than it is to worry the defenders. Alphonse Karr compared the painting to the presentation of the 'fatted calf' and considers Trajan to look like 'a butcher boy lit up in brick red'.[73] Théodose Burette considers it to be unpleasantly reminiscent of 'a *gros point* tapestry copy of an old master'.[74] Here we can see the manifestation of a recurring and prevalent 'anti-Romantic' argument, which unites a criticism of colour with the decorative arts and especially tapestry!'[75]

But the criteria for the opposition between the two camps is still no clearer: the stylistic differences implied by this comparison of Romantic painting with tapestry is not, in itself, enough to prove strategy eclipsing aesthetics. There are other factors at stake here. Should we eliminate all the contingent factors that distract us from the simple opposition between the two camps, in order to leave them most evident? It would seem as if the arguments put forward by either camp are pretexts, weapons that could just as easily be levelled at the accuser.

The reversible nature of the critics' arguments suggests, at least, that hypothesis. I have argued that the issues of colour, draughtsmanship, composition, subject-matter, inspiration, audacity and assimilation were inflammatory issues, the mere mention of which was liable to create two opposed camps: Gautier himself concurred with this. Yet the critics of Delacroix, whose work proved to be a

bone of contention among them, seems to illustrate the opposite. The whole gamut of arguments was used by critics of *both* camps, concepts were used indiscriminately to fuel changing debates. Stylistic criteria were changeable and the 'thorny' debate over subject-matter proved inconclusive with similar themes being found in each camp, while the arguments about colour also proved inconclusive.

Should we, then, deny the existence of the opposition between the Romantic and Neo-classical traditions? It is tempting to think that this opposition was entirely rhetorical, if it were not for the fact that the critical debate which we might have considered to be exaggerated by the frenzy of nineteenth-century criticism, cannot be simply negated. There is a profound and enduring split in the view that we continue to have of Delacroix's work. If we take an overall view of the criticism of Delacroix, we can see that the positions taken by critics about the painter all seem to have something of the abstract and 'universal' about them. Critics, while claiming to be referring to a specific painting, discuss issues that go beyond the works themselves and address another level of controversy altogether. The work is reduced to being a simple pretext, and is placed in a position of inferiority to the critical text itself. Is this a condition of all critical discourse, which exists by virtue of the work which is its pretext but which is thereby suppressed by the process? This issue too could be explored. But the question of the domination of the written text over painting, as we find it in art criticism, should not occlude the primacy of strategical thinking over aesthetics – to return to the theme under exploration here.

The only conclusion we can draw with any certainty is that none of the mid-nineteenth-century criticism has anything to do with aesthetics, whatever might seem to be the case. Criticism may aim at irony, mockery; it may be strategic or tactical; it is likely to be the product of a group, and in the climate of the 'Romantic' struggle this group was characterised more by its 'will to oppose' than by any specific programme of ideas or any ideational content. There is no doubt that Delacroix was a hostage to the fortune of many critical strategies, but we can have reasonable doubts about whether this criticism casts any light on the aesthetics of either Romanticism or Classicism. Critics made ample use of many concepts from aesthetics, but the way in which these concepts were used as weapons precluded any aesthetic discourse emerging from art criticism.

Delacroix was certainly aware of this. He advised artists to 'kiss the hand of these viziers of the public, ministers of its anger and guardians of the honour of art'. The honour of art is not art, far from it. As for the function of critics, Delacroix was well aware of

the limitations of criticism: 'far from contributing to the progress of art, these discussions muddle the simplest questions and pervert all ideas'. He adds that 'professionals (painters) contest the right of theorists to fight on their territory and at their expense'. Yet Delacroix experienced an 'intense anxiety' when confronted with 'the judgements of these people who are mad judging': and judgement here overrides aesthetics. Criticism is a 'battle of minds', where there are 'endless discussions on the precedence of drawing over colour, whether music should start with harmony, whether composition is the most important quality'. But all these discussions are only pretexts; the goal of some criticism is simply to assert the 'rights of the bourgeoisie', the taste of fashion, the chastisement of innovation.[76] Delacroix's comments are strongly partisan, and not very subtle: but what could be more convincing than such single-minded clarity to overcome a criticism that was barely aesthetic and, above all, strategic in its aim?

Notes

I wish to thank Claire Pajaczkowska for her translation.

1 The Academy of Art was one of the five Academies that comprised the Institut de France. Maxime Du Camp, *Souvernirs Littéraires*, 1882–83 (Paris, Balland, 1984), p. 225.

2 'The tiger, stalking his prey, does not have such shining eyes, nor such impatient quivering of muscles, as was visible in our great painter when his entire soul was reaching out towards an idea, or when he was seeking to grasp a dream', wrote Baudelaire in *Eugene Delacroix, sa vie, ses oeuvres*, in 1863. Thereafter this analogy had a remarkable fate. Gautier's *Histoire du Romantisme* describes Delacroix as 'mellow, soft as velvet, seductive as one of those tigers whose extraordinary supple grace he excelled in rendering'. The condensation of the pictorial motif of the tiger and the personality of the artist himself led Odilon Redon to write: 'When I saw Delacroix in 1859, he was as beautiful as a tiger' (written in his journal *A soi-meme* (Edition Corti), p. 180). Jean Cassou depicts Delacroix as a 'loner, quivering with his tiger-like walk, with the eyes and the muzzle of a tiger', a 'carnivore' who 'finds his brothers' at the zoological Jardin des Plantes! *Delacroix* (Editions du Dimache, 1947). Maurice Sérullaz also describes a 'fauve', 'alone and a prisoner of his art, like the lions and tigers that he liked to paint in their proud solitude, and their great dreams of escape' (Introduction to the *Mémorial*, p. XV). Guy Dumur, in *Delacroix, romantique français* (p. 91), notes that for 'some biographers' the image of the tiger is 'the emblem, the totem animal of the young Delacroix', and that in discussing Delacroix they extend the metaphor: the 'fauve' was greedy, and 'could sink his claws in when necessary'.

 In a letter to Charles Rivet dated 16 May 1830 Delacroix himself makes reference to this theme, discussing his wish to travel in Italy: 'I shall go, I shall go alone like a bear, like a tiger if necessary. I shall bare my claws for any tedious nuisance.'

3 See Lionello Venturi, *Histoire de la critique d'art* (1936, French edition, Paris, Flammarion, 1969), pp. 229ff., and Anne Marie Christin, 'L'écrit et le visible. Le 19e siècle français', *L'Espace et la lettre* (Cahiers Jussieu No. 3, Paris, U.G.E.), pp. 163–92.

4 'Delacroix est-il vraiment un héros de l'art bourgeois?' is the title of the article by R. Lebel in the journal *Preuves*, in 1963. Lebel, in contrast to G. Besson (*Les Lettres françaises*, 16 May 1963) refuses to see Delacroix simply as a 'type of bourgeois grocer' (épicier poujadiste).

5 See René Huyghe, *Delacroix ou le combat solitaire* (Paris, Hachette, 1964); André Joubin, *Introduction* to Delacroix's journal (Paris, Plon, 1931); Philippe Jullian, *Delacroix* (Paris, Albin Michel, 1963).

6 See Pierre Daix, *Delacroix le libérateur* (Paris, Club des Amis du Livre progressiste, 1963), and Guy Dumur, *Delacroix, Romantique français* (Paris, Mercure de France, 1973).

7 See Pierre Daix, quoted by Nicos Hadjinicolaou, 'La *Liberté guidant le peuple* de Delacroix devant son premier public', in *Actes de la recherche en sciences sociales*, no. 28 (June 1979), p. 11.

8 Philippe Jullian, *Connaissance des Arts*, April 1963, 'Delacroix et le thème de Sardanapale', and Pierre Granville, 'Une optique nouvelle sur Delacroix', *Connaissance des Arts*, August 1963, pp. 30–41.

9 René Huyghe, *Delacroix ou le combat solitaire* (Paris, Hachette, 1964).

10 André Joubin offers the second edition of the *Journal* which was completely re-edited in 1931–32, when the Centenary anniversary of Romanticism was being celebrated in France. A significant retrospective of paintings at the Louvre featured Delacroix's work prominently. The second edition remains the current edition.

11 André Joubin, Introduction to Delacroix's *Journal*.

12 See Eugenio d'Ors, *Du Baroque*, 1935 edition (Paris, Gallimard, 1968).

13 Theophile Gautier, *Histoire du Romantisme*, first chapter (Paris, Charpentier, 1874, republished 1877, 1878).

14 The drawing, for which this phrase is a caption, depicts a duel on horseback fought between Delacroix and Ingres. The latter is flying the banner of Raphael, and the former that of Rubens: the personification of a colourist.

15 See also my essay on David, Delacroix and politics in *Les Fins de la peinture*, ed. R. Démoris (Paris, Desjonqueres, 1990).

16 Exclamation attributed to Mlle Clarke. Gautier also quotes this witticism without attributing it to a specific author. See J. Gaudron, 'Hugo juge de Delacroix', *Gazette des beaux arts* (September 1966), pp. 173–6, fragment from the *Journal de l'exil* edited by Adele Hugo, the daughter of the poet. The narrator tells of the soiree of 27 March 1856, at Mlle Clarke's: 'Delacroix was there'; 'and as soon as he had left Mlle Clarke exclaimed 'He certainly is witty, that M. Delacroix; what a shame he is a painter!' In the *Histoire du Romantisme*, T. Gautier writes: 'In the salons everyone was saying: 'What a shame that so charming a man paints such paintings!'

17 'Lettre à Achille Ricourt sur les concours', *L'Artiste* (1 March 1831). Achille Ricourt was editor of this new journal.

18 *The Lament of Tasso* by Byron was published in French in 1818, the same year
 as Galignani published the original English-language edition. If Delacroix
 was particularly moved by the theme of the 'genius' crushed by power, it
 was doubtless through reading Byron, and no doubt he read him in French
 rather than in the, for him, more difficult English language. The theme of
 Tasso incarcerated, to which he returns throughout his life and which inspired
 a number of paintings, is for him the very symbol of helpless despair. In a
 letter to his friend Pierret, dated 22 September 1819, he describes how much
 he empathises with this predicament: 'Tasso's life is so interesting. The man
 was so unhappy! One is so indignant at his oppression at the mercy of the
 "protectors" who imprison him ... One weeps for him: it is impossible to sit
 still whilst reading about his life; one's eyes bulge and one's teeth are clenched
 with fury when one thinks about it'.

19 See Nicos Hadjinicolaou, 'La *Liberté*'.

20 *Les barbus*, literally the bearded men, carries a range of connotations in the
 idiom of Romanticism. Delacroix's *Journal* entry for 16 April 1853 reads:
 'They brought Millet to my studio this morning ... He belongs to that
 constellation or crew of bearded artists who made the 1848 revolution, or
 encouraged it thinking, apparently, that it would bring equality of talent,
 as well as equality of wealth.' The symbolism of the beard does not only
 make an appearance in Gautier's *Histoire du Romantisme*; it has been extensively
 analysed by Etienne Delécluze in the appendix to *David, son école et son temps*,
 entitled 'Les barbus du présent et les barbus de 1800' (republished by
 Macula, Paris, 1983), p. 420.

21 See Moreau-Nélaton, *Delacroix*, Vol. 2 (Paris, 1916), pp. 10 – 11, and Maurice
 Sérullaz, *Les Peintures murales de Delacroix* (Paris, 1963).

22 In 1838 Delacroix had just been commissioned to decorate the library of the
 Palais Bourbon: he had just single-handedly completed the King's apartments;
 two years later he received a commission to decorate the Libraries of the
 Chambre de Deputies and the Senate in the Luxembourg Gardens. He then
 worked on the two projects simultaneously with the help of the employees
 he had just recruited.

23 Dumas wrote: 'three days before the ball everyone was at work, Alfred
 Johannot was sketching out his scene of the Fifth of March; Tony Johannot
 his Isidore de Giac; Clement Boulanger his Tour de Nesle; Louis Boulanger
 his Lucretia Borgia; Jadin and Descamps were collaborating on their
 Debureau, Granville was painting his Orchestra, Bayre his tigers, Nanteuil
 was painting his two door panels, one representing Victor Hugo, the other
 Alfred de Vigny.
 Only Delacroix was missing: the others wanted to take over his panel but
 I took his side ...'

24 Dumas, *Mémoires*, chapter CCXXIX.

25 The conflict between the 'master' and his 'pupil' Lassalle-Bordes is very
 telling. A manuscript by Lassalle-Bordes (Bibliothèque d'Art, Paris) provides
 evidence of the author's feeling of injustice, the pupil, from his account,
 having single-handedly executed a number of the paintings conceived by
 Delacroix. This desire to sign a work which one has executed is evidence of
 new aspirations which were opposed to the old studio system. Whereas
 Delacroix does not challenge the tradition that subjugates the pupil of the

master and accords the primacy of the conception over the execution of the painting, his pupil, or more precisely his employee, wants recognition which is being withheld from him. This affair is significant in that it prefigures the transformations in the status of the work of art which culminate in the radical upheaval of the end of the century. The Lassalle-Bordes affair is evidence of a growing conflict between the new demands of a nascent 'individualism' and the tradition of the 'painter's trade' in which vestiges of corporate organisation subsist. Following the industrial revolution this traditional process increasingly appears to be exploitative: Delacroix's absence from the workplace, his ill health, his long periods of rest in the countryside during the execution of the works all contributed to his 'pupil's' exasperation. Beyond this anecdote itself the whole affair is particularly representative of a cultural transformation in process.

26 'Des critiques en matière d'art', *Revue de Paris* (May 1829), vol. 2.

27 'Des critiques'.

28 Marie-Madeleine Dujon, 'A la recherche du regard sur l'oeuvre de Delacroix', MA thesis (Paris, 1979), p. 81: the artist's 'stardom' is a product of the polemic surrounding his work.

29 Silvestre, *Eugène Delacroix, Documents nouveaux* (1864), pp. 8 and 47.

30 Quoted in Silvestre, *Delacroix*, pp. 8 and 47.

31 Charles Blanc, *Les Artistes de mon temps* (Paris, 1876), p. 24.

32 Quoted in Dujon, 'A la recherche', p. 6.

33 See 'Delacroix, sa vie, ses oeuvres', an article published in 1863 in the *Opinion Nationale*. Baudelaire, who had 'overheard people accusing Delacroix of egoism and greed', comparing him with Machiavelli and seeing him as 'sickly and aloof', thanks his editor for allowing him to speak 'freely' of this man whose politeness was mistaken for coldness, whose irony was mistaken for nastiness, and whose thriftiness was mistaken for greed, and he remains the main conduit for the transmission of Delacroix's work. The poet admired Delacroix's work wholeheartedly, but may well have had reservations about the man himself, who was inhospitable and aloof towards him. Baudelaire claims that it is only the spiteful who circulated critical stories about Delacroix: but is not this device of attributing one's own critical thoughts to another a familiar strategy amongst those who eulogise, a device which was as current then as it is today? See A. Moss, *Baudelaire and Delacroix* (Paris, A.G. Nizet, 1973), and J.R. Mantion's article on Girodet in *Les Fins de la peinture*.

34 Maurice Tourneux, *Eugène Delacroix devant ses contemporains. Ses écrits, ses biographes, ses critiques* (Paris, J. Rouam, 1886), introduction, p. XI. Tourneux's book is a valuable source for research into criticism of Delacroix: it catalogues all the articles written about the painter's work in various journals and magazines, and gives a comprehensive bibliography of contemporary texts.

35 Piron, *Eugène Delacroix, sa vie, ses oeuvres* (Paris, Jules Claye, 1865), p. 23.

36 Pontus Grate, *Deux critiques d'art à l'époque romantique* (Stockholm, 1959), pp. 1–11.

37 Armand Moss, *Baudelaire et Delacroix*, p. 42.

38 Tourneux, *Delacroix*.

39 Gautier also describes the 'deafening outcry', and the 'storms' of 'furious debate' that surrounded Delacroix (*Histoire du Romantisme*, chapter on Delacroix).

40 Tourneux, *Delacroix*, Introduction, p. VII.

41 Dujon, *A la recherche*, p. 72.

42 Gautier, *Histoire*, Delécluze describes the *Dante and Virgil* as 'tartouillade' (*Le Moniteur universel*, 18 May 1822), but was later to prove himself less antagonistic towards Delacroix than such an insult might lead one to suppose. He liked the *Medea* and the decorations of the *Salon du Roi* at the Palais Bourbon, as Tourneux notes in his *Eugène Delacroix devant ses contemporains*. In his *Journal* Delacroix corroborates this: 'Delécluze clasped me by the shoulder with an amiability which I hardly expected from a man who has rarely praised me in writing, in the thirty years that he has been attacking me at every Salon' (28 March 1853).

43 Quoted in Tourneux, *Delacroix*, p. 51.

44 Charles Brun, quoted by Picon, *1863: Naissance de la peinture moderne* (Geneva, Skira, 1974), p. 14.

45 F. de Foreinx, *Histoire du Romantisme en France* (Paris, Dureuil, 1829), p. 5.

46 In the same book Foreinx asks, 'Does it remind you of the corpses in the "massacre at Scio", filthily piled up on top of one another?' (p. 127).

47 For a discussion of these themes see Hajdinicolaou, 'La *Liberté*', pp. 3 – 26.

48 Quoted by Tourneux, *Delacroix*, p. 90.

49 Quoted in Pierre Pétroz, *L'Art et la critique en France depuis 1822* (Paris, Germer Baillère, 1875), p. 65.

50 Pétroz, *L'Art et la critique ...*, pp. 3, 22 – 34, 63, 334.

51 Burty's text and the analysis of this phenomenon may be found in E. Estève, *Byron et le Romantisme français* (Paris, Hachette, 1987).

52 Estève, *Byron*.

53 We find an appreciation of educated artists in Baudelaire's *Salon of 1859*: 'The artist today is, and for many years has been, a mere spoiled child. What honours and prizes have been heaped upon these men who are quite without soul and without education!' On the other hand Delacroix is described as 'worthy of conversing with a philosopher or a poet'.

54 Sainte-Beuve, *Nouveaux Lundis* (Paris, Michel Lévy Frères, 1872), vol. V), pp. 51 – 3.

55 Sainte-Beuve, *Nouveaux Lundis*.

56 When Delacroix was anticipating being commissioned a second time, on the strength of the patronage already offered him by Thiers, to take on a vast project of decorative murals at the Palais, the work was in fact divided up into a number of smaller projects, and amongst those commissioned to undertake the murals was Horace Vernet, who had also been defended by Thiers, particularly in the 1824 Salon. In the end Delacroix's only commission was for the Library of the Palais Bourbon.

57 E. Delécluze, *David, son temps et son école* (Paris, republished by Macula, 1983), p. 302.

58 Undated fragment on p. 316 of the Paris Plon edition of the *Journal*.

59 Sainte-Beuve, *Nouveaux Lundis*, pp. 78–9: 'Horace [Vernet] did not work for such an effect, with his painter's eye he saw and immediately portrayed what he saw. He took the clothes as worn by the model and rendered them onto canvas: it is the thing pure and simple, the very same shade. Send a sample to the tailor and he would be able to identify the cloth itself. Now, in Delacroix's painting of *Liberty* look at the boy's shirt: the painter has not tried to reproduce the exact colour of the shirt, he looks for a colour that will complement the scheme of the painting itself, that will create the best effect. Horace Vernet does not use these schemes, he does not traduce colour: he never alters.' The old opposition between fidelity to 'local colour' and deliberate choice of 'overall tone' was, even then, not yet resolved.

60 Delacroix, *Journal*, 4 February 1847: 'As soon as I came in [to the Palais Bourbon] I noticed Vernet's decorations on the cove of the ceiling. A whole book could be written on the appalling decadence of nineteenth-century art as exemplified by these paintings. I am not speaking only of the wretched taste and poor handling of the coloured figures, the grisailles and ornaments are equally lamentable.'

61 Delacroix, *Journal*, 15 April 1823: 'I must read Daphnis and Chloe, it is one of the themes from classical antiquity that is most acceptable.'

62 A. D. Vergnaud, *Examen du Salon de 1834* (Paris, Delaunay et Roret, 1834).

63 Pamphlet cited by Tourneux in *Delacroix*, p. 63. See also Tardieu's critique in *Le Courier français* (30 March 1835), which sets up the same opposition with its implicit assumption that the subject-matter divides them: *Christ on the Cross*, a religious subject, is praised whilst the *Prisoner*, a Byronic subject, is severely criticised.

64 Delécluze, *Journal des débats* (8 March 1838).

65 Charles Blanc, *La Réforme* (16 March 1845), quoted by Tourneux, in *Delacroix*, p. 78.

66 Delécluze, *Journal des débats* (7 May 1831).

67 Anonymous article in the *Constitutionnel* (12 March 1838), quoted by Tourneux, *Delacroix*, p. 66, on 'La Bataille de Taillebourg'.

68 *Moniteur universel* (18 May 1822), frequently reprinted.

69 There is advice in every one of Delécluze's articles on Delacroix. He is proud of the fact in *Les Beaux-Arts dans les deux mondes en 1855*, a collection of articles published by Charpentier the following year, noting that he always sought to guide the painter, who was a victim of his foolishness.

70 Delécluze, *Journal des débats* (26 April 1833), quoted by Tourneux, *Delacroix*, p. 56.

71 Gautier, 'Salon de 1833' in *France Littéraire*, magazine edited by Charles Mano, vol. VI, p. 159, quoted by Tourneux, *Delacroix*, p. 56.

72 C. Lenormant, *Le Temps* (23 April 1833), quoted by Tourneux, *Delacroix*, p. 57.

73 A. Karr, *Les Guêpes*, April 1840, p. 65, quoted by Rosenthal, *Du Romantisme au Réalisme* (Paris, reprinted by Macula, 1987), p. 134.

74 T. Burette, 'Salon de 1840', *Revue de Paris* (April 1840), p. 131, quoted by Rosenthal, *Du Romantisme*.

75 It is not unusual to find colour being held in lower esteem than draughtsmanship, and perhaps the best example of this is in Charles Blanc's famous *Grammaire des Arts et du Dessin*; but the association of colour with applied arts, especially tapestry and carpets, plays on a complex mixture of fantasies which link the imaginary 'Orient' with contempt for the decorative arts, uselessness and femininity. The *Women of Algiers*, a breviary of this aesthetic, combine colour, textiles, femininity and Orientalism – and are also a colourist's manifesto. A misogynistic comment attributed to Delacroix when he was visiting a harem in Algeria, according to Charles Cornault (quoted by Burty in his article in *L'Art*), and Elie Lambert (in *Delacroix and the Women in Algiers*), synthesises this complex mixture of fantasy: 'How beautiful! It's like the age of Homer! The women in the gynaeceum taking care of the children, spinning wool or embroidering marvellous fabrics. This is woman as I understand her to be!'

Can it really be a simple coincidence that F. Villot compares certain of Delacroix's paintings to 'the wrong side of a tapestry', when Dumas calls to mind the Indian cashmeres, Du Camp speaks of Persian carpets, and Charles Blanc notes that the Venetian colourists were influenced by the array of knick-knacks and artefacts that were brought to the quaysides of Venice by tradesmen from the Orient? (See my forthcoming anthology *Conversations avec Delacroix*, especially the chapter on colour.)

76 Delacroix, 'Des critiques'.

5

Printmaking as metaphor for translation: Philippe Burty and the *Gazette des Beaux-Arts* in the Second Empire

SÉGOLÈNE LE MEN

Although art criticism had existed as a literary genre for quite some time, Philippe Burty (1830 – 90)[1] was one of the first writers in France to be properly categorised as an 'art critic'.[2] As early as 1870 he was acknowledged as such in Vapereau's *Dictionnaire des contemporains*, where he is said to be a 'collectionneur et *critique d'art*' (my italics), a phrase which does not seem to be used elsewhere in the dictionary.[3] It is perhaps no coincidence that during the 1860s Burty also specialised in writing criticism of the graphic arts for the *Gazette des Beaux-Arts*, a leading journal widely illustrated with etchings, and directed by Charles Blanc, an amateur engraver who himself became an art critic. According to Tourneux, when Blanc

> founded the *Gazette des Beaux-Arts* and formed his group of editors, he did not forget Burty, to whom he entrusted the reviewing of the public auctions and diverse exhibits considered to be secondary in the hierarchy of genres, so important at that time, such as engraving, photography and the 'minor arts'.[4]

This article will focus on Burty's criticism of the 1860s, a crucial decade for the development of both engraving and art criticism, in order to raise the question of the parallel between the profession of the printmaker and that of the art critic. It is based on the assumption that art criticism is not restricted to being a literary genre (*Kunstliteratur*), but also embraces a kind of visual critique that is communicated through visual means, especially when one interprets criticism as a process of intersemiotic *translation*. I will argue that Burty's reviews for the *Gazette des Beaux-Arts* of the engraving section of the Salon during the 1860s can be read as a kind of oblique '*ars critica*' in which, through his discussions of the declining art of reproductive engraving as well as the contemporary etching movement, Burty elaborated a kind of metaphorical definition of the role of art criticism as he conceived it.

Reproductive prints and art criticism as translations: an implicit *paragone*

Unlike writers and poets such as Baudelaire, Huysmans, Valéry or Apollinaire, Burty never directly addressed the issue of art criticism.[5] However, his articles on printmaking in the 1860s reveal an implicit *paragone* between art criticism and reproductive engraving, as both have commonly been referred to as 'translations'. Moreover, these activities are perceived as derivative, second-hand expressions because they depend upon the works of art to which they are devoted. Charles Blanc, in his famous *Grammaire des arts du dessin*,[6] introduces a long chapter on engraving as an 'annex' to the third volume devoted to painting, and explains that 'engraving is bound to painting'. In the three parts of his book, 'engraving' is positioned as an appendix to 'painting' (part three) as 'glyptics' are to 'sculpture' (part two) and 'gardens' to 'architecture' (part one). Engraving's relationship to painting has been described with the metaphor of translation and has been used throughout the history of engraving to express its reproductive aim as well as its creative potentials. Blanc himself uses this same metaphor in the first lines of his chapter on printmaking:

> When it is a question [of engraving a] painting, the engraver only has black and white at his disposal for depicting colour and thus he ceases to be a copyist and becomes a translator. He truly translates painting's colour through light and shade, and by making these colours abstract, he only gives it value.[7]

This identification with translation is still made today. In 1984, Douglas Druick, perhaps influenced by the vocabulary of the nineteenth-century art critics he read closely, claimed that 'Degas appreciated the intrinsic merit of the reproductive print (an engraved reproduction exhibited at the Salon of 1855) when it rose to the level of the art of the medium it *translated*... Degas was probably responding to the example of Manet's several *etched translations* of works thought to be by Velázquez' (my italics).[8]

In a similar way, the art critic is sometimes described as a kind of 'translator'. In an extreme case, like Mario Praz's recollection of Croce's aesthetics, such a translation is found to be an impossible goal: 'every content differs from another, because nothing repeats itself in life; and from the continuous variety of contents there follows the irreducible variety of the expressive facts, which are the aesthetic syntheses of the impressions'.[9] And Praz adds: 'this passage in Croce's *Aesthetic* immediately precedes his statement that translations are impossible tasks and that each translation

creates a new expression. And consequently, Croce would dismiss as inappropriate any discussion of a parallel between the various arts.'[10] Nevertheless, this question of translation persists, as demonstrated by Thibaudet's moderate formulation:

> The reason why art criticism is reserved for writers and the reason why the writing of art criticism is difficult are one and the same.
> This same reason claims that no perfect translation exists. Art criticism is a translation of one language to another, from a plastic language to a literary language ... a translation can never surpass mediocrity.[11]

To clarify the relationship between art criticism and engraving as equivalent modes of 'translation', it is useful to refer to the theory of translation given by Jakobson in a threefold model.[12] To the usual meaning of translation as occurring from one language to another (interlingual translation), Jakobson adds two other categories, and names them respectively 'intersemiotic translation' or 'transposition' (when the 'object-language' is different from the 'metalanguage', as is the case in art or music criticism), and 'intra-semiotic translation' or 'reformulation' (when they are the same, as in engraving or literary criticism). Reproductive engraving 'reviews' pictures as literary criticism 'rewords' texts; both belong to the category of 'reformulation', and are restricted to one single kind of expression, whereas the transpositional quality of art criticism implies a double competence, one in artistic connoisseurship and the other in writing.

The metaphor of translation stresses the function of printmaking and art criticism in what linguists call 'shifters' from one expression to another, and it places art criticism in a reciprocal function to that of illustration, in which the 'reformulation' inverts text and image. Burty's articles demonstrate that he was sensitive to the similarities lying between these various kinds of 'translations' and 'code-switching'[13] processes: engraving, illustration and art criticism. Their common feature is their functional role as a bridge between diverse types of artistic production. This conception may be related to the fact that Burty, born in 1830, belonged to the generation of late romanticism.[14] Already in the 1830s, romanticism was a movement which sought to eliminate the barriers between artistic genres and expressions. Burty's personal taste for artists and writers who dared to cross the border between visual and verbal expressions is rooted in the same predicament: he wrote about Delacroix as an author and Hugo as a draughtsman. He liked his friend Jules de Goncourt's etchings and was attracted to the figure of Fromentin, the painter-writer; he wrote a preface for

a portfolio called *Sept dessins de gens de lettres*. Tourneux, who knew him, mentions that Burty never forgot his readings of romantic illustrated books during his youth, where the illustrator represents a reverse role of the art critic understood as intersemiotic translator.[15] Thus, the diverse range of Burty's interests as a critic – printmaking and transpositional expressions, either visual or verbal – appear to be structurally related to the social role of the art critic defined as a go-between, crossing the boundaries between the arts and the public at large, by his 'translations' of contemporary printmaking.

The crisis of printmaking: reading Burty's defence of engraving as an *ars critica*

In writing about reproductive engraving and photography, as well as etching, Burty brings out the very issues which are central to defining art criticism at a time when printmaking procedures were being challenged. Curiously, Burty chose to be an advocate of the dying art of engraving, despite the fact that these engravings did not personally appeal to him as much as etchings did.[16] This paradoxical attitude is particularly revealing, since Burty did not actually examine prints themselves, but rather their 'critical' mission and their institutional status. Thus, what he really explained in his discussion on divergent printmaking techniques was what he thought to be the role of art criticism: on the one hand, as a preserver of artistic works and, on the other, as a sensitive translator who can probe beneath the surface of a copy. As an art critic, he clearly privileged this second role.

During the 1860s, the crisis of printmaking was strongly felt; it was a polemical issue which brought about an outburst of critical response. Up to this time, engraving's primary role had been to reproduce paintings but, with the introduction of new techniques which were less labour-intensive and less expensive, this role was seriously challenged.[17] Reproductive engraving's failure to compete with these new techniques is poignantly demonstrated by the example of Henriquel-Dupont's[18] commission to copy Delaroche's mural at the Ecole des Beaux-Arts. It took Henriquel-Dupont ten years to make this engraving,[19] one of the most famous of the time,[20] and he was paid more than most painters commissioned by the State. Despite this tremendous cost and effort, the work was quickly and cheaply reproduced with photographic methods, and created a scandal among reproductive engravers. Reproductive engraving was rendered obsolete.[21]

Despite the greater appeal of 'artistic' printmaking techniques such as etching, Burty and his contemporaries repeatedly lament the 'death' of reproductive engraving.[22] But Burty's ultimate support for reproductive engraving is in fact a veiled rhetorical strategy to develop arguments for engraving's institutional role. Reviewing the Universal exhibition or the engraving section of the Salon, in *La Gazette des Beaux-Arts*,[23] Burty explained why the role played by reproductive engraving was so important. According to Burty, the only possible saviour of engraving was the public authority of the State, demanding the creation of an official conservatory for engraving, parallel to the Gobelins for tapestry and the Sèvres manufacture for porcelain:

> It is of no use that the battle against photography should last any longer. We see only one solution: create a national repository [*chalcographie nationale*] similar to the *Imprimerie imperiale* or the production plants of Sèvres and of Gobelins; what I mean to say is that this would entail a vast amount of work which would have no hope for total compensation.[24]

And four years later, Burty takes up this idea again:

> If publishers have renounced commissioning large plates which require considerable monetary advances and which are copied by photography the very same day that they are first issued; if the public itself no longer decorates its home with prints ... then engraving must become an art of the State, like the tapestry of the Gobelins and like the ceramic products of Sèvres.[25]

Burty's argument is interesting insofar as it shows how he understands both the role of the State and the social context of engraving. His proposal would protect certain artistic media from the laws of the free market, which is governed by financial profit, and linked to public taste. In other words, the role of the State would be to preserve the posterity of the medium itself. This conservatory ought to be devoted, like the *Salon* and the musée du Luxembourg, to the works of 'living artists', as opposed to the 'Pantheon' of the Louvre[26] ('a temple which only opens its doors to the celebrated dead'). Thus, the 'Pantheonisation' process seems to draw the line between the present and history, between the Salon and the museum, between the history of art and art criticism. Artistic policy is understood as a civil service confronted with technological changes rather than as an aesthetic patronage which protects favoured artists; and the art critic has to take position in the debate over the role of the State within the arts. Burty's proposal was not taken up because engraving was closely linked to the 'academic system' through its role as a reproducer of academic work. The

decay of the 'academic system' led engraving to depend upon the free market, or the 'dealer-critic system',[27] and the critic Burty took up its defence.

The advent of photography not only economically outstripped reproductive engraving, it provoked a profound debate concerning the definition of what is a copy and what is a translation. While Burty ascribes a practical role to photography, he still finds that it falls short in the task of reproducing works of art:

> Photography provides artists with subjects …, it provides the curious who have no monetary funds with an inexpensive means to travel …; to the antiquarian, reproductions of monuments; to the physiologist, pages of anatomy …, but it will never translate Prud'hon like Roger and Aubry-Lecomte.[28]

What is missing in the photographic reproduction is the interpretative translation, a gap which can be filled by the art critic.

The fact that photography had taken over printmaking's role of 'copying' works of art meant that printmaking techniques were free to develop other modes of artistic production.[29] For example, the 'painter's etching', a print executed by an artist rather than a professional printmaker, did not exist as a category of printmaking before photography became an established medium. Thus, these divergent media, photography and etching, helped to define the polarities between mechanical copy and translation.[30] This new dichotomy could also be applied to Burty's conception of art criticism since the photographic document could never replace the art critic's sensitive eye.

When Burty equates engraving with the act of translation, he in fact takes up a well-developed historical notion. However, the process by which he derives this notion differs from the traditional or idealist notions developed by his predecessors Henri Delaborde[31] and Charles Blanc. Already in 1856, Delaborde referred to Marcantonio Raimondi's engravings after Raphael as 'these delightfully deceitful translations', a phrase which plays on the Italian expression *traduttore traditore* ('translator – traitor'). Delaborde perceived the task of translating images to be like the task of translating a text: one can never create a 'literal copy' by replacing the original words with one's own. By this reasoning he defined the task of engraving:

> Engraving has thus a double task to fulfil. It must simultaneously copy and comment upon painting or it risks losing its privileges and gives up the criteria of art. Photography, in contrast, deriving only from fact, begins and finishes there.[32]

Thus, commercial reproductions and photographs were accepted as documents and could be included in works of art criticism – such as Blanc's *Rembrandt* – which as a result were relieved from their task of 'copying'/describing.

Delaborde's theme was to be developed further by Charles Blanc, who writes:

> Contrary to Emeric David's opinion [*Histoire de la gravure*], we agree with Diderot that engraving is less of a copy than it is a translation. Like the musician who transposes a tune, like a writer of prose who translates foreign poetry into his own tongue by preserving above all the genius of the poem, the engraver who engraves a painting onto the copper plate makes it come alive again.[33]

To explain his metaphor of reproductive engraving as an artistic 'translation' of painting, Blanc refers to other forms of artistic expression such as music and poetry, and replaces the principle of 'literal' similarity (to which tracing and 'copy' are reduced) with that of 'equivalence of difference' which implies that 'translation' is an act of creative interpretation.[34] His sentence anticipates Roman Jakobson's ideas that poetry pulls translation beyond its limits: 'poetry, by definition, is untranslatable. Only creative transposition is possible.'[35]

This notion of parallel creation was equally fundamental to the formation of the 'livre de peintre'. Like the painter's etching, the painter's book included prints executed by an artist rather than a professional printmaker. These artist's works were thus considered as interpretative images rather than literal illustration. Burty played a key role in cultivating a taste for these prints which were creative interpretations for poetic texts. In fact, he supervised the publication of *Sonnets et Eaux-fortes* (1868) which included poems by writers including Gautier, Hérédia, Coppée,[36] and illustrations by artists such as Manet, Corot, Daubigny, Nanteuil and even Victor Hugo.[37]

The idea of copy and translation as conceived by Blanc can be read as a foundation to the formalist approach to art. But Blanc's 'formalist' reasoning, unlike Burty's, derives from a profoundly classical conception of engraving which promoted it as a kind of artistic orthodoxy.[38] Such a normative use of engraving had started with Marcantonio's engravings after Raphael:

> Marc-Antonio conceived engraving's role to be as one should do when faced with the great masters. He conceived it to be a concise translation which highlights the essential aspects and yet knows how to capture everything, how to reveal everything; and without the language of colour, it emphasises the supreme beauty of contour.[39]

Ever since the celebrated portfolio of reproductive engravings entitled *Tableaux du roi* (1677 and 1679), engraving decreed a homogeneous standard for viewing an image, assured by the reproductive monopoly of the Academic engravers. These engravings produced a single meaning of the royal paintings; they showed how the paintings of the king's collection ought to be seen.[40] The accompanying explanations by Félibien made the message transmitted by the medium itself clearer, especially the Vasarian concept of *disegno* (drawing and composition) produced by black and white line-engraving. The strict visual conventions of engraving and its technical difficulty perpetuated the standards of the 'academic' vision.

The argument raised by Burty in favour of engraving is completely different from Blanc's traditional position, and would seem more applicable to his favourite medium, etching. He begins with Delaborde's *traduttore traditore* theme when he writes: 'Translations are all the more beautiful when they are more personal, and thus less faithful ...; Photography is impersonal; it does not interpret, it copies'. But he develops a more radical position with the new theme of the private idiom of each 'translation':

> leaf through the numerous works by the interpreters of Raphael at the Cabinet des Estampes, you will see that the most skilled ones were only interested by one facet of this multi-faceted genius Each one, without knowing it ..., only revealed their intimate personality.[41]

The contrast between Blanc and Burty's positions towards engraving exemplifies two opposite trends of the *Kunstliteratur*. While Blanc claims a normative 'grammar' of the visual arts understood as 'the art of drawing', Burty roots his art criticism in interpersonal subjectivity, on the 'I/you' pronominal relationship. When he uses the 'we' as an author's plural form, he uses it as an expanded 'I' which includes the audience, and develops it by the phrase, 'we, public and critic'.[42] Burty really develops an original, rather élitist, perception of the art critic, who simultaneously operates in two directions: in a 'horizontal' way, the art critic develops a privileged interpersonal relation with the artist by his activity as an 'inter-semiotic translator'; and, in a 'vertical' way, he presents his personal interpretative translation of contemporary works of art to the public which he sees himself as representing. The interpersonal 'I/you' relation operates both between artist and critic, and between critic and public and the crucial link between the various players of the art world becomes the 'I' of the art critic.

'Ceci tuera cela': the engraver pushed aside

Burty believes that engraving should be supported because it preserves a visual record of how contemporaries viewed the arts of their times. Engraving seems thus to be a kind of visual archive of contemporary artistic reception, as Burty states in 1863:

> Last but not least, let us have [the works of] our contemporary French masters reproduced. The history of our past proves this point; painters are only translated well by their contemporaries: Raphael by Marc-Antonio, Rubens by Bolswert, Poussin by Jean Pesne, Watteau and Chardin by the Cochins, Prud'hon by Roger and Copia etc. Who has, then, from our own day directly taken on Géricault? Do we have, with the exception of a few *crayon manner* prints by M. Calamatta, the most important and worthy works of M. Ingres? Do the decorative works by M. Eugène Delacroix not merit some attention? Do the paintings by Meissonier not attract the burin of the artist who would devote himself entirely to them? The following generation may only see the weaknesses in these masters.
>
> In any case, this generation will interpret these works with its own sensibility and will inevitably ascribe to them a reflection of their own ideals... Let us try to bequeath to our nephews, through engraving, the aspirations of our contemporaries.[43]

This historicist conception represents a view of art criticism as a response to contemporary art. It is based on the premise of aesthetic values which are linked to the concept of artistic generations and to periodisation. It also implies the necessity of visual documents, which literally 'review' the masterpieces for the current generation, in order to preserve its heritage of the future. Thus, Burty claims that the role of the engraver as a cultural witness has to be preserved. If no engraver 'translates' Ingres, Delacroix, Géricault and Meissonier, the art critic is ready to take over this task.[44]

As far as reproductive engraving is concerned, Burty developed the idea of the historical value of documents, either written or visual, which were *contemporary* to the subjects or events they depicted. This argument, which relies on posterity, was often expressed from the 1840s until the end of the century. It sought to legitimise ephemeral expressions, linked to contemporary events, such as caricature, illustration and journalism, as historical documents for future generations.[45] Thus, the role of the engraver is ironically parallel to the role of the press art critic: a journalist in search of social recognition among the 'gens de lettres' (especially among the writers of books who leave their creative *oeuvre* for posterity), and a contemporary witness of the art of his time. Given this similarity between the reproductive engraver and the art critic,

the death of engraving created a vacancy for the art critic to fill, since an art critic is another type of art 'reviewer'. The term *revue* refers in French to a periodical devoted to contemporary events, including the fine arts, the very field of the art critic.

In Burty's above statement on the role of engravers as translators of their contemporaries, the word 'engraving' could easily be replaced with 'art criticism'. As a matter of fact, Burty begins his article by slipping in a famous quotation by Victor Hugo which stresses the underlying competition between visual and verbal expression; his quote comes from the title of a famous chapter of Hugo's *Notre-Dame de Paris*, 'this will kill that',[46] which refers to the defeat of medieval architecture by the printing press, that the image is killed by the word. Burty focuses on the idea of the technological revolution and overlooks another implication of the sentence, familiar to the reader:

> *This will kill that*, mumbles one of the poet's characters. Photography will kill engraving, we can say with no less certainty. Yes, the day is near when engravers will be no more numerous than were scribes and illuminators after the fifteenth century. Niepce and Daguerre would have been, in their own way, the Fausts of a new age. Their invention, simultaneously so marvellous and imperfect, responds only too well to our epoch's need for economy and speed. If science were to endow photoengraving with the capacity to reproduce shades, at least their relationship to luminous intensity, then the last engraver, no matter how great his genius, would have nothing left to do but to break his burin in half, [since it is] deemed as useless and deceiving by a generation in a panic over literal exactitude.[47]

'Ceci tuera cela' reveals a latent message that the text will kill the image, that art criticism, and not only photography, will provoke the demise of engraving. For Burty, as for Delaborde and Baudelaire (among others), photography is seen as a mechanical and 'literal' copy, which fails to capture the 'spirit' of the work of art, expressed by contemporary engraving as well as by art criticism. This shift from image to text is made all the easier since the parallel between the printing revolution of the 'Gutenberg galaxy' and the revolution of engraving is a recurring theme throughout the literature on engraving.[48] For instance, Charles Blanc used this same comparison:

> What a marvellous coincidence! Engraving, which is the medium for printing visual arts, was discovered at the same moment as printing, which is the medium of engraving the literary arts. The means for popularising the works of the artist were created at the same time as the means for propagating the thoughts of the poet or philosopher.[49]

The common function of these printing presses is to disseminate the production of art and literature. But there is also a major difference between them. Whereas the printer simply assembles type and follows a typographical code, the engraver is an artist as well as a publicist. This twofold competence fits well with Burty's own definition of the art critic, who finds his most complete role model in the etcher.

Etching and its affinities with the art critic

Over the years, Burty developed another theme linked to the etching revival, and reveals that engraving is also threatened from within, by etching, the more creative and spontaneous medium which Burty favours:

> Maybe etching ... would not be appropriate for depicting the most important canvases with the necessary care, [but] it would translate the pride of M. Eugène Delacroix's painting with greater flair. ... If engraving seems to be undergoing a sluggishness at this moment, etching, in contrast, is the younger sister of painting and this year follows the youthful animation of her older sister.[50]

With the promotion of etching by the etching revival of the 1860s, etching seemed destined to replace engraving because, like engraving, it respected the spirit rather than the materiality of the work but it was seen as accomplishing this task with greater sensitivity.[51]

According to Burty, the decline of reproductive prints started when they stopped conveying the 'thought' of the paintings, and when personal feelings and sympathy for the painter were frozen by the academic conventions of technique (*métier*): 'To translate the masters should we not, above all, interrogate their thoughts, become inspired by their will, and follow them passionately in their quest for the ideal?'[52] In this sentence, Burty expresses his own *ars critica*, at the same time as he addresses the notion of reproductive engraving. According to Burty, the failure of reproductive engraving dates back to the hated Neo-classical period, which reacted against the valuable art of the eighteenth century.[53] Etching is seen as the secret to the spontaneous and vivid art of eighteenth-century printmaking, and is held to be the best reproductive process, and the right answer to the triumphant instrument of photography:

> Certainly the vivacious, colourful, improvisational and varied qualities of eighteenth-century prints are especially due to the excellence of the etching process. Etching is the hyphen between painting and printmaking. The sketch must be drawn by an artist's hand, and by 'artist', I always mean the one who immediately obeys his inspiration.[54]

The art of etching appealed to Burty, because it paralleled his conception of the role of the critic and because, as a medium, it can capture the artist's individual idiosyncrasies. Speaking of the Société des Aquafortistes, the organisation which served to promote the revival of etching, Burty writes: 'the new generation has understood every possibility that this technique offered for the quick and adequate translation of thought and feeling.'[55] Blanc and Jules de Goncourt were both amateur etchers, Burty an amateur lithographer of reproductions: their shared goal was to get closer to the work of artists to whom they were attracted. The ideas propagated by Burty, and to a certain extent Blanc and Goncourt, were adopted by certain practising etchers such as Maxime Lalanne.[56] In his *The Technique of Etching*, he writes: 'more than any other kind of engraving on metal, it bears the imprint of the character of the artist. It personifies and represents him so well, it identifies itself so closely with his idea, that it often seems on the point of annihilating itself as a process in favour of this idea. Rembrandt furnishes a striking example of this.'[57]

As a practising etcher, Lalanne's adoption of the notions promoted by critics demonstrates that the campaign for etching also promoted the goals of art criticism. Their shared task of sensitively conveying the artist's expression implies their conjunction but it also implies the risk of their competition. In other words, the boundaries between art critic and printmaker, between commentator and translator, came into conflict. This conflict is demonstrated by Burty himself in his role as 'artistic director' of the *Paris-Guide* in 1867 and of the book *Sonnets et Eaux-fortes* the following year. For example, the writer Henri Cazalis protested against Burty's role in the latter project by stating that 'it is absurd to entrust Burty with St Peter's keys to heaven, when Burty is neither an etcher nor a poet'.[58] Cazalis' remark raises an important issue, since Burty's status as art critic was not obtained through traditional means: through professional ties as a writer or as a practising artist.

The formulation of art criticism's role as a profession, as opposed to a mere literary genre, runs parallel to the decay of reproductive engraving. This parallel is particularly poignant in the 1860s. The conflict between old and new media raised important issues concerning the nature and the aims of the reproductive visual arts, and helped to draw a line between the 'mechanical' copy and the artistic interpretation. These categories were applied not only to prints but also to art criticism, as they are linked to the history of reproductive prints through the metaphor of translation. Burty's articles on printmaking imply a double-reading, especially the texts about the agony of engraving where it is clear that Burty felt

a sudden gap in an important function belonging to the art world: the function of the translator-witness who transmits to a public the major contemporary works of art. Thus appears an underlying contradiction between his position as an advocate of the printing media and his own identity as an art critic, more or less pushing aside the printmakers for whom he fights. Through his unintentional 'portrait of the art critic as a printmaker', Burty appears as an exemplary figure in a complex situation where competition and co-operation are brought together in the relationship between the journalist art critic and the artistic circles.

Notes

I wish to thank Anna Arnar for her help in improving the English translation of this article in its final version.

1 For Burty, see his own articles and writings and the following listed in chronological order: Maurice Tourneux, 'Philippe Burty', *Gazette des Beaux-Arts* (May 1907), pp. 388 – 402 (hereafter *GBA*); Gabriel P. Weisberg, 'Philippe Burty: a notable critic of the nineteenth century', *Apollo* (1970), vol. 91, pp. 296 – 300; Gabriel P. Weisberg, *The Early Years of Philippe Burty: Art Critic, Amateur and Japoniste, 1855 – 1875* (Baltimore, The Johns Hopkins University, 1967); Henriette Bessis, 'Philippe Burty et Eugène Delacroix', *GBA* (October 1968), pp. 195 – 202; Janine Bailly-Herzberg, *L'eau-forte de peintre au dix-neuvième siècle: La Société des Aquafortistes 1862 – 1867* (Paris, Léonce Laget, 1972), 2 vol.; Pierre Georgel, 'Le romantisme des années 1860: Correspondance Victor Hugo-Philippe Burty', *Revue de l'art*, no 20 (1973), pp. 9 – 64; *La Promenade du critique influent: Anthologie de la critique d'art en France 1850 – 1900* (Jean-Paul Bouillon, Nicole Dubreuil-Blondin *et al.*, eds) (Paris, Hazan, 1990).

2 For instance, in the *Grand Dictionnaire universel du XIXè siècle* (Paris, Librairie classique Larousse et Boyer, 1866 – 1876), 15 vol., printed in instalments from 1864 to 1876, Pierre Larousse calls him 'littérateur français contemporain' and 'collaborateur de la *Gazette des Beaux-Arts*'; Charles Blanc remains 'littérateur et graveur français' and Théophile Thoré 'publiciste français'.

Burty is categorised as a critic as well as Delécluze (1781 – 1863), who was also a painter, and Gustave Planche (1808 – 57): the first is 'peintre, littérateur et critique français', according to Larousse, who writes: 'il y a deux hommes chez Delécluze: le critique d'art et l'écrivain proprement dit'; the second is 'littérateur et critique': 'ses critiques d'art resteront comme des modèles d'analyse lumineuse, de jugement solide et sain, de savoir, de bon sens et de raison'.

3 Vapereau, *Dictionnaire des contemporains* (Paris, 1870), vol. 1, [np].

4 '... confia le compte rendu des ventes publiques et de diverses expositions tenues comme secondaires dans la hiérarchie, alors toute-puissante, des genres, telles que celles de la gravure, de la photographie, des "arts mineurs", etc.' (Tourneux, 1907, 'Philippe Burty', p. 390); when one lists the articles written for *GBA* between 1859 and September 1870, Burty's contribution appears larger, as he was also reviewing the art exhibitions in the provinces (Lyon,

Nantes, Tours, Limoges and Bordeaux), and in London (mostly at the Royal Academy); he also wrote a few articles about decorative arts and enamels, and one about Delacroix's correspondence. He wrote three articles about the teaching of drawing and one about public auctions (October 1859). However, his main focus was the graphic arts, including photography, even though it represented one-third of his activity (sixty articles): he reviewed the engraving section of the Salon (ten articles) and wrote catalogues and articles about the etchers he favoured (ten articles), from Meryon (1863) to Mrs O'Connor (March 1860). After he left, no other critic took over the same role, as their contributions on the subject did not last long: two articles by Paul Leroy (1873 and 1874), three by Louis Gonse (1875, 1876, 1877) and Lostalot (1882, 1888, 1892); Ménard and Béraldi reviewed one exhibition each (in 1872 and 1891). See the index of the *GBA Table centennale 1859 – 1959* (Paris, 1968).

5 The exception is Burty's 'Sainte-Beuve critique d'art', *GBA* (November 1869), pp. 458 – 65. In this article, printed shortly after Sainte-Beuve's death, he regrets that Sainte-Beuve was not an art critic for his romantic friends and explains that he would have been superior to Gustave Planche.

6 Charles Blanc, *Grammaire des arts du dessin* (Renouard, 1867). The book was published after a long series of thirty-seven articles which run from April 1860 to December 1865 in the *Gazette des Beaux-Arts*: 'Grammaire historique des arts du dessin: architecture, sculpture, peinture'; they were followed by the nine articles of the 'Grammaire des Arts décoratifs, pour faire suite à la Grammaire des Arts du dessin' (February 1866 to July 1874). The three articles on 'gravure' were published in 1866 (October, pp. 331 – 48, November, pp. 422 – 43 and December, pp. 505 – 23).

7 'S'agit-il d'une peinture, le graveur n'ayant à sa disposition, en ce qui touche la couleur, que du noir et du blanc, cesse d'être un copiste pour devenir un *traducteur*. Il *traduit* vraiment en clair-obscur le coloris du tableau et, faisant abstraction des teintes, il n'en donne que la valeur.' Blanc, *Grammaire*, p. 620. See *GBA Table centennale*, no 334.

8 Douglas Druick and Peter Zeger, 'Degas and the printed image, 1856 – 1914', *Degas: the painter as printmaker* (Boston: Museum of Fine Arts, 1984), p. XIX. Other nineteenth-century instances are given in my article which is a complement to the present one, 'La Gravure, instrument critique', *48/14* (1993).

9 Benedetto Croce, *Estetica come scienza dell'espressione e linguistica generale teoria e storia*, 3rd ed. (Bari, Laterza, 1908), p. 78.

10 Mario Praz, *Mnemosyne: The Parallel between Literature and the Visual Arts* (Princeton University Press, 1974 (1970)), p. 27.

11 'Or la raison qui réserve la critique d'art aux écrivains et la raison qui explique la difficulté de la critique d'art se confondent en une seule. La même qui fait qu'il n'existe pas de traduction parfaite. La critique d'art est une traduction d'une langue dans une autre, de la langue plastique dans la langue littéraire ... une traduction ne peut jamais s'élever au-dessus de la note passable.' *Intérieurs. Baudelaire, Fromentin, Amiel* (Paris, Plon-Nourrit, 1924), p. 124, quoted by David Scott, *Pictorialist Poetics, Poetry and the Visual Arts in Nineteenth Century France* (Cambridge University Press, 1988), p. 21.

12 Roman Jakobson, 'Aspects linguistiques de la traduction', *Essais de linguistique générale* (Paris, Éditions de Minuit, 1963), chapter 4, pp. 78 – 86. Initially the

article was published in a book edited by Reuben A. Brower, *On Translation* (Harvard University Press, 1959, pp. 232 – 9), to which the editor contributed an article about 'Visual and verbal translation of myth: Neptune in Virgil, Rubens and Dryden'.

13 Roman Jakobson, 'Le Langage commun des linguistes et des anthropologues: Résultats d'une conférence interdisciplinaire' (1952), *Essais* (1963), p. 34.

14 See Georgel, *Le Romantisme*, 1978.

15 As a matter of fact, Burty was, with Baudelaire's friend Asselineau, one of the first critics in the second half of the nineteenth century to appreciate and study the romantic 'vignette', and not only the rococo vignettes like the Goncourt brothers.

16 Pierre Larousse claimed about Burty that: 'ces divers écrits (critiques) dénotent chez leur auteur un sentiment élevé du beau, une horreur instinctive de la tradition académique et une vive sympathie pour les audacieux' (*Grand Dictionnaire universel du XIXè siècle*, Paris, Librairie classique Larousse et Boyer, 1864).

17 This was a recurring theme throughout the nineteenth century; for example, Le Breton, in 1814, already thought that burin-engraving was threatened by the taste for 'English prints': 'Il y a environ trente ou quarante ans qu'un goût irréfléchi mit en vogue les gravures Anglaises. … [En France], on fut inondé tout-à-coup d'un genre d'estampes, moitié au pointillé et moitié à l'eau-forte, qui composa une manière bâtarde, très-expéditive et sans caractère. Ces gravures, coûtant peu à faire, étaient données à bon marché' (*Rapports à l'Empereur sur le progrès des sciences, des lettres et des arts depuis 1789 V. beaux-arts*, par Joachim Le Breton, Paris, Belin, 1989, original ed. 1814). Later on, lithography was accused of the same competition.

18 Born in 1797, Louis-Pierre Henriquel (called Henriquel-Dupont) was the last famous academic engraver, following the grand tradition of his master Bervic. His reputation was widely acknowledged. Vapereau, for example, in the *Dictionnaire des contemporains* (p. 882), sums up all the honours received by this engraver: 'cet artiste éminent, décoré le 14 août 1831, a remplacé Richomme à l'Académie des beaux-arts, en 1849. Aux expositions de 1853 et de 1855, il a obtenu la grande médaille d'honneur. En décembre 1863, il fut nommé professeur en taille-douce à l'Ecole des beaux-arts réorganisée'. Henri Delaborde refers to his eminent position and writes: 'les nombreux et beaux travaux accomplis … par M. Henriquel sont trop généralement connus et trop unanimement appréciés pour qu'il ne paraisse pas superflu d'en rappeler les mérites. … [Il] est aujourd'hui non-seulement le chef incontesté de notre école de gravure, mais, de l'aveu de tous aussi, le plus éminent des graveurs contemporains, à quelque pays qu'ils appartiennent' (*Le Département des Estampes à la Bibliothèque nationale. Notice historique suivie d'un catalogue des estampes exposées dans les salles de ce département*, Paris, E. Plon et Cie, 1875, pp. 429 – 30).

19 'En 1853, après dix ans de travail, il termina et exposa, d'après Paul Delaroche, la grande fresque de l'hémicycle des Beaux-Arts', writes Vapereau, *Dictionnaire*, p. 882.

20 It was still on show at the *cabinet des estampes* of the Bibliothèque nationale when Henri Delaborde wrote his catalogue in 1875: '259. *L'Hémicycle de la salle des Prix, à l'école des Beaux-Arts*, d'après Paul Delaroche. Epreuve avant la lettre offerte à la Bibliothèque par le graveur lui-même, en 1853' (p. 430).

21 The texts are reprinted in André Rouillé, *La Photographie en France. Textes et Controverses: Une anthologie; 1816–1871* (Paris, Macula, 1989), p. 298: Henri Delaborde in 1856 and Léon Boulanger in 1859, followed by a petition of engravers against photography, started a 'battle' against photography, which was perceived as counterfeit. Burty still referred to the case in 1868 in a text where he also sums up the difficult labour of the engraver: 'il est bien peu de nos lecteurs qui se doutent que telle planche au burin est payée dix, quinze, vingt-cinq mille francs; qu'elle exige de l'artiste une éducation générale complète, un sentiment supérieur du détail et du caractère, une habileté d'outil qui ne peut s'acquérir du premier coup, une application qui doit ne pas se lasser, une verve qui doit ne pas se refroidir pendant les deux, trois, cinq ans et quelquefois plus, que l'on reste courbé sur un cuivre, à combiner des travaux, à choisir et à creuser des tailles, à les reprendre jusqu'à ce qu'elles expriment la relation exacte des blancs, des gris et des noirs avec les valeurs colorantes de l'original. Et qu'arrive-t-il aujourd'hui? C'est que, le jour où la première épreuve est mise en vente, un photographe peut l'acquérir, la copier en secret et créer ainsi une concurrence qui décourage à jamais et l'éditeur et l'artiste. C'est ce qui a eu lieu pour l'*Hémicycle* de M. Henriquel-Dupont, un des derniers grands burins que l'on ait osé entreprendre' ('La gravure, le bois et la lithographie au Salon de 1868', *GBA* (August 1868), p. 110).

22 For example, see: M. de Saintin, 'De Quelques Arts qui s'en vont. (La Gravure au burin, la lithographie)', *GBA* (October 1865), pp. 304–17; for other references, see the reviews and articles in Cadart's journal *L'Union des arts*, and the prefaces and prospectus to the portfolios of etching quoted by Bailly-Herzberg, *L'eau-forte* (1972), vol. 1, pp. 50, 124, 128, 129 (Banville), 266 (Gautier), 268 (Janin); also Druick and Zeger, *Degas* (1984), pp. XV–LXXI.

23 'La gravure et la lithographie à l'Exposition de 1861', *GBA* (second semester 1861), pp. 172–9; 'La gravure et la lithographie au Salon de 1863', *GBA* (second semester 1863), pp. 147–60; 'La gravure et la photographie en 1867', *GBA* (second semester 1867), pp. 252–71; 'La gravure, le bois et la lithographie au Salon de 1868', *GBA* (second semester 1868), pp. 108–22.

24 'Il est impossible que la lutte avec la photographie dure plus longtemps. Or, il n'y a selon nous qu'un moyen: c'est de créer un établissement de chalcographie national analogue à l'Imprimerie impériale ou aux manufactures de Sèvres et des Gobelins, je veux dire entreprenant de vastes travaux sans espoir de rémunération complète.' *GBA* (second semester 1863), p. 159. Here again, Burty has in mind the case of Henriquel-Dupont's engraving after Delaroche. The Louvre maintained a special depository for prints called 'la chalcographie', but this contained only works after deceased painters.

25 'Si les éditeurs renoncent à commander de grandes planches qui exigent des avances de fonds considérables et qui sont contrefaites par la photographie le jour de la mise en vente de la première épreuve, si le public lui-même ... n'orne plus sa demeure d'estampes ... il faudra bien que la gravure devienne un art d'État, comme la tapisserie de la manufacture des Gobelins et les produits céramiques de la manufacture de Sèvres.' *GBA* (1868), p. 110.

26 However, in 1868, he mentioned the private initiative of the Société française de gravure: 'Dans des comptes rendus de Salons, antérieurs à celui-ci et publiés à cette même place, nous avions avancé cette proposition: le seul moyen de sauver en France l'art de la Gravure serait de distribuer aux

graveurs de vastes travaux d'ensemble; d'entreprendre, par exemple, la reproduction des grands travaux décoratifs, anciens ou récents, qui ornent les palais nationaux, les édifices publics ou religieux; d'ouvrir une sorte d'album de cette Ecole française, si visiblement et injustement négligée par la Chalcographie du Louvre, et de faire un choix … dans les oeuvres qui ont traversé le musée du Luxembourg …

Le gouvernement n'a rien tenté de semblable. Cependant la ville de Paris a entrepris la reproduction des peintures murales de ses églises …

Une association d'artistes, d'écrivains et d'amateurs distingués vient de reprendre notre programme et de lui donner un sérieux commencement d'exécution.

Tous nos abonnés ont eu avis de la formation de la *Société française de gravure* … Le succès si rapide de cette souscription a donc prouvé que le but à atteindre préoccupait sérieusement l'opinion publique.' The first plate was engraved by Danguin, a pupil of Henriquel-Dupont. Burty, *GBA* (August 1868), pp. 108–9.

27 See Harrison and Cynthia White's categories, in *Canvases and Careers; Institutional Change in the French Painting World* (John Wiley and Sons, 1965; Paris, Flammarion, 1991).

28 'La photographie … offre aux artistes des matériaux …; elle donne aux curieux qui n'ont point de fortune le moyen de faire à peu de frais des voyages …; à l'antiquaire des reproductions de monuments; au physiologiste des pages anatomiques …; mais jamais elle ne traduira Prudhon comme l'ont fait Roger et Aubry-Lecomte.' 'Exposition de la société française de photographie', *GBA* (1859), pp. 209–21. Although he was a prominent advocate of the etching revival, Burty was able to show a positive response to photography as a medium of visual reproduction, used for documentation as 'indispensable references for those who collect an artist's works', according to his own words: this certainly shows that he was able to shape his responses differently according to both new and old reproductive media in a way that was 'less one-sided – and more positive' than expected (Druick and Zegers, 'Degas', p. XXI). Charles Blanc comes to a similar conclusion, despite his traditionalist bias: his epitomisation of Marcantonio's engravings after Raphael did not prevent him from understanding the etching revival, nor did it prevent him from using photography to illustrate his *catalogue raisonné* of Rembrandt's prints in the pioneering enterprise of a serial monograph published from 1853 to 1858. The folio volume was illustrated with around a hundred photographs. Druick and Zegers have stressed the complexity of the responses to the advent of photography, and underlined that, for instance, Cadart, the printmaker of the *société des aquafortistes*, had started as a publisher of photographs, in 1859, and his partner in 1861 was a photographer.

29 Druick and Zegers, 'Degas', p. xxi.

30 A differentiation which arose slowly and less clearly about lithography in the 1830s; but lithography had a different status, as it was perceived as 'printed drawing' rather than as print.

31 Henri Delaborde (1811–99), initially a painter and a pupil of Delaroche, contributed as an art critic to *La Revue des Deux-Mondes*, in the 1850s, then to *La Gazette des Beaux-Arts*; he was curator of the cabinet des estampes of the Bibliothèque nationale from 1855 to 1885. See *La Promenade du critique influent* (1990), pp. 32–4.

32 'La gravure a donc une double tâche à remplir. Elle doit à la fois copier et commenter la peinture, sous peine d'abdiquer ses privilèges et de se dérober aux conditions de l'art. La photographie, au contraire, ne procédant que du fait, commence et finit avec lui.' Delaborde, 'La Photographie et la gravure', *Revue des Deux-Mondes* (1 April 1856), pp. 617–38, reprinted in Rouillé, *La Photographie* (1989), pp. 228–9.

33 'Contrairement à l'opinion d'Emeric David (*Histoire de la gravure*), nous croyons avec Diderot que la gravure est moins une copie qu'une traduction. Semblable au musicien qui transpose un air, semblable au prosateur qui interprète dans sa langue les poètes d'une langue étrangère en s'attachant avant tout au génie du poème, le graveur qui burine sur le cuivre une peinture en fait revivre l'esprit.' Blanc, *Grammaire*, p. 658.

34 Roman Jakobson, 'Aspects linguistiques de la traduction' (1970 (1963)), p. 80: 'l'équivalence dans la différence est le problème cardinal du langage et le principal objet de la linguistique'.

35 Roman Jakobson, 'Aspects', p. 86.

36 Burty rejected the participation of Mallarmé, whom he had asked for: see Ségolène Le Men and David Scott, 'Philippe Burty et la genèse du livre de peintre: *Sonnets et eaux-fortes*', in Alain Montandon (ed.), *Iconotextes* (Paris, C.R.C.D.-Ophrys, 1990), pp. 39–58.

37 This book is usually considered as the point of departure of the 'livre de peintre', a concept further developed in 1875 in *Le Corbeau*, where Manet and Mallarmé co-operated on the visual and verbal translation of Poe's poem, *The Raven*. See François Chapon, *Le Peintre et le Livre* (Genève, Skira, 1990).

38 The complex position of Charles Blanc has been well analysed by Neil M. Flax, 'Charles Blanc: le moderniste malgré lui', *La Critique d'art en France 1850–1900*, Actes du colloque de Clermont-Ferrand, 25, 26 et 27 mai 1987, réunis et présentés par Jean-Paul Bouillon, CIEREC, (Université de Saint-Etienne, 1989), pp. 95–103.

39 'Marc-Antoine conçoit la gravure comme il la faut concevoir quand on est aux prises avec les grands maîtres. Il la conçoit comme une traduction concise qui met en lumière l'essentiel, qui sait pourtant tout indiquer, tout dire, et qui, privée du langage des couleurs, insiste sur la suprême beauté des contours.' Blanc, *Grammaire*, p. 626.

40 I am grateful to Stefan Germer for this development linked to his lecture on the *Tableaux du roi* in the Centre d'étude de l'écriture (Université de Paris 7).

41 'Les traductions sont d'autant plus belles qu'elles sont plus personnelles, et par cela moins fidèles ...; la photographie est impersonnelle; elle n'interprète pas, elle copie.'
 'Feuilletez au Cabinet des estampes l'oeuvre des innombrables graveurs de Raphaël, vous verrez que des plus illustres ne se sont passionnés que pour une des faces de ce génie multiple. ... Tous, à leur insu ... n'ont fait que mettre au jour leur personnalité intime. Burty, *GBA* (1859).

42 'Au couple *je/tu* appartient en propre une corrélation spéciale que nous appellerons, faute de mieux, *corrélation de subjectivité*.' 'L'emploi de "nous" estompe l'affirmation trop tranchée du "je" dans une expression plus large et diffuse: c'est le nous d'auteur ou d'orateur'. 'D'une manière générale, la personne verbale au pluriel exprime une personne amplifiée et diffuse',

Emile Benveniste, 'Structures des relations de personne dans le verbe', *Problèmes de linguistique générale* (Paris, Gallimard, 1966 (1946)), pp. 232 and 235.

43 'Enfin et surtout, que l'on donne à reproduire nos maîtres français et contemporains. L'histoire de tout le passé est là pour le prouver; les peintres ne sont bien traduits que par leurs contemporains: Raphael par Marc-Antoine, Rubens par Bolswert, Poussin par Jean Pesne, Watteau et Chardin par les Cochin, Prud'hon par Roger et Copia etc. Qui donc, de nos jours, s'est franchement attaqué à Géricault? avons-nous, en-dehors de quelques crayons de M. Calamatta, la partie importante et faisant poids de l'oeuvre de M. Ingres? les travaux décoratifs de M. Eugène Delacroix ne sont-ils pas dignes de quelque intérêt? Les tableaux de M. Meissonier n'appellent-ils pas le burin d'un artiste qui s'y consacrerait tout entier? La génération suivante ne verra peut-être de ces maîtres que leurs faiblesses. En tout cas, elle interprétera dans son sentiment propre leurs qualités et leur prêtera inévitablement le reflet de son propre idéal. ... Cherchons donc enfin à léguer à nos neveux, par la gravure, les aspirations de nos contemporains.' *GBA* (1863), p. 160. Five years later, Burty goes back to the same idea: 'Rubens, Watteau, Prud'hon ont bien trouvé autour d'eux des graveurs qui ont dégagé la dominante de leur effet, de leur dessin, de leur couleur, de leur sentiment. Pourquoi Géricault, Eugène Delacroix, Decamps, n'en feraient-ils pas naître dans cette génération si critique et si indépendante, si apte à tenter les voies nouvelles? Mais il faut pour cela des encouragements effectifs'. *GBA* (1868), p. 110. For Burty, these encouragements belong to the State as well as the critics and the publishers.

44 Charles Clément's first article on Géricault in the *Gazette des Beaux-Arts* of June 1866 is but one example of this.

45 This aim was explicit in the press and the illustrated book of the July Monarchy, when for instance *Les Français peints par eux-mêmes* wanted to leave for posterity a self-portrait of the society; it belongs for instance to the writings about Gavarni, especially by the Goncourt brothers in 1873. The same argument is developed about caricature by Jaime, Champfleury, Dayot, and, later on, about the 'vieux papiers, vieilles images' by John Grand-Carteret.

46 'Ceci tuera cela'; this phrase was added in 1832 to the novel published two years earlier.

47 '*Ceci tuera cela*, murmure un des personnages du poète. La photographie tuera la gravure, pouvons-nous dire avec non moins de certitude. Oui, le jour est proche où les graveurs au burin ne seront pas plus nombreux qu'après le XVè siècle ne le furent les scribes et les enlumineurs de manuscrits. Niepce et Daguerre auront été, à leur façon, les Faust des temps nouveaux. Leur invention, à la fois si merveilleuse et si imparfaite, ne répond que trop bien aux besoins d'économie et de rapidité de notre époque. Que la science, demain, donne à l'héliographie le moyen de reproduire les tons, au moins dans leurs rapports d'intensité lumineuse, et le dernier buriniste, quel que soit son génie, n'aura plus qu'à briser son burin, jugé inutile et trompeur par une génération affolée d'exactitude littérale', Philippe Burty, 'La gravure et la lithographie au Salon de 1863', *GBA* (second semester, 1863), pp. 147.

48 In the evocation of its birth and of each new invention, especially lithography, the inventor of which, Senefelder, was often spoken of as a 'new Gutenberg'.

49 'Coïncidence merveilleuse! la gravure, qui est l'imprimerie des beaux-arts, fut découverte au moment où on inventait l'imprimerie, qui est la gravure des belles-lettres. Le moyen de populariser les oeuvres de l'artiste naquit dans le même temps que le moyen de propager les pensées du poète ou du philosophe.' Charles Blanc, *Grammaire des arts du dessin*, Renouard, 1883 (1880), p. 617.

50 'Bien que l'eau-forte ... soit peu propre à rendre, avec le soin nécessaire, les toiles importantes, peut-être traduirait-elle avec plus d'accent la fierté de la peinture de M. Eugène Delacroix'. 'Si la gravure au burin semble en ce moment témoigner d'un certain engourdissement, l'eau-forte au contraire, cette soeur cadette de la peinture, suit cette année la jeune animation de son aînée'. *GBA* (second semester, 1861), p. 174.

51 However, reproduction was not the major aim of 'painters-etchers' who promoted original etching: the artists themselves left the way free for the art critic. Their own reproductive etchings eventually became identified with art criticism when they were issued by the art journal who fought the battle on their side, the *Gazette des Beaux-Arts*, to which Burty was appointed, and where the etcher Armand Gaucherel was the artistic director.

52 'Traduire les maîtres, n'est-ce pas avant tout interroger leur pensée, s'inspirer de leur volonté et les suivre avec passion dans leur recherche particulière de l'idéal?' *GBA* (second semester, 1863), p. 148.

53 'L'académisme outré de l'école de l'Empire a rompu violemment la tradition de cette école du XVIIIè siècle, sans laquelle nous ne connaîtrions qu'à demi Watteau et Chardin. ... le triomphe de l'outil sur l'esprit n'a été que trop complet depuis, et notre école a plus que jamais besoin de se retremper aux sources vives de la liberté'. *GBA* (second semester, 1863), p. 148.

54 'Il est certain que l'aspect vivant, coloré, imprévu, varié, des estampes du XVIIIè siècle, est dû surtout à l'excellence des préparations à l'eau-forte. Or, l'eau-forte est le trait d'union entre la peinture et la gravure. L'ébauche doit être tracée de main d'artiste, et par "artiste" j'entends toujours désigner celui qui obéit immédiatement à l'inspiration'. *GBA* (second semester, 1863), p. 148.

55 'La génération nouvelle ... a compris tout ce que ce moyen offrait des ressources pour la traduction rapide et suffisante de la pensée et du sentiment'. *GBA* (second semester, 1863), p. 151.

56 Blanc relates the discovery of Rembrandt's etchings as the reason for his entry into the studio of Calamatta and Mercuri: 'These prints had taken such hold upon my imagination that I desired to learn, from Bosse's "Treatise", how the Dutch painter had managed to produce his strange and startling effects and his mysterious tones, the fantastic play of his lights and the silence of his shadows'. 'Letter from Charles Blanc', Maxime Lalanne, *The Technique of Etching* (1866), 2nd ed. 1878 (New York, Dover Publications, 1981), pp. XXV–XXVI.

57 Lalanne, *The Technique of Etching*, p. 6.

58 Cazalis wrote this letter to his friend Mallarmé: 'Deux mots. Tu me vois fiévreux ... Samedi, quand je suis arrivé avant un sonnet fort beau de Lefébure, Lemerre m'a répondu que Burty, l'imprésario de cette affaire, avait maintenant plus de sonnets que d'aquafortistes, et n'en accepterait

plus, fût-il un sonnet de Dieu lui-même. Je lui ai répondu qu'il était un sot, que son volume serait aussi ridiculement fait que *Le Parnasse*, qu'il était absurde de confier à Burty les clefs du royaume de saint Pierre, quand ce Burty n'était ni aquafortiste ni poète; enfin, je lui aurais volontiers cassé ma canne sur le dos, si sa femme n'était pas enceinte. N'importe, je reviendrai à l'assaut.' Stéphane Mallarmé, *Correspondance*, vol. 1 (1862–71) (Paris, Gallimard, 1959), p. 281.

6

The depoliticisation of Gustave Courbet: transformation and rehabilitation under the Third Republic

LINDA NOCHLIN

Two quite different pursuits lead to the place from which to contemplate the late-nineteenth-century 'rehabilitation' of Gustave Courbet. The first is my ongoing investigation of Courbet within the framework of those issues of realism that were his concern. The second is a meditation on the questions feminism poses for art history and theory: the pair, of which one part is 'Why have there been no great women artists?' and the other, its corollary, 'Why *have* there been great male ones?' Why has this entity, the great artist, existed at all, in short? And more specifically, what configuration will the notion of the great artist have at given moments in history? How is this entity 'the great artist' constructed? And to what purposes? What political needs, what psychological yearnings, what ideological functions, does such a notion serve? And more concretely, how was a former Communard, an exile, a still-controversial and prickly painter like Courbet transformed, during the decade between 1879 and 1889, into something approaching a cultural hero of the Third French Republic?

The steps in Courbet's actual rehabilitation are easy enough to follow and have been succinctly outlined in the current literature.[1] In 1877, a year before his death, Courbet was still in official disfavour, in exile in Switzerland, as a result of his participation in the Commune, and more to the point, his supposed responsibility for the destruction of the Vendôme Column. As late as 26 November 1877, a little more than a month before the artist's death, the court-ordered sale of his works for payment of the reconstruction of the column brought in, altogether, the derisory sum of 10,000 francs. Courbet died on New Year's Eve of 1877, on the uneasy brink of the Republic of the Opportunists, a year before MacMahon was replaced by Jules Grevy, a veteran of 1848, a year before the republic was actually controlled by the republicans.

In 1878 Courbet made a minor showing at the Exposition Universelle and a far larger one at the Retrospective Exhibition

of Modern Masters at Durand-Ruël, where he was represented by thirty works. But it was not until 1881–82 that a more definite and official blow for the rehabilitation of the artist was struck with the brief ascension of Gambetta and the left wing of the Opportunist Republicans to power, and the creation of a Ministry of Art, with Antonin Proust, the boyhood friend of Manet, at its head. It was during this period that Courbet's family donated the *Burial at Ornans* to the Louvre, and the state and the city of Paris bought five major works for a price of 150,000 francs, an impressive sum. It was during this period, too, that the critic Jules Castagnary, friend and supporter of the painter, Courbet's family, and the government got together to organise a major exhibition of his works at the Ecole des Beaux Arts, an exhibition sanctified by the approving presence of the president of the republic himself.[2] By 1889 Courbet was quite literally enshrined within the great tradition of French art in a major republican celebration of that tradition: eleven of his works were featured in the Great Centennial Exhibition of One Hundred Years of French Art at the Paris World's Fair of 1889, an exhibition celebrating the hundredth anniversary of the Revolution.

These, then, are the basic facts of Courbet's promotion to the ranks of greatness: it is the how and the why of this promotion which is of more interest. Both the goals and the strategies of the reconstruction of Courbet need to be examined through several critical texts from this period, texts that both justified and at least to some degree prompted this new republican interpretation.

In the years from 1878 to 1889 there seem to have been three main tasks, all of them interrelated, facing Courbet's republican reconstructors. First, and perhaps most urgent, Courbet had to be definitively separated from his politics. Not, of course, from his wholesome and sympathetic interest in the peasant and the popular subject, which was – within certain limits of decorum – laudable, and even necessary to republican ideological stragegy.[3] But more specifically he had to be detached from his all-too-well documented participation in the Commune – a terrible thorn in the side of the supporters of the Republic of the Opportunists – and from his equally notorious responsibility for the destruction of the Vendôme Column.

Secondly, Courbet's practice and his production had to be firmly attached to the realm of nature. In all the republican critics we will be concerned with, a dichotomy is established between the sociopolitical and the natural. Externalised, this dichotomy is envisioned as an opposition between his subject paintings of the 1850s (seen as bad or, at best, as limited) and his later landscapes, hunting

scenes, nudes, and still-lifes (seen as poetic, expansive, more universal). Internalised, it is posed as an opposition between the 'natural' Courbet, the creature of pure intuition and 'unerring instinct', and what one might be tempted to call the 'corrupted' or 'fallen' Courbet, the Courbet who misguidedly attempted to make choices or formulate theories, to participate – in short – in history.

And third, these critics, Castagnary especially, attempt to transform Courbet into a suitable great artist by inserting him into the ongoing, uninterrupted tradition of great art – great French art above all – in a ploy that is at once aesthetic and nationalistic, elevating and neutralising. The Courbet of 1889 has been assimilated to the pantheon of national artists who shed glory on the republic. In so doing, Courbet is, like his predecessors, transformed into a kind of commodity – a French tourist attraction, as it were – and hero at once.

One hundred years after Courbet's birth, Théodore Duret, journalist, art critic, long-time republican, supporter of Manet and the impressionists, could state with complete assurance: 'Today, in 1918, Time has made its action felt. Courbet the political man has vanished from our attention; the passing judgments brought to bear on his works by his contemporaries are forgotten. The works themselves remain in all their power.' But in the early days of the Third Republic, the case was less clear-cut. One could not eradicate the memory of the political Courbet quite so easily. In 1878, the year following Courbet's death, when the artist becomes the object of history, so to speak, rather than an agent still acting upon it, the situation was less assured; the political Courbet, Communard and fabled destroyer of the Vendôme Column, was still a living memory. Nor had the works themselves yet been recuperated, bought by the nation, exhibited at the Ecole des Beaux Arts. In 1878, the artist was, if no longer among the living, still problematic. His status as a Communard could not so easily be dismissed in the years preceding the General Amnesty of 1880, years in which the questions of whether Communards should be forgiven and to what degree were still much debated.

In 1878, three relatively serious studies of the recently deceased artist appeared, two in the form of books, by Camille Lemonnier and by the Comte d'Ideville, and one book-length, three-part article in the *Gazette des Beaux-Arts* by Paul Mantz. Mantz, one of the *Gazette*'s most active writers, had been a government administrator in a minor capacity under the Second Empire and was finally but briefly promoted to the post of Director General of the Beaux Arts in the early 1880s, under the Republic.[4]

The first two studies can be disposed of fairly easily; Mantz's work, more ambivalent and complex, deserves more detailed analysis. But what seems clear, first of all, about all three – ranging in tone as they do from the sceptically positive to the positively ecstatic – is that they are as anxious as Duret to detach their version of Courbet as effectively as possible from the taint of the political. D'Ideville's strategies are fairly simple-minded. He admits that Courbet's politics are indeed interesting, and goes so far as to devote a whole chapter to 'Courbet homme politique', but ends up by completely discounting Courbet's political activities and ideas on the grounds of the artist's total incapacity in that realm. 'If we have a deep admiration for Courbet the painter; if, despite its faults, we place the author of the *Covert of Roe Deer* in the ranks of the greatest artists of our century, we must admit with no less sincerity that Courbet, as a philosopher, as a moralist, and as a politician, seems to have been a simple idiot. ... Politics,' d'Ideville declares, as though this were a self-evident proposition, 'has nothing to do with art. ... Even if he actually took down the [Vendôme] Column, which he denies, the friend of Proudhon has nevertheless painted – and it is both his glory and ours – the *Covert of Roe Deer*, the *Stags at Bay* ..., which will be the glory of our museums.' In his clumsy way, d'Ideville has effectively, if unconsciously, set about the task of 'professionalising' the artist by declaring that his is a very specialised realm of competence; by the same token, his very proficiency as an artist is what renders him incompetent in any other areas of expertise – the political above all.

What is it that saved Courbet the painter from what d'Ideville terms these 'pernicious influences', that is to say, complex or political ideas, and made him the marvellous interpreter of nature that he in fact was? Nothing else but Courbet's unique intuitive powers, or what d'Ideville terms 'une intuition de paysan contemplateur.' Courbet's intuition, like his political naïveté, becomes an article of faith of Third Republic Courbet hagiography, an essential feature of the 'difficult but talented' artist. More than once, Camille Lemonnier reiterates this notion of the instictive Courbet: 'Courbet was an instinct more than a brain' and 'he painted things as they are, with a dumb instinct which had something of genius in it'. Paul Mantz, who from the start insists upon Courbet's faulty intellectual culture, declares that for him 'many things remained in a state of instinctuality'.

Mantz's entire formulation of Courbet is marked by a kind of irritated or regretful ambivalence. He begins what is after all an extended obituary notice not with the expected encomium, but with a put-down, a long, rambling account of the artist's exaggerated

opinion of himself: 'Courbet s'est follement aimé.' By privileging the notion of Courbet's overweening pride, Mantz achieves two things. He distances himself and, by implication, his readers, from his subject; and he prepares the ground for the artist's eventual downfall: Courbet's hubris serves to justify his future punishment. Throughout, although Mantz expresses sympathy and admiration, he at the same time emphasises formal flaws and missed opportunities. If in 1851 Courbet seemed to be the ideal opponent of the modish insipidness of the time, he aroused hopes that to a large measure remained unfulfilled, hopes that he would be an artist of poetry, of feeling, an artist who might have expressed the pathos of the life of the poor and disinherited, a kind of Octave Taessaert writ large, as Mantz put it, or, to borrow another his phrases, 'un Shakespeare de la rue Mouffetard'.

But such, alas, was not to be. Courbet was not the long-awaited poet. It is around the words *poet* and *poetry* that Mantz's invention of Courbet begins to intensify. Mantz worries the notion of poetry like a dog with a bone. He is never quite sure where the artist stands in relation to poetry, or to put it another way, where he is going to make his version of Courbet stand in relation to it. The reconciliation of Courbet with poetry might at first seem like an impossible dream, Mantz admits, but, nevertheless, he maintains, in Courbet's best work of the later 1850s and sixties, above all in his landscapes and seascapes, the impossible occurs: Mantz's Courbet becomes a poet in spite of himself. He literally falls under the spell of poetry, the seductress. 'At the very moment when the artist proclaims himself the humble translator of external spectacles and objective realities, he invariably adds, often without realising it, something that he takes from his own thought.' This personal feeling, this legitimate exaggeration, is his concession involuntary made to the ideal. 'Courbet', Mantz concludes, 'railed against poetry just when he submitted to her adorable despotism'.

Courbet's practice, or at any rate a certain part of it, can be summed up to contravene his foolish theories, his fatal manifestos, his misguided participation in the Commune, which Mantz slides by so discreetly that we hardly realise what he is talking about, excusing himself all the while by saying that such 'events' (as he calls them) are simply outside the framework of his habitual competence. Rather, it is only in contact with nature that this unconscious, seductive, but redeeming poetry finds its best expression in Courbet's work – and, one might add, that Courbet's political theories, his awkward notions of subject-matter, and what Mantz thinks of as his errors in taste and construction are most notably absent.

'What is best in the work of Courbet', Mantz concludes, waxing rather poetic himself, 'are his landscapes, his green valleys of the Franche-Comté, his rocks carpeted with grey moss, his wooded interiors where hidden streams flow, and, above all, his blond banks of the Mediterranean or the Atlantic, where, in the midst of fiery redness, the sun sinks slowly into the infinity of the sparkling sea.'

These themes, sounded by the proto-republican writers of 1878, are taken up and developed with far greater range, depth, and sophistication by Jules Castagnary in his biography of Courbet, left unfinished at the time of the critic's untimely death in 1888.[5] Castagnary was a long-time republican, friend and defender of Courbet in the disastrous aftermath of the Commune; and, for a brief period from 1887 until his death in May 1888, director of the Beaux Arts under the ministry of Eugene Spuller. His fragmentary study of Courbet can only be understood in the context of the writer's other critical efforts at the time.

First of all, Castagnary's construction of Courbet must be interpreted in the light of his ongoing attempt, throughout the 1860s, to establish France as the pre-eminent artistic nation of the time on the basis of her achievement in landscape, which he held to be the most progressive form of painting. Second, and more materially, Castagnary's vision of Courbet in the later 1880s must be seen against the critic's engagement in the plans for the great exhibition of 100 years of French art that he had conceived to celebrate the centennial of the French revolution. Castagnary's Courbet, then, must be located in the context of the biographer's ongoing engagement with landscape as both French and progressive, but even more particularly, with the critic's attempt to create a continuous French – specifically a post-revolutionary republican French – tradition.

His account begins with a simple statement of origins in which the national and the natural aspects of his subject neatly coincide. 'Gustave Courbet was born on 10 June 1819 in Ornans, a little town of the Franche-Comté in the valley of the Loue. No other territory seems to have been as well prepared as this to be the cradle of a painter. The picturesque abounds there.' Courbet, Castagnary maintains, comes from a region at once profoundly rooted in French traditional culture and unparalleled in its richness and variety of natural beauty.

For Castagnary, Courbet's realist masterpieces of the early 1850s were great achievements, expressions of contemporary life rooted in his Franc-Comtois heritage, devoid of any conscious or overt political overtones. Of Courbet's three major offerings to

the 1851 Salon, the *Burial at Ornans, The Peasants of Flagey Returning from the Fair*, and the *Stonebreakers*, Castagnary declares, 'One might have said that these were a fragment of the Franche-Comté detached from that robust province and transported to Paris.'

Yet it is clear that the critic's heart is with the later works, the landscapes above all. His Courbet, the hero of that French tradition he is in the process of constructing, must be something more than a mere regionalist; he must have ambitions on a national scale. To use Castagnary's own words, 'The Franche-Comté is not all of France, popular customs are not all customs. Courbet, without abandoning his ideas in any way, felt the necessity of enlarging his frame of reference.' What Castagnary means by 'enlargement' is Courbet's turning away from concrete subjects taken from contemporary life to a more diffuse, varied, and, although Castagnary never says it in so many words, a less politically provocative kind of subject. 'Without exactly fleeing humanity, [Courbet] now considered to a greater extent the sky and the sea, leafage and snow, animals and flowers. He loved them with a particularly tender feeling.' Courbet's abandonment of his earlier projects, the depiction of contemporary, popular subjects, Castagnary breathlessly mythologises as a fantastic voyage of discovery into the mysteries of nature, a *symboliste* journey into an invigorating realm of the unknown:

> Avid to see and to penetrate the world open to his observation, he had in his quest the happy surprises of the ancient navigators: he discovered virgin territories where no one had yet set foot, aspects and forms of landscape of which one might say that they were unknown before his arrival. He climbed free heights where his lungs could expand; he plunged into mysterious caves; he was curious about unnamed places, unknown retreats. Each time he plunged thus into the deep bosom of Nature, he was like a man who has gone through a beehive and comes out of it covered with honey; he returned weighed down with perfume and poetry.

The penetration of the unknown and of nature, the transformation of nature into landscape – these are Courbet's triumphs, and poetry the prize of this mythic daring. *Poetry* – once more this word comes to the fore in the Third Republic's image of Courbet. If Mantz's Courbet, the Courbet of 1878, had been a painter plagued by weakness, who from time to time succumbed to the lure of poetry more or less in spite of himself, Castagnary's Courbet is a painter for whom poetic sensibility is a defining virtue. An exquisite sensibility, an incomparable technique, with these, 'Courbet has made a new stream of poetry gush forth', declares the critic.

Yet even this is not enough to justify Courbet as a great painter, an artist hero of the Third Republic. To complete his project, Castagnary feels another step must be taken. Courbet must be made secure not merely within the feminine bosom of nature but within the more masculine precincts of tradition – French tradition above all. To secure tradition for Courbet and Courbet for tradition, however, Castagnary must temporarily abandon his Courbet the poetic landscape painter, and return to the earlier Courbet, the pictorial translator of the social realities of his time.

Having established firm historical precedents in the Dutch school of the seventeenth century, in the German Holbein, and the Spaniard Velásquez, all of whom, like Courbet, represented the society of their times with unmediated veracity, Castagnary turns to the tradition of France itself, above all, that established by the major artists of the preceding hundred years. In his penultimate paragraph he calls forth that grand procession of painters of living history in which his Courbet will now take a place. Castagnary calls the roll with rhetorical questions: 'Did not Louis David look for truth above all, when, seizing the events of his time, he sketched the *Oath of the Tennis Court* and captured on canvas the portrait of the murdered Marat?' 'And Gros?' he continues, 'Has there ever been anyone more taken with contemporary events, more in love with the human spectacle? The whole society of his time lives again in his painting. And Géricault?' Castagnary demands, 'In what path was he going when death stopped him? Is not the *Raft of the Medusa* a simple *fait divers de journal* writ large, dramatised, and translated into painting by means of the most eloquent of compositions?' Courbet's art is authorised by precedents at once national and revolutionary, in the broadest sense of the term. By this process, innovation itself can be justified by precedent, daring assimilated to the best of tradition and transformed from contemporary scandal into cultural contribution.

I might say, parenthetically, that, of all the strategies employed to transform the ambiguous Courbet of the pre-republican period to Courbet the culture hero of 1889, the strongest and most enduring is the one based on the premise that there is in fact an ongoing and continuous stream of great art with which the artist can be fused. This is that same tradition that Harold Bloom has recourse to in his formulation of the great (male) writer, and the lack of which Virginia Woolf postulated as equally responsible for the difficulties faced by his female counterparts when, in *A Room of One's Own*, she declared, 'But whatever effect discouragement and criticism had upon their writing ... that was unimportant compared with the other difficulty which faced them when they came

to set their thoughts on paper – that is that they had no tradition behind them, or one so short and partial that it was of little help.' Nor is the avant-garde by any means immune to the blandishments of tradition when it comes to asserting their claims to greatness. It was Guillaume Apollinaire who, in 1912, established the pedigree of cubism as a valid art by declaring that 'Courbet was the father of the new painters', as though this recourse to the tradition of French art, albeit a revolutionary tradition, in some way justified the new movement.

To return to Castagnary's account of Courbet, it is not so much that the critic, a good, leftish republican, eliminates Courbet's politics from his painting in his account of the artist, but that he neutralises it. For Castagnary's Courbet was not being outrageous when he painted his *Stonebreakers* or his *Burial at Ornans*, he was simply following something called the dictates of the times: he could hardly have done otherwise. 'Certainly,' Castagnary asserts, 'in 1848, at the time when Pierre Dupont rimed the miseries of the workers and when George Sand wrote *La Mare au diable*, there was nothing excessive in the fact that a painter, born of the people, republican by custom and education, took for the subject of his art the peasants and burghers of the milieu in which his childhood had unfolded. The humility of his subjects in no way militated against their aesthetic value; the important thing was to treat them with force and seriousness. In painting them on a natural scale, in giving them the force and character which had hitherto been reserved for gods and heroes, he created an artistic revolution.' So much for Courbet the political painter. This is the Courbet of the survey of art history and of canned culture. With very few changes, Castagnary's paragraph could serve as the catalogue introduction for a present-day Courbet exhibition without attracting any particular notice. Castagnary's construction of Courbet is not so far from what one might term the contemporary 'mainstream' view of Courbet.

But what of Courbet the political activist of recent memory, his undeniable participation in the Commune, his implication in the destruction of the Vendôme Column?[6] Castagnary first of all dulls the effect of Courbet the Communard by carefully embedding his brief account of the matter in a more general one of Courbet's patriotic activities during the defence of Paris that preceded it and the unjust severity of the punishment that followed. This technique resembles that of the child who disguises the taste of a particularly unappetising morsel of food by embedding it in a heavy coating of mashed potatoes.

In the second place, Castagnary effectively detaches Courbet from his own political activity by constructing Courbet the

Communard entirely in the passive voice. The Commune, by implication, was simply something that happened to poor, unwise Courbet. 'Named member of the Commune in the complementary elections of April 16,' Castagnary explains, 'he did not have the wisdom to decline this mandate. ... After the taking of Paris by the troops of Marshal MacMahon, he was arrested, led a prisoner to Versailles, and included in the general accusation which weighed on all the members of the Commune, accused more specifically of having toppled the Vendôme Column.' With this latter issue, Castagnary breaks out of the passivity of historical apologia into contemporary indignation. 'The Vendôme Column!' Castagnary explodes. 'He was as foreign to the affair as you or I.' And Castagnary has the documents to prove this. There follows an account of Courbet's trial, his imprisonment, the wild exaggeration of his fine, and his exile, followed by the assertion that concludes Castagnary's discussion of the political Courbet: 'With his death, hatreds and rivalries are obliterated and justice, which was silent, rises to formulate the indisputable judgment.' What Castagnary means, of course, is that Courbet the artist has been redeemed by history, while Courbet the Communard has conveniently been forgotten. The Commune, then, was simply something that happened to poor, naïve Courbet, his complicity in the destruction of the column simply part of a plot on the part of the closed-minded and the envious to discredit – and ultimately, to destroy – the artist.

In a way, this sounds like a credible account. It goes along with the Courbet we have become familiar with during the course of this text – a countryman, not too bright, a powerful observer and recorder of peasant customs, a poet deeply involved with nature and intuitively capable of transforming it into substantial art, gullible, enamoured with his own not too clear-headed ideas, quick to fall under the sway of political agitators – a marvellous, mindless artist who unwittingly got himself into trouble.

This sounds like the truth and seems to be supported by a certain amount of evidence. Or, at the very least, one might say that it is the consensus of Courbet's supporters in the first decade following the artist's death. Yet not quite. Before we accept this as a balanced view of Courbet, we should at least become aware that other views – positive views, that is – were possible. We should realise that another Courbet could be articulated in 1878, a very different one from any of those we have been considering: a Courbet for whom the experience of the Commune was central, a Courbet whose political and artistic practice were seen as inseparable – two sides of a single being, rather than

opposing tendencies. This is the Courbet of Jules Vallès, novelist, journalist, and fellow Communard, who wrote about his Courbet a week after the artist's death, on 6 January 1878, under the name Jean de la Rue, when Vallès himself was still in exile in England.

In Vallès's account of Courbet, it is the Commune that provides the controlling imagery for Courbet's achievement. Far from trying to detach the artist from his political activism, he centres his Courbet within it. He begins his obituary notice solemnly, with the column itself: 'The Column has lost its hostage; the one who had to pay the damages.' Nor is the image of Courbet he creates that familiar one of the passive, bumbling political naïf, but rather, of a lucid participant. 'Man of peace, thrust into battle, he looked for the blow he could strike without any arms', Vallès explains. 'He who painted the *Spinner*, the *Stonebreakers*, the *Burial at Ornans* inevitably had to be – the day when he had to choose – on the side of labour, poverty, and paving stones.' Unlike Castagnary, who spares no effort to exonerate Courbet in the affair of the destruction of the Vendôme Column, Vallès credits him with participation in the event. 'Poor mad man,' says Vallès ironically, 'you don't attack bronze fetishes with impunity.' But no, he goes on, 'He wasn't so crazy; he knew perfectly well what would happen to him. The day that the Column was toppled, he was there, at the *Place*, with his twenty-sou cane, his four-franc straw hat, his ready-made overcoat. ... "It'll crush me as it falls, you'll see!" he said, turning to a group of friends.'

If Vallès's Courbet, like Mantz's and Castagnary's, is a man of nature, it is a very different relationship of artist to nature that Vallès projects. If for Courbet's other biographers, Courbet the nature lover, the painter of landscapes, the countryman is constructed as the redemptive antithesis to Courbet the man of the left and of political scandal, for Vallès, nature is firmly united with the political. In Vallès's final peroration, the final paragraph of his obituary for a dead friend, nature itself is politicised, swept up into the élan of the vanished Commune:

> He crossed the great streams; he plunged into the ocean of the crowds; he heard the heart of a people beat like the thuds of a cannon; he ended up in the heart of nature, in the midst of trees, breathing the scents which had intoxicated him in his youth, beneath a sky unstained by the fumes of great massacres, but which tonight, perhaps, set ablaze by the setting sun, will spread itself out on the house of the dead man like a great red flag.

Finally, far from trying to aggrandise his Courbet by inserting him into a great tradition, Vallès explicitly cuts his artist off from

it: his Courbet was a 'deserter' who boldly rejected the barracks of established art, and was singled out for punishment because of that. 'The pistol shots that are fired against tradition, even when the barrel of the pistol is a paintbrush, disturb the tranquility or the servility of those who lick their fingers over paintings, who lick their fingers over ministers', declares Vallès. This shooting against tradition irritates even the independent spirits, who, although they may be worthy in the face of people, are cowardly when it comes to theories. If Delacroix had been alive, would he have saved Courbet from execution, if Courbet had started to say, with his coarse laugh, speaking of the Louvre ceiling, or the frescoes of Saint-Sulpice, of the *Entry of the Crusaders into Constantinople*, 'You actually knew them, then, you, Apollo, and Saint Thingamabob and Jesus Christ?' The bourgeois, Vallès concludes bitterly, are more pitiless than the soldiers. Not for Vallès the easy connection of Courbet with an existing tradition of great art. On the contrary, it is Courbet's difference, his irrevocable disjunction even from the most innovative achievements of the recent past that arouses Vallès's admiration and sympathy.

If I have cited Vallès's text last and at length, it is not because it is 'right' and the others 'wrong', but rather to indicate that like his the others are selections, constructions, based on an ultimately limitless material; that the 'facts' in each case are chosen; that the vision of the artist embodied in each text, far from being a mere recounting or commonsense description, is to a greater or lesser extent a work of creation, like a short story or a novel but with different intentions, strategies and premises. Vallès's text, then, must not be taken as an antidote but rather as an alternative, the alternative of an outsider, a *réfractaire*, an alternative that, however, sets the basically constructed and ideological character of all the other accounts of his time into the sharpest possible relief.

At the present time, when the artist's biography is introduced more and more to explain the work of art, it is interesting – if not particularly original – to consider how the artist's biography, or rather the texts that set forth the artist, are no more privileged as empirical givens – as a species of raw data – than the art works themselves that such texts are called on to explain. Rather, they are complex constructions. Artists' biographies must be considered as artistic creations, mediating the various ideological and psychological positions of those who create them.

Notes

1 See Jean-Pierre Sanchez, 'La Critique de Courbet et la critique du réalisme entre 1880 et 1890', *Histoire et Critique des Arts*, vols 4–5 (1977–78), 78–9, for a summary. My interpretation of this criticism is somewhat different from that of Sanchez.

2 Théodore Duret, *Courbet* (Paris, Bernheim-Jeune, 1917), pp. 117–18. All other citations of Duret refer to this text.

3 This strategy must, of course, be understood within the context of the more general goals of the early Third Republic, especially those of its liberal wing, dominated by the figure of Gambetta. The government was intent on maintaining a coalition among the economically dominating *haute bourgeoisie*; the more recently created, upwardly mobile middle bourgeoisie, the so-called *nouvelles couches*; and the peasantry through the creation of a cultural front at once aggressively secular, popular, and progressive, spiced with a certain democratic combativeness, yet at the same time bearing the promise of social and political stability to a nation recently shaken by conquest and civil strife. Both the democratic aspirations and the craving for stability and order were reinforced by nostalgia for the sturdy virtues of French provincial tradition, the vanishing strengths of the *menu peuple* of the countryside, at the very moment when this population was deserting the country for the city.

4 These studies are: Camille Lemonnier, *G. Courbet et son oeuvre* (Paris, 1878); Henri d'Ideville, *Gustave Courbet, notes et documents sur sa vie et son oeuvre* (Paris, 1878); and Paul Mantz, 'Gustave Courbet', *Gazette des Beaux-Arts* (1878); Part I: (t. XVII), pp. 514–27; Part II: (t. XVII), pp. 17–30; Part III: (t. XVII), pp. 371–84.

5 [Jules] Castagnary, 'Fragments d'un livre sur Courbet', *Gazette des Beaux-Arts* (1911): Part I (January), 5–20; Part II (December), 488–97; Part III (1912) (December), 19–30.

6 Castagnary had explicitly exonerated Courbet from all responsibility in the Vendôme Column affair in his pamphlet, *Gustave Courbet et la Colonne Vendôme. Plaidoyer pour un ami mort* (Paris, 1883).

7

Reinventing Edouard Manet: rewriting the face of national art in the early Third Republic

MICHAEL R. ORWICZ

In the months following Edouard Manet's death in 1883, his reputation as one of the artists most influential on the development of modern French painting was well on its way to being 'officially' secured. In January 1884, the first major retrospective of his work was staged, along with the usual mechanisms of cultural legitimation – an exhibition catalogue, a monograph and the reviews that followed. This provided writers, critics and arts administrators associated with the liberal and moderate factions of the newly consolidated Republican ruling bloc with the occasion to inscribe Manet into the history of an emerging 'national art' and Republican culture. While the precise contours of that art and culture remained highly contested among this heterogeneous group of writers, critics and administrative personnel, the consensus was that Manet's achievement would be crucial.[1] Yet, in the discursive process of 'officialising' Manet, a series of strategies were to be played out. Manet's supporters, both liberal and moderate, needed to reformulate his career. They had to reappraise his work in ways that directly countered the image that the conservative opposition critics produced of the artist as a scandalous *rapin*: the Manet of the *Déjeuner sur l'herbe* and the infamous *Olympia*.[2] In other words, the 'official' Manet had to be domesticated and his achievement reinvented. But this procedure was itself subject to numerous divisions that fractured his supporters' consensus. What emerged in the discourses of Manet's 'Republican' supporters then, was a Manet rewritten according to one of two different scenarios, themselves underpinned by the problem of how to define his achievement and interpret the nature of his role in the development of modern French painting.

I

There can be little doubt that the exhibition canonising Manet was designed to have strategic impact in the broader spheres of cultural politics. Organised by a committee headed by the liberal Republican deputy and arts administrator Antonin Proust, Léon Gambetta's ex-*Ministre des Arts* and Manet's lifelong friend, the retrospective was given official government sanction by the Republic's minister of education and fine arts, who personally intervened in securing the strategic exhibition space: the main gallery of the Ecole Supérieure des Beaux-Arts, still the Academy's cultural and educational stronghold.[3] The Ecole's exhibition roster for that year was devoted almost entirely to shows that either reinforced Academic standards or shored up the Ecole's educational principles.[4] This was, in fact, precisely the argument with which the Ecole's director countered the minister's request to exhibit Manet's work, along with some of the other shows that the minister proposed for 1884. Since the Ecole's educational mandate had priority, he argued, its galleries were to be reserved for exhibiting the work of its students and faculty, the results of the student *concours* that played such an essential role in the Ecole's pedagogical structure, and for the judging of works submitted to the diverse *concours* run by the Academy (among which was the prestigious Prix de Rome).[5] Voicing his anxiety over the proposed retrospective, the director ended his letter claiming: 'If we sacrifice [our exhibition spaces], would it not be better to give them over to the instruction of our students and to allow only exhibitions that could provide them with a high level of instruction and an example? ... We don't want our students bothered by exhibitions of a less elevated order.'[6] The Republicans also recognised that the artists and works that the Ecole chose to exhibit were clearly conceived as *models* – albeit of a relatively conventional sort – of the aesthetic nature and technical standard of French art that future generations of artists who would comprise 'the French school' were to emulate. Accordingly, Proust and his allies saw the symbolic importance that a complete retrospective of Manet's work would acquire in granting Manet the same institutional honors routinely conferred upon the Academy's and the State's established artists. Consequently, they staged their show with all of the symbolism of a major state affair; French national flags decorated the façade of the entrance to the exhibition, 'as if it were a national celebration', as the critic for the royalist opposition's *Moniteur universel* put it.[7] The exhibition itself was inaugurated by none other than Jules Ferry, leader of the Republican Opportunist party, then President

of the Council of Ministers and ex-minister of education and fine arts, in the company of Armand Fallières, the acting minister of education and fine arts, and a host of other ministers, *deputés* and even members of the Academy, along with a vast number of guests.[8] The President of the Republic himself was scheduled to make a private visit.

Clearly such an 'apotheosis', as opposition critics disparagingly called the show, was more than simply a personal homage by a group of Manet's well-placed friends and influential admirers. For it carried with it all the requisite symbolism and institutional weight needed to *relocate* Manet out of *avant-garde* marginality and position him within the very structures of mainstream acceptance, now redefined through the hegemonic role that the Republican State would assume over the Ecole and the Academy.[9] Providing Manet with cultural capital within establishment circles, the exhibition was the official legitimation that gave art critics and administrative personnel the authority to reclaim him for subsequent 'official' manifestations in which 'the French school' was to be represented. Indeed, from this moment on, Manet acquired a central place in the history of French painting. Proust, and others, repeatedly sought to have his work purchased by the State and represented in national collections, the Louvre among them.[10] As head of the organising commission for the *Exposition centennale de l'art français*, held at the 1889 Exposition Universelle, Proust was consequently later able to put on an exhibition whose historical narrative produced a lineage from the works of David, Géricault and Delacroix, through the Barbizon painters, Millet and Courbet, culminating in the work of Manet, whose conspicuous presence in the exhibit's prestigious *Salon d'honneur* – which now included *Olympia* among the fourteen pictures exhibited – constituted Manet's art as the logical pinnacle in the development of modern French painting.[11]

There was, however, a deeper political significance to the 1884 Manet show. Seen within the context of the liberal Republicans' cultural politics of this period – as opposed to the cultural agenda of the more moderate and conservative factions within the Republican ruling bloc – the Manet retrospective reveals the continuity of the liberals' earlier programme to dismantle the Academy and undermine its bases of institutional power – primary among which was the Ecole – in order to supplant it with a more liberal state policy. Once Léon Gambetta, leader of the liberal wing of the Republican party, won a momentary electoral victory over the more moderate Ferryists in November 1881, Proust and his allies were immediately called upon to radically redefine the

fine arts administration.[12] Part of their efforts – in both institutional terms and in their art-critical writing – focused on dissolving the Academy's hold over the goals and nature of art education, by entirely restructuring the curriculum and organisation of the Ecole des Beaux-Arts. Attacking the Academy's continuing élitism in teaching the outmoded 'processes of the old [Italian Renaissance] Masters that they proposed as models', Proust claimed the State's job was not to produce an élite corps of future Prix de Rome winners, but rather artists and designers capable of carrying out the vast reconstructions of the monuments destroyed in the wake of the Commune and other major decorative schemes initiated by the Republic.[13] To achieve this, the liberals proposed to *diversify* the Ecole's artistic instruction by introducing the techniques and values of competing *contemporary* artists into its curriculum. For Proust and other liberal critics and administrative personnel, this meant introducing a contemporary naturalist aesthetic into official teaching. Proust himself was very clear about the form that this naturalism would take. For him, the subjects of modern painting were to be drawn exclusively from the 'spectacle of contemporary life', and represent 'the expression of the age in which we live'.[14] Exhorting artists to paint and sculpt only 'things observed, and not reproduce what has moved artists of the past', Proust claimed that depicting the past was irrelevant: 'The variety of a spectacle incessantly renewed has replaced the monotony of archaeological restorations.'[15] For Proust, and other liberal naturalist art critics like Roger Marx and Louis de Fourcauld, it was Edouard Manet who most exemplified these new 'official' values in painting.

By January 1884 however (the date of Manet's retrospective), Proust and his liberal republican constituency had lost the reins of ministerial power and were now obliged to manoeuvre from the sidelines.[16] In this way, Proust's success in negotiating the Manet retrospective reveals, I think, both the degree to which he continued to wield social and cultural capital within the Republican ruling bloc, and one of the cultural stakes around which Republicans of various factions could forge some consensus by the mid-1880s. But it also indicates one of the ways in which state power continued to be deployed, particularly by those no longer in the most visible positions of authority. For exhibiting Manet at the Ecole des Beaux-Arts could be read as signifying the persistence of Proust's earlier mandate to attack the Ecole's traditional curriculum by imposing aesthetic directions and technical models entirely alien to its academic principles.

II

The overlapping symbolic and political significance of the retrospective constituted the immediate conditions in which the criticism on Manet was produced in January 1884. For critics of the conservative opposition, whose opinions positioned them within a broadly academic ideology, the exhibition was the ideal pretext for attacking the Republicans' cultural policies and proclaiming the decadence of French painting under the new Republican regime. Vehemently objecting that an 'irreconcilable adversary' of the Ecole such as Manet, an 'artistic Luther ... who spent his time protesting violently against [it]', was now exhibited there, these critics insisted that proposing Manet as a model to either the Ecole's students or the French public signified the Republicans' cultural bankruptcy.[17] Edmond About, voice of the Academy, articulated their sentiment: 'Never has indifference in educational matters been pushed so far; never has the holiest of holy places, the tabernacle of the Ecole, been profaned by someone with such contempt of principles, of rules, of taste, of simple good artistic sense.'[18] And Marius Vachon, in the Opportunist Republican *La France*, accused not only the government, but Proust in particular, of planning a 'coup' against the Academy, and an 'attack on the dignity of French painting'.[19]

To sustain their claims, the conservative opposition resuscitated the arguments that had long been rehearsed over the past two decades.[20] For Vachon, for instance, 'Manet remains a simple capricious Parisian, very uneven, extremely incorrect ... and most often ridiculous, grotesque, because he possessed neither true science, nor a deep level of artistic education, nor real passion for *le beau* and *la vérité*.'[21] Most critics agreed, though taking the slightly more tempered view that Manet *did* have a measure of technical skill, but ill-conceived and inappropriately used. Jean de Nivelle, writing in *Le Soleil*, considered that Manet's work showed 'a great effort and considerable labor, but it's so vulgar and *l'idéal* preoccupies [him] so little.'[22] Meurville, in the right-wing and monarchist *Gazette de France*, echoed: 'he was concerned neither with *le beau* nor *le vrai* and preoccupied himself only with appearances. He took the effect for the cause, the result for the principle, the state of reflection for the condition of stagnancy; it's that which renders his method absurd.'[23] And finally Albert Wolff: 'Manet was principally an *improviser* ... so much searching, hesitation and pain in all these paintings that seem to have been done in an hour! ... Lacking a basic artistic education, his multiple efforts most often remained sterile; his eye saw remarkably well [but] his

hand betrayed him.'[24] For these critics, Manet lacked not the skill necessary to anchor his paintings *within* traditional conventions of pictorial representation – the Academy's *'le vrai'*, *'le beau'*, *'l'idéal'* – but worse, he lacked all respect for the values that underpinned them.

As ready evidence of his militant anti-academicism, Manet's critics cited the second, so-called 'naturalist' phase of his career, the *'école'* of which they most often claimed him as leader. 'His naturalism', claimed Georges Berger in the moderate Republican *Journal des débats*, 'takes pleasure in starkly reproducing subjects which are vulgar or which are seen in a coarse light.'[25] Once again, it was *Olympia* that was made to carry the full weight of the critics' hostilities. For de Nivelle, *Olympia* signified the extent to which Manet actively accentuated vulgarity at the expense of idealisation. Referring to Manet's *Portrait of Eva Gonzales*, the critic asserted: 'if this is life in painting, as Edouard Manet's overly zealous friends affirm, then how does one represent motionlessness and death? Would it take the form and the drab color of this reclining odalisque, on whom two bandages have been made with boot-polish, after having tried the brush on her neck, ringed as it is with a black shoelace?'[26] But for Meurville, and others, *Olympia* signified much more. She revealed the very nature of Manet's strategy: 'this Venus of the gutter spread nude on cushions ... [shows that] Manet's speciality [is] to play the fool'.[27] As Edouard Drumont put it, 'this bizarre *Olympia* who seems intended to irritate the public ... [proved that Manet was] the eccentric who at first aimed only to *épater les bourgeois*'.[28] For these critics, Manet, like Courbet before him, was ultimately bent on provoking public scandal, on destroying the Ecole's practises and the Academy's very principles:

> Manet's good work is lessened ... by the memory of so many inten-
> tional mediocrities. ... Most of these paintings are what are called in
> today's terms pyrotechnics, which is to say noise-makers, something
> like a *fausse nouvelle* which doesn't fool those who launch it and which,
> without having any real value, nevertheless has the license to command
> attention.
>
> Not long ago Gustave Courbet... died. He was also a pyrotechnician
> who, in his youth and even later, challenged public opinion more
> than once.[29]

By attributing to Manet a programmatic desire to shock the bourgeoisie, most conservative critics forged a link between Manet's supposed strategies and those of Courbet, inscribing Manet even more firmly within 'independent' (i.e. *avant-garde*) artistic status. But to seal that construction, Manet's working methods, his

personality and his social status were themselves reconstructed, fitted into the biographic trope of the undisciplined, unsuccessful non-academic artist.[30] Albert Wolff, for instance, described Manet as indecisive and extremely hesitant. Lacking proper artistic training, unable to draw or to progress from acquired knowledge, he was doomed to constant improvisation. Incapable of finishing or even refining his work, he was, at best, a painter of *morceaux*, producing an inconsistent body of paintings that lacked overall unity.[31] And to drive home the theme of professional failure, most conservatives went on to claim that his followers were no more than a group of 'undisciplined' and 'impotent' painters, 'inept' artists who by any standards were '*des ratés* [failures] of all the schools.'[32] But Drumont went even further. Considering painting as a direct reflection of the artist's hidden nature, he called Manet's personality and social formation into question:

> impotent and arrogant ... he never had the energy to carry out an artistic endeavor to the end; work, which alone constitutes creation, always stopped him. ... He had innumerable inclinations, but never once acted with serious and lasting determination. ... Embittered by life, by the intimate belief that the small place he had in this Paris that he dreamt of dominating was due him, the painter with a nervous temperament reached the point of seeing humanity only as sneering. In women he no longer sees the soul, the captivating and sweet smile; in men, he no longer seeks the idea, the expansive or meditative intelligence; living creatures no longer appear to him except as multicolored puppets; he seizes them at the moment that they dance in the light and he abandons them afterwards since, always preoccupied by his own ego, [he is] superficial through egotism and inattentive to others through vanity; he doesn't take the trouble, like real artists, to interrogate, to scrutinise, to disclose his model in order to render visible the interior being.[33]

Meurville reinforced this profile of the anti-social, anti-bourgeois artist by raising the specter of left-wing politics. Professing an equivalence betwen Manet's – and Courbet's – paintings and the Commune, he alleged that Manet made 'barricades in art as others did in the streets ... it is astonishing that the Ecole des Beaux-Arts is invaded by the works of this irreconcilable adversary, like the ragged mob of the past invading the Tuileries.'[34]

The effect of such criticism was, of course, to produce a Manet who was as far from the mainstream as possible, at least by Academic standards: an artist who could function metonymically for the Republican State and the decadence of cultural and social values under the new regime. What is significant is the way in which artistic and professional competence are made to spill over into

the personal and private sphere in order to produce this unified subject. In the discursive fusion of a body of personal traits, constituted as anti-social, politically dangerous and certainly anti-bourgeois on the one hand, with 'failures' in the artistic field on the other – the inability to draw, constant indecision and improvisation, a refusal to submit to rules outside of one's own, and provocation for its own sake – the conservatives sought the ultimate legitimation of Manet's professional incompetence in his private life.

III

I would argue that the 'Republicans'' construction of Manet was certainly structured dialogically, formulated in part as a self-conscious response in an immediate intertextual negotiation.[35] But it was also organised *intratextually*, as part of the broader diachronicity of the discursive network which Jean-Jacques Courtine has referred to as discursive memory on the one hand, and the instance of anticipation on the other.[36] The Republicans' discourse was one which was deployed to counter those familiar positions long held by Manet's conservative detractors and by ardent academicians like Edmond About, and designed perhaps to reassure more moderate partisans about Manet's naturalism. But the 'Republicans'' Manet – and particularly the one constructed by naturalist writers and critics closest to Antonin Proust – was also modeled upon some of the central elements of the liberal Republican's cultural politics.[37] A key instance is the biographical construction which Edmond Bazire, Gambettiste supporter and naturalist critic for Henri Rochefort's radical *l'Intransigeant*, produced in his monograph on Manet that accompanied the exhibition.[38] Bazire's Manet was reinvented and placed firmly *within* a respectable tradition of artistic practise, and made to serve as an example of the very failures of official teaching and cultural politics under the Second Empire.

From the very first pages of the monograph, establishing Manet's social identity becomes a crucial issue, since the reader is constantly assured of just how solidly bourgeois the milieu to which Manet belonged really was. Born into a financially stable family of *hautes fonctionnaires*, educated at the prestigious Collège Rollin, then sent off to the merchant marines – both prerequisites for a career in a judicial or military profession – Manet, despite his parents' initial desires, finally became a painter.[39] The earliest source of this artistic orientation – a matrilineal uncle noted as an attaché of a military school – simultaneously confirms that Manet's vocation ultimately derived from within his social class and his family milieu.

This further endorses its acceptability as a serious pursuit of bourgeois masculinity. Manet's belonging to the *haute bourgeoisie* and his social respectability are reinforced throughout Bazire's account by descriptions of his physical appearance and social demeanor: 'a balanced and gay personality, *never undisciplined ...* He was a delicate and tender youth ... who possessed [social] distinction which never left him.'[40] And further on; 'his enemies tried to make him out to be a dishevelled *rapin* [a painter without talent], his clothes stained with paint and oil, ungainly and ungraceful, badly taught and badly brought up'.[41] Bazire argues, on the contrary, that

> he liked elegance, frequented *le monde*, [and] charmed others by the distinction of his manners and the finesse of his language. He had the most sympathetic manner; with a lean waist, and a handsome face that was framed by a well-groomed blond beard ... [a] well-proportioned face, alive with the vivacity of his eyes and a slightly mocking smile on his lips; it would be difficult to meet a more seductive man than this so-called monster'.[42]

A successful marriage to an equally refined woman from the same social milieu is coupled with descriptions of personal work habits that project the naturalness and ease with which Manet deployed artistic skill and invention, and the disciplined, decisive, assiduous and logical manner in which he developed his painting. This, along with the portrayal of a career whose internal coherence and progression were apparent in its ability to be consecutively periodised, produced a Manet whose social profile not only directly contradicted that produced by the conservative opposition, but conformed remarkably closely to that of an 'official' artist under the Third Republic.[43]

Other partisans, ranging from liberal naturalist critics like the solid Gambettistes Philippe Burty and Roger Marx to moderate supporters such as Henry Havard and Paul Mantz, replied to Drumont's, de Nivelle's and Meurville's positions in much the same way. Burty, for example, writing in Gambetta's *La République française*, saw Manet as 'a man of high society, cheerful, impassioned, very gifted, who liked a battle for the thrill of it in this Parisian center'.[44] And Henri Havard, in the Opportunist Republican *Le Siècle*, asserted, 'With an ardent disposition, sufficiently energetic not to fear conflict, he was, however, too proper in essence and too polished in education to let it degenerate into violence.'[45] It is here that Bazire's and these critics' insistence on Manet's respectability, his bourgeois status and refined personality becomes significant. For it positioned Manet outside the social/professional

profile of the isolated, failing and socially unacknowledged 'independent' artist; attributes which, at least for these critics, had not yet come to signify the celebrated features of an '*avant-garde*'. But it also distanced Manet from the legacy of Courbet, whose militant realist aesthetic, disregard for traditional artistic practises, and mythical artistic persona provided him with the label of an *artiste-ouvrier* throughout much of his career.

Putting aside, for the moment, the broader question of how art criticism often invoked representations of class in constituting or negotiating artistic identity, Bazire's and the critics' commentary, careful as it was to position Manet firmly *within* the bourgeoisie, functions to *contain* his 'revolution' to the artistic field alone. Unlike Courbet, whose aesthetic convictions spilled over into the realm of politics and who, as Linda Nochlin has shown, was discursively 'rescued' by Republican critics from his participation in the Commune, Manet is clearly neither an 'outsider' nor a *rapin* out to *épater les bourgeois* or raise thorny social questions: rather he is represented as solidly bourgeois.[46] The traits of an ardent conviction and a willingness for confrontation are indeed allowed him, but, mediated by the endowments of class, they are easily transformed into the virtues of Republican individuality: personal independence, motivation, tenacity and sincerity.

To clinch their argument, Manet's supporters readily turned to *Olympia* and the *Déjeuner sur l'herbe*, in order either to minimise their importance in Manet's *oeuvre* or deny it altogether. Burty, for instance, clearly took his distance as far as the latter was concerned, stating, 'the attempt is bold; but we don't feel much satisfaction with it. The best part is the landscape and this bathing woman in her chemise. *Olympia* no longer persuades us either.'[47] Other critics were much more circumspect. Drawing on the convention of criticism to assign discrete periods to artistic production, they located both paintings either in Manet's 'first period' or in a 'transitional phase'. In either case, both works now demonstrated Manet's 'youthful hesitation and uncertainty as to what school to follow', his 'complete imitation of the Masters', his subjugation to the influence of his teachers, or his working out of formal problems.[48] *Olympia* and the *Déjeuner* could thus be neutralised, explained away not as anomalies in his career, but rather as examples of his respect for past traditions or as attempts to find his artistic voice. For these critics, neither painting indicated the 'real' Manet, nor revealed the true 'personality' that would later emerge in his 'mature' work, for they displayed none of the signs – or precious few at best – of Manet's 'originality', his individuality or 'independence'.[49] Here, the fissures that periodisation could

produce in constructing the artistic subject allowed Manet's supporters to contain those paintings, and to disavow their – and indeed his – role in actively seeking to *épater les bourgeois*.

But if periodisation alone could not entirely secure Manet from the charges of scandalising his public in the 1860s, then claims of victimisation might. Bazire, like most of the liberal naturalist critics, consistently affirmed that it was not Manet, but the Second Empire's own cultural institutions – the Academy, the Ecole, the official jury and conservative critics – that had created the scandal around him.[50] Roger Marx, for example, appropriated an earlier argument when he claimed, 'Manet never wanted to protest. On the contrary, protests were made against him ... because there is a traditional education which dictates the forms, means and elements of painting, and artists brought up in such educational principles no longer concede others.'[51] For other critics, Manet was 'a painter jeered at, laughed at, rejected [by the jury] as if he had the plague'.[52] The political currency that the myth of a misunderstood, persecuted artist could acquire in Republican art criticism and other art discourses at this time escaped few of Manet's supporters. Mobilised here, as it had been to promote Rousseau, Daubigny and Corot as 'Republican' painters, its effect was to transform Manet, to produce him as having no particular program and certainly no naturalist *parti-pris*, wanting only to get on with the job of 'sincere' painting.[53] Manet's moderate supporters, however, shifted the cause of provocation onto his own coterie of naturalist critics, Zola in particular. According to Havard, from the moment that Manet exhibited *Olympia* he fell prey to

> dangerous friendships [which] would begin to completely take Manet over. ... Those who had everything to gain from an uproar and a scandal forced him to throw himself into the fray. ... For Manet, these friendships had the major drawback of expropriating him from himself. Because of them, he became the incarnation of vague, uncertain and ill-defined theories, whose application he then had to follow, whether he liked it or not, to the bitter end.[54]

For both groups of supporters, rehabilitating Manet meant reinventing that second phase of his development, the phase of 'brutal naturalism', as hostile conservatives continued to call it. Keen as they were to place as much distance between him and Courbet as possible, as far as social and political controversy were concerned, Manet's naturalism was made respectable and entirely neutralised. In the end, Manet is again produced without agency, as an artist simply concerned with artistic innovation, itself contained safely *within* the aesthetic field.

Part of that containment comes from the way in which Bazire, and others, construct Manet's respect for aspects of conventional artistic practise, reiterated throughout the monograph as forming an important part of his own development. Already in his youth, Bazire claims, Manet demonstrated 'a lively passion for drawing', and continued throughout his career to be 'seduced by the charm of lines'.[55] The early drawing instruction he so assiduously undertook with his first teacher, the maternal uncle at a military school, reinforces not only the longevity and primacy of drawing over painting for Manet, but is located in an educational arena in which drawing instruction played a central, and for most Republicans an increasingly important role, as the foundation of a generalised professional training.[56] Bazire's insistence on drawing as the essential and continued basis of Manet's art is not only frequently repeated – in passages such as 'Drawing was his first strength and remained his strength [although] he was accused of not knowing how to draw' – but is given the weight of visual evidence, as the monograph reproduces no fewer than twenty-three facsimiles of Manet's sketches and nine reproductions of his line engravings, as opposed to only six illustrations of his paintings.[57] Manet's brief passage through Thomas Couture's studio is followed by numerous voyages, first to Germany, twice to Italy, and finally Spain, where in each case he sketches and 'faithfully copies' the 'masters' – Tintoretto, Titian, Rembrandt, then Goya, Velásquez, Hals – before finally returning to France, the site of 'self-discovery'. Here, the structure of Manet's development – a solid foundation in drawing (youth), then the acquisition of technical proficiency in painting (the atelier of Couture), followed by the practice of copying the Italian and other ancient masters – is made to parallel the early stages of an 'official' education, the kind which, as Albert Boime has demonstrated, structured a student's pedagogical formation at the Ecole des Beaux-Arts during the Second Empire.[58] The difference, however, is that Manet's trajectory, according to this biography, deviates from the Academic model. It de-emphasises the primacy of Rome as the exclusive site of a student's foreign inspiration – the monopoly over which was held by the Academy – emphasising instead a diversity and multiplicity of foreign sites, which finally culminate with France itself. Manet's artistic success could thus be read as an implicit demonstration of the advantages of what were then Proust's ministerial plans to limit the Academy's influence over art education – particularly at the more advanced stages – by expanding foreign study well beyond the confines of the Academy's authority. Moreover, while virtually all of Manet's Republican supporters confirmed his technical proficiency by citing

his respect for the Italian, and particularly Spanish, traditions, they were equally anxious to demonstrate their limited importance in Manet's career. Consigned to his early (developmental) 'phase', these traditions would be surpassed when Manet reaches artistic 'maturity' which, for the liberal naturalist critics, occurs precisely in his own national context.[59]

Manet's break with Couture's teaching fulfills, of course, one of the standard tropes of artistic biography: the artist's growing independence and search for originality. But in Bazire's account this rupture results not from Manet's inability to adapt to Academic principles or the Imperial regime's official art education – an inability which would conform to the trope of the 'independent' artist – but rather from the inherent failures of the system itself. Each of the academic or official artists Bazire describes are portrayed as oppressive and their teaching as restrictive. Couture, for example, is the embodiment of the 'official' system, stifling and limiting his students' originality, and suppressing their individuality:

> Couture was not extremely pleasant and did not like students freeing themselves from his control. He intended that his disciples should not go beyond the sphere of his teaching. He wanted to perpetuate himself in the work of the young people that he directed. He had the pretension of creating little Coutures and of bringing down to his stature all of the individualities guilty of revealing themselves.[60]

When it came to Manet's own competence as a teacher, portrayed through his influence on his student Eve Gonzalès and, more obliquely, on Berthe Morisot, Bazire reverses the situation entirely. Under Manet's guidance, Gonzalès, a former student of Chaplin ('the passionate painter of languishing and rice-powdered flesh')

> unexpectedly showed extraordinary evidence of strength, color and precision. In her work, nothing is neglected, the contours are clear and tight; the colors never weaken. She has calm nerves and reliable impressions ... to the instruction of the effeminate charmer, Manet added the exact ruggedness of his manner. [Henceforth] There was in Mlle Gonzalès the combination of two opposite natures, analysed by an independent and serene mind, who made an originality come out of this unexpected mixture ... leaving behind Chaplin's irritating affectations, she managed – with long study and sound direction – to furnish energetic, masculine, human notes.[61]

Similarly Morisot – after Manet's inspiration, that is – is said to paint 'genre scenes [that are] quite feminine in conception and very virile in execution'.[62] In other words, unlike the Ecole's professors, Manet not only encourages, but actually awakens the individuality and originality latent in these artists' work, especially

once they have acquired basic skills. He allows them to retain their 'essential femininity', while providing them with the formal language for its articulation. If, as Tamar Garb and Anne Higonnet have both argued, the traits of an *art féminin* were discursively located in surface, color and *facture* – rather than in the tight compositional structure and subject-matter commonly associated with the masculine and academic characteristic of 'conception' – then I would argue that Bazire's Manet legitimises both these artists' work precisely by masculinising them.[63] For Manet's influence enables the nature and location of femininity to be transposed, to migrate from the picture's surface into its content. Like conventional male artists, these women *do* possess a conception and express an idea whose precision, clarity and strength is articulated (with 'calm' and 'certainty', in the case of Gonzalès) through an execution described as virile, energetic and masculine. While the gendering of critical language remains entirely intact here, it is momentarily reversed to rescue Gonzalès', Morisot's and indeed Impressionist painting, from charges of impotence and an undisciplined (feminine) nature – the terrain of the *avant-garde* – in order to secure it, along with Manet's legacy and his own importance as a teacher, firmly within the parameters of a respectable (masculine) art.

Here, Bazire's text reproduces some of the language of Proust's and other liberals' 1881 critiques of the curriculum and teaching program at the Ecole des Beaux-Arts and its exclusive focus on replicating an artistic élite of future Prix de Rome winners trained in the Academic traditions of *grande peinture*. The model of 'artistic independence' and 'individuality' that Manet is made to embody functions as a critique of the image of official teaching under the Imperial regime. It was the same critique that was produced by liberal cultural administrators and critics who supported Jules Ferry's and Proust's claims of *la liberté de l'art* and their formulations that the State's goal was to encourage neither an official doctrine nor an official aesthetic. For Proust in particular, this pluralism transformed the Ecole des Beaux-Arts' 'official' mandate into one which would be to provide students with a solid technical foundation in their early years, while simultaneously allowing their more independent personal development afterwards; what Burty, in reviewing the Manet retrospective, praised as 'a precise but independent education'.[64] In this way, the vocabulary of 'independence', of 'artistic individuality' and of the artists' 'revolt' against conventional pictorial systems and traditional technical formulae became the official language of the State, promoted by Opportunists like Jules Ferry and others. A dominant theme that organised

much of the art criticism in the Republican press, it enabled the rhetorical differentiation between a Republican and a pre-Republican order. At the same time, it is the discourse of a new liberal ideology, in which private initiative, individuality, stylistic diversity and competition are all encouraged as part of the State's initiative to expand, diversify and differentiate the art market in an attempt to develop a liberal economy.

There is, however, another way in which this idea of a separation between a Republican and a pre-Republican order comes into play in Bazire's biographical narrative. For it is precisely with the fall of the Second Empire and the emergence of the Republican regime that Manet's artistic fortunes change abruptly. Both his personality and his artistic style 'mature' simultaneously as a result of a 'crisis' (yet another trope of artistic biography). Yet this cataclysm is not simply an artistic crisis, but rather that of French nationalism, marked by the foreign invasion of Paris and the fall of the Imperial regime. It is precisely Manet's patriotism, confirmed by his momentary *abandonment* of painting and his enrollment in the National Guard during the Prussian offensive, that allows Bazire to claim not only that 'his personality clearly asserts itself', but that 'we will no longer find foreign inspiration in him; he proves himself an innovator'.[65] Manet is now Frenchness incarnate, purified of foreign influence and no longer victimised by the Second Empire's cultural institutions. With the advent of the Republican regime – both the Commune and Courbet are conveniently avoided here – Manet begins to acquire critical acclaim, to sell his work successfully and to have followers. And in Bazire's invention, both Manet's subject-matter and style – his *facture* and touch – are increasingly defined as the crucial signs of 'Frenchness'. Once again, *Olympia* and the *Déjeuner sur l'herbe* are erased as having any real importance in this definition. Rather Bazire's choice lies in images like the *Polichinelle*, contentious in ways that were now entirely appropriate to liberal Republicans and critics: 'This Polichinelle is not Italian, he is indeed French. He has the costume or disguise of a *pupazzo*. But he is not at all foreign. The model is, indisputably, among us. He has his brutalities and his impertinences; his impertinences and his brutalities have never gone beyond the Alps.'[66] The satirical reference of the *Polichinelle*, its barely shrouded allusion to MacMahon – by now a reminder of the Republicans' decisive victory over the Right – confirmed, for Bazire, that Manet's 'mature' painting was indeed intimately bound up with Republican politics.

IV

Bazire's appropriation of this Italian figure which, he contends, Manet transmutes into an expression of his Frenchness, is significant in still another way. For his argument overlaps a different order of politics that emerged in the liberal naturalists' assessment of Manet's achievement: nothing less than the wholesale transformation of modern French painting towards impressionism. Roger Marx, for instance, credited Manet with nothing less than the regeneration of modern art:

Manet's value is not limited to his paintings ... it is also in his role as a regenerator. ... His exhibition comprises an ensemble of works that summarise the whole of modern art. His *cafés concerts*, his *restaurants*, his *boating parties at Argenteuil*, all these scenes *prises sur le vif* and painted in direct light, have served as models for the contemporary school. The Impressionists learned by studying his landscapes ... The finesse of all of his pastels has made them accepted by the most academic and most difficult [critics]. ... If artists are judged as much by their influence as by their works, then Manet must undoubtedly be considered a master. He has been one of the most energetic instigators of *la peinture claire*, studied in the full light of the modern milieu; little by little he has pulled our Salons out of their black bituminous stew and brightened them with a shot of real sunshine.[67]

And Albert Leroy:

in becoming modern ... [Manet] remembers that he is a Parisian and, in this vaporous atmosphere that surrounds the people and things of Paris, finds the true and living subjects of study for his *plein air* paintings that will revolutionise modern art and induce fear in the Institute's *pompiers*. ... From that moment on [1873], the artist casts off the old clothes of the past. He affirms himself as a great painter and takes up *plein air* painting with a courage that brought admiration from all who knew him. In the flickering of raw sunlight or the yellowish brightness of gas, he knew how to fix the impression received by the eye, proceeding by large touches, with astutely combined values, leaving it up to the ambient light to put the values in opposition, so as to produce the effect of reality.[68]

What the liberal naturalist critics produced as *their* Manet was unequivocally the Manet of the 'last period': the painter of modern life, whose themes they defined as the culture of contemporary (bourgeois) Paris and its environs, a Manet rather familiar to us today. In what are clearly descriptions of an Impressionist aesthetic and its formal – particularly tonal – devices, these critics consistently attributed to Manet the singlehanded reinvention of French painting. Nevertheless, they were careful to avoid explicitly naming

him as an Impressionist or calling him the *chef d'école des Batignolles*. Evading these epithets served their strategy well, since the term 'Impressionist' continued to provoke varying degrees of hostility not only among Manet's academic and conservative critics, but with his more moderate supporters as well.

For the moderate Republican critics, on the other hand, Manet had unfortunately degenerated precisely into an 'Impressionist', and thereby negated 'the principles that have made the greatness of the ancient and modern schools'. Labeled as the founder of the '*école des Batignolles*' he had, in his 'last manner', become 'false and mannered', deviating from his 'true' artistic direction.[69] In the end, it was Manet's 'Impressionism' that constituted, for the moderates, his downfall and had destroyed any potential of his having an enduring effect on French painting. Their Manet was located in that early phase when, still respectful of the Spanish or Dutch traditions, he showed the artistic potential that might have earned him an 'honorable place' in France's artistic heritage.[70] For them, Manet's ultimate 'achievement' was primarily technical, and his prominence was lost as soon as he moved over into Impressionism.

However, we should not conclude from this that for most of Manet's liberal supporters, canonising him within a new mainstream of French painting meant the officialisation of Impressionism. But it was, I think, intended to signify the final blow to Academic principles. For what consistently organises these critics' descriptions of Manet's achievement – their explicit emphasis on a lightened palette, applied to the scrupulous observation of modern subjects that are themselves defined as contemporary and Parisian – is its structural opposition to the practises and procedures of academic convention. Manet's painting represented the antidote to the 'old formulas', the ancient and 'banal subjects' 'invented by the scoundrels of Italian decadence!' that had dominated French painting since the Empire.[71] And as such it marked, for these critics, the decisive victory of anti-Academicism in the visual field.

Notes

I wish to thank Annie E. Coombes for the critical reading and valuable suggestions she brought to this article.

1 For an account of the stakes in the formation of Republican cultural politics during this period, see Michael R. Orwicz, 'Anti-academicism and state power in the early Third Republic', *Art History*, vol. 14, no. 4 (December

1991), pp. 571–92; and Nicholas Green, ' "All the flowers in the field": the state, liberalism and art in France under the early Third Republic', *Oxford Art Journal*, vol. 10, no. 1 (1987), pp. 71–84.

2 The designation 'liberal', 'moderate' and 'conservative' used throughout this study to describe the 'critics' needs some explanation. While clearly not 'neutral', the terms are meant to indicate the positions of critics in relation to a configuration of, on the one hand, aesthetic issues such as 'naturalism', 'idealism', a range of artistic processes, etc., and on the other, to questions concerning the cultural politics of the early Third Republic (e.g. the legitimacy of contemporary institutional practices, the mandate of the State, the Ecole des Beaux-Arts, the Académie des Beaux-Arts). These positions were, of course, relatively unstable, being constituted and negotiated in the process of discursive transactions and subject to the on-going changes that occurred in cultural policy during the 1880s. The Manet exhibition represents, moreover, a particular case in which realignments among critics' positions occurred. Clearly, these designations should not be identified with such ready-made categories as the 'left', 'right' or 'center' of political formations, nor with the political perspectives (themselves shifting) of the press during this period. The critics on whom I have chosen to focus my study were drawn predominantly from a wide spectrum of the Parisian political daily press and comprised two coherent discursive formations. In a highly schematic manner, the 'conservative' (in some cases designated as 'Academic') critics were those who defended the Académie des Beaux-Arts, its conventions and practices, then broadly instituted in the teaching program of the Ecole des Beaux-Arts. The designation 'moderate' and 'liberal naturalist' critics used to signify Manet's 'Republican supporters' transforms, to some extent, what have been designated as the '*juste milieu*' and 'naturalist' critics of the earlier period. The 'moderates', while supporting many of the institutional reforms introduced by the new Republican regime – indeed many of these critics were themselves instrumental in designing Republican cultural policy – nevertheless maintained an aesthetic discourse that was close to the principles of the Academy. The position of the 'liberal naturalist' group is defined below.

The reviews of the 'conservative' critics on which this study is based are found in: *Le XIXème Siècle*; *Le Moniteur universel*; *Journal des débats*; *Le National*; *La Liberté*; *Le Monde*; *La Lanterne*; *Gil Blas*; *La Gazette de France*; *Le Soleil*; *La France*; *Le Figaro*.

Reviews of critics designated 'moderate' and 'liberal naturalist': *La Bataille*; *Le Petit Journal*; *Le Petit Parisien*; *La Presse*; *La République française*; *Le Rappel*; *La Libre Revue*; *Le Gaulois*; *La Justice*; *Gazette des Beaux-Arts*; *Le Siècle*; *L'Intransigeant*; *L'Evénement*; *La Justice*; *Le Réveil*; *Le Temps*; *Journal des Arts*; *Le Voltaire*; *Gil Blas*; *Le Radical*; *Le Cri du peuple*.

For a more conventional and entirely depoliticised account of some of the Manet criticism, see Jean-Paul Bouillon, 'Manet 1884: Un bilan critique', in Jean-Paul Bouillon *et al.* (eds), *La Critique d'art en France 1850–1900* (Saint-Etienne, 1989), pp. 159–75.

3 Antonin Proust, *Edouard Manet. Souvenirs* (Paris, 1913), pp. 137ff. For a slightly different account, see Théodore Duret, *Critique d'Avant-Garde* (Paris, 1885). For an overview of events leading to the exhibition, see Tabarant, *Manet et ses oeuvres* (Paris, 1947), pp. 472ff.

4 Archives Nationales, Paris, AJ52 838. These comprised either the works of Academicians such as Ingres' pupil Lhemann, then professor at the Ecole, the work of Sellier (Grand Prix de Rome in 1861), copies of Michelangelo's and Raphael's religious paintings by Paul Baudry (then member of the Institut), a series of Old Master drawings or the work of conventionally trained artists like Debuf and Grenier.

5 Archives Nationales, Paris, AJ52 838: Letter, Directeur de l'Ecole des Beaux-Arts to Directeur des Beaux-Arts (16 October 1883).

6 Archives Nationales, AJ52 838.

7 *Le Moniteur universel* (6 January 1884).

8 Philippe Burty, *La République française* (7 January 1884). Burty estimated that 5,000 guests attended the opening and another 1,000 were obliged to wait in line. Tabarant puts the number of paying visitors to the exhibition at 13,000 (*Manet et ses oeuvres*, p. 497).

9 For the redistribution of State power and the Republicans' increasing attempts to gain control over some aspects of the Académie des Beaux-Arts and the Ecole des Beaux-Arts, see Orwicz, 'Anti-Academicism'.

10 See Proust, *Manet. Souvenirs*, and 'Discours prononcé aux obsèques d'Edouard Manet', in Ecole Nationale des Beaux-Arts, *Exposition des Oeuvres d'Edouard Manet* (Paris, 1884).

11 *Exposition universelle internationale de 1889 à Paris. Catalogue général officiel. Beaux-arts. Exposition centennale de l'art français (1789–1889)* (Lille, 1889).

12 Proust became Minister of Arts on 14 November 1881, nominating a range of liberal naturalist art critics and administrative personnel (including Roger Marx and Louis de Ronchaud) to key positions in his cabinet. For an account of Proust's objectives, see Antonin Proust, *Art sous la République* (Paris, 1892), and Orwicz, 'Anti-Academicism', pp. 578ff.

13 'Le Ministère des arts', *La Revue politique et littéraire* (25 February 1882), pp. 237–8.

14 'L'expression de l'époque dans laquelle nous vivons', *Art sous la République*, p. 168.

15 '[des] choses vues, et à ne point rééditer ce qui a pu justement émouvoir les artistes du passé … Après les tentatives successives de résurrection et d'adaptation du passé, notre siècle a pris le sage parti de s'inspirer du présent. On ne peut que s'en louer. La variété d'un spectacle sans cesse renouvelé a succédé ainsi à la monotonie des restitutions archéologiques.' (*Art sous la République*).

16 Vapereau, *Dictionnaire universel des contemporains*, 6th ed. (Paris, 1893), p. 1282.

17 Meurville, *La Gazette de France* (9 January 1884); Vachon, *La France* (11 January 1884).

18 'Jamais l'indifférence en matière d'enseignement n'avait été poussée si loin; jamais le saint des saints, le tabernacle de l'Ecole, n'avait été profané par un tel contempteur des principes, des régles, du goût, du simple bon sens artistique.' (*Le XIXe Siècle*, 7 January 1884).

19 See also Berger, *Journal des débats* (7 January 1884).

20 The best account is T.J. Clark, *The Painting of Modern Life: Paris in the Art of Manet and his Followers* (Princeton, 1984), particularly chapter 2. See also George Heard Hamilton, *Manet and his Critics* (New Haven, 1954), and Eric Darragon, *Manet* (Paris, 1989).

21 'Manet reste un simple fantaisiste parisien, très inégal, fort incorrect ... et le plus souvent ridicule, grotesque, parce qu'il n'y a eu en lui ni science véritable, ni éducation artistique profonde, ni réelle passion du beau et de la vérité.' Vachon, *La France*.

22 'Prise dans l'ensemble, l'oeuvre est considérable et témoigne d'un grand effort et d'un grand labeur. Mais comme elle est vulgaire, et quelle petite préoccupation de l'idéal!' de Nivelle, *Le Soleil* (10 January 1884).

23 'Il ne s'inquiétait ni du beau, ni du vrai et ne s'occupait que du vraisemblable. Il prenait l'effet pour la cause, le résultat pour le principe, le miroitement pour un état stagnant, c'est là ce qui rend absurde sa méthode.'

24 'Manet fut donc surtout *un improvisateur* ... Que detâtonnements, d'hésitations et de douleurs dans toutes ces toiles qui semblent venues en une heure! ... les efforts multiples restaient les plus souvent stériles, faute d'une éducation artistique première; l'oeil voyait remarquablement juste; la main trahissait le peintre.' (My italics) *Le Figaro* (5 January 1884).

25 'Son naturalisme s'est complu dans la copie brutale de sujets vulgaires ou envisagés sous leur côté grossier.'

26 'Si c'est cela la vie en peinture comme l'affirment les amis trop zélés d'Edouard Manet, comment représentera-t-on l'immobilité et la mort? Sera-ce sous la forme et sous la couleur terreuse de cette odalisque couchée, à laquelle on a fait deux bandeaux avec du cirage, après avoir préablement essayé le pinceau sur le cou, entouré ainsi d'un lacet noir?' *Le Soleil*.

27 'Mais que dire de cette Vénus du ruisseau étalée nue sur des coussins et montrant effrontément sa laideur, ses jambes trop courtes, son buste ignoble et son sourire bête. Car j'en reviens à cela, c'est la spécialité de Manet de faire bête ...' *La Gazette de France*.

28 'Cette bizarre *Olympia* qui semble faite exprès pour agacer les passants. Comme il arrive, l'excentrique qui n'a pretendu d'abord qu'*épater les bourgeois* est dupe de lui-même ...' *La Liberté* (8 January 1884).

29 'Les bonnes choses du peintre Manet se trouvent diminuées ... par le souvenir de tant de médiocrités voulues. ... La plupart de ces toiles sont ce qu'on appelle dans le langage actuel, des pétards, c'est-à-dire du bruit, quelque chose comme une fausse nouvelle à laquelle ne se trompent point ceux qui la lancent et qui sans valeur réelle, a, quand même, le privilège de forcer l'attention.

 Il n'y a pas longtemps que Gustave Courbet ... est mort. Ce fût aussi un homme à pétards et qui, dans sa jeunesse, et même plus tard, porta plus d'un défi à l'opinion publique.' *Le Soleil*.

30 See Marie-Claude Genet-Delacroix, 'Vies d'artistes: art académique, art officiel et art libre en France à la fin du XIXe siècle', *Revue d'histoire moderne et contemporaine*, vol. 33 (January–March 1986), pp. 40–73.

31 *Le Figaro*.

32 *La Gazette de France*.

33 'Impuissant et orgueilleux en même temps, il n'a jamais eu l'énergie d'accomplir jusqu'au bout sa tâche d'artiste; il s'est arrêté toujours devant le travail qui constitue seul la création. ... Il a eu d'innombrables velléités, et n'a pas fait acte, une seule fois, de volonté durable et sérieuse. ... Aigri par la vie, par la conviction intime qu'il a du peu de place qu'il tient dans ce Paris qu'il avait rêvé de dominer, le peintre au tempérament nerveux en vient à ne concevoir plus l'humanité que par le côté grimaçant. Dans la femme il ne voit plus l'âme, le sourire captivant et doux; dans l'homme il ne cherche plus la pensée, l'intelligence expansive ou recueillie; les créatures vivantes ne lui apparaissent plus que comme des pantins multicolores; il les saisait au moment où ils dansent dans la lumière et il les abandonne de suite, car, préoccupé toujours de son propre *moi*, superficiel par égoisme et inattentif aux autres par vanité, il ne prend pas la peine, comme les vrais artistes, d'interroger, de scruter, de confesser son modèle afin de rendre visible l'être intérieur.' *La Liberté*.

34 'Faire des barricades dans l'art comme d'autres en faisaient dans la rue. Ainsi n'est-ce pas sans étonnement que l'école des beaux-arts a vu s'installer chez elle les oeuvres de cet adversaire irréconciliable, comme autrefois la foule en guenille envahissant les Tuileries'. *La Gazette de France*.

35 For the dialogical structure of discourse see Mikhail Bakhtin's work in V. N. Volosinov, *Marxism and the Philosophy of Language* [1930], trans. L. Matejka and I. R. Titunik (New York, 1973), and Tzvetan Todorov, *Mikhail Bakhtine: Le Principe dialogique suivi des écrits du cercle de Bakhtine* (Paris, 1981). See also Julia Kristeva, *La Révolution du langage poétique* (Paris, 1974).

36 Jean-Jacques Courtine, 'Quelques problèmes théoriques et méthodologiques en analyse du discours, à propos du discours communiste adressé aux Chrétiens', *Langages*, no. 62 (June 1981), pp. 23ff. See also Michel Pêcheux, 'L'Etrange Miroir de l'analyse de discours', *Langages*, no. 62 (June 1981), pp. 5 – 8.

37 See Orwicz, 'Anti-Academicism'.

38 Edmond Bazire, *Manet* (Paris, 1884).

39 Bazire, *Manet*, pp. 1 – 2.

40 'D'humeur égale et gaie, jamais indiscipliné ... C'était alors un garçon délicat, svelte, la figure pâle et douce; il portait en lui, sous la grossière vereuse, la distinction qui ne l'abandonna pas.' Bazire, *Manet*, p. 2.

41 'Vainement ses ennemis essayaient-ils de faire de lui un rapin hirsute, aux habits tachés de couleurs et d'huile, dégingandé, mal-appris ou mal-élevé.' Bazire, *Manet*, p. 24.

42 'Mais au contraire, il aimait l'élégance, fréquentait le monde, charmait par la distinction de ses manières et la finesse de son langage. Il avait, d'ailleurs, l'abord le plus sympathique: d'une taille élancée, il portait bien la tête, qu'une barbe blonde, très soignée, encadrait. Le teint était rose, et le visage régulier s'égayait à la vivacité de ses yeux et au sourire quelque peu moqueur de ses lèvres; on eût eu de la peine à rencontrer un homme plus séduisant que ce monstre.' Bazire, *Manet*, p. 24.

43 Bazire, *Manet*, pp. 15 and 25ff. The importance of establishing coherence in Manet's career as a way of positioning him within the category of 'official' artists is suggested by the writer for the socialist *La Bataille*, for whom the mere ability to periodise Manet's production was enough to disqualify him

from 'independent' status: 'Il y a dans Manet trois peintres, ce qui est inexplicable chez un independant' (8 January 1884). For the profile of 'official' artists during this period, see Genet-Delacroix, 'Vies d'artistes'.

44 'Il était un homme d'excellent monde, gai, emporté, bien doué, aimant la lutte pour ce qu'elle a de capiteux dans ce centre parisien.' *La République Française* (7 January 1884).

45 'D'un naturel ardent, suffisamment énergique pour ne pas craindre la lutte, il était cependant d'un esprit trop correct et d'une éducation trop soignée pour la faire dégénérer en violence.' *Le Siècle* (9 January 1884).

46 See Linda Nochlin, 'The depoliticisation of Gustave Courbet: transformation and rehabilitation under the Third Republic', chapter 6 in this volume; on Courbet and languages of class, see Jean-Pierre Sanchez, 'La Critique de Courbet et la critique du réalisme entre 1880 et 1890', *Histoire et Critique des Arts*, nos. 4–5 (May 1978), pp. 76–82.

47 'La tentative étant hardie; mais nous n'en éprouvâmes pas grand contentement. Le meilleur, c'est le paysage et cette femme, en chemise, qui se baigne. L'*Olympia* ne nous convertit non plus.' *La République Française*.

48 See Roger Marx, *Journal des Arts* (11 January 1884) and *Le Voltaire* (7 January 1884); Sutter Lanmann, *La Justice* (6 January 1884); Nestor, *Gil Blas* (9 January 1884); Fermin Javel, *L'Evénement* (6–9 January 1884). See also Albert Leroy, *Le Réveil* (8 January 1884), Henry Havard, *Le Siècle* (9 January 1884), and Paul Mantz, *Le Temps* (16 January 1884).

49 See, among others, Javel, *L'Evénement*, and Marx, *Journal des Arts*.

50 See, for example, Bazire, *Manet*, pp. 44ff.

51 The argument came from the preface to the 1867 exhibition catalogue: ' "M. Manet n'a jamais voulu protester. C'est contre lui qu'on a protesté au contraire, parce qu'il y a un enseignement traditionnel de formes, de moyens, d'aspects de peinture, et ceux qui ont été élévés dans de tels principes n'en admettent plus d'autres" '. *Le Voltaire*, and Bazire, *Manet*, pp. 35ff and 44ff.

52 'Un peintre bafoué, raillé, repoussé ... comme un pestiféré, c'est-à-dire comme un artiste original. Maintenant du moins on peut les étudier, ces fameux tableaux, effroi des jurys officiels.' Javel, *L'Evénement*.

53 For the promotion of Rousseau, Daubigny and Corot in similer terms, see Jules Ferry, 'Discours prononcé à la distribution des récompenses aux artistes exposants du Salon de 1879', in *Explication des ouvrages de peinture, sculpture, architecture, gravure et lithographie des artistes vivants, 1880* (Paris, 1880), p. vi.

54 'Les amitiés dangereuses commencèrent à s'emparer complètement de Manet. ... Eux qui avaient tout à gagner au tapage et au scandale, ils le forcèrent à se jeter dans la mêlée. ... Pour Manet, ces amitiés ont eu le grand inconvénient de l'exproprier de lui-même. Il devint, grâce à elles, l'incarnation de théories vagues, incertaines, jamais bien définies, dont il devait, bon gré mal gré, poursuivre l'application à l'outrance.' *Le Siècle*.

55 'Ce qui n'est nullement douteux, c'est qu'il fut pris, très tôt, d'une passion vive pour le dessin ... L'élève ... fut séduit par le charme des lignes.' Bazire, *Manet*, p. 2.

56 Bazire, *Manet*. For the implementation of drawing instructiuon at all levels of public education and its relationship to the regeneration of industrial

production, see Eugène Guillaume and Jules Pillet, 'L'Enseignement du dessin', *Mémoires et documents scolaires publiés par le Musée pédagogique*, 2nd series, no. 36 (1889); and Christian Mauve, 'L'Art à l'Ecole?', *Les Révoltes logiques: l'esthétique du peuple* (1985), pp. 131–44.

57 'Le dessin, qui fut sa première force et qui est resté sa force, à lui qu'on accusa de ne pas dessiner'. Bazire, *Manet*, p. 10.

58 Bazire, *Manet*, chapters 2 and 3; Albert Boime; *The Academy and French Painting in the Nineteenth Century* (London, 1971). See also Boime, *Thomas Couture and the Eclectic Vision* (New Haven, 1980).

59 See below.

60 'Couture n'etait pas d'une douceur extrême et il n'aimait pas surtout que l'on s'émancipât. Il entendait que ses disciples ne sortissent pas du cercle de ses leçons. Il voulait se perpétuer dans l'oeuvre des jeunes gens qu'il dirigeait. Il avait la prétention de former de petits Couture et de niveler à sa taille toutes les individualités coupables de se manifester'. Bazire, *Manet*, p. 5.

61 'Le passionné peintre des chairs languissantes et poudrées-de-riz. [Elle] ... montra inopinément d'extraordinaires témoignages de force, de couleur, de précision. Dans son oeuvre, rien ne s'abandonne; les contours sont nets et serrés; les colorations ne s'affadissent jamais. Elle a des nerfs calmes et des impressions sûres. ... Manet avait ajouté aux indications de l'efféminé enchanteur les rudesses justes de sa manière. [Henceforth] Il y avait en Mlle Gonzalès la combinaison de deux natures contraires,, analysées par un esprit libre et serein, qui faisait de cet amalgame inattendu sortir une originalité. ... partie des mièvreries énervantes de Chaplin, elle arriva, – par la longue étude et une saine direction, – à fournir des notes énergiques, masculines, humaines.' Bazire, *Manet*, pp. 76–7.

62 'Exerça ... en des scènes de genre bien féminines par la conception et très viriles dans l'exécution'. Bazire, *Manet*, p. 72.

63 Tamar Garb, ' "L'Art féminin": the formation of a critical category in late nineteenth-century France', *Art History*, vol. 12, no. 1 (March 1989), pp. 44ff, and Anne Higonnet, 'Imaging gender', chapter 8 in this volume.

64 'Une education précise mais libre'. *La République Française*.

65 'Sa personnalité s'affirmait nettement'. 'On ne retrouvait plus en lui l'inspiration étrangère; il faisait acte de novateur', p. 66.

66 'Ce Polichinelle n'est pas Italien, il est bien Français. Il a le costume ou le déguisement du *pupazzo*. Il n'est cependant pas du tout étranger. Le modèle est parmi nous, ce n'est pas contestable. Il a ses brutalités et ses insolences; ses insolences et ses brutalités n'ont point franchi les Alpes' (p. 85). On the reference to Marshal MacMahon and the seizure of Manet's prints of Polichinelle by the police, see Juliet Wilson-Bareau, 'Manet and the Execution of Maximilian', in Juliet Wilson-Bareau (ed.), *Manet: The Execution of Maximilian. Painting, Politics and Censorship* (London, 1992), p. 72.

67 'La valeur de Manet n'est pas limitée à ses tableaux ... elle est aussi dans son rôle de régénérateur. ... Son exposition renferme un ensemble d'indications qui résument tout l'art moderne. Ses *cafés concerts*, ses *restaurants*, ses *canotages à Argenteuil*, toutes ces scènes prises sur le vif et enlevées en pleine lumière, ont servi de modèles à l'école contemporaine. Les impressionistes se sont formés en étudiant ses paysages ... la finesse de tous ses pastels, les a fait

accepter par les plus académiques et les plus difficiles. ... Si les artistes se jugent autant à leur influence qu'à leurs oeuvres, on doit assurément considérer Manet comme un maître. Il a été un des instigateurs les plus énergiques de la peinture claire, étudiée dans le plein jour du milieu moderne; il a tiré peu à peu nos Salons de leur noire cuisine au bitume et les a égayés d'un coup de vrai soleil.' *Journal des Arts*. See also Marx, *Le Voltaire*; Burty, *La République française*; and Gustave Geffroy, *La Justice* (29 – 30 January 1884).

68 'En se modernisant ... [Manet] se souvienne qu'il est parisien et trouve dans cette vaporeuse atmosphère qui entoure les gens et les choses à Paris, de vrais et vivants sujets d'études pour ses plein-air qui vont révolutionner l'art moderne et porter l'effroi dans le camp des pompiers de l'Institut. ... A partir de ce moment [1873], l'artiste a jeté au vent toute la défroque du passé. Il s'affirme grand peintre et s'attaque en plein air avec un courage qui a fait l'admiration de tous ceux qui l'ont connu. Dans le papillotement de la lumière crue du soleil ou de la clarté jaunâtre du gaz, il a su fixer l'impression reçue par l'oeil en procédant par larges touches, au moyen de valeurs savamment combinées, laissant à la lumière ambiante le soin de mettre les valeurs en opposition, de façon à produire l'effet de la réalité.' *Le Reveil*.

69 'Des principes qui ont fait la grandeur des écoles anciennes et modernes. ... faux et maniéré', Nestor, *Gil Blas*.

70 Henry Havard, *Le Siècle*.

71 'Inventés par les misérables de la décadence italienne!', Gustave Geffroy, *La Justice*.

8

Imaging gender

ANNE HIGONNET

In 1892 the art critic Fanny Field Hering translated Frédéric
Masson's mid-century words about the painter Jean-Léon-Gérôme:

> What the pen cannot describe is the loving sweetness of those eyes,
> the look of resolution and virility which is the predominating
> characteristic of this physiognomy, the will to understand and press
> onward expressed by the whole personality ... To seek, to attempt,
> to undertake, this is what is necessary to [his paintings'] existence –
> *not to dream!* Their intellects, exact and keen, demand facts, not
> phrases. A search for the truth is Gérôme's uninterrupted occupation.
> It is this conscientiousness in research which binds together all his
> work ...[1]

That same year the art critic Gustave Geffroy wrote about the
painter Berthe Morisot:

> And here affirms itself an art of delicious hallucination, of a truth
> vaguely fantastic, that evokes the clear shadows in this forest light,
> from the depths of the water, from the pure crystal where it suits this
> woman who is a rare artist and who accomplishes that rarest thing:
> a painting of reality observed and living, a delicate painting, caressed
> and present, – which is a feminine painting.[2]

Each critic not only spells out the gender they assign their images
and their artist – 'the look of resolution and virility', 'a feminine
painting' – but reinforce gender labels with constellations of
attributes which in their time carried clear gender connotations.
One text endows Gérôme's virility with the 'will to understand',
because it 'presses onward', 'seeks', 'attempts', 'undertakes',
'demands facts', is 'keen', 'exact', 'uninterrupted', 'conscientious',
and based on 'research'. The other text discretely describes
Morisot's femininity as belonging to her work rather than her
person – lest the woman become too noticeably an author – with
the words 'delicious', 'hallucination', 'vaguely fantastic', 'evokes',

'pure', 'crystal', 'rare', 'observed', 'living', 'delicate', 'caressed', and 'present'.

Of course these passages mark extreme positions in late-nineteenth-century French criticism of painting. Between Gérôme and Morisot, Hering and Geffroy, stretches a continuous spectrum of gender attributions. However extremely or moderately, art criticism sought – among other tasks it set itself – to write the gender of the image. By means which were, internally speaking, generally consistent, art critics designated the subjects of their texts as being more or less masculine or feminine.

In a broad, vague sense, art critics attributed gender to paintings in order to conform their writing to the habits of their highly gendered and gendering culture. More specifically, critics wrote the gender of paintings in order to position their texts advantageously in relation to the images about which they wrote, and to position their texts and the images about which they wrote together advantageously in relation to all other aspects of visual culture. Writing the gender of the image was not an incidental feature of art criticism, but an intrinsic and crucial strategy by which art criticism defined its cultural functions.

Let me begin therefore with the internal logic of art criticism's gendering of painting, and then work backwards and forwards in time across its theory and practice in a wider field of visual culture. By art criticism I mean (provisionally) writings that purported to evaluate paintings, whether those texts appeared in general-interest newspapers, specialised periodicals, monographs, or catalogues.

According to what criteria did art criticism assign masculinity or femininity around 1890? What correspondence did it establish between aspects of a painting and their gender? The answers are all the more consistent in that the same criteria were applied whether judgement, in the end, was positive or negative. Only the interpretation of the criteria changed.

The situation would seem simpler if art critics had termed all work authored by women feminine, and all work authored by men masculine. Yet this was not the case. The painter Rosa Bonheur and the sculptor Camille Claudel, though women, were described as either neutral, or masculine. Mathias Morhardt wrote of Claudel in 1898: 'Mademoiselle Camille Claudel is less, in fact, a woman than an artist – a great artist – and her works, few though they may still be in number, confer on her a superior dignity. ... She is of the race of heroes!'[3] A male painter like Pierre-Auguste Renoir, for example, could be termed feminine, by Théodore de Wyzéwa in 1890: 'He was, of all the Impressionists, the most

delicate, the most feminine, the one in whom we recognised the most perfect expression of our somewhat sickly sentiments.'[4]

The argument proceeded along two axes. According to a first, iconographic axis, masculine art was intellectual. This meant that its iconography must be the product of study, preferably the study of classics and antiquity, of mythology, history, or foreign places and cultures. Alfred de Tanouarn praised the quintessentially masculine painter Jean-Léon Gérôme in 1865:

> Assuredly, to represent an animal, a tree, a flower, there is need of correct judgement, a poetic spirit, and a skilful pencil; but to attack historic genre, entirely different arms are necessary ... one can only represent, in their striking reality, the nations and heroes with whom one has become familiar through study and reflection. Here science is not the enemy of inspiration, since, on the contrary, inspiration cannot spring forth where there is no science.[5]

Gérôme was acclaimed through the last four decades of the century for his exotic field trips, as was the painter of military anecdotes Detaille for his scholastic precision. Subjects such as these, at a distance from the quotidian, belonged to the domain of the ideal, where true beauty was possible, where the spirit improved matter. Only the power of the spirit created art.

By contrast, personal experience of a subject was feminine. A lived subject could be painted by instinct and required little reasoning. Roger Marx, for example, wrote on the quintessentially feminine painter Berthe Morisot in 1907: 'Nowhere does Berthe Morisot appear more personal, more exquisite, and never, really, has there been so decisive a harmony, so close a correlation, between facture's expeditious, instantaneous quality, and the nature itself, so impulsive, of the artist.'[6]

Women were themselves a more feminine subject than men. The least intellectual subject, the most inconsequential, was therefore the contemporary woman pictured in the course of daily life. Joining this criterion to the criterion of experience, we can easily understand why Morisot, whose chief subject was the daily life of women like herself, would seem to incarnate femininity in painting. Stéphane Mallarmé characterised Morisot as 'she of whom current praise decrees that her talent denote woman'.[7]

According to a second, stylistic, axis of argument, drawing was masculine and color feminine. Drawing, understood as the linear outline of volumes, functioned by the fixed rules of anatomy and perspective, and built a painting rationally. Color, on the other hand, was deemed treacherous or unstable. By the end of the nineteenth century these distinctions had a long history, recapitulated

in popular pedagogical treatises such as those by Paillot de Montabert or Charles Blanc. According to both Montabert and Blanc, the deployment of linear technique disciplined a harmonious disposition of volumes in pictorial space, as well as the homogeneous diffusion of light that created both volumes and space and unites them. Morisot however, to return to our feminine reference point, built forms with color, sometimes outlining volumes with colored line, but more often working chromatic nuances against each other to represent volumes and space.

A distinguished performance in one category could mitigate weakness in another. If an artist's iconography were not cerebral enough, a magisterial technique might suffice. The mastery of line and form was recognised as powerful knowledge in the cases, for instance, of Bonheur, Edouard Manet and Edgar Degas. Conversely, even a learned technique could be afflicted by its subject: Charles Chaplin, Alfred Stevens and James Tissot, who specialised in the subject of modern woman, flirted dangerously, in the eyes of critics, with a feminine identity. The allegation of femininity could just as well be directed by the *avant-garde* at conservatives as vice-versa. Edmond Duranty chastised painters like Chaplin, Stevens and Tissot in his famous manifesto *The New Painting*.

> Others, their rivals, follow the footsteps of Fortuny. They have discovered shimmering iridescences, brilliant highlights, and scintillating contrasts. They turn out a virtuoso pageant of arpeggios, trills, chiffons and crepons derived without benefit of observation, thought, or the desire to examine. They have dressed up, made up, and prettied Nature, covering her with curls and frills. Like hairdressers, they have coiffed and styled her as if for an operetta.[8]

Almost any painter could be graphed along these two axes, iconographic and stylistic, and thus situated in the territory of visual gender.

In short, masculinity was perceived by critics as objective, while femininity was subjective. The masculine painter established a critical and intellectual distance from his work, while the feminine painter extended herself into her work. This gendered opposition of objectivity to subjectivity was reinforced in art criticism by the extent to which a critic spoke of a painter as a personality detached from his paintings. Long passages evoke Gérôme's house, his travels, his social life, his riding, his personal appearance. Hering explained in 1892: 'Whoever would fully understand the work of Gérôme ... must know him not only as painter, sculptor, poet, savant, and teacher, but as *man*.'[9]

In Morisot's case, at the other end of the gender spectrum, the artist had no authorial existence or independent personality; her only public attribute was her connection by marriage to Edouard Manet's family. Moreover, critics repeatedly suggested that Morisot's work suffered from exhibition and belonged instead to a secluded domain which might be evoked but should remain hidden from a public gaze.

The form of art criticism carried its message even more compellingly than its content. Embedded in art critics' use of language itself lay their best claim to their own power. For by the very way in which they wrote about gender, they defined the values of painting in relation to the values of the word, the word over which they were exercising control.

A differentiation of feminine and masculine as the difference between subjectivity and objectivity was written into the rhetorical construction of critical texts. A discourse of femininity unfolded in juxtapositions, suggestions, strings of phrases heavy with adjectives. The language of femininity spoke of dreams, hallucination, evocation. The feminine image sprang unconsciously from primal elements, made of ephemeral qualities and substances that verbal description pursues without reaching. As early as 1878, Théodore Duret wrote:

> Colors, on Mme Morisot's canvases, acquire a delicacy, a smoothness, a remarkable *morbidesse*. White is nuanced with reflections that lead from the nuance of old rose to ash grey, carmine passes imperceptibly into peach, the green of foliage takes on all accents and palors. The artist finishes her canvases by placing light touches here and there, over the background; it's as if she were brushing flowers.[10]

According to this critical discourse, the word carried meaning not only grammatically, but as allusions that accompanied the text without belonging to it. The language of femininity induced the reader to recall something outside the text. Its words described color, the intangible, sensations, the ineffable immediate: intimations of a world without words, preceding words, preceding reason. Gustave Geffroy wrote in his preface to a catalogue of Morisot's work in 1892:

> beyond any painting usually seen, a special atmosphere emanates from colored surfaces ... a tender luminosity ... a grace of gesture and smile ... it is a light that wanders in the woods ... that illuminates itself with the diamond drops of rain and the gleam in precious stones of insect flights ... this natural clarity ... It seems as if the light ... must have penetrated by infraction, through a crystal limpid as a block of ice. It has maintained its blue tenderness and its green ash, and it has

developed a fragile sparkle, it diffuses itself in new palpitations that quiver and twinkle ... It's a shiver of flesh beneath the atmosphere's caress ... a luminous exaltation ...[11]

Rhetorical references to the elementary, to intuition, and to the natural situated the feminine prior to the word and its rationalisations. Femininity was represented, by both signifier and signified, as preceding language, as a mode of expression that took place outside linguistic consciousness. Charles Ephrussi wrote of Morisot's work in 1881:

> Subjects for her are only of secondary importance, almost insignificant, they are merely pretexts for luminous effects, for harmonious combinations accepted or rather tolerated so that the eye can pause on a perceptible form, but whose lines and contours are barely determined... two other pastel sketches mark the extreme limit at which the painter's tendency to content herself with too fugitive indications must cease; one step more and nothing could be discerned, nothing could be understood.[12]

Feminine painters merged with their subjects, understood them from within, represented them without mediation, and created images through which the viewer too could lose herself or himself in a lyrical identification. André Fontainas wrote of Morisot's work in 1902:

> No affectation. The woman displays no belief in superiorities; indeed she has confronted nothing, except herself. By an intuition, rather than by a usurping will, her brush ingeniously attracts to itself every delicate universal marvel, and we know, henceforward, that the palpitating pulp of flowers, the murmuring fronds, and the silences of water in summer gardens, the shivering atmosphere of calm clear days, equal in ecstasy [ivresse] the frail colored radiance of her face and eyes, the sighing inflexions of her supple voice, her gazes, the trembling emotion of her lips, the generous agitation of her splendid bosom. She is, in festive nature, the inevitable center, luminous and divine.[13]

Feminine painting elided distinctions between self and other − painter and subject, spectator and painting, and, therefore, subject and painting.

Art criticism by its language invested femininity with an ideological interpretation. By situating femininity prior to reason, the art critic enunciated the difference fundamental to social gender relations. From the situation of the feminine outside the domain of language and conscious creation sprang all other critical arguments concerning femininity and women's art. Yet the purpose closer at hand, more nearly intended, more immediately effective, of art

criticism's gender rhetoric was to consolidate its control over high culture. Femininity provided a way to define the iconicity of the image with written language.

Art criticism's promotion of painting's iconicity depended both on chronology and on political point of view. Schematically, pure visuality became increasingly valued as the century drew to a close, a tendency led by the cultural left or '*avant-garde*' and followed by more esthetically conservative critics.

In 1876 Duranty may have alleged the femininity of painters like Chaplin, Stevens and Tissot, who were stylistically conservative despite their commitment to innovatively contemporary themes, but he was still in a minority. Other critics recuperated the same painters as depictors *of* the feminine, in a subtle distinction from femininity itself. Until around 1890, most stylistically conservative painters – such as Gérôme, Bonheur, Detaille, Chaplin, Stevens or Tissot – tended to be characterised as masculine. Meanwhile younger *avant-garde* painters, Naturalists or Impressionists, were often labelled feminine hysterics, compared with an earlier *avant-garde* generation which in retrospect began to seem more masculine. In 1886, the critic Jean Dolent visited that year's Impressionist exhibition. To him, Manet's influence seemed effeminate, but Gustave Courbet's would have been a guarantor of masculinity. He wrote of the Impressionists:

> Several no doubt were thinking of M. Manet; none leaned towards M. Courbet. He [Dolent, enhancing his own objectivity with the grammatical use of the third person] thus attributed to these artists who were so passionate, a bit sensitive, febrile even, a feminine temperament; he sought for the male and did not find it.[14]

Edouard Manet was among the painters whose gender evaluation shifted most conspicuously. At first often characterised as a rebel who could not or would not conform to the rules of the Grand Tradition, he quickly became the incarnation of new rules, those of Modernism, which claimed him as its Father. In his re-gendered wake followed – in ascending order of femininity – Edgar Degas, Claude Monet, Camille Pissarro, Alfred Sisley, Mary Cassatt, and Pierre-Auguste Renoir. (Though a painter of feminine domestic scenes and a woman herself, Cassatt's style earned her the occasional tribute of masculinity.) Morisot remained unredeemably feminine. Gérôme virile? What made Manet seem impotent from an Academic point of view made him seem masterful from an *avant-garde* point of view, which then overturned Gérôme's reputation; Gérôme, whose linearity came to seem fastidious and his eroticism saccharine. And of course the evaluations continue to change.

Modernist macho has given way to Post-modernist *laisser-faire*; Gérôme and Manet are now both well-hung in museums.

The values art criticism articulated and defined in opposition to each other as being those of gender structured the relationship between late-nineteenth-century images and texts, even when gender was not ostensibly at issue. Beyond its use of a rhetoric of gender to situate paintings relative to each other, art criticism used gender values to situate itself in relation to all images. Beyond a discourse that attributed gender to particular painters or paintings, the rhetoric of femininity contributed powerfully to a definition of visual signification as its difference from textual signification. For conservative critics, for almost all criticism prior to Impressionism, the 'feminine' image was the predominantly visual image, while the 'masculine' image retained some narrative significance. Iconicity, or the autonomy of formal qualities, was associated with femininity, while textuality, or the subordination of formal elements to their communication of something other than themselves, was associated with masculinity. The feminine image was about itself; the masculine image was a part that stood for a whole outside itself, metonymically evoking a sequence of meanings of which it was only one segment. Masculine images told their own stories, feminine images had their stories written for them by art critics.

Theory and practice followed the same course. *Avant-garde* art criticism evolved into a literary genre, attracting an increasing number of eminent authors, writers as successful in other genres as Charles Baudelaire, Emile Zola and Stéphane Mallarmé.[15] Their critical texts described the image more and more lyrically. What mid-century critics had deprecatingly called feminine, *fin-de-siècle* critics called pictorial genius. Oscar Reutersvärd has described how by the end of the century an initial condemnation of the Impressionists' visual preoccupations turned into praise of a scientifically accurate physiological perception.[16] André Mellerio wrote in 1900: 'In the pursuit of their goal they [the Impressionists] have adapted, benefiting from the scientific attainments of their time and from works concerning color, a technique that increasingly approximates the effects of light.'[17] Monet, especially, received the accolade attributed to Paul Cézanne: 'Only an eye, but what an eye!'

The ideological value awarded to images by criticism presented itself as the objective response to the spontaneous abstract lyricism of art. Painting purported to spring from a primordial source, as the artist and the art historian affirmed that Great Painters paint 'what they see', locating pictorial intelligence in the organic eye.[18] By the end of the Impressionists' careers, art criticism admitted

the compatibility of a primarily visual signification with High Art. Painting no longer had to be narrative to belong to the *grande tradition*. The Impressionists' insistence on the visuality of their work, on painting as the record of intuitive optical sensation was now the sign of their artistic greatness. It was, again, above all through Monet's work that art criticism expressed the new values of Modern painting: an art of pure vision.[19] No painter had ever collaborated so closely with his admiring critics.

Art criticism evolved dyadically with easel painting. The values of image and word that both art criticism and painting purported to separate existed as functions of each other. More insistently than any other literary genre, art criticism affirmed a distance between the image and the word, confirming the possibility of speaking of the image incessantly but objectively. Yet if art criticism took painting as its point of rhetorical departure, painting, inversely, passed into the domain of high culture through art criticism; a painting existed as a part of legitimate pictorial culture only if it was situated there by the art-critical system. The volume of words increased in proportion to the importance accorded to the visual. The more silence was valorised, the more it was written about. Art criticism approached at the beginning of the twentieth century no closer to visual meaning than it had in the mid-nineteenth; it still kept the image at a distance from its text. The figure remained pre(-)text, allowing figure and text to ratify each other's definition of high culture, each other's definition of cultural power.

I am not challenging nineteenth-century definitions of visual and textual signification. But I do question the myth of their autonomies. Despite its pretence to objectivity, art criticism worked to create a meaning in pictorial culture that tied the image to the word. This meaning-in-between will always be elusive; perhaps one of its functions is to be a meaning that can always be denied. The historical significances of the art-critical text, it seems to me, are the modalities of its role in a dynamic of silence and enunciation, presence and absence, by which the text engages its words with images.

Late-nineteenth-century art criticism worked to situate its definition of visual femininity in an ideological context. It created a situational meaning for the images to which it refers. This meaning was neither intrinsic to the work nor to the critical text; it floated in between, in the resonant ideological space that hovers between the words of the art-critical text and the images it purports to describe. Perhaps an easier way to assess this meaning would be to remember images of another era: the mural paintings in Renaissance or Baroque churches and palaces, for instance.

Such images may mean something in themselves, and so may their architectural setting, as well as the ceremonies that occur in that setting. But yet another kind of meaning is the meaning inherent in the relationship among all three: image, setting, and ceremony. If we thought of a site as being only ostensibly a tangible place, and more broadly an ideological economy or ecology, then situational meaning could describe the cultural function of art criticism. For in the late nineteenth century, it was art criticism that provided the image with a cultural ecology. As Victor Hugo so influentially observed in *Ceci tuera cela*,[20] the printed word had succeeded to architecture as the most eloquent exponent of cultural values.

The means had changed by the late nineteenth century, but not the ends. What was the purpose of situation before the advent of the art critic, but the placement of art in a political context, the involvement of art in the visual tactics of cultural power? And what was femininity as a category of critical thought but the involvement of images in contemporary sexual politics? If the discourse of femininity in art criticism can be thought of as an intermediary between painting and public, it is only inasmuch as art criticism created an ideological frame for the image, a message other than its visual content. Critical situation assigned meaning to the image by giving it a cultural context, a meaning that bound the image to contemporary ideological issues.

Gender might have intended only to affirm the dominance of painting and art criticism rhetorically, but it implicated actual women, and materially affected women's artistic opportunities. When someone like Mallarmé translated James McNeill Whistler's 'Nature who, for once, has sung in tune, sings her exquisite song to the artist alone, her son and her master – her son in that he loves her, her master in that he knows her,'[21] in 1888, he wrote in metaphors, but in metaphors that could be literally applied.

Nature was a woman. The artist was a man. The artist mastered nature. Art criticism kept women in their place – a culturally marginal place. It is certainly true that women were entering the painting profession in growing numbers by the end of the century. Tamar Garb has shown how women were not only lobbying for entrance into exclusively male professional institutions like the Académie des Beaux-Arts and forming professional organisations of their own like the *Union des femmes peintres et sculpteurs*, but were even being assimilated into the conservative discourses of femininity and nationalism, voiced notably in the *presse féminine*: what in English would be called women's magazines.[22]

Art criticism, however, effectively contained women's professional endeavours. The immense majority of these new female

painters were stylistically and conceptually conservative. They had not heeded the terms on which *avant-garde* critics redefined high art. Morisot and Cassatt remained exceptions: women who were not just professional painters, but were integrated into the heterogeneously visual and verbal élite of high culture. It was much more difficult for women to accede to the positions that controlled the terms of painting's canon than it was for them to merely produce paintings.

In the simplest sense, women virtually never became high art critics. A glance through the other essays in this volume confirms art criticism's exclusively male roster. While in the first half of the century Georges Sand had at least incorporated probing suggestions about the gendered structures of the art world into several novels,[23] and Anna Jameson could lay claim to being England's first professional art historian,[24] women did not join the increasingly prestigious ranks of *avant-garde* painting critics. The Modernist word remained resolutely masculine.

More fundamentally, women were artistically restrained by the very voices that seemed to speak for and about their talents. Both Ann Pullan and Garb have shown that women's painting was promoted by women's magazines.[25] Citing both texts and visual evidence in the form of fashion plates from magazines like *La Belle Assemblée, La Famille*, and *La Gazette des femmes*, Pullan and Garb demonstrate that painting in some form had become quite an acceptably feminine activity. The two most elegant French women's magazines of the late nineteenth century, *Le Moniteur de la mode* and *La Mode illustrée*, along with the most popular magazine of the same type, the *Petit Echo de la mode*, similarly used fashion plates depicting women at work with brush and easel to confirm the femininity of art-making. Yet by presenting women's painting in conjunction with other visual practices ranging from the viewing and purchasing of art objects through fashion and domestic crafts, the women's magazine as a whole, and the fashion plate in particular, associated what appeared to be high art with what was culturally marginal.[26]

There was painting – and there was Great Painting. The very fact that images of women painting appeared so much more frequently in women's magazines than in other types of periodicals, and even more so in fashion plates, acted to distinguish one kind of painting from another. That differentiation was simultaneously a triage by gender and by artistic status. Not only did women's magazines, such a powerful component of feminine visual culture,[27] show women at work on floral or domestic subjects in small formats, but, more insidiously, they declined to speak of

élite art to their audience. Virtually no women's magazines regularly published columns devoted to élite painting, let alone to *avant-garde* art (although, significantly, such columns did appear in some avowedly feminist periodicals). Columns evaluating élite art ran in either gender-neutral family magazines such as *L'Illustration* and newspapers such as *Le Siècle* or in distinctly masculine, specialised professional journals such as the *Gazette des Beaux-Arts*.

The kind of writing we somewhat automatically call 'art criticism' was in fact only the most élite fragment of a proliferating literature devoted to visual culture. Women's magazines, for instance, were packed with articles on various aspects of taste, taste understood both as practices of production and practices of consumption: how to buy a hat, which play to see, what linens to embroider, etc. By advocating with its increasingly specialised textual rhetoric a rarefied form of iconicity, *avant-garde* art criticism distanced itself as far as it could from the forms of visuality offered to women. Faced with both the commodification of art into a leisure industry and female incursions into that industry, *avant-garde* art criticism perfected a rhetorical strategy which at once set one kind of painting apart from the rest of visual culture, including many other kinds of painting, and allowed art criticism to maintain that status. Modernist privilege came with its own mechanism for self-defence and self-perpetuation.

This same mechanism, of course, contained the means of its undoing. However well-suited in the short run the rhetoric of gender was to the exclusion of women from the highest ranks of culture, in the long run any positive use of femininity as a concept was bound to lead women from the edges in toward the center of artistic power. The process was to be a slow one, but in the late nineteenth century it was already under way. Women could and did wield verbal influence over taste, as long as it remained within marginal domains. Take the case of Etincelle. Etincelle, the pen-name for a woman, managed to become a popular taste-maker with her own column in the extremely well-read *Le Figaro*. Her advice gained enough currency to be gathered together into a book in 1881. On the whole, Etincelle confined herself to questions like what was *chic* and what was not. But that esthetically marginal position none the less allowed her to venture some opinion about high art, even if it was only to ratify conventionally gendered artistic roles. For men, according to Etincelle, 'all the arts are chic – especially painting'.[28] For women, only *bibelots* were definitely chic;[29] familiarity with the terms and the collection of the decorative arts were among the forms of knowledge that for women were 'useless', but 'of the highest interest'.[30] By the end of the century, as I wrote

at the beginning of this essay, a woman, Fanny Field Hering, felt able to write about Gérôme's painting. True, the words were not exactly hers but the translation of a man's, Frédéric Masson's. And Hering in 1892 was not championing a member of the currently powerful *avant-garde*, but instead merely ratifying the already established reputation of a safely conservative and elderly academician. Yet the incremental difference between Etincelle and Hering was only one of successively incremental differences that would eventually allow women the power of speech. The theory of gender's rhetoric cannot be reduced to the practice of female art critics. But neither can the possibilities of women's speech be excised from the abstract processes by which gender was represented and imaged textually. Even the marginalised words of someone like Etincelle, which mimic a masculine voice and hide behind an assumed name, even the words of someone like Hering, who translates one man's praise of another man's masculinity, these are words whose femininity is being altered, whose hybrid gender art criticism has elicited.

Notes

This text owes its existence to Thomas Y. Levin and D. N. Rodowick. It was first presented at a symposium on art criticism in late-nineteenth-century France at the University of Clermont-Ferrand in the spring of 1987, and an initial version published in *Genders* in the fall of 1988 (no. 6, pp. 60–73). My thanks to Dario Gamboni, Ségolène Le Men, and Michael Orwicz for their comments.

1 Fanny Field Hering, *The Life and Works of Jean Léon Gérôme* (New York, Cassell, 1892), pp. 27–8. Translated from Frédéric Masson, *Gérôme et son oeuvre*.

2 'En dehors de toute la peinture habituellement visitée, une atmosphère spéciale qui émane des surfaces colorées ... une tendre luminosité ... une grâce de geste et de sourire ... C'est une lumière qui a erré sous bois ... qui s'illumine des gouttes diamantées de la pluie et des éclairs en pierres précieuses des vols d'insectes ... cette clarté de nature ... Il semble ... que la lumière ait dû pénétrer par effraction, à travers un cristal limpide comme un bloc de glace. Elle a conservé sa douceur bleue et sa cendre verte, et elle a pris un éclat fragile, elle se propage en palpitations nouvelles qui frémissent et étincellent ... C'est un frisson de chair sous une caresse atmosphérique ... l'exaltation lumineuse ... Et voici que s'affirme un art de délicieuse hallucination, d'une vérité vaguement fantastique, qui évoque des ombres claires dans cette lumière de la forêt, du fond de l'eau, du cristal pur où se plaît cette femme qui est une rare artiste et qui accomplit une chose rare entre toutes: une peinture de réalité observée et vivante, une peinture délicate, effleurée et présente, – qui est une peinture féminine.' Gustave Geffroy, *Exposition de tableaux, pastels et dessins par Berthe Morisot*, Paris, Boussod Valadon et Cie (1892), preface; reprinted in *La vie artistique* (Paris, Dentu, 1892–5): 3e série, pp. 261–7.

3 'Mademoiselle Camille Claudel est moins, en effet, une femme qu'une artiste – une grande artiste – et son oeuvre, si peu nombreux encore qu'il soit, lui confère une dignité supérieure ... Elle est de la race des héros!', Mathias Morhardt, 'Mlle Camille Claudel', *Mercure de France* (25 March 1898), pp. 709, 755.

4 'C'était, de tous les impressionnistes, le plus délicat, le plus féminin, celui en qui nous reconnaissions la plus parfaite expression de nos sentiments un peu maladifs.' Théodore de Wyzéwa, 'Pierre-Auguste Renoir', *L'Art dans les deux mondes*, 3 (6 December 1890), p. 27.

5 Excerpted from Alfred de Tanouarn's *Salon de 1855*, on the subject of Gérôme's *Age of Augustus*, and translated in Hering, *Gérôme*, p. 3.

6 'Nulle part Berthe Morisot n'apparaît plus personnelle, plus exquise, et jamais, en réalité, ne se rencontra accord aussi décisif, corrélation aussi étroite entre la qualité du procédé expéditif, instantané et la nature même de l'artiste, toute du premier mouvement.' Roger Marx, 'Les femmes peintres et l'impressionisme, Berthe Morisot', *Gazette des Beaux-Arts*, 3e période (December 1907), p. 496, reprinted in 'Berthe Morisot', *Maîtres d'hier et d'aujourd'hui* (Paris, Calmann-Lévy, 1914).

7 'Celle dont l'éloge courant veut que son talent dénote la femme.' Stéphane Mallarmé, preface to the Durand-Ruel catalogue of Morisot's posthumous exhibition, 1896, in *Oeuvres complètes* (Paris, Gallimard, 1961), p. 537.

8 'D'autres, qui sont leurs rivaux, ont trouvé des chatoiements des éclats, des oppositions étincelantes, en marchant derrière Fortuny, tout un virtuosisme d'arpèges, de trilles, de chiffons, de crêpons, qui ne procèdent d'aucune loi d'observation, d'aucune pensée, d'aucun vouloir d'examen. Ils ont chiffonné, maquillé, troussé la nature, l'ont couverte de papillotes. Ils la traitent en coiffeurs, et la préparent pour une opérette.' Louis Emile Edmond Duranty, *La nouvelle peinture* (Paris, Dentu, 1876), p. 479, republished and translated in *The New Painting: Impressionism 1874–1886*, exh. cat. (San Francisco, The Fine Arts Museums, 1986), p. 41.

9 Hering, *Gérôme*, 1892, p. 1.

10 'Les couleurs, sur les toiles de Mme Morisot, prennent une délicatesse, un velouté, une morbidesse singulière. Le blanc se nuance de reflets qui le conduisent à la nuance rose thé au gris cendré, le carmin passe insensiblement au ton pêche, le vert du feuillage prend tous les accents et toutes les paleurs. L'artiste termine ses toiles et donnant de ci de là, par dessus les fonds, de légers coups de pinceau, c'est comme si elle effeuillait des fleurs.' Théodore Duret, *Les peintres impressionistes* (Paris, Heymann et Perois, 1878), pp. 29–30.

11 Geffroy, *Exposition*, pp. 261–7.

12 'Pour elle les sujets n'ont qu'une importance secondaire, insignifiante presque, ils ne sont qu'un prétexte à effets lumineux, à combinaisons harmonieuses acceptées ou plutôt tolérées pour que l'oeil puisse s'arrêter sur une forme sensible, mais dont les lignes et les contours sont à peine déterminés ... Deux autres croquis au pastel marquent la limite extrême où devre s'arrêter la tendance du peintre à se contenter d'indications trop fugitives; un pas de plus et on arriverait à ne plus rien discerner, à ne plus rien comprendre.' Charles Ephrussi, 'Exposition des artistes indépendants', *La Chronique des arts et de la curiosité*, XV, 17 (23 April 1881), p. 134.

13 Aucune affectation. La femme n'affiche pas une croyance à des supériorités: même elle ne s'est à rien, sinon à elle-même, confrontée. Par une intuition, et non par une volonté usurpatrice, son pinceau s'ingénie à apparier à soi toutes les délicates merveilles universelles, et l'on sait, désormais, que la pulpe palpitante des fleurs, les frondaisons murmurantes et les silences d'eau dans les jardins d'été, le frisson des atmosphères parmi les calmes journées claires, s'égalent avec ivresse au frêle éclat coloré de son visage et de ses yeux, aux inflexions soupirantes de sa voix souple, à ses regards, au tremblement ému de ses lèvres, à l'agitation généreuse de son sein splendide. Elle est, de la nature en fête, l'inévitable centre, lumineux et divin.' André Fontainas, 'Art moderne. Berthe Morisot,' *Mercure de France*, XLII (6 June 1902), pp. 811 – 12.

14 'Plusieurs songeaient sans doute à M. Manet; aucun n'allaient vers M. Courbet. Il [l'auteur] prêtait ainsi à ces artistes passionnés, un peu nerveux, fébriles même, un tempérament féminin; il cherchait le mâle et ne le trouvait pas.' Jean Dolent, *Le livre d'art des femmes* (Paris, 1877), p. 111.

15 See Dario Gamboni, 'Rapports entre champ littéraire et champ artistique', *Lendemains* 36 (1984), pp. 21 – 32, especially p. 22: 'Les capacités métadiscursives du langage viennent ainsi s'ajouter à son statut intellectuel pour renforcer la suprématie de ses utilisateurs légitimes, les littérateurs, sur les autres producteurs de biens symboliques.' Gamboni demonstrates, moreover (p. 27), how visual artists themselves are brought to the paradoxical defence of the image by means of the word.

16 Oscar Reutersvärd, 'The accentuated brushstroke of the Impressionists. The debate concerning decomposition in art', *The Journal of Aesthetics and Art Criticism*, X, 3 (March 1952), pp. 273 – 8.

17 'A la poursuite de leur but ils [les impressionnistes] ont adapté, bénéficiant des acquêts scientifiques de leur époque et de travaux relatifs aux couleurs, une technique serrant de plus en plus près les effets de la lumière.' André Mellerio, *L'exposition de 1900 et l'impressionnisme* (Paris, Floury, 1900), p. 12.

18 One way of gauging the evolution of this idea is to measure the distance between the critic Roger Ballu in 1877 and Jules Laforgue in 1903. Ballu writes about the Impressionists: 'Pour tout esprit sage et éclairé, l'impressionniste est l'artiste qui cherche à rendre l'aspect premier et comme instantané sous lequel un objet se présente au regard. – ... l'oeil semble n'avoir pas eu le temps d'analyser le spectacle qui est devant lui; il n'embrasse que l'ensemble, et c'est cet ensemble qu'on se propose de reproduire dans sa confusion complète. Une telle recherche, bien évidemment, ne constitue pas l'art, mais elle ne lui est pas contraire.' *Chronique des arts et de la curiosité*, V, 15 (14 April 1877), p. 147. Laforgue on the same paintings: 'Essentiellement l'oeil ne doit connaître que les vibrations lumineuses ... donc un oeil naturel (ou raffiné puisque, pour cet organe, avant d'aller, il faut redevenir primitif en se débarrassant des illusions tactiles), un oeil naturel oublie les illusions tactiles et sa commode langue morte: le dessin-contour ... l'objet et le sujet sont donc irrémédiablement mouvants, insaisissables et insaisissants. Les éclairs d'identité entre le sujet et l'objet, c'est le propre du génie ... Plus de mélodie isolée, le tout est une symphonie qui est la vie vivante et variante... comme l'Inconscient, loi du monde, est la grande voix mélodique résultant de la symphonie des consciences de races et d'individus. Tel est le principe de l'école du plein-air impressionniste.' 'L'art impressionniste', *Mélanges posthumes* (Paris, Mercure de France, 1903), pp. 135 – 6, 141, 137 – 8.

19 This critical phenomenon led to a considerable tension between the concepts of pure painting and decorative art. See: Robert L. Herbert, 'The decorative and the natural in Monet's cathedrals', in John Rewald and Frances Weitzenhoffer (eds), *Aspects of Monet* (New York, Abrams, 1984), pp. 160–79; Steven Z. Levine, 'Décor/Decorative/Decoration in Claude Monet's art', *Arts Magazine*, 51 (February 1977), pp. 136–9; Steven Z. Levine, 'Instant of criticism and Monet's critical instant', *Arts Magazine*, 55 (March 1981), pp. 114–21; and Richard Shiff, *Cézanne and the End of Impressionism* (Chicago University Press, 1984).

20 Victor Hugo, *Notre Dame de Paris* [1st ed. 1831] (Paris, Flammarion, 1967), pp. 198–211.

21 James McNeill Whistler, *Ten O'Clock* (Boston, The Riverside Press, 1988), p. 15. Mallarmé's translation: 'La nature qui, pour une fois, a chanté juste, chante un chant exquis pour le seul artiste, son fils et son maître – son fils en ce qu'il l'aime, son maître en cela qu'il la connaît', in Stéphane Mallarmé, *Oeuvres complètes* (Paris, Gallimard, 1961), p. 574.

22 Tamar Garb, ' "L'Art Féminin": The formation of a critical category in late nineteenth-century France', *Art History* 12, no. 1 (March 1989), pp. 39–65, reprinted in Norma Broude and Mary D. Garrard (eds), *The Expanding Discourse. Feminism and Art History* (New York, HarperCollins, 1992).

23 In *Lucrezia Floriani* (1846), *Elle et Lui* (1858) and most radically in *Consuelo* (1842).

24 See Adèle Holcomb, 'Anna Jameson: The first professional English art historian', *Art History*, 6, no. 2 (June 1983), pp. 171–87.

25 Pullan writes about England at the beginning of the nineteenth century, Garb about France at its conclusion. See Ann Pullan, ' "Conversations on the arts": writing a space for the female viewer in the *Repository of arts* 1809–1815', *Oxford Art Journal*, 15, no. 2 (1992), pp. 15–26; Garb, ' "L'Art Féminin" '.

26 See Garb, ' "L'Art Féminin" ' and Pullan, ' "Conversations on the Arts" '.

27 See Anne Higonnet, 'Feminine visual culture in the age of mechanical reproduction', in *Berthe Morisot's Images of Women* (Cambridge, Harvard University Press, 1992), pp. 84–122.

28 Etincelle, *Carnet d'un mondain* (Paris, Edouard Rouveyre, 1881), p. 19: 'Tous les arts sont chics – surtout la peinture'.

29 Etincelle, p. 34.

30 Etincelle, p. 31: 'Connaissances *inutiles* du plus haut intérêt'.

9

From art criticism to art news: journalistic reviewing in late-nineteenth-century Paris

MARTHA WARD

In a stunning article published in 1979, Nicos Hadjinicolaou analysed how reviewers of the Salon of 1831 described Delacroix's *La Liberté guidant le peuple*, and established that the divergences among their accounts corresponded with the political affiliations of the papers for which they wrote.[1] Yet when this method of interpreting critical reception is applied to the Paris newspaper reviewers who addressed a similarly large, ambitious painting more than a half-century later – Paul Signac's vision of an anarchist utopia, *Au temps d'harmonie* – the results are very disappointing. At least thirteen newspapers reviewed the Independents exhibition of 1895, where the painting was prominently displayed, but none described it in detail, nor, for that matter, any other work at the show. Critics remarked upon Signac's attachment to the system of Neo-impressionism. Indeed, the only remotely discerning comment came from Gustave Geffroy, who noted that the painting was made to be seen from a distance and as part of an ensemble.[2] There were no significant differences among papers of varying political orientation. In short, the method of research and interpretation that succeeded dramatically for interpreting Delacroix's reception in 1831 fails miserably for Signac's in 1895.

The utter banality of the journalistic response in 1895 would seem to make it unworthy of further art-historical consideration. These repetitive notices can lead to no positive insights about the painting or its audiences. The best that can be done with such research, it would seem, is to ask what went wrong. Along these lines, the failure of the critics to say anything interesting about *Au temps d'harmonie* might be construed as the failure of the painting to provoke them into saying something interesting, e.g., the failure of the painting to disrupt a deadening discourse that took note only of art-movement affiliations. Another option for interpreting such a reception would be to find fault not with the painting itself, but with the circumstances of its exhibition. Had Signac shown the

painting at the Salon, which generated a much larger critical response than did the Independents exhibition (one of many alternative exhibition venues that competed for publicity during the spring art season), then *Au temps d'harmonie* would perhaps have received more seriously engaged commentary, or at the very least, a description or two in the newspaper press.

Although I think there is truth in both of these interpretations of what went wrong in 1895, neither is ultimately satisfying.[3] For the failure of the journalistic critics to say anything interesting about a painting – and by that, I mean something beyond the application of a school label and a few incidental or chatty comments – is not an isolated instance in newspapers of the decade, but rather a general phenomenon. So much of the history of reception has been based on the collection of criticism about individual paintings, artists and groups, rather than on the analysis of more widespread trends in criticism as such, that phenomena like the ones I want to consider here are exceedingly difficult to situate historically or to account for accurately. Still, I want to explore the possibility that the routinisation of newspaper criticism in the 1890s can be understood to result from economic and social developments in the journalistic press. This has less to do with reviewers' responses to artists than with papers' homogenising projections of readers. The innovative formats and styles of mass-circulation dailies; the new promotional categories of the profession-alising press; the unprecedented operations of the press-clipping agencies: developments such as these altered, I think, the writing and reading of criticism. Basically, then, this article asks how the marketing of newspapers affected the production and consumption of journalistic art reviews.

I will be primarily concerned with broadly circulating papers, with writing on art for everyday readers rather than with that for art and literary journals or for the readers of, say, the *Revue des deux mondes*. Criticism flourished in these select publications at the end of the century, when many *littérateurs* despised the idea of quotidian production for a widely-read column, work which during the July Monarchy writers had already associated with, in Gautier's memorable phrase, the 'industrialisation of literature'. Yet, at the beginning of the period under consideration here, newspapers still dominated among the sources for art criticism. When, in 1880, the *Moniteur des arts* compiled a list of consequential commentary devoted to the Salon of that year, Paris newspapers far outnumbered all other types of publications, including ones devoted exclusively to art.[4] Twenty years later, it would have been more debatable whether newspapers were the primary sites – or the two Salons,

the primary occasions – for criticism that a journal servicing the art world, like the *Moniteur*, would have deemed most consequential. This is in part owing to changes in the art world, where small exhibitions proliferated, and to the transformation of the specialist press, where art periodicals multiplied. But neither of those developments explains why the criticism in newspapers so often became a matter of labels, predictable evaluations, and brief assessments of innovation.

It is a commonplace that over the course of the nineteenth century the Paris newspaper became more commercialised and the writing for it more commodified. Instead of the subscriptions and private subventions that had been the primary bases for financial support at the century's beginning, journals had come by its end to depend on advertising revenues and the street sales of daily issues. Richard Terdiman has analysed the logic that emerged with this new commercial daily as one based on the production of 'articles', each autonomous and detachable, each designed to sell itself and the paper as well. Claiming to represent the world exhaustively, the newspaper masked internal differentiation and conflict by the layout of its many texts. Like the commodity form, Terdiman argues, each article related to the social whole only through the principle of its availability to be marketed and consumed.[5] The political chronicle on the front page, the *roman-feuilleton* in the *rez-de-chaussée* beneath, the Senate debates on page two, the human-interest anecdotes on page three – all were articles bought and sold, just like the boxed-in advertising on page four. Art criticism, usually to be found between the far right of page one and the far left of page three, was no exception. While generally agreeing with Terdiman that all texts in the commercial daily were reduced to the common denominator of the 'article', regardless of their status in the symbolic economy of the newspaper's layout, I think that it is also important to understand how editors re-situated their goods to appeal to new audiences. Old senses of how to order the world across four sheets had to give way to the necessity for page-one attractions. And this was especially so at the century's end, when it became clear that mass-dailies were taking the market over. The four largest papers then – *Le Petit Journal, Le Petit Parisien, Le Matin* and *Le Journal* – would control three-quarters of the newspaper circulation in Paris by 1914.[6] By examining the place of criticism in these papers, we can gain a better sense of how production for new markets re-styled, re-positioned, and in that ineluctable way, re-valued art criticism.

Among the four mass-circulation dailies that dominated the market by the 1890s, the most ostensibly innovative in style was *Le Matin*. Founded in 1884, with a masthead framed by vignettes of telegraph poles, *Le Matin* exemplified the American-style *journalisme d'information*. Unlike older styles that relied on lengthy and anonymous front-page commentaries to set forth the paper's political positions, the new mode favored signed articles about recent events, short texts with numerous subheadings, and a single, large bold-faced headline. Reporters, gatherers of facts, replaced chroniclers, gatherers of observations. Each reader should make up his or her own mind, and accordingly *Le Matin* gave its political column each day to a journalist of different conviction. Commentary in the first seven issues progressed from the monarchist Cornély to Jules Vallès.[7]

When and where did *Le Matin* offer articles on contemporary Paris art to its readers? The annual event that had traditionally been the primary focus for art criticism, the Paris Salon, was not initially reviewed in the daily pages. Instead, the paper issued its Salon review as a de-luxe supplement, illustrated and printed on fine paper, available for twenty centimes in 1884, fifty by 1888. So the high point of the Paris artistic calendar was not only produced and priced for a more specialised audience than the readership of the daily paper, but coverage was in fact only available to the special purchaser, having been omitted from the daily *Le Matin*.[8] In later years, the Salon surfaced along the right of the front pages of *Le Matin*, but usually in incidental articles: a who's who at the *vernissage*, a humorous dialogue-critique, a short-winded tour with artists' names in bold-face for quick reference. *Le Matin* never had time for the lengthy coverage that Second-Empire papers had accorded the Salons, as when *Le Petit Journal* had allowed Edmond About to stretch his review of 1864 across thirty articles, or when the *Journal des débats* had regularly turned its *feuilleton* over to Charles Clément for eight or ten instalments. Indeed, like the *roman-feuilleton* itself, *Le Matin* dispensed with expansive criticism in favor of information.[9] In addition to the brief Salons, art dealings showed up in *Le Matin* among the human-interest anecdotes in the *fait divers*, and in various reports on government decisions, school prizes and statues' inaugurations. The majority of the art criticism was provided by the reviewer Gustave Goetschy, who covered society and gallery shows in short paragraphs, mostly on page two. Applying descriptive tags and art-group affiliations, Goetschy produced 'art news' rather than art criticism for *Le Matin*.[10] While there was a formalised similarity between political reporting and art reviewing – named reporters and named critics, making a set

of rounds, providing information quickly and succinctly – these were clearly different articles, occupying distinguishable zones in the paper's layout. Art news had its place.

Coverage of the art world was an altogether different matter in *Le Petit Journal*. The first and most successful of the populist newspapers, this was an appropriately named small-format production that led the way in France towards low priced, widely circulating dailies. Begun in 1863, when no paper sold more than 50,000 copies, *Le Petit Journal* attained a circulation of around one million in 1890.[11] It was credited with spreading throughout provincial France a new and homogenised culture, one designed for small *propriétaires*, peasants, and the *petite bourgeoisie*.[12] Initially aiming to be a popular version of the élite culture produced in Paris journals of the Second Empire, *Le Petit Journal* learned to avoid the ultra-Parisianism of papers like *Le Figaro*, to stay far from the boulevardism of an Albert Wolff and the publicity he gained by exploiting his insider's position in the art world. (Wolff, in the early 1880s, miraculously scooped the story of the Salon, publishing a 'Salon complet' on the front page of *Le Figaro* the same day as the *vernissage*, before critics were supposed to have been admitted to the show. He awarded medals in his reviews, and the accord between his recommendations and the jury's subsequent selections reportedly convinced readers that he controlled the outcomes.)[13] *Le Petit Journal* also avoided the American-style *journalisme d'information* as exemplified by *Le Matin*. The Independents' exhibition of 1895 was not 'news' in *Le Petit Journal*. Nor were many of the decade's other small shows.

Aside from brief news notices about such matters as competitions at the Ecole des Beaux-Arts, recent auctions and arts administration decisions, Paris art regularly appeared only once a year in the columns of *Le Petit Journal*, at the time of the annual Salon, and then remarks were brief. The review of the Salon of 1880, for instance, simply listed the paintings and sculptures to see.[14] Located above the *roman-feuilleton*, the recommended inventory of the Salon filled the entire upper two-thirds of the front page, a space that *Le Petit Journal* usually gave over to a single chronicle: brutal murder, political scandal, recent avalanche, patriotic sacrifice. In the tract so often charged with drama and sentiment, a Salon list must have seemed a staid account, perhaps an obligatory cultural item, and this probably continued to be the case in later years when the exhibition was discussed in this space in a personalised and heart-felt manner under the collective pseudonym Thomas Grimm. Occasionally the paper carried a separate three- or four-part review on page two. *Le Petit Journal*'s attachment to the Salon and

its relative neglect of the expanded calendar of small Paris shows cannot simply be explained as an avoidance of what was novel in urban culture, for later such activities as cinema appeared in its pages. Instead, contemporary Paris art seems to have lost ground over a half-century as the paper evolved to meet readers' tastes and interests in other domains. *Le Petit Journal* retained the Salon as 'the' fine-arts story of the year.

Although it had been established in 1876, *Le Petit Parisien* began to approach mass circulation only after 1888, when it was taken over by Jean Dupuy. His moderate Republican politics and enthusiasm for sports helped to reshape the paper's contents and expand its circulation. Designed partly to appeal to a working-class audience in the industrial regions of north-eastern France, *Le Petit Parisien* reached 600,000 readers by 1896.[15] During this decade, it usually printed on page two or three a lengthy inventory-like review of the Salon by the paper's chronicler and drama critic, Paul Ginisty. Although the Salon was thus often a second-page event, some arts-related stories provided *Le Petit Parisien* with front-page articles. From early February to early May 1895, for instance, the pseudonymous Jean Frollo discussed in the paper's central forum the problem of what should become of many past portraits of national leaders, and on another occasion, the merits of a recent petition that Paul Chenavard's plans for *Philosophie de l'histoire* at the Pantheon be executed.[16] Discussions such as these, considering art in relation to national traditions and public spaces, warranted consideration in the front-page chronicle of *Le Petit Parisien*. Second-page material during this same period in 1895 included a piece on the participants in the Orientalists' exhibition at Durand-Ruel.[17] *Le Petit Parisien* did not review the Independents' exhibition in April, 1895, and indeed the paper addressed very few of the shows during these months, the height of the Paris art season. So like *Le Petit Journal*, which it resembled in being a mass-daily designed to sell to the lower classes in the provinces as well as those in Paris, *Le Petit Parisien* had little place in its pages for new art *venues*. But more than its fellow 'petit', *Le Petit Parisien* evaluated art articles according to the traditional hierarchical format: depending on the story, it appeared somewhere between national interest at the top right of page one and the amusing *fait-divers* at the bottom of page three.

Le Journal, last in circulation among the '*journals à grands tirages*', reached around one-half million readers by 1900. It was founded in 1892 by Fernand Xau, a journalist and the impresario for the trip that Buffalo Bill's circus made through France. Xau wrote that he wanted to unite the new *journalisme d'information* with the

'purely literary', a refinement necessary for the French sensibility which never could be satisfied, he claimed, with 'dry reporting'.[18] His paper would bring 'within the reach of shopkeepers, workers, teachers, and clerks a little literature ... the set menu at a reduced price'.[19] Deliberately eclectic in its selection of stories and novels, *Le Journal* carried two *feuilletons* after 1905: one for élite literary tastes, the other for popular consumption.[20] Politics as traditionally practiced in the *grands journaux*, with discussion of doctrinal positions infusing current events, was notably absent in *Le Journal*, whose front page displayed an unprecedented mixing of news, criticism and fiction.

As one would expect from this strategy, *Le Journal* foregrounded the arts, extensively covering the Salon and picking up on the many smaller Paris shows as well. It regularly employed such writers as the immensely popular journalist, novelist and critic, Octave Mirbeau, one of whose sensationalised articles for *Le Journal* featured a discussion about mysticism in recent art with a returned-from-the-dead Botticelli.[21] Such arresting art and literary criticism made it to the front page and indeed, sometimes occupied the upper left column, a space usually reserved for political chronicles in *journaux d'opinion*.[22] But while literature and art were meant to compensate for dry reportage, *Le Journal* had its own deadening routines in these domains. Such was Gustave Geffroy's review of the Independents' exhibition of 1895, a brief account which aimed only to state schools' innovations and individuals' evolutions. This review appeared on page two as did much comparable material, fillers in the output of a critic, awaiting more exciting events.

Although it had its share of dross and routine, *Le Journal*, among the mass-dailies, most up-ended the traditional hierarchies. *Le Matin* had initially dispensed with the *feuilleton* and, along with it, literature and the Salon. But *Le Journal* might be said to have expanded the *feuilleton* all over the front page and along with it, literature and criticism. Here it was less a matter of where culture might fit in with the world than where the world might fit in with culture, whether it be sensationalised or routinised.

This survey of the places of art criticism in mass-circulation dailies has dealt with a period in French newspaper history that can conveniently be bracketed and characterised by two events. On the one side, the press laws passed by the Republicans in 1881 abolished political censorship as well as the right of the government to require, when deemed necessary, that certain texts be printed. This meant, as Raymond Manevy has pointed out, that the reader could be represented for the first time as the sole judge of what should be included in newspaper columns, inaugurating a new

period of freedom and experimentation in press design.[23] On the other side, beginning around 1901, developments in rotary printers allowed papers to expand to include up to eight or sixteen pages.[24] The four-page format had been the norm for over a century, and its abandonment not only meant that a greater diversity of interests could be accommodated, but that contents would be radically rearranged: by the 1920s, sports might begin at the center of page one, be continued on page six and conclude on page eight. Within this broader perspective, the last two decades of the nineteenth century emerge as a time when many dailies appealed to new readers but did so by adjusting formats that were still traditionally designed, and thus symbolically charged. If literature came to occupy a slot where politics belonged, it was the sign of a new market, a new reader.

Whether criticism was an obligatory set-piece hauled out once a year for the day's principal chronicle (*Le Petit Journal*), a sensational report in the page-one political tract (*Le Journal*), or another form of information on page two (*Le Matin*), the mass-circulation dailies re-calibrated journalistic art criticism. If the commentary on the Independents' exhibition of 1895 and similar shows is a fair indication, reviews seem overall to have lost out in the process, as a number of papers assimilated *Le Matin*'s tendency to report on smaller shows as 'art news'.[25] The *journalisme d'information* became the root of all evil for those who pronounced and lamented a decline in the art of criticism. Writing in 1888 about the new *journalisme d'information*, Emile Zola claimed that it had destroyed discussion in newspaper articles and literary criticism.[26] Jules Antoine similarly complained in *Art et critique* in 1889:

> Art criticism has been really sick for several years. The causes of this decrepitude are numerous and diverse: the intrusion into criticism of dealers in second-hand goods, the coteries organised to champion a group cause, the ferocious bidding for the slightest advertisement, and above all, the transformation of the contemporary newspaper whose need for rapid information forces the best-intentioned critics only to skim the surface of subjects that they would with more time have studied thoroughly.[27]

Littérateurs blamed the banality of criticism on the rapid production required by *journalisme d'information*. But this style was, as we have seen, only one development among others that contributed to the changing orientations (and the low-intensity) of criticism in mass-circulating papers.

Readers were newly represented as controlling the content of papers in the age of mass-circulation, but an increasingly self-conscious

journalistic corps had its own motivations, categories and interests that affected criticism during this period. One of the apogees of the French newspapers in terms of circulation growth, the late nineteenth century was also a pivotal moment in the press's professionalisation; journalists formed syndicates and associations, published a compendium of trade information and engaged in other activities that helped to promote self-awareness and standardisation among participants.[28] Begun in 1879, the *Annuaire de la presse française* was a massive compilation of data gathered primarily by questionnaire. It published its first rosters of Paris critics in 1891, with subheadings for theatre, literature, music and art. The first list of art reviewers included 22 papers. By 1893 there were 80, and by 1900, 126.[29] The *Annuaire* positioned critics in a section that also contained press syndicates and associations, and in fact, by 1899, a syndicate for art reviewers and the art press had been founded, and by 1902, a syndicate for Paris critics. These facts suggest a rapid growth among the ranks of reviewers and an increasingly self-interested promotion of the professional rubric of the 'critic'. My question is how these developments might be linked with the banality of newspaper art commentary during this decade.

A preliminary point. It might seem that the increasing number of positions for art critics was not a matter of professional promotion but rather a direct response to the proliferation of Paris art exhibitions during this period. That is, because there was more 'news' to cover, as more exhibitions were mounted and the art season grew longer, the income of the critic became more stable. Indeed, the average 1890s newspaper critic does seem to have discussed far more shows than did the typical mid-century reviewer. The latter's fare might have included the yearly Salon exhibition, competitions at the Ecole des Beaux-Arts, government decisions about the arts, new decorative or architectural ensembles in Paris, and recent art books. In contrast, the critic at *La Bataille* wrote in 1890 that he was beginning to find his task quite impossible, and he packed an article with statistics to make his case. He had calculated that the number of new works of art to be exhibited in Paris during the coming spring would amount to well over 15,000, and he hammered home the point that this was far too many for a single critic to see, much less review.[30] Yet the multiplication of shows may actually have served to justify the art critic's position at the newspaper, not on his own terms, but by bringing his position more into line with that of the theatre critic. Regularly producing a column for page three or four, printed near the performance advertisements, the theatre critic had throughout the century been the single reviewer most essential to the newspaper; he was closely

linked with gathering advertising revenues, often doubled as a publicity agent, sometimes sold favorable notices in his columns, and usually claimed to have more performances to review than was possible.[31] It is not surprising that in the promotional listings of *Annuaires* of the 1890s, theatre critics should outnumber art reviewers three to one. The press's general promotion of the rubrics of critics, for both theatre and art, may thus have neatly coincided with the increase in the number of shows in the art world. In any case, the art reviewer now became, at many upstart as well as established papers, a standard feature, an advertised asset, a professionally posted position.

In comparison to the sporadic journalism of mid-century criticism, when the Salon was the major and perhaps only review, the regularised production in the 1890s of many small articles no doubt made the tasks of the newspaper-reviewer even less appealing than it already was to those authors who aspired to compose distinguished commentary. Writing on the Salon had a long and prestigious history, one that was becoming readily available at the end of the century. (Several of Mérimée's Salons appeared in 1880, a collection of Diderot's in 1883. Compilations of criticism by a spate of early realist supporters followed: Castagnary in 1892, Thoré in 1893, and Champfleury in 1894.) The many shows that might occupy the art critic in the 1890s required a different sort of production, a routine more uncomfortably close than ever to the 'industrialisation' of writing. When Albert Wolff abandoned lengthy Salons in the early 1880s and began to issue one-day 'Salons complets', the novelist and critic Gustave Toudouze complained that reasoned consideration no longer entered into criticism, for Wolff's articles had become like those of the drama critic, who dashed off comments on the same night as the performance. The long descriptions that Théophile Gautier had offered in his reviews of Second-Empire Salons, Toudouze continued, were far preferable to Wolff's hasty rulings: better to portray a painting than to snap a judgement.[32] The press's professionalisation offered more opportunities for reviewing and thus stabilised the art critic's position by bringing it more into line with the theatre critic's, but the frequency of the articles and their brevity, even when addressing the Salon, surely lessened the position's appeal to those who aspired, say, to write the rival-successors to Diderot's Salons.

Who wrote journalistic art criticism at this time? I have sought to characterise reviewers very broadly by considering the expertise of those who wrote on the Salon of 1892, insofar as expertise can be suggested by their book publications.[33] As can be seen in table 1, around one-fourth of the identifiable critics published books on

Table 1. Newspaper art critics, 1892*

Total: 50 (does not include anonymous reviewers)
Did not publish books: 16
Not identified: 17

Publications	number	% overall
Art-related subjects	11	22
Collections of art criticism	4	8
Literature	28	56
History	4	8
Politics and social concerns	6	12
Economics	0	0
Agriculture	0	0
Religion	2	4

* See n. 33 for sources.

art-related subjects at some time during their career. Those subjects were, in declining order of popularity: artist's monographs, art museum guides, travel guides, prefaces for dealers' or collectors' catalogues, art histories and essays. Nearly one-tenth of these authors were such specialists that the great majority of their books were about art. This latter set also tended to write for art reviews, and most held art-related positions during their careers, either teaching art history or serving in the arts administration.[34] (Writing about art was one means to advance one's chances for such employment, a situation recognised in the early 1880s by the young poet Jules Laforgue, who noted with irony that he should produce 'works on art to become in my country some civil servant or other, at the Louvre or in a ministry.'[35]) However, most of the book-writers among the critics in 1892 published some works on art and some on other subjects, especially literature, which here includes theatre, poetry, novels and criticism of these genres. Outside the general categories of art and literature, the critics shared few publishing interests.

One tendency stands out from this rough profile of art critics in 1892: despite the press's construction of the category of 'art critic' in its professional annual, for most writers serving in such capacities in 1892, the subject of art was, if not insignificant, then at least not a very central part of their life's *oeuvre* or their identity as book-publishing authors. Thus there was a slippage between the professional (and promotional) categorisation advanced by the press, on the one hand, and the authorial reputations or pursuits

of those who filled its ranks, on the other. While the press sought for its own reasons to further the establishment of art criticism as a regular position and a credible specialisation, most of the writers did not orient their independent production along these lines.

To what extent do the profiles of reviewers in 1892 suggest that older patterns of employment continued, even as professional groups advanced the representation of the 'art critic'? A comparison of the critics who reviewed the Salon of 1892 with those who did so in 1863 (a year chosen for the relative completeness of its bibliography among Second-Empire shows) reveals that the earlier *salonniers*

Table 2. Newspaper reviewers of the Salon, 1863*

Total: 31 (does not include anonymous reviewers)
Did not publish books: 8
Not yet identified: 8

Publications	number	% overall
Art-related subjects	10	32
Collections of art criticism	3	10
Literature	11	35
History	7	23
Politics and social concerns	7	23
Economics	2	6
Agriculture	1	3
Religion	2	6

* Data taken from Christopher Parsons and Martha Ward, *A Bibliography of Salon Criticism in Second Empire Paris* (Cambridge University Press, 1986), pp. 94 – 119.

were more likely to have published in the fields of history, politics, economics and religion. Rather than being 'Renaissance men', each writing in many areas, this was an anomalous lot of authors, collectively approaching criticism from a variety of fields.[36] And this distinction seems to have continued into the 1890s, even as literary names came to dominate the rosters of reviewers.[37]

The routinised aspect of much journalistic criticism in the 1890s, then, would not seem to result from any particular specialisation or expertise among those who wrote it, even though they had as a group narrower authorial interests than did Second-Empire reviewers. Instead, the banality of the reviews probably owed less to the individuals who took the job than to what the job had become by virtue of its professionalisation and promotion: namely, an

assignment to deliver quick reviews on a round of events. In short, to hack.

Just as the mass-circulation newspapers and the new *journalisme d'information* worked to change the content of criticism, so another initiative in newspaper publishing and information distribution – the press-clipping agency – altered how art news was received, read, evaluated and preserved. These developments did not affect 'everyday readers', but exhibiting artists, who were transformed by the new enterprises into steady consumers of their own reception. Sent by wire services and prepared by press-clipping agencies, exhibition news came from all directions, and its systematic collection must have seemed, to artists, to meet their need to keep track of an increasingly internationalised market for French contemporary art. Owing to the new technologies and services, reviews now circulated far from their original place of publication and the readers whom they were meant to address. A new trade developed for articles of criticism, now scissored free from the newspaper's hierarchical layout of the world, its reviewing routines and page-one attractions.

It was in the 1880s that savvy French artists began to subscribe to Paris press-clipping services. Although generalised clipping agencies flourished in the 1870s,[38] specialised channels for artists developed only later, typically offering to relay to the subscriber all of the reviews that mentioned his work at a particular exhibition. The first of the French agencies tailored to artists was started in 1879 by the enterprising Alfred Chérié, editor of the *Moniteur des arts*, who promoted his 'L'Argus de la presse' with the claim that clippings would allow artists to thank critics for support in Salon reviews and to keep track of their reputations worldwide.[39] Several years later, E. Bonneau, associated with a rival paper, the *Journal des artistes*, began a comparable service with offices in London and Paris and extended exhibition coverage beyond the Salon to a range of contemporary shows.[40] This was the agency that the Impressionists preferred. 'Le Lynx', under the direction of the Paris *littérateur* Charles Virmaître, went beyond the usual newspapers, art reviews and *journaux des lectures* to canvass French *avant-garde* publications like the *Revue indépendante*. The appeal of these services was such that in the late 1880s the young and ambitious painter Georges Seurat subscribed to all three agencies, the better to keep watch on his reputation.[41]

Press-clipping agencies edited and, in that sense, determined the content of criticism. Subscribers were often not sent entire articles but just the section or sentence that included their names, so criticism arrived as a 'sound-bite', a line of praise or fault.

Together with the effects that the *journalisme d'information* was thought to have had on the writing of reviews, the practices of the press-clipping agencies minimised the potential for types of commentary that might once have allowed journalistic criticism to be an interface between audiences and artists, reviewers and readers, a public forum. Artists saw their name clipped from around the world, clips without intertextual connection, and without contextual tie to place of publication. The exchangeability of critical 'articles' in this new market could scarcely have been clearer.

Just as the press-clipping agency altered the ostensible purpose of criticism, making it not a review for a reader but publicity for an artist, so during this same period artists recycled commentary about themselves for promotional purposes. Rarely had the endorsement value of criticism been so obviously manipulated. Take, for instance, the series of publications planned in 1883 by the Galerie des Artistes Modernes, a Paris-based venture which joined exhibition and publication initiatives. The Galerie issued de-luxe monographs on living artists as a subscription series, a series that was supposed in the end to amount to an illustrated dictionary of contemporary art. Quotations from various critics' comments served as captions for each reproduction. Introductions profusely cited reviewers who were described as the 'most authorised'.[42] The publications of the Galerie des Artistes Modernes displayed the authority that critical evaluations of the right sort were recognised to have in establishing artists' reputations, especially with the dealers and collectors who might have displayed these volumes. And just as obviously, this series that was to constitute a definitive dictionary showed that even art criticism dashed off for quotidian consumption might emerge from the waste-bin or the press-clipping archive to find a place in history alongside the artist, a part of his life and work.

It hardly seems coincidental that during this period, which saw critics' commentary instated in artists' monographs, and publicity accordingly converted into history, the great bibliophile Maurice Tourneux should compile what was probably the first substantial historical monograph of a nineteenth-century artist's reception: *Eugène Delacroix devant ses contemporains*. Tourneux justified this study of an artist's press, a year-by-year sampling of critical commentary, with these remarks:

> Today now that Delacroix has been definitively accepted, is it really necessary to revive the traces of these extinguished polemics? What can one show, after all, by going to newspapers, whose titles we don't know, to get the opinions of men whose names we've never heard? ... Yet I don't think that it's useless, if these endeavours document at what price the immortality of a true artist has been acquired.[43]

Similarly, criticism at this time provided much of the ballast in the most popular form of amateur art writing, the artist's monograph. Whatever it was that critics did in artists' monographs – write an appreciative passage so beautiful that it was worth quoting; recognise the genius of the artist so early on that it should be commended; defend an aesthetic courageously, polemicise needlessly, miscomprehend grotesquely – the critic was seen to act in relation to the artist principally and his readers secondarily. The inclusion of excerpts from reviews in the narration of the artist's travails and triumphs worked to restrict the historical sphere within which criticism was seen to be effective and to leave relatively unexamined the connections of criticism with other domains and practices. Overall, the writing of monographs, the publishing initiatives of contemporary artists, and the practices of the press-clipping agency were mutually supportive.

The artist's monograph and the painting's archive have continued to be the dominant forms for the collection and interpretation of nineteenth-century art reviews. What has not often been observed in recent critiques of these familiar uses of criticism, and what I have tried to bring out here, is that these were shaped in a period when the value of the critical article was being brought home through a variety of practices, including the press-clipping agency. The bulk of the commentary in publications like the Galerie des Artistes Modernes was from élite journals, but much of the support for the recycling of these materials as comments about artists rather than reviews for readers came from the commercial initiatives of the press and its networks for marketing information.

From the early to late 1880s, Paul Signac pasted and numbered in scrapbooks the texts he received from press-clipping services: it was an archive and a monograph in the making by a young painter.[44] By the time he showed *Au temps d'harmonie* at the Independents' exhibition in 1895, however, Signac had ceased to record his reception. He must have found the great bulk of the journalistic commentary on his work in the 1890s as I have found it to be: remarkable only for its redundancy and, dare I say it, hardly worth reading. Signac's abandoned scrapbook project provides a poignant image with which to close this paper, for it shows how various of the developments I have described might conjoin in an historical instance. Thus, just at the time that journalistic criticism began to be systematically disseminated to artists, it became increasingly routinised by mass-circulation papers and the press's professionalising rubrics.

Signac may well have kept several of the evaluations of *Au temps d'harmonie*, particularly the two discussions that appeared in the

literary and artistic journal, *La Revue blanche*. One of these was a highly formalistic appreciation by Thadée Natanson; the other, by Henry Van de Velde, was a more politically based assessment published on the occasion of the painting's exhibition at La Libre Esthétique.[45] Both reviews were of the sort likely to be valued by people in Signac's milieu. Both have since become part of monographs on the artist and bibliographies of *Au temps d'harmonie*. As for what was written for the everyday reader in 1895, the painter saw no reason to preserve it for his own history. What place that material might now assume is uncertain, for it fails to count in ways that would interest contemporary art historians, except, perhaps, as just that: failure.

Notes

1 Nicos Hadjinicolaou, ' "La Liberté guidant le peuple", de Delacroix devant son premier public', *Actes de la recherche en sciences sociales*, no. 28 (June 1979), pp. 3–26.

2 Gustave Geffroy, 'Petits Salons', *Le Journal* (11 April 1895).

3 For a fuller discussion of these aspects of the reception of *Au temps d'harmonie*, and a bibliography of reviews, see my forthcoming book, *Pissarro, Neo-impressionism and the Spaces of the Avant-Garde* (University of Chicago Press).

4 'La Tribune des artistes devant la presse', *Moniteur des arts* (30 April, 24 May, 4 June, 1880). Of the 89 publications listed, only three were not published in Paris. The following is the breakdown of the remaining 86 into categories of publication:
 political daily: 55
 beaux-arts: 10
 'lectures': 9
 women, family, youth: 2
 comic: 4
 education: 1
 races, hunting, games: 2
 theatre: 2
 catholic: 1
 I have adapted these categories from Henri Le Soudier's *Annuaire des journaux* (Paris, Soudier, 1881).

5 Richard Terdiman, *Discourse/Counter-Discourse: The Theory and Practice of Symbolic Resistance in Nineteenth-Century France* (Ithaca, Cornell University Press, 1985), p. 127. Terdiman's primary concern is with how such autonomous articles serve to empty out any logic of connection and rationalise disjunction in the representation of the world, a process he finds analogous to commodification.

6 Claude Bellanger *et al.*, *Histoire générale de la presse française*, vol. 3 (Paris, Presses universitaires de France, 1972), p. 297.

7 Bellanger, *Histoire*, vol. 3, p. 309, n. 3.

8 *Le Figaro* also issued an illustrated Salon supplement in 1884, but included a review on the front page of its daily paper. Its Salon supplement became a regular publication the following year. *Le Petit Journal* began issuing an illustrated supplement in 1884, but not on the Salon. On supplements, see Bellanger, *Histoire*, vol. 3, pp. 303 – 4.

9 The abandonment of the *feuilleton* was short-lived; by 1900, *Le Matin* was publishing three of them each day.

10 See, for example, 'Au cercle Volney', *Le Matin* (2 April 1888).

11 Bellanger, *Histoire*, vol. 3, p. 300.

12 Michael B. Palmer, *Des Petits Journaux aux grandes agences: Naissance du journalisme moderne* (Paris, Aubier, 1983), pp. 23ff.

13 Gustave Toudouze, *Albert Wolff: Histoire d'un chroniqueur parisien* (Paris, Victor Havard, 1883), pp. 317 – 27.

14 'Le Salon de 1880', *Le Petit Journal* (2 and 6 May 1880).

15 Bellanger, *Histoire*, 307; Palmer, *Des Petits Journaux*, 16. See also Micheline Dupuy, *Un Homme, un journal: Jean Dupuy 1844 – 1919* (Paris, Hachette, 1959).

16 See 'Doyen des peintres', and 'Vieux Portraits et vieilles statues', *Le Petit Parisien* (21 February and 1 March 1895 respectively).

17 'Les Orientalistes', *Le Petit Parisien* (26 February 1895).

18 Palmer, *Des Petits Journaux*, p. 89.

19 'À la portée des petits commerçants, des ouvriers, des instituteurs, des employés un peu de littérature ... la table d'hôte à prix réduit'; as quoted by Bellanger, *Histoire*, vol. 3, p. 314.

20 Raymond Manevy, *L'Evolution des formules de présentation de la presse quotidienne* (Paris, 1956), pp. 35 – 7.

21 Octave Mirbeau, 'Botticelli proteste!', *Le Journal* (4 – 11 October 1896); rpt. Mirbeau, *Des artistes* (Paris, Union générale d'éditions, 1986), pp. 234 – 50.

22 Manevy, *L'Evolution*, p. 39.

23 Manevy, *L'Evolution*, p. 28.

24 Bellanger, *Histoire*, vol. 3, pp. 93 – 4.

25 As in the case of *Le Journal*, adoption of the *journalisme d'information* did not always affect the various contents of the paper equally. Consider *La République française*. This paper, which had been called the 'Journal des débats' of democracy because of its long and spirited explorations of issues, adopted the *journalisme d'information* in the mid-1880s. Defenders argued that shorter articles were better suited to the quick reading necessitated by modern society (Palmer, *Des Petits Journaux*, pp. 99 – 100). While the politics on the front page rather dramatically changed appearances, art criticism was seemingly unaffected. Philippe Burty, and after his death Edouard Hubert, continued to write lengthy evaluations of various art exhibitions. This practice suggested that strong support for individual initiatives in the arts was the paper's policy. (Such support was in fact frequently articulated by Burty in the name of the paper's founder, Gambetta.)

26 Zola, Preface to *La Morasse* (Paris, 1888), p. iii; as quoted by Palmer, *Des Petits Journaux*, p. 92.

27 'Depuis quelques années, la critique d'art est bien malade. Les causes de cette décrépitude sont nombreuses et diverses: l'intrusion dans la critique de brocanteurs honoraires, les cotories organisées en vue de la défense quand même du petit groupe, le quémandage féroce de la moindre réclame, et, par-dessus tout, la transformation du journal contemporain dont le besoin d'information rapide force les mieux intentionnés à ne faire qu'effleurer des sujets qu'avec plus de temps ils eussent approfondis.' Jules Antoine, 'La Critique d'art', *Art et critique* (June 1889); as quoted by Jean-Paul Bouillon in *La Promenade du critique influent* (Paris, Hazan, 1990), p. 200.

28. On the professionalisation of journalism, see Marc Martin, ' "La Grande Famille": L'Association des journalistes parisiens (1885 – 1939)', *Revue historique* vol. 275 (1986), pp. 129 – 57. Also on professional organisations, see Chantal Georgel, *Les Journalistes*, Paris, Editions de la Réunion des musées nationaux (1986), pp. 19 – 21; series, Les Dossiers du Musée d'Orsay, no. 5. Raymonde Moulin has commented suggestively on the professionalisation of art criticism in *Le Marché de la peinture en France* (Paris, Minuit, 1967), p. 155.

29 Henri Avenel, *Annuaire de la presse française* (Paris, 1891, 1893, 1900).

30 Aubry Vézan, *La Bataille*, 3 January 1890.

31 It was well known that at smaller newspapers, the drama critic doubled as the dealer for theatre publicity in the paper. The critic sold advertising space in several parts of the paper for varying rates; for a higher price, he sold favorable mentions in his review or among the gossipy titbits of the theatre chronicle. In return for each type of transaction, the critic got from the paper a set commission. The provision of drama reviews for publicity revenues helped to consolidate the drama critic's position as a journalistic mainstay. See J. Bezard-Falgas, 'La Presse', in *La Grande Encyclopédie* (Paris, 1900), p. 591. See also Theodore Zeldin, *France 1848 – 1945: Taste and Corruption* (Oxford University Press, 1980), p. 170.

32 Toudouze, *Albert Wolff*, p. 319.

33 Who filled the ranks of these newly promoted positions is rather difficult to determine, for it turns out that the lists of critics in the *Annuaire* are quite unreliable. The lack of correspondence between the names in these rosters and the names signing criticism in small papers suggests that editors were hard pressed to complete the questionnaire about staffing. To establish an alternative to the *Annuaire*, I have compiled a bibliography derived from references in artists' monographs and my own research on the papers indexed in contemporary brochures for journal subscription (see appendix). I drew from the detailed bibliographies in Monique Le Pelley Fonteny's *Léon Augustin Lhermitte (1844 – 1925): Catalogue raisonné* (Paris, Editions Cercle d'art, 1991), and supplemented these with my research on the lists in Henri Avenel's *Annuaire de la presse française* (Paris, 1892), and in Henri Le Soudier's *Annuaire des journaux* (Paris, Soudier, 1892). Le Soudier's publication is a guide for those wishing to subscribe to Paris journals, and is one of the only efficient means for establishing a representative table of the French press in any given year. (Similar guides were published in the Second Empire, beginning with the firm of Schulz and Thuillié: *Catalogue des journaux publiés à Paris en ...*, 1854 – 1869.) My tabulations of book publications were based on the *Catalogue générale des livres imprimés de la Bibliothèque nationale*, 221 vols. (Paris, 1897 – 1981).

34 Gustave Vapereau, *Dictionnaire universel des contemporains* (Paris, 1893); and Anon., *Qui êtes vous?* (Paris, 1908). On the social origins and educational formations of art historians, including the observation that they tended to write art criticism, see Marie-Claude Genet-Delacroix, 'L'Enseignement supérieur de l'histoire de l'art (1863–1940)', in *Le Personnel de l'enseignement supérieur en France aux XIXe et XXe siècles* (Paris, Editions du Centre national de la recherche scientifique, 1985), pp. 79–107. She further develops these subjects in 'Art, histoire et politique en France: 1870–1940', *Sources*, no. 26 (1992), pp. 25–42.

35 'Ouvrages d'art pour devenir, dans mon pays, un fonctionnaire d'art quelconque, au Louvre ou dans un ministère.' Jules Laforgue, *Oeuvres complètes*, vol. 4 (Paris, 1925), p. 179.

36 Neil McWilliam has discussed the backgrounds of art critics in the first half of the nineteenth century: 'Opinions professionnelles: critique d'art et économie de la culture sous la Monarchie de Juillet', *Romantisme*, no. 71 (1991), pp. 19–30. See also the sociological profiles of journalists constructed by Marc Martin, 'Journalistes parisiens et notoriété (vers 1830–1870): Pour une histoire sociale du journalisme', *Revue historique*, vol. 266 (1981), pp. 31–74.

37 This survey differs in emphasis and categorisation from James Smith Allen's analysis of the profiles of literary reviewers, but may ultimately be compatible with it. Considering reviewers from 1800 to 1940, he found that the occupational structure of the critics remained remarkably homogeneous and stable: 'The vast majority of reviewers were professional writers, journalists especially, the rest of whom supplemented their income in business or the professions by turning out occasional reviews for a newspaper or literary journal. By the turn of the century, critics seem to have shared a common professional outlook that clearly distinguished their style of reading new works.' (Smith, *In the Public Eye: A History of Reading in Modern France, 1800–1940* (Princeton University Press, 1991), p. 107.) See also *idem*, 'Critics in Search of a Text: Book Reviewers as an Interpretive Community in Modern France', in Gordon C. Bond (ed.), *Proceedings of the Annual Meeting of the Western Society for French History*, vol. 18 (Auburn University, 1991).

38 The history of the press-clipping agency can be deduced from the listings in the *Annuaire de la presse française*. As is clear from those lists, a number of specialised '*correspondances*' had developed by the 1890s, including ones for subscribers of various religious and political affiliations.

39 A. Chérié, 'Correspondance des artistes', *Moniteur des arts* (30 April 1880).

40 See the advertisement in *Journal des artistes*, 5 January 1883.

41 The observation about Seurat is based on the press-clipping tags still appended to documents in his collection, now in the Bibliothèque d'art et d'archéologie, Paris.

42 Of a large series of planned monographs, only three were published. See Bernard Prost, *Octave Tassaert: Notice sur sa vie et catalogue de son oeuvre* (Paris, L. Baschet), 1886. For a similar venture, see G. Haller, *Nos Grands Peintres* (Paris, Goupil, 1899), which includes an extensive anthology of criticism concerning Gérôme, Henner, Lefebvre and Detaille. The supplements published by *Le Figaro* on the Salon also included quotations from various critics about the works illustrated.

43 'Aujourd'hui que Delacroix est définitivement accepté, est-il bien nécessaire, dira-t-on, de raviver les traces de ces polémiques éteintes? Que prétendez-vous nous démontrer en allant emprunter à des journaux, dont nous ignorons les titres, l'opinion de gens dont nous n'avons jamais su les noms? Sans me faire plus d'illusion qu'il ne convient sur la valeur de mes trouvailles, je ne crois pas qu'il soit inutile de montrer à quel prix s'acquiert la véritable immortalité.' Maurice Tourneux, *Eugène Delacroix devant ses contemporains* (Paris, Jules Rouam, 1886), p. viii.

44 I am grateful to Mme Françoise Cachin for allowing me to examine the collection of criticism kept by Paul Signac.

45 Natanson, 'L'Art des salons', *La Revue blanche* n.s. (1895), p. 422. Henry Van de Velde, 'La Peinture au troisième salon de la libre esthétique', *La Revue blanche* n.s. (1896), p. 286. Signac recorded his own satisfaction with the reception accorded the painting: diary entry of 26 April 1895, in John Rewald, ed., 'Extraits du journal inédit de Paul Signac', *Gazette des Beaux-Arts* 6e pér., vol. 36 (July – September 1949), p. 118.

Appendix: Paris newspapers reviewing the salons of 1892

Autorité: 'Mécène'
Avenir national: O. de Gourcoff
Bataille: Camille de Saint-Croix
Clairon: Arsène Alexandre
Cocarde: Anon.
Constitutionnel: Etienne Bricon
Courrier républicain: Paul Jousset
Courrier de Paris: Cacardo
Courrier du soir: de Basselan
Croix: Georges-Claudius Lavergne
XIXe Siècle: Marcel Fouquier
Echo de France: Tavernier
Echo de Paris: Armand Silvestre
Echo républicain: Anon.
Eclair: A. Alexandre
Estafette: A. Hustin
Evénement: A. Privat
Figaro: Octave Mirbeau
Fin de siècle: René Emery
France: Etienne Bricon
Gazette de France: Louis de Meurville
Gaulois: Louis de Fourcaud
Gils Blas: René Maizeroy
Indépendant français: Paul Viteau
Intransigeant: H. A. Degeorge
Journal des débats: A. Michel & Anon.
Justice: Gustave Geffroy
Laterne: Anon.
Libéral: Anon.
Liberté: Anon.
Libre Parole: P. Bacout & P. Pascal
Matin: Gustave Goetschy
Monde: Henri Dac
Monde illustré: O. Merson

Moniteur universel: R. Doumic
Mot d'ordre: Anon.
Nation: Anon.
National: P. Marcieux
Nouvel Echo: Pepin d'Ars
Observateur français: Henry Cuénot
Paix: Flamans
Paris: Arsène Alexandre
Parti national: Alfred Ernst & Flamans
Parisien: de Basselan
Patrie: P. Japy
Patriote: André Marty
Pays: Jean de Polane
Petit Journal: Anon.
Petit Moniteur universel: H. Lemaître
Petites nouvelles: Anon.
Petit Parisien: Anon.
Petite Presse: Firmin Javel
Petite République française: Henri Pellier
Presse: A. de la Pérelle
Public: Roger Marx
Radical: P. Hensy
Rappel: Charles Fremine
République française: Paul Bluysen
Siècle: Roger-Milès
Soir: Roger-Milès
Soleil: Alphonse de Calonne
Télégraphe: M. de Fontissant
Téléphone: H. Chapoy
Temps: Anon.
Univers illustré: Robert Vallier
Verité: R. A.
Voltaire: Roger Marx

10

The relative autonomy of art criticism

DARIO GAMBONI

Where should one place the limits when studying 'art criticism' as an institution in nineteenth-century France? Philippe Junod has proposed a distinction between two interpretations of the term. In a narrow sense, 'art criticism' applies to a specific literary genre that appeared in France in the eighteenth century, at the moment when public exhibitions were once again regularly organised, and of which the *Salons* of Diderot can be considered a paradigm. In a broad sense, it designates any commentary of a contemporary or past work of art, encompassing other literary genres such as poetry, fiction, biography, essays, correspondence or diaries.[1]

In this second sense, 'art criticism' amounts to what Julius von Schlosser called *Kunstliteratur*, that is, all 'secondary, indirect, written sources'.[2] In a theoretical and methodological *mise au point* about the study of the relationship between art and literature, Jean-Paul Bouillon made a provisional list of the 'categories' of texts included in this 'art literature', referring to the names of well-known authors as examples: 'the press articles and the dictionary entry, the art chronicle (Burty, Geffroy), the exhibition review (the *Salons*), the museum guide, the travel account, the monograph (Champfleury, Goncourt), the historical study (Thoré, Chesneau), the polemical text (Silvestre, Mirbeau), the manifesto (Duranty, Courbet, Manet), the collection of aphorisms (Dolent), the novel on art (Burty, Goncourt, Zola), the art novel, ... the art correspondence (Pissarro, Van Gogh, Cézanne)'.[3]

Authors considered as 'art critics' have contributed to all of these categories, and there are not only personal but institutional and functional links that exist between the *Salon* – or the exhibition review in general – and the other genres. In fact, the very boundaries that separate the narrow and the broad definitions of art criticism are themselves permeable, vague and even polemic. As definitions they are not only a matter of academic argument, but were at stake in contemporary practice and theory. Therefore, in

order to understand the structure of nineteenth-century art criticism, we have to take into account the entire 'art literature' of the period.

A tripolar typology

This is, of course, a very heterogeneous ensemble, made up of all kinds of texts, authors and publications, and dealing with very different topics. Its analysis needs a typology, or rather typologies.

In an unpublished study of the description of art works in Paris in 1890, Catherine Lepdor distinguished between two conceptions of art criticism each associated with contrasted publications, socially defined collaborators, and distinct market positions. On one hand, a 'scientific' one, calling for objectivity and precision, defended by connoisseurs, teachers and administrators of the fine arts such as Georges Lafenestre, Eugène Müntz, Louis Courajod and Paul Mantz in prestigious and stable journals such as *La Revue des deux mondes* and *La Gazette des Beaux-Arts*. On the other, a literary notion, claiming a right to subjective expression in the tradition of Baudelaire's 'poetic criticism',[4] practised by young independent writers like Albert Aurier and disseminated in the small, self-financed and mostly ephemeral symbolist periodicals.[5] Rather than thinking of these 'scientific' and 'literary' models as well-defined entities, I want to consider them as poles, and add a third, the 'journalistic' pole, developed in particular by professionals of the press in the daily newspapers. My hypothesis is that during the nineteenth century, and particularly in its latter half, as a result of the expansion of the press and a transformation in the system of diffusion and consecration of art, art criticism in France went through a process of professionalisation.[6] It is at this point that the journalistic pole gained dominance, the scientific pole became specialised as 'art history' dealing, in principle, with the art of the past, and the literary pole was marginalised into a form of 'pure literature'.

Evidence of such a typology and its chronological framework can be found in late-nineteenth- and early-twentieth-century statements on art criticism. In 1893, in order to stress the exceptional critical qualities he attributed to Joris-Karl Huysmans, Roger Marx admitted that 'l'heure présente ne manque ni d'historiens érudits, ni de reporters à l'affût de l'actualité, ni de chroniqueurs séduisants et diserts'.[7] Here Marx's 'erudite historians' evokes the scientific pole, the 'reporters on the lookout for the present interest' the journalistic one, while the 'charming and voluble chroniclers' point both to the literary pole (due to the importance placed on language) and to the journalistic one (embodied in the chronicle). In 1903,

Camille Mauclair, remarking that 'many artists have despised the profession because of the professionals', voluntarily exluded the journalistic pole by declaring that 'l'idée du critique est presque pareille à celle du poète, et mixte entre celle du poète et du savant'.[8]

While this tripolar scheme may be used as a guideline, more precise typologies are needed in order to analyse the range of authors, publications and objects of criticism, both synchronically and diachronically. This last aspect is closer to the 'categories of text' already mentioned, but requires further distinction. One finds in the press, for instance, reviews of one-person shows as well as of group exhibitions, or of groups of exhibitions or *salons*, alongside interviews, inquiries, retrospective examinations of the work of one or several artists, necrologies, programmatic definitions of groups or movements, contributions to aesthetic, historical or political debates, and so forth. These more or less well defined genres, with their own norms and chronologies, are mutually structured by elements of hierarchisation, among which the oppositions between the general and the particular, the permanent and the ephemeral, play an important role.

A typology of publication vehicles should take into account their periodicity (from the daily newspaper to the book), their degree of specialisation, their print run and diffusion, and the socio-political composition of their writers, financial backers and publics.[9] Here again, elements of division and hierarchisation can be traced, based on partially divergent and conflicting principles. Critics of the 'literary' type tended to postulate the superiority of the book, and J.-K. Huysmans progressively renounced writing reviews in favour of essays. Mauclair, who deplored that 'the present interest be the constant pretext of criticism', advised the 'intelligent' critic to 'consider the articles as many fragments of a future book', so that at the end of the year he may only need to 'rid them of the paragraphs pertaining to the passing event'.[10] But an artist deeply interested in art criticism such as Odilon Redon, while at the same time regretting the inherent limitation of exhibition reviews to the ephemeral and the particular, could in 1878 hail the *revues* as a 'new form of the book' and regret only their specialised audience.[11]

As far as authors are concerned, the main fact is that during the nineteenth century, art criticism was neither a full-time nor lifelong employment. The concentration of public (and particularly journalistic) attention on the official Salon made it a seasonal occupation until the 1890s when, thanks to the appearance of several salons and the visibility obtained by galleries and private exhibitions, a regular commentary on artistic life could find a place in the press.[12] Nor was the practise of art criticism – like that of journalism in

general – prepared by any specific professional training. It should be all the more illuminating to compare the educational and the occupational systems and trajectories of the various authors, along with their social origins and institutional affiliations. Who came to write art criticism, how and when? Apart from this activity, did critics work in other ways for the press (for example with literary, theatrical or music criticism)? Did they write poetry, fiction or drama, essays on history, literary or art history; did they teach, act as museum or administration officials, collaborate with dealers, create works of art themselves? The multiplicity and the – sometimes – synergetic effect of the critics' activities have rarely been taken into account to interpret their writing and influence.[13]

In 1903, Mauclair described (negatively) 'the critic' at the commercial and institutional heart of the art world: 'He is connected with the dealers, indirectly negotiates purchases and sales. He intrigues for official charges, the Fine Arts inspectorate, the insignia, the participation in the State commissions'.[14] The systematic (even if partial and provisional) inquiries of Neil McWilliam and Martha Ward yield more complex results. According to McWilliam, art criticism was not only a seasonal but often a temporary or even exceptional endeavour: of some 800 critics traced under the Second Empire, fewer than 5% wrote more than four reviews of the Salon between 1852 and 1870, and more than 50% wrote only one.[15] In a sample of 59 critics active during the first decade of the Second Empire, some 57% were journalists, a category partially overlapping that of professional writers (37%); 23% were artists (generally minor ones), and 14% functionaries, mostly in the cultural administration.[16] Comparing the types of books published by the 80 art critics listed in the *Annuaire de la presse française* in 1893 with those of the 91 authors of reviews of the Salon of 1859, Ward observes a feeble yet growing specialisation in artistic matters and a majority of writers treating both artistic and literary subjects (42% with books on literature in 1893).[17]

The field of art criticism

As these data show, the task of confronting the immense body of 'art literature' and making a large part of it more easily accessible has fortunately begun to be addressed.[18] The fact has generally been regretted, or denounced in this context, that previous 'policies' of publication and examination of art-critical sources should have depended mainly on their ease of access, the literary 'quality' granted to the texts, and the literary fame of their authors.[19] This appears of course tendentious and restrictive in light of present

needs and aims, but the meaning of this mechanism of selection is worth clarifying: during a period that may be drawing to an end, the conservation and transmission of the art criticism of the past depended more on literary piety, criticism and history than on art history.

This academic double dependence derives from the dual nature of art criticism and from its intermediary position. From a semiotic point of view, art criticism is linked to the iconic as well as to the verbal system and is reputed to connect the two. In sociological terms, art criticism can be located at the intersection of several fields, foremost the artistic and the literary ones.

The concept of 'field' was developed by Pierre Bourdieu to define the relatively autonomous social spaces that human activities, among which cultural ones, progressively formed, in a process in which the nineteenth century represents a crucial stage.[20] This fundamentally dynamic view helps us understand the essential interdependence which unites the diverse conceptions and positions coexisting in such spaces, as well as the conflicts opposing them around principles of hierarchy and the delimitation of borders – in our case, questions of what was 'true' or 'the best' art criticism, and where it stopped. One may thus consider nineteenth-century 'art criticism' as a field of its own, and try to analyse its structure and evolution – the structure being but a temporary state in an ever-evolving transformation. But one of its major traits was a particularly low degree of autonomy, and a strong submission to the attraction of the other fields meeting and overlapping inside it.

The most visible attraction was that of the literary field, of which the aforementioned selection of the corpus is only a more or less indirect testimony. This influence of the literary model and of literary men – women remaining an exception[21] – was particularly strong and durable in France, as has often been noted.[22] It was not limited to art criticism but extended over the whole artistic field and the press. At the turn of the century, an embittered Paul Gauguin thought it thus justified to denounce in his *Racontars de rapin* a monopoly exercised by the *gens de lettres* over the main key positions in the art institutions: not only of art critic, but of inspector and of director of the Fine Arts, of curator and of director of museums.[23] As for the press, Chantal Georgel has remarked that an essential link united French journalism and the literary world in the first three quarters of the nineteenth century, provoking 'astonishment and admiration among foreign observers', and that it became looser during the last decades.[24]

Belonging to a field defined a certain number of specific interests – symbolic as well as material – that contributed to shape action.

In the context of a study of Odilon Redon's relation to writers and literature, I have tried to identify the interests resulting from the 'decadent' and symbolist art critics belonging to the literary field, from their position inside this field, and from the position of art criticism as a genre and activity within it.[25] The last one was to some extent ambiguous. Fundamentally, it was marginal or even inferior, because of the association with the *littérature industrielle* of the press[26] and of the importance of an extra-linguistic referent; but the cultural prestige of the fine arts (particularly painting) and the example of famous writers made it appear as a way to enter literature as well as to make a living.[27]

A similar analysis – always diachronic as well as synchronic – should be made of the position of art criticism within the field of the press and the artistic field, in order to identify the interests associated with these positions. What could writing – and what kind – of art criticism mean for a journalist (with the distinction made between political and cultural journalists and, among the latter, between critics of the fine arts, of literature, of theatre and of music), for an inspector of the fine arts, for a university or an academy teacher? How could their respective trainings, possibilities and expectations contribute to the definition of their conception and practise of art criticism? How was the influence of the political field transmitted (for instance by the organisation of the press) and reinterpreted inside the field of art criticism?

These multiple affiliations did not necessarily preclude all possibility of a specific kind of interest at stake in writing art criticism, that could contribute to uniting (even if in a competing way) the various sorts of critics. Such an aim was the 'authority' obtained as a result of the currency gained by a critic's choices and judgements and – a parallel to the obligation of novelty in artistic production – of the priority of these judgements.

In 1885, J.-K. Huysmans (pseudonymously) hailed his own art-critical achievement in this perspective: he had been the first to 'explain seriously' the impressionists, to give Degas his rightful place, to point out Raffaëlli and to launch Redon.[28] Eight years later, Roger Marx noticed that the value of Huysmans' writings had been first recognised in the case of his art criticism and explained that 'le temps a rempli ici l'office de consécrateur, ... en confirmant un à un les verdicts rendus'.[29] In this sense, the discovery of the 'genius of the future', defined by Anita Brookner as a major trait of French art criticism up to Huysmans,[30] probably constituted a goal or at least an ideal common to most critics. But a still more fundamental stake was the very principle of the right to exercise the power of criticism.

Power and competence

There are other links than time between the critic's individual judgement and the collective consecration which retrospectively transmutes it into 'authority'. The power bestowed upon art critics, criticised and caricatured since the second half of the eighteenth century,[31] became ever more visible as it grew during the nineteenth century. In 1829, Delacroix pretended to plead the critics' cause before his fellow-artists, recalling that even when critics injured them, they thus revealed their existence to the world.[32] In 1890, contemplating a century of Salon criticism, Philibert Audreband wrote in L'Art that 'très réellement, un salonnier en renom distribue, à la manière d'un dieu, la gloire et le dédain, la réputation et l'oubli, la vie et la mort';[33] Mauclair spoke of a 'discretionary power'.[34]

Harrison and Cynthia White have shown that during the second half of the nineteenth century, a new system of diffusion and consecration of art (called 'dealer-critic system'), based on a free market of economic and symbolic values, progressively replaced the traditional Academy- and State-ruled system.[35] The central role and increased power that the new system bestowed upon art criticism sharpened the dispute over the legitimate right to exercise it, as the expansion of the press did for journalism in general. The various groups and individuals involved – in relation to the already mentioned origins and affiliations – competed to promote or impose the definition of art criticism (of its nature, its value, its methods and its 'function' or 'mission') corresponding to their own conception and capacities; a definition bound to give them a dominant or hegemonic position in its field. Important contributions to this debate took the form of elements of a theory of art criticism, that remain to the present day scattered in the critical writings of the period – another evidence of the lack of autonomy of art criticism, as an object of research.[36]

By using the categories I propose, the criteria of competence put forward in this debate could be classified as being primarily of a linguistic or of a referential nature, and as corresponding more to a literary, a scientific or a journalistic conception of art criticism. On the one hand they included, for example, the ability to write (beautifully) as such, to create a verbal equivalent of the visual work, to reconstruct its intention on a discursive plane,[37] or to explain its subject-matter with the help of literary sources, and, on the other, connoisseurship and art historical knowledge, a familiarity with technical and formal problems, a keeping abreast of artistic news or a direct access to the artists' own statements.

A radical attitude was adopted by artists who tried to revive the old notion of their exclusivity in matters of critical competence. James Abbott McNeill Whistler took law and the public to witness when in 1878 he sued John Ruskin for libel, and declared art criticism an unnecessary evil in *Whistler vs. Ruskin. Art and Art Critics*;[38] his thesis was known in France, where Mallarmé translated his *Ten O'Clock* in 1888. It was explicitly to prove the same point that Emile Bernard later founded and published his own periodical, *La Rénovation esthétique*.[39]

But the function of 'revealing [the artists'] existence to the world' and of 'distributing ... life and death' was indispensable and could not be fulfilled by the artists themselves. Pierre Bourdieu has defined it as the 'production of value', stressing the fact that modern works of art are not produced by their authors alone but through a collective process requiring the collaboration of the whole artistic field.[40] A caricaturist could thus ridicule the exception taken by Courbet to the refusal of his works at the Universal Exposition of 1855 and the organisation of his own parallel exhibition as a derisory self-coronation,[41] and Mallarmé reproached the jury of the Salon in 1876 for not having been able to declare Manet 'a self-created pontiff, charged by his own faith with the cure of souls'.[42] The taboo of self-consecration was also to enable the New York conservative critic Royal Cortissoz to write at the beginning of the twentieth century that 'the art critic may be forgiven if he smiles at the Whistlers of this world, with their *ipse dixits* as to who shall and who shall not open his mouth about painting'.[43]

Therefore, despite the element of antagonism in their relations, artists and critics were mutually dependent and even supportive. The dispute over questions of jurisdiction and competence, a corollary of the absence of any absolute authority after the collapse of normative aesthetics, brought all protagonists together and gave evidence of a relative autonomy. Yet the relativity is shown again in the fact that the opposite radical position, postulating the self-sufficiency of art criticism, was less frequently expressed. It was brilliantly formulated by Oscar Wilde in 1891, as an implicit answer to Whistler.[44] Five years later, Charles Maurras defended in comparable terms the 'dignity' of literary criticism by stating that criticism, dealing with literature rather than the world, was an even purer creation than literature itself.[45]

In 1903, Camille Mauclair proposed in his turn to consider 'true and beautiful' art criticism as creation and possibly an art.[46] But his plea for a 'new criticism' sounded like a nostalgic defense of the old literary model (criticism 'should be an object of pride for the writers, they should be as proud of a beautiful piece of criticism

as of a beautiful poem') against the predominance of the professional journalists, whom he tried to ridicule as *'articliers'*, *'occupants de rubrique'* and *'feuilletonistes patentés'*.[47] By then, journalism had begun to be regarded and organised more systematically as a profession;[48] academic art history was defining its own territory, and the purist insistence on each art's specificity made intersemiotic and referential practises, in literature as well as in painting, all the more peripheral.

Notes

1 Ph. Junod, 'Critique d'art', in *Petit Larousse de la peinture*, vol. 1 (Paris, Larousse, 1979), pp. 405 – 10. For the 'specific literary genre' of art criticism, see Albert Dresdner, *Die Entstehung der Kunstkritik (Die Kunstkritik. Ihre Geschichte und Theorie. Erster Teil* (Munich, Bruckmann, 1915), p. 11), where it is defined (in relation and contrast to art judgement, art history and art theory) as 'the autonomous literary genre, the object of which is the study, valuation of and influence upon contemporary art'. The present article is an updated version of a paper delivered in 1990 at the 78th annual congress of the College Art Association in New York, a first version of which was published in French in *Romantisme* (vol. 21, No. 71 (1991), pp. 9 – 18).

2 J. von Schlosser, *Die Kunstliteratur. Ein Handbuch zur Quellenkunde der neueren Kunstgeschichte* (Vienna, Scholl, 1924), pp. 1 – 2.

3 J.-P. Bouillon, 'Mise au point théorique et méthodologique', in *Revue d'histoire littéraire de la France* (November – December 1980), pp. 880 – 99 (p. 897).

4 Wolfgang Drost, 'Kriterien der Kunstkritik Baudelaires. Versuch einer Analyse', in Alfred Noyer-Weidner (ed.), *Baudelaire: Wege der Forschung*, vol. 283 (Darmstadt, Wissenschaftliche Buchgesellschaft, 1976), pp. 410 – 42 (pp. 410 – 12).

5 C. Lepdor, *Ekphrasis 1890. Fonctions et formes de la description dans le commentaire d'art* (mémoire de licence, University of Lausanne, June 1989). An exception to this ephemerality was the *Mercure de France*.

6 While the importance of this process for the very nature of art criticism is now generally recognised, its precise history remains to be traced. Important elements can be found in particular in recent studies by Richard Wrigley, 'Censorship and anonymity in eighteenth-century French art criticism', in *Oxford Art Journal*, vol. 6 (1983), no. 2, pp. 19 – 28; 'Appelles in Bohemia', in *Oxford Art Journal*, vol. 15 (1992), no. 1, pp. 92 – 107; *The Origins of French Art Criticism: the Ancien Régime to the Restoration* (Oxford University Press, 1994), and by Susan L. Siegfried, 'The politicisation of art criticism in the post-revolutionary press' (chapter 1 in this volume) for the eighteenth and early nineteenth century; by Neil McWilliam, 'Opinions professionnelles: critique d'art et économie de la culture sous la monarchie de Juillet', in *Romantisme*, no. 71 (1991), pp. 19 – 30; 'Presse, journalistes et critiques d'art de 1849 à 1860', to appear in *Quarante-huit/Quatorze*, for the second third of the century; and by Martha Ward, 'From art criticism to art news: journalistic reviewing in late-nineteenth-century Paris', chapter 9 in this volume) for the last decades.

7 R. Marx, *J.-K. Huysmans* (Paris, Kleinmann, 1893), p. 9.

8 C. Mauclair, 'La mission de la critique nouvelle', in *La Quinzaine* (1 September 1903), pp. 1 – 25 (pp. 15 and 13).

9 The political aspect is particularly important in the press, but also particularly complex, and has often been oversimplified. Censorship laws like those of 1800 could also be decisive and make at times 'the criticism of culture [serve] as a surrogate for the free expression of political opinions (Siegfried, 'The politicisation of art criticism'; for a comparable phenomenon under the July Monarchy and the Second Empire, see McWilliam, 'Presse, journalistes et critiques d'art'.

10 Mauclair, 'La mission' (p. 23). Neil McWilliam has noted that already in the 1850s, the publication or republication of reviews in the form of books is becoming common practise ('Presse, journalistes et critiques d'art').

11 O. Redon, *A soi-même. Journal* (1867 – 1915). *Notes sur la vie, l'art et les artistes* (Paris, Corti, 1961), p. 66.

12 Pierre Vaisse, 'Avant-propos', in *Romantisme*, no. 71 (1991), p. 4; P. Vaisse, 'Salons, expositions et sociétés d'artistes en France 1871 – 1914', in Francis Haskell (ed.), *Atti del XXIV Congresso Internazionale di Storia dell'Arte*, vol. 7: *Saloni, Gallerie, Musei e loro influenza sullo sviluppo dell'arte dei secoli XIX e XX* (Bologna, Cooperativa Libraria Universitaria Editrice, 1981), pp. 141 – 51.

13 D. Gamboni, *La Plume et le pinceau. Odilon Redon et la littérature* (Paris, Minuit, 1989), pp. 79 – 84. On the passage from art criticism to official functions in the administration in the 1880s, see Michael R. Orwicz, 'Anti-academicism and state power in the early Third Republic', in *Art History*, vol. 14, no. 4 (December 1991), pp. 571 – 92 (pp. 584 – 5).

14 Mauclair, 'La mission', p. 5.

15 N. McWilliam, 'Opinions professionnelles', p. 23. The figures are based on Christopher Parsons and M. Ward, *A Bibliography of Salon Criticism in Second Empire Paris* (Cambridge University Press, 1986), and do not take into account anonymous and pseudonymous reviews.

16 McWilliam, 'Presse, journalistes et critiques d'art'. The number of data needed to analyse professional activities as well as their overlapping character compels one to treat these figures more cautiously: the 59 critics represent only the 62% of identifiable names in an alphabetical sample (A – H) designed to make use of the *Dictionnaire de biographie française*; yet the results were found to coincide generally with those of Marc Martin's research on journalism ('Journalistes parisiens et notoriété (vers 1830 – 1870). Pour une histoire sociale du journalisme', in *Revue historique*, vol. 266 (1981), no. 1, pp. 31 – 74).

17 Ward, 'From art criticism'.

18 See in particular the series of bibliographies of Salon Criticism published by Cambridge University Press (N. McWilliam. Pascale Méker. Vera Schuster and Richard Wrigley, *A Bibliography of Salon Criticism in Paris from the Ancien Régime to the Restoration 1699 – 1827*, 1991: N. McWilliam, *A Bibliography of Salon Criticism in Paris from the July Monarchy to the Second Republic 1831 – 1850*, 1991; Parsons and Ward, *A Bibliography*; J.-P. Bouillon (ed.), *La critique d'art en france 1850 – 1900* (Saint-Etienne, Université de Saint-Etienne (Travaux LXIII), 1989); J.-P. Bouillon, Nicole Dubreuil-Blondin, *et al.* (eds), *La promenade du critique influent. Anthologie de la critique d'art en France 1850 – 1900* (Paris, Hazan, 1990).

19 See for example Bouillon, 'Mise au point', pp. 889, 892, 893, and Parsons and Ward, *A Bibliography*, p. 1.

20 See P. Bourdieu, 'The production of belief: contribution to an economy of symbolic goods', in *Media, Culture and Society*, vol. 2, 3 (July 1980), pp. 261–93, reprinted in *Media, Culture and Society, A Critical Reader* (London, Sage Publications, 1986), pp. 131–63; 'The genesis of the concepts of habitus and field', in *Sociocriticism*. Theories and Perspectives II, no. 2 (December 1985), pp. 11–24; and recently, *Les règles de l'art. Genèse et structure du champ littéraire* (Paris, Seuil, 1992).

21 N. McWilliam found only two women in his global sample of 94 critics (see note 16).

22 See recently P. Vaisse, 'Avant-propos', p. 5. Harrison C. and Cynthia A. White explain this particularity with reference to the academic doctrine and the mode of education: 'As remains true to the present day, an educated Frenchman felt himself qualified to write on any subject – and most particularly on the arts. The conception of art as a learned profession, fostered by the Academy, had placed it within the range of topics upon which a learned man might discourse.' (*Canvases and Careers: Institutional Change in the French Painting World* (New York, London and Sydney, Wilney & Sons, 1965), p. 10).

23 P. Gauguin, *Racontars de rapin* (Paris, Falaize, 1950) (written in 1903, 1st edition 1919).

24 C. Georgel, *Les journalistes*, Paris, Réunion des musées nationaux (Dossiers du musée d'Orsay, 5) (1986), pp. 8, 20–1.

25 Gamboni, *La plume et le pinceau*, pp. 70ff.

26 Sainte-Beuve, 'De la littérature industrielle', in *Revue des deux mondes*, vol. 3 (1839), pp. 675–91.

27 See Marx, *Huysmans*, and, for the same observation about criticism and journalism in general, McWilliam ('Opinions professionnelles', p. 22), who states that for people like Sainte-Beuve, Gautier, Berlioz or Jouffroy, writing as critics in the press could even 'consolidate the reputation they had already acquired in other domains of intellectual production and enable them to rise to the rank of recognised arbiters of cultural values' (p. 19).

28 A. Meunier [J.-K. Huysmans], *J.-K. Huysmans* (Paris, Vanier (*Les Hommes d'Aujourd'hui*), 1885), republished in J.-K. Huysmans, *En marge* (Paris, Losage, 1927), p. 59.

29 Marx, *Huysmans*, p. 8.

30 A. Brookner, *The Genius of the Future. Studies in French Art Criticism. Diderot – Stendhal – Baudelaire – Zola – The Brothers Goncourt – Huysmans* (London, Phaidon, 1971).

31 See in particular the criticism of art criticism developed by Charles-Nicolas Cochin (*Lettre à un amateur en réponse aux critiques qui ont paru sur l'exposition de tableaux. Salon de 1753*, 1753; *Les misotechnites aux enfers ou examen des observations sur les arts par une société d'amateurs* (Amsterdam, 1763, reprint Geneva, Slatkine, 1970), which I thank Philippe Junod for bringing to my attention; and Wrigley, 'Appelles in Bohemia'. On the image of art criticism and art critics and its polemical dimension, see my article 'L'image de la critique d'art, essai de typologie', in *Quarante-huit / Quatorze*, in print.

32 Eugène Delacroix, 'Des critiques en matière d'art', in *Revue de Paris* (May 1829), vol. 2, p. 68 (reprint Caen, L'Echope, 1990).

33 P. Audreband, 'Pages d'histoire contemporaine. Les salonniers depuis cent ans', in *L'Art* (1890), t. 49, pp. 237–8, quoted in Lepdor, *Ekphrasis 1890*, p. 42.

34 Mauclair, 'La mission', p. 4. Neil McWilliam mentions a play entitled *L'Ecole des journalistes*, published in 1839 by Delphine Gay, the wife of the owner of newspapers Emile de Girardin, in which an incompetent and irresponsible art critic provokes the suicide of an aging and talented painter ('Opinions professionnelles', p. 25), and an article of 1864 by Théophile Silvestre ('La Critique d'art', in *Les Artistes français* (Paris, 1926), vol. 2, p. 3) which notes the obvious antipathy of artists against journalists claiming to be experts in painting ('Presse, journalistes').

35 H. and C. White, *Canvases and Careers*.

36 See my article 'Critics on Criticism: A Critical Approach', in Malcolm Gee, ed., *Art Criticism since 1890 – Authors, Texts, Contexts* (Manchester University Press, 1993).

37 Thus Gustave Kahn praised Roger Marx for understanding 'what the painter or the sculptor would have done, had he been acquainted with another mode of translating thought' ('Roger Marx', in *Mercure de France* (October 1898), pp. 43–52).

38 Reproduced in J. Whistler, *The Gentle Art of Making Enemies* (New York, Dover, 1967) (1st ed. London, 1890); see Linda Merrill, *A Pot of Paint. Aesthetics on Trial in 'Whistler v Ruskin'* (Washington and London, Smithsonian Institution Press, 1992). On the renewed debate about the specificity of the visual arts and their relation to literature in the last decades of the nineteenth century, see Gamboni, *La plume et le pinceau*, and James Kearns, *Symbolist Landscapes. The Place of Painting in the Poetry and Criticism of Mallarmé and his Circle* (London, The Modern Humanities Research Association, 1989).

39 See for instance Francis Lepeseur, 'Sur la critique', in *La Rénovation esthétique* (June 1906); MaryAnne Stevens, 'Bernard as a Critic', in *Emile Bernard 1868–1941. A Pioneer of Modern Art. Ein Wegbereiter der Moderne*, exhibition catalogue (Mannheim and Amsterdam, Zwolle, Waanders, 1990), pp. 68–91.

40 P. Bourdieu, 'Lettre à Paolo Fossati à propos de la Storia dell'arte italiana', in *Actes de la recherche en sciences sociales*, no. 71 (January 1980), pp. 90–1.

41 Bertall, 'A la fin de son Exposition universelle, Courbet se décerne à lui-même quelques récompenses bien méritées, en la présence d'une multitude choisie, composée de M. Bruyas et son chien', in *Journal amusant* (12 January 1856), reproduced in *Courbet selon les caricatures et les images, documents réunis et publiés par Charles Léger, préface de Théodore Duret* (Paris, Rosenberg, 1920), p. 35, and in Patricia Mainardi. *Art and Politics of the Second Empire. The Universal Expositions of 1855 and 1867* (New Haven and London, 1987), p. 119.

42 Stéphane Mallarmé, 'The Impressionists and Edouard Manet', in *The Art Monthly Review* (30 September 1876), republished in *Documents Stéphane Mallarmé I* (1968), and in Penny Florence, *Mallarmé, Manet and Redon. Visual and Aural Signs and the Generation of Meaning* (Cambridge University Press, 1986), pp. 11–18 (phrase quoted p. 12).

43 R. Cortissoz, *Personalities in Art* (New York and London, Scribner, 1925), pp. 5ff.

44 O. Wilde, 'The Critic as Artist', in *Intentions* (London, Methuen, 1919) (1st ed. 1891).

45 C. Maurras, 'Essai sur la critique', in *Revue Encyclopédique*, vol. 6 (1896), pp. 969–74.

46 Mauclair, 'La mission', p. 11.

47 Mauclair, 'La mission', p. 15.

48 Associations were founded since the 1870s, and the Ecole supérieure du journalisme created in 1899; yet the professional status of the journalists remained ambiguous, the first legal clarification being voted in 1935 only (C. Georgel, *Les journalistes*, pp. 19–21). The Syndicat de la presse artistique française was also founded in 1899; typically, it included curators, experts, historians, collectors and artists writing occasionally as well as journalists – the more selective *Syndicat professionnel des critiques d'art* appearing only in 1936 (Raymonde Moulin, *Le marché de la peinture en France*, 2nd ed. (Paris, Minuit, 1967), p. 155).

Index

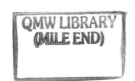